FEROCIOUS AMBITION

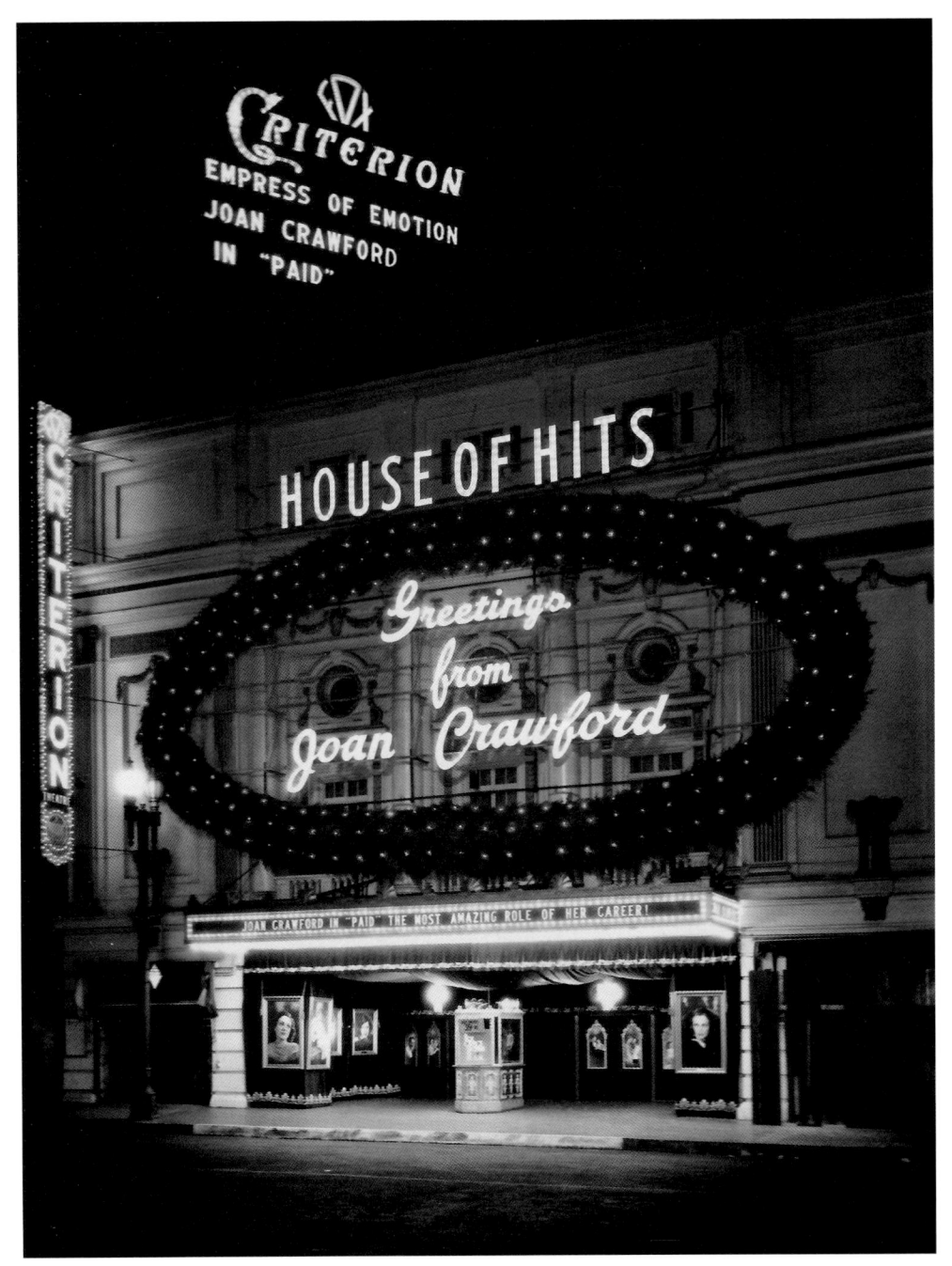

The Criterion Theater in Los Angeles posted Christmas greetings from Joan Crawford in December 1930 while her film *Paid* was the featured attraction.

FEROCIOUS AMBITION

Joan Crawford's March to Stardom

ROBERT DANCE

UNIVERSITY PRESS OF MISSISSIPPI / JACKSON

The University Press of Mississippi is the scholarly publishing agency of the Mississippi Institutions of Higher Learning: Alcorn State University, Delta State University, Jackson State University, Mississippi State University, Mississippi University for Women, Mississippi Valley State University, University of Mississippi, and University of Southern Mississippi.

www.upress.state.ms.us

Designed by Peter D. Halverson

The University Press of Mississippi is a member of the Association of University Presses.

First printing 2023

∞

Library of Congress Cataloging-in-Publication Data

Names: Dance, Robert, 1955– author.
Title: Ferocious ambition : Joan Crawford's march to stardom / Robert Dance.
Description: Jackson : University Press of Mississippi, 2023. | Includes bibliographical references and index.
Identifiers: LCCN 2023014319 (print) | LCCN 2023014320 (ebook) | ISBN 9781496846518 (hardback) | ISBN 9781496847478 (epub) | ISBN 9781496847485 (epub) | ISBN 9781496847492 (pdf) | ISBN 9781496847508 (pdf)
Subjects: LCSH: Crawford, Joan, 1908–1977. | Motion picture actors and actresses—United States—Biography.
Classification: LCC PN2287.C67 D36 2023 (print) | LCC PN2287.C67 (ebook) | DDC 791.4302/8092 [B]--dc23/eng/20230711
LC record available at https://lccn.loc.gov/2023014319
LC ebook record available at https://lccn.loc.gov/2023014320

British Library Cataloging-in-Publication Data available

DEDICATION

To Robert Loper

CONTENTS

ACKNOWLEDGMENTS

The following friends and colleagues encouraged and assisted me while I wrote this book: Richard Bekins, Margery Cantor, Scarlet Cheng, Suzy Colt, Simon Crocker, Prudence Crowther, Barbara Dau, Derek DeWitt, Eve Golden, Kathy Hart, Peter Hawkins, Cheryl Hurley, David Huss, Amelia Kahl, Roger Mitchell, Valerie Nelson, Kelly Pask, Richard Rand, Pete Peterson, Christina Polischuk, Scott Reisfield, Furio Rinaldi, Michael Selleck, Bruce Siddons, and Sandy Walcott.

Crawford's legacy continues to be sustained by websites devoted to her life and career. The following have assisted me over the years: "Legendary Joan Crawford," "Joan Crawford Heaven," "The Best of Everything: A Joan Crawford Encyclopedia," and "The Concluding Chapter of Crawford."

The team in Jackson—Craig Gill, Emily Bandy, and Courtney McCreary—have worked hard to make this book. Special thanks to ace designer Pete Halverson, who has employed his magic for the third time in a row.

Peter Tonguette is both a gifted film historian and copyeditor.

My gratitude is owed to Joanna Rapf who generously gave me access to her grandfather's papers and photographs, and who provided an exquisite editorial touch.

FEROCIOUS AMBITION

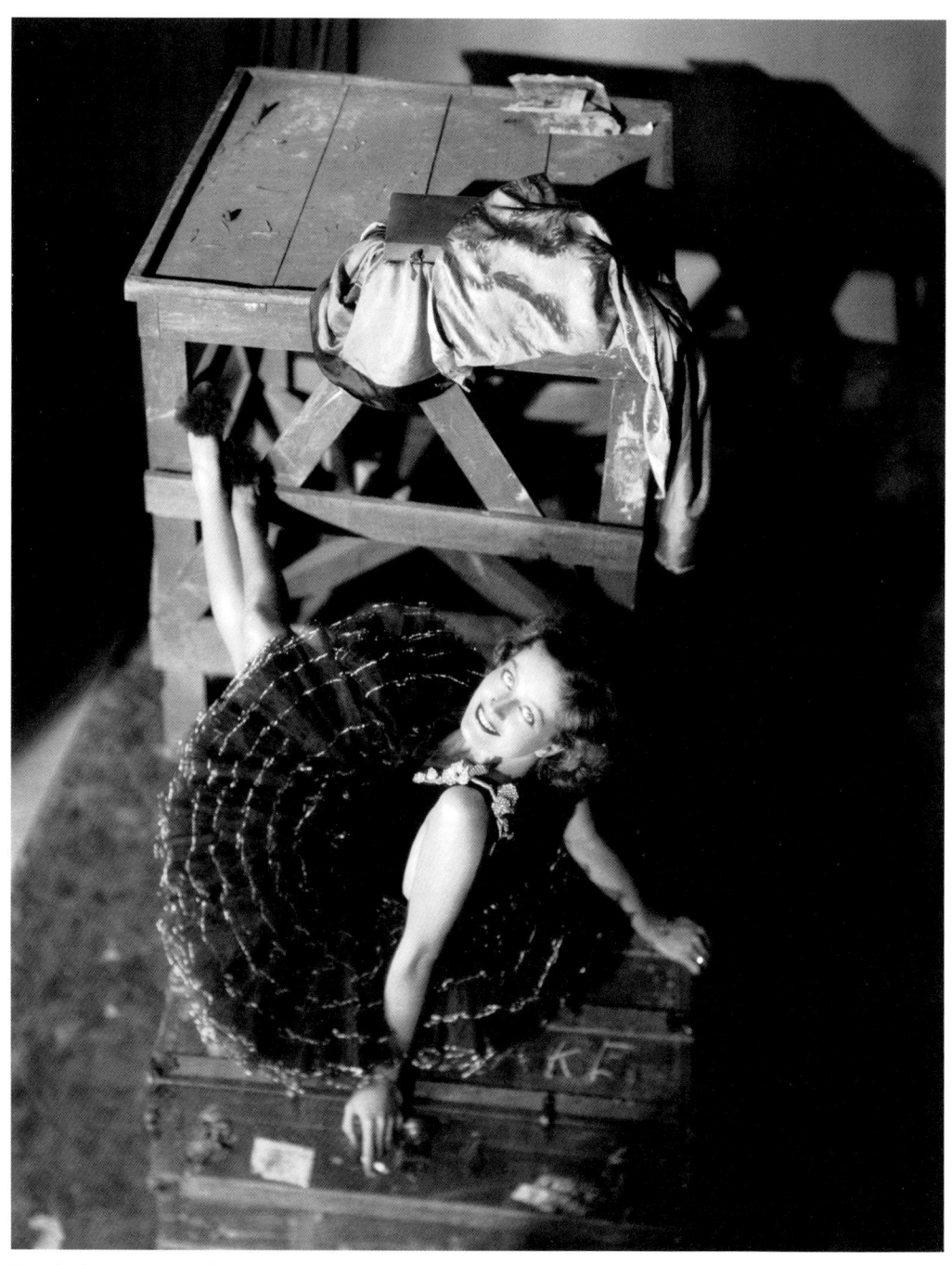
Crawford was a newly minted star when she posed for Ruth Harriet Louise in October 1929. John Kobal Foundation.

Introduction

WHY DOES JOAN CRAWFORD'S LIFE AND CAREER DESERVE A re-evaluation almost a half century after her death? She was among the motion picture elite who reached the pinnacle of film stardom. Accordingly a flood of books has appeared chronicling her life and career. Few of her biographers, however, have dealt critically with the drive that propelled her forward, or her difficult personal life beginning as a child, which became more complicated during the gyrations of her acting career, and following her decision to become a mother. Lacking too has been a sequential examination of her films looking closely at the strategy of producers, and Crawford herself, that allowed her to win her stardom and sustain it for decades. Her films have been widely discussed but primarily from the point of view of narrative. A broader spectrum of inquiry will look at the details of her work: why was she cast in particular films; who were her co-workers on-screen and behind the camera; and how did financial results—good or bad, and always carefully scrutinized—affect the type of roles she was offered.

As a film star of the first order, Crawford was essential to the Hollywood motion picture enterprise of the twentieth century. Adolph Zukor established a hundred years ago that it is stars who bring audiences into theaters and that box-office revenues, whether we like it or not, are one of the main indicators of a film's success. To be sure many great movies generate modest revenues, but the industry relies on hits, popular with the public, to fuel new productions. An oft-repeated quip of unknown origin, and referring to MGM in the thirties, goes something like this: Shearer got the prestigious productions, Garbo supplied the art, and Crawford paid for them both. It is not exactly true—most of Norma Shearer's pictures made money, and Garbo had a single bust with *Conquest*—but the point is that Crawford was a goldmine, and her films revenues routinely outstripped her studio rivals.

It took four years in Hollywood before Crawford was accorded the status of a movie star. She began humbly as one of many prospects signed in 1925 to a ten-week contract paying $75 a week. During those years she worked hard to learn her

new trade. There is nothing in Crawford's early screen appearances that suggest the legendary persona that would captivate audiences for decades beginning in mid-1929. Her looks changed, her personality changed, even her name changed. Crawford and her MGM contemporary Garbo both began their MGM careers in 1925 as attractive nineteen-year-olds who matured, through the passing of time, and the magic of Hollywood, into sensational beauties. Garbo had an advantage arriving from Sweden as protégée of a famous director, and was immediately given top stories and the best directors and cameramen under the watchful eye of producer Irving Thalberg. Crawford was hired by Harry Rapf, another top MGM producer, who managed her early career at the studio. Rapf had little to work with except her remarkable determination. Unlike Garbo, who had some schooling at the Swedish Dramatic Academy, Crawford was untrained and did not reveal any natural screen magnetism, so her journey was more protracted. She appeared in over twenty-five films before stardom was hers. The first miracle in the Crawford story is that she managed to land a contract at MGM. The second miracle is that it was renewed.

Starting her first day, Crawford befriended anyone at the studio who she thought might help her learn something about the movie business. She became pals with members of film crews, writers and costumers, and when permitted watched directors work. Her first on-set experience was serving as a body double for Norma Shearer. She was cast in small but good parts in her next two films, and assigned a better role in her fourth, but they were minor offerings and hardly signaled a breakout success. She kept at it, learned the business, developed her craft, and was assigned increasingly better roles over the next two years. Attractive and capable, in her third year Crawford was cast opposite Lon Chaney. Now she was being tested: could she hold up to the biggest male stars? After working with Chaney, she supported John Gilbert, Billy Haines, and Ramon Novarro. The reviews were good; not Garbo or Shearer good, but her performances encouraged Rapf to continue developing her career as MGM desperately needed talented women to populate the fifty features the studio was releasing annually. In the fall of 1928, *Our Dancing Daughters* premiered. For the first time, Crawford would be on the spot for the success or failure of a film. The box office approved, and a new MGM star was in the making. It became official the next year.

During the 1930s, Crawford became Hollywood's (and perhaps the country's) top fashion influencer. Her primary audience was not the elegant Park Avenue ladies who looked to the famous Parisienne couturiers for guidance. Rather, it was middle- and working-class women, most of whom had been hit hard in the Depression, who flocked to Crawford's films to spend ninety minutes or so watching tales of a woman who might resemble a sister or friend, and who managed brilliantly to rise above hardship. Costumer Adrian supplied her characters a spectacular wardrobe. Unlike the costumes he sometimes designed for Garbo, such as the extraordinary but outrageous outfits for *Mata Hari* and *Wild*

Crawford in her backyard in the summer of 1933 signing photographs for her fans. Photo by Clarence Sinclair Bull. John Kobal Foundation.

Orchids, Adrian typically attired Crawford in smart contemporary clothing. The suits, dresses, and evening gowns were calculated to seem as though they might be available to average middle-class women if they took care of their figures and were willing to spend just a little bit more at the department store. In fact, dresses worn by Crawford on film were routinely copied, sometimes within days of a film's premiere. Versions of a dress she wore in *Letty Lynton,* to name one famous example, appeared in stores across the country while the film was still in its first run. These affordable knockoffs were mere shadows of the originals but they gave the buyer a taste of movie glamour—and helped insure that lines would form when the next Crawford film was released.

She made herself available to fan magazine and newspaper writers, recognizing from the start that audiences alone kept a star shining. Long before the era of television chat shows, Crawford used the print medium as a vehicle to reach out to her followers. She spoke candidly (if vaguely) about the rocky road that led her to Hollywood, and spoke on the record as if she were conversing with a friend. Whether or not the interviews were entirely truthful, they appeared frank and allowed readers to feel they were intimates rather than merely ticket-buyers.

Here Crawford was the first to break down the wall between a star and her public. She headlined movies to be sure, but seemed approachable in a way that set her apart from most of her peers. No matter how earnestly an author tried to present the real Garbo or Shearer, or Gloria Swanson or Mary Pickford years earlier, the stories ring hollow. Writers now quoted Crawford, who was truthful as no star had been before. After all, really, she was just like us. From the dawn of the studio system right through the 1950s press offices had worked tirelessly to protect stars' images. But Crawford figured out that part of her appeal was her candor, and as long as the stories stayed safely within the era's notions of decorum, she was free to speak honestly. The added bonus was that because writers were anxious to interview Crawford, more stories were published about her than any of her contemporaries, with the possible exception of Garbo. The silent, elusive Swede might have been Hollywood's highest wattage star, with an enormous paycheck to match, but Crawford won the affection of her fans and they repaid her and MGM at the box office.

Much has been made of Crawford as a dancer. She was proud of her background working in the chorus of two Broadway revues, her triumph at winning many Charleston competitions after she moved to Los Angeles, and the success of a few of her films in which she danced, one time even partnering with Fred Astaire. But looking back at her work from the late twenties and thirties, she was not an accomplished dancer. She got her start in her hometown of Kansas City, when she answered an ad looking for dancers. Her experience had been as an amateur kicking up her heels at college fraternity parties. Still, she was hired, and this led to further work, and she learned on the job when she got a series of third-rate gigs in and around Kansas City. With ambition outpacing experience, she headed to Chicago where she met a small-time booking agent who found her work at local halls and roadhouses, culminating in a pretty good job dancing at a Detroit club. One of the Shubert brothers saw her there and offered her work in New York in a revue at the Winter Garden Theatre. She must have been a capable member of the chorus, for she was hired for a second show.

After both closed, she worked at a New York nightclub where she came to the attention of Rapf, but it was unlikely her dancing talent that caught his eye. After Crawford arrived in Hollywood, the studio did not make much use of her limited dancing abilities. In her ninth film, *The Taxi Dancer* (1927), surviving scene-stills show Crawford dancing, but as the film is presumed lost her abilities in this role cannot be evaluated. Eighteen months later, in the fall of 1928, Crawford appeared in *Our Dancing Daughters*, the film that put her on the map. She performs the Charleston, and there are many shots of her dancing, but her movement is frantic rather than skilled. "Her legs were beautiful," wrote Louise Brooks in 1957, "though she used them to dance the Charleston like a lady wrestler."[1] Nonetheless, her remarkable vitality and radiance captured the camera's and audience's attention, and movie stardom was finally in sight.

Dramatic roles followed; MGM was not going to risk promoting a second-rate hoofer when they had the prospect of a first-rate leading lady. There were still occasional outings on the dance floor, most best forgotten, and in *Dancing Lady*, she is an undistinguished partner for Astaire. Still, she continued to be identified as a dancer, as Crawford, rightly, was considered a key exemplar of the so-called Jazz Age of the Roaring Twenties. She embodied the energy of dancing as a joyous tonic for an anxious time. What took hold with the public was Crawford as the modern woman with an independent spirit, smartly dressed, and possessing a willingness to jump up on any table to perform. She would transform herself again in the early thirties, becoming the chic sophisticate who was still, underneath Adrian's spectacular wardrobe, the young woman from the wrong side of the tracks who had made good.

Even with all the money she made for MGM, Mayer felt that she (along with Garbo and Shearer) had had it by the early forties. Garbo was scheduled to work in 1943, but with no suitable film proposed, star and studio agreed to cancel her contract. Shearer's last film opened in the summer of 1942. Crawford worked that year, and after eighteen years, her final MGM film premiered in 1943. Tired of being offered what she considered unworthy roles, Crawford did not renew when her contract expired that year.

Jack Warner thought she still had possibilities. Warner Bros. films from the 1940s relied less on old-fashioned Tinseltown glamour and more on dramatic ability. Crawford was a proven glamour girl but as she approached forty, it was unrealistic that she could continue in that guise. She had already demonstrated that she could act, MGM's florid productions notwithstanding. Warner Bros., the studio that continued to nurture the career of Bette Davis, might have room for Joan Crawford as well. It was a shrewd gamble. Her first outing, *Mildred Pierce*, won her an Oscar, and was a critical success and box-office bonanza; hits and further Oscar nominations followed over the next decade. Crawford had successfully reimagined her stardom and continued to be a bankable commodity for the next two decades.

There is a long list of authentic thirties and forties stars who are largely forgotten: Marion Davies, Constance Bennett, Kay Francis, to name three. What separated Crawford from those names and allowed her to find a secure place in the Hollywood pantheon alongside Greta Garbo, Katharine Hepburn and Bette Davis? Great stars have strong and easily identifiable public images. Had Crawford's career ended with the advent of talkies she would be little remembered today. It was not the enthusiastic Charleston dancer that caught and held audiences' attention, but the glamorous Crawford of the 1930s, the driven young woman, usually working-class, who by force of personality overcame obstacles and rose to the top. She was Hollywood's Cinderella, on-screen and off. Confidence and determination, sometimes with an intensity that bordered on the ferocious, became her hallmark. Few performers owned the screen as successfully as Crawford. "She

Crawford with MGM costume designer Adrian, with whom she forged an important collaboration that made her a totem of style in the 1930s. John Kobal Foundation.

is five feet four but she looks six feet on the screen," Steven Spielberg said of her. "In a two shot with anyone, even Gable, your eyes fix on her."[2] Whether by force of will or the art of cinematography, she became beautiful. Her background as a dancer taught her carriage, her movement was graceful and elegant. And, unlike Garbo, Hepburn, and Davis, Crawford retained vulnerability, even if slightly below the surface, that made her the most popular star in Hollywood.

She found an ideal partner with the dress designer Adrian, who designed most of her costumes from the late twenties until he left MGM in 1941. The dresses he made for Crawford, and the way she wore them on the screen, both have achieved fabled status. Her collaboration with photographer George Hurrell created a corpus of images that are so extraordinary that they have come to define Hollywood in the thirties. Crawford must be regarded as one of the portrait camera's greatest subjects. When she teamed with Clark Gable in *Laughing Sinners* (1931), it marked the advent of one of cinema's great screen partnerships. Many other actresses worked with Adrian, Hurrell, and Gable, but none as efficaciously and without these three Crawford may never have become one of cinema's iconic figures.

Crawford's forty-year reign (1929–1970) as a star is one of Hollywood's longest. Once she got through the front gate at MGM she did not let the fact that she couldn't act, or that her dancing skills were rudimentary, stand in her way. She moved forward with grit, intelligence, and purpose. "Unlike most movie stars," wrote a critic in 1949, "she owes practically nothing to luck. The determining factor of her career has been her own unflagging resoluteness."[3] Although she continued acting until 1970, a second parallel career also kept her in the public eye in the 1960s when she served on the board of PepsiCo, working indefatigably as an ambassador for the soft drink. From her teenaged days in the summer of 1924, dancing in the chorus at the Winter Garden Theatre, until film and corporate work subsided in the 1970s, Crawford overcame nearly every obstacle and succeeded spectacularly. This book will trace her path and reveal how the pieces of a complicated mosaic came together. It started with a new name, and the opportunity to create, from scratch, a new persona. Four years of diligence was needed before a thrilling screen personality emerged: Joan Crawford. She developed it, refined it, and polished it to a brilliant sheen. She became a movie star and a twentieth-century legend.

Lucile Le Sueur

WHEN REINVENTING HERSELF AS JOAN CRAWFORD, THE WOMAN WHO was born Lucile[1] Fay LeSueur sought to erase much of her past from her official biography, beginning with the year of her birth. She was born in San Antonio, Texas, but the year is a matter of dispute. She claimed March 23, 1908, as her birthday, and stuck to it until her death, and it is the date that appears on her death certificate and gravestone. Her eldest daughter Christina, and first husband, Douglas Fairbanks Jr., both believed the year was actually 1904.[2] But that might also be inaccurate. Registering births was not mandatory in Texas in the early years of the last century, or so goes the story, thus no birth certificate was issued. Or, perhaps Crawford managed sometime later to make this incriminating bit of evidence disappear. She was the daughter of Anna (or Annie) Bell Johnson and Thomas Le Sueur, and had an older brother, Hal. Hal's death certificate records his birthday as September 3, 1903. If this is accurate then it is impossible that Crawford was born six months later. 1905 seems to be the year of Crawford's birth, and she is listed as being five in the 1910 census taken in April. She entered Stephens College in September 1922, likely when she was seventeen. Her mother may have been married before and had an older daughter, Daisy McConnell, who died in 1904. Thomas Le Sueur abandoned his family when Crawford was an infant and she met him only once, many years later when he showed up on the MGM lot.

When Crawford was four her mother married Henry Cassin in Ft. Worth, Texas; the newlyweds moved to Lawton, Oklahoma, where Henry managed vaudeville theaters. For convenience, Anna began to use the last name Cassin for the children, although there is no evidence that her new husband adopted them. Crawford was devoted to her stepfather, and he always called her Billie, a name that stuck, and from about 1909 until she started working in New York, she was known as Billie Cassin. She remembered him with affection, "[H]e was the center of my child's world—a short stocky man, black-haired, with small brown eyes and a pervasive quietness. A mature man, he was not the type to romp with children, but I could always crawl in his lap . . . And I knew he loved me."[3]

As a little girl Billie preferred the company of boys to girls. Her brother (with whom you see her here) was her staunch ally, along with his friends, in helping her with theatricals in the old barn. The girls, however, made fun of her make-believe and of the little mannerisms which she copied from theatre people she'd met.

Crawford and her brother Hal about 1908 when she was three, and he two years older. [Walter Ramsay, *The True Story of Joan Crawford*, circa 1930, 9.]

He also provided her first taste of the theater. "His two memorable gifts were this love and the privilege of playing in the barn where he stored scenery and costumes for his vaudeville house. . . . I must have been stagestruck from the first. It was entrancing to watch the dancers backstage at the theater."[4]

Crawford wanted to be like those dancers she admired, and "Harry encouraged me—he seemed to think I had talent. This made my mother furious, naturally—no daughter of hers was going to be a dancer."[5]

Until Crawford was about twelve, she seems to have enjoyed a relatively stable childhood. Then, in 1917, Cassin was on put trial. The way Crawford tells the story is that one day she found a sack of gold coins hidden in their basement. Excited, she ran to her mother. It seems Cassin was holding stolen loot for a friend. He was tried as an accomplice in the theft, although acquitted of the charges. With the trial and its publicity behind him, the family relocated to Kansas City. Cassin, a Roman Catholic, paid the tuition to send Crawford to St. Agnes Academy, and she recalled being happy during her short time there. Before long Anna and Henry's relationship crumbled, and he moved out. Crawford met her stepfather only one more time, when they had a chance encounter on a Kansas City street and he treated her to an ice cream soda.[6]

"I had an awful childhood, if you can even call it that," Crawford told one biographer.[7] Without money for tuition, Crawford changed schools and was sent to the Rockingham Academy where she was expected to work for her tuition. "I found myself . . . keeping a fourteen-room house, cooking, making beds and washing dishes for thirty other boys and girls," and she described the woman who ran the school as "a sadist or a bully, or both."[8] Crawford spent three years at Rockingham and recalled running away many times. Her daughter, Christina Crawford, wrote that when Cassin moved out, the family "was plunged into total poverty," and that working in a laundry was the only job her grandmother could find. Broke, "she made arrangements for herself and the two children to live in one unused room behind the laundry . . . There was no cooking stove, no proper bathroom."[9]

After splitting with Cassin, Anna took up with Harry Hough, and it is unknown whether they ever married. Crawford said of him, "Mr. Hough was moody, he seldom spoke to me."[10] Money problems continued, and if the introduction of a new man was meant to help the family, it did not. This second "stepfather" didn't show much interest in her or Anna if Crawford's later memories are correct. How long he stayed in the picture has been lost to history, but regardless of its duration, Hough did not provide the family the sort of emotional and financial grounding they had known with Henry Cassin, at least before his legal troubles began. "Boarding houses and kitchenette apartments and a few sleazy rented houses" was the way Crawford remembered those years.[11]

When she was a young teenager she developed what would be her real passion, dance, and discovered clubs, like downtown Kansas City's Jack-o'-Lantern, where she won her first dance contest, and fraternity houses at the city college. She claimed never to have had any training, and this is likely as no local dance instructor came forward with a story about teaching Crawford her trade. And like other girls her age, she became interested in boys. "The wealthy boys who

came to the school liked me. That woman [who ran the school] used to let me go out and dance with them so they'd keep coming to the school! It was then that it began to dawn on me that men might be useful to a woman."[12]

When she was about fifteen, she had developed a serious crush on a fellow, Ray Sterling. She always claimed he was five years older, but he is certainly the same man who is buried in Miami, and the cemetery records state that Sterling was born in September 1905, which would make him six months younger.[13] Regardless of his age, when she recalled that period in her life she always spoke affectionately about him. The same could not be said about Hough. Although at first he may have shown little interest in the adolescent Crawford, as she matured, she caught his eye. "I ran away finally because the one thing Mr. Hough tried to pick up was me."

Whether or not Anna was aware of this incident, she did help arrange for her daughter to attend Stephens College in Columbia, Missouri; Crawford enrolled in September 1922. Again, she would be a work-study student, but safely away from Kansas City. Ray Sterling escorted her to her new school. She admitted later that she was not academically qualified to attend Stephens, and that the principal at Rockingham "gave me forged high-school credits."[14] Crawford told her daughter that due to her erratic schooling, and the work necessary to cover tuition, "she'd never gotten more than an eighth grade education."[15] As a result, she was overwhelmed by the coursework—"the classes were Greek to me."[16] She was ambivalent about Stephens, first enjoying the freedom and the camaraderie of fellow students, but soon began feeling, once again, social inferiority, writing later, "most girls wouldn't accept a waitress."[17] In the 1922–23 yearbook, she is listed, along with a photograph, as Lucile Cassin, 403 East Ninth Street, Kansas City, but unlike the other girls her entry doesn't list the name of a sorority, club, or activity (or multiples of both) under her name. The photo depicts an attractive young woman, smartly dressed, who appears to be the ideal of the young college student. Even at this point, Crawford must have understood the power of images to create illusions.

"There were glorious dances at the University of Missouri," Crawford remembered, "where Orville Knapp's orchestra played. Often we got in way past curfew."[18] A friendly watchman at the college would leave a window unlocked so the late returners could sneak back in unobserved. Again, it was music, and dancing, and young men that most appealed to her, not the academic opportunities Stephens afforded students. It did not take long before Crawford knew she was out of her depth. But before leaving she made an ally, James Wood, the school's president. After a single semester, she met with him, and he agreed that the college experiment had not proven successful. According to Crawford, he gave her three bits of advice: "Never stop a job until you finish it. . . . The world is not interested in your problems. . . . If you find you can do a job, let it alone, because you are bigger than the job already, and that means you will shrink to the size of that job." Good advice for any of us, and Crawford seems to have taken it to heart. He also

gave Crawford the train fare back to Kansas City. She always referred to him as "Daddy Wood," and would consider him a friend long after leaving Stephens. He even visited Crawford at MGM, and on one visit she presented him a photograph that she inscribed, "To my dearest and only 'Daddy' Wood. My life's ambition is to make you proud of me."

Back in Kansas City in the winter of 1923, Crawford needed work and found a job selling clothing at Kline's, which billed itself as "The Dominant Store in Kansas City." Part of her weekly paycheck went to her mother. In 1929, interviewed by journalist Harry T. Brundidge at her home in Los Angeles, she recalled that she took "the Bell Telephone Company's training course and became an operator." But, not liking that job, she "got a position at the Wolff Clothing Company as a bundle wrapper." Since money was tight, "I was offered a dollar a week more to do the same work at Rothchild's [Rothschild's] and went there."[19]

She resumed her friendship with Ray Sterling. "He was my pal, my friend and my sweetheart."[20] "He made learning sound like an adventure. . . . Ray understood how I felt. . . . Somehow Ray knew me better than I knew myself."[21] Impossible to be sure, but this sounds like the first of many close and important relationships Crawford would have throughout her life with gay men. He provided the steady influence she needed, and the security of having a peer, who watched out for her. He also supported her ambition to work as a dancer.

Unlike many other young women, she did not aspire to be a movie star. Silent films captivated her as a fan, but the stage, with live music and dance, was the real thrill. She went to the movies as did most Americans in the late teens and twenties, and there is a single record of her writing to one of her favorites, Pauline Frederick, for a photo. Frederick, who was a big silent star for Paramount, saved this letter along with other fan mail she received, and it was published posthumously in her 1940 biography. In 1929, the two would work together at MGM. Crawford's letter is dated January 3, 1917:

> Dear Miss Frederick:
> You are my favorite of all actresses. I think that you are wonderful.
> Will you please, please send me a picture of yourself?
> Lovingly,
> Lucile LeSueur[22]

Crawford signed the note "Lucile LeSueur" and not "Lucile Cassin," the name she would use five years later when she enrolled at Stephens. At twelve, "Billie" was a nickname she was using, and one she liked, but it was not her real name. Nor was Cassin. It must have been difficult for a child who never knew her father to have multiple first and last names depending on, in part, with whom her mother was living. At twenty, she would give up both "Lucile" and "Billie," as well as "Le Sueur" and "Cassin," and be christened for a third time.

The year 1924 was the decisive one in Crawford's life. When it began, she was an eighteen-year-old salesclerk in a downtown Kansas City shop harboring modest dreams of becoming a dancer. It was not a career on Broadway that she imagined, but the chance to work in local clubs and theaters. She got her wish, and in spring she would leave Kansas City for Detroit, and then move to New York to appear on one of the most important stages in live entertainment. In December, fortune would strike and she would be offered a Hollywood contract at a studio that wasn't even in existence at the beginning of that year.

Kansas City was a lively and prosperous city in 1924 with a population of more than 300,000. Although there were many theaters, clubs, and other places of entertainment, opportunities were limited for a young woman without training to get work as a dancer. That winter a notice was posted calling for sixteen dancers to work in the company of Katherine Emerine, a name lost to history aside from her brief connection to Crawford. Aspirants were called to the swanky Hotel Baltimore to audition. At the head of the tryout line was Crawford, and when it was her turn Emerine asked if she had any stage experience. The answer was no, but Emerine nonetheless gave her a chance. The newly constituted company was engaged for a short run in Springfield, Missouri.[23] No details have emerged about Crawford's debut as a professional entertainer, but after the brief stint on the road she was back home in Kansas City, living with her mother, working at the department store, and relying on Sterling for moral support.

This brief taste of the limelight was enough to propel Crawford to seek more work. Speaking with Brundidge in 1929, she told the journalist that Emerine "invited me to join her in Chicago."[24] She corrected herself slightly thirty years later, writing more honestly that when the company disbanded after the short run in Springfield, Emerine told the troupe, "Any of you kids come to Chicago look me up. I know a producer, Ernie Young, he'll get you a job."[25] Those were magic words, and Crawford believed they were directed at her.

Using her paltry savings, she booked train passage from Kansas City to Chicago. Sterling dutifully accompanied her to the station. Crawford recalled his parting words, but they sound more like her later memories than the words of a young man seeing off his best friend: "You're like a little filly you're so high strung."[26] Crawford (or perhaps it really was Sterling) was right. She was a spectacularly ambitious and confident young woman on the verge of finding a place in one of the toughest arenas imaginable, the Broadway stage. But this would be only gentle preparation for what was to come years later when she found herself on the most competitive field of all, striving for the top spot in Hollywood.

Crawford had every right to feel optimistic in the winter of 1924; the world was at peace, the economy was sound, and she had the address of a woman who promised to help. Getting on that Chicago-bound train, with only two dollars in her pocketbook—or maybe it was five, her memories varied—and with virtually no professional experience (or training), she was off to seek fame in the big city.

Imagine the idea of a young person today with a hundred dollars, or even a thousand, without substantial preparation (and probably little education) trying to break into show business. Who would give a chance to an aspiring dancer who couldn't dance well? Crawford, a century ago, was that person. She made it to Chicago but discovered what was left in her purse would not even cover a taxi. "A man who had helped me with my grips on the train was passing by. . . . He laughed at my fears and said he would deliver me to my friend's."[27]

She imagined an elegant dwelling as Emerine's home but found instead a "little rooming-house." The landlady was there and told her that her hoped-for mentor was not in Chicago. Surprisingly, but perhaps not to Crawford, the woman let her stay the night in Emerine's room.[28] "I was ugly, freckle-faced, white-lipped, scared and shabby," Crawford told a reporter in 1927 remembering her arrival in Chicago.[29] The next morning, she pulled out the second name she brought along, Ernie Young, the producer, found his name in the telephone book, and made haste for downtown. Young worked at the bottom rung of the entertainment world, but still his office was besieged by hopefuls. Brashness was always part of the Crawford character, so she made sure that she was seen by the producer: "I rushed into his private office and shouted in his face, 'Mister, I gotta have a job.' . . . 'Can you dance?' he asked calmly. . . . 'A little,' I confessed."

> He took me to the tenth floor of the building, turned on a Victrola and said, "Hop to it." I danced for him and he got me a job at the Friar's, a night club, doing a little song and dance act. I received an advance on my salary, got a room in a cheap hotel, bought some material, made a dress, and did my first bit that night. A few weeks later I was sent to Detroit to join a revue at the Oriole Terrace Café.[30]

There is much "song and dance" to this 1929 memory, aside from the facts that Young got her a job and she found lodgings in a cheap hotel. The job may well have been at the Fritzel's Friars Inn, a well-known and popular Chicago speakeasy in the basement of a building on Wabash Avenue. Although it was Prohibition, a writer for *Variety* back in 1922 wrote, "There isn't a dead moment from the time the place's doors open until they close." The article concluded that the club was "without a revue or chorus," and relied on "permanent entertainers," but maybe that had changed three years later. Or did Crawford exaggerate the sorts of places she worked when she began her dancing career?[31] Ginger Rogers, long before she went to Hollywood, performed at the Friar's in 1926, and Gilda Grey danced her famous "shimmy," but liquor flowed too freely, notoriety followed, and the police closed the place in 1927.

And, it was more than a few weeks later that Crawford found herself working in Detroit, for after the initial stint in Chicago she found a job in Oklahoma City. By mid-spring, Young had secured her work dancing at the Oriole Terrace

Café in Detroit. Crawford remembered that she was one of thirty-two girls who performed eight routines a night.[32] Crawford must have been a quick study and, working with women who had more experience, learned well the craft of performing in a dance chorus. She also figured out how to position herself to take advantage of every opportunity. The strokes of good luck that followed Crawford in 1924, and allowed her miraculous ascent, seem more the basis for a romantic movie script rather than a biography, but, indeed, one successful encounter after the next propelled her nascent career forward.

Jacob J. Shubert (known as J. J.) and his brother Lee owned and operated theaters in New York City, eventually becoming among the most influential and profitable Broadway producers. Alongside the many shows they produced, the brothers specialized in putting on annual musical revues at their flagship theater, the Winter Garden. In 1924, they produced two dazzling spectacles, *Innocent Eyes*, which would open in New York in the late spring, and *The Passing Show of 1924*, which would premiere in mid-summer. The Shubert revues rivaled in extravagance the *Ziegfeld Follies*, playing eight blocks south on Forty-second Street, and each tried to outdo the other by featuring the best star entertainers and the most beautiful (and scantily clad) showgirls. Shubert productions typically started life traveling around the country before opening in New York. *Innocent Eyes* played in Pittsburgh in February and Chicago in March, before moving to Detroit. Successful shows might continue to tour after the Broadway run.

The oft told story goes that J. J. Shubert was in Detroit overseeing *Innocent Eyes* and late one evening he went to the Oriole Terrace. There he saw Crawford dance. Crawford told a variety of versions about their first encounter including one in which "my twirling skirt knocked a glass off a table and onto J. J. Shubert."[33] However they were introduced, she claims he invited her to see the next day's matinee of *Innocent Eyes*, and then offered her a job with the company in New York, telling her, "I want you to leave Saturday night as a member of the chorus."[34] This sounds suspicious as the show was weeks away from its Broadway opening, and would have been fully cast before its Detroit preview. Whatever the details, Crawford caught Shubert's eye and he was her ticket east. She claimed in 1929 to not "remember a single thing about that trip to New York,"[35] but many years later wrote that she "jumped the show" at the Oriole Terrace leaving the producers scrambling to find a replacement.[36]

The New York opening night took place on May 20, 1924. French musical star Mistinguett headlined *Innocent Eyes*, a revue that had no real plot but instead a series of vaguely interconnected vignettes intended to show off the leading lady's talents as well as the attractive supporting cast. The program for *Innocent Eyes* lists the featured players and about fifty dancers, showgirls, and other members of the chorus. Nowhere do the names "Lucile Le Sueur" or "Billie Cassin" appear. The show's star, Mistinguett, left in mid-July and was replaced by Fay Marbe, and a new program was printed reflecting this and a few other cast changes. Still

no Le Sueur or Cassin. It is possible that she had an unbilled role as one of the dancers working in the back of a crowded stage, or was an understudy. Perhaps she was trying out a new stage name but with two to choose from this seems unlikely. There is a familiar name among the chorus, Jack Oakie, listed as one of the *Moulin Rouge Boys*. He would go on to have a film career as a comic second lead at Paramount in the 1930s.

A concrete bit of evidence that Crawford appeared in the show is a photograph reproduced in the September 1924 issue of a barely remembered magazine, *Red Pepper*, "A peppy periodical for peppy people." A full-page image of Crawford, standing barefoot and posing cheesecake, identifies "Lucille Le Sueur" as appearing in *Innocent Eyes* at the Winter Garden. Taken by John de Mirjian, who was one of the photographers working for the Broadway set, it may be the first image of Crawford to appear in print. And, it confirms that Crawford had a connection to the show, even if only as an uncredited background dancer or an understudy. De Mirjian had a reputation for risqué photographs (although the picture of Crawford reproduced in *Red Pepper* is tame). At about the same time he photographed Crawford, Louise Brooks, who was a dancer in the 1925 edition of the Ziegfeld Follies, filed a restraining order against de Mirjian, asking that he stop "circulating nearly nude pictures of her."[37] She was on the verge of a film career, and what was acceptable for a Ziegfeld showgirl might be an impediment for a motion picture actress. Although Crawford must have posed for many de Mirjian portraits during their single session, only a few have been positively identified. This time she is photographed half-length, draped modestly with a cloth under her arms with her neck and shoulders exposed. He did not have the chance to capitalize on these photographs when Crawford became a Hollywood star as he died in an automobile accident in September 1928, just as she was becoming well-known in Hollywood.

Crawford had a significant role in the year's second Shubert revue, *The Passing Show of 1924*. It was their crown jewel, an annual offering, conceived a dozen years earlier as *The Passing Show of 1912*, and was the first Shubert spectacle to take direct aim at Ziegfeld. The 1924 incarnation opened September 3, right on the heels of *Innocent Eyes*, with hardly five days to change the sets and to ready a new production. Headlining the new show was song-and-dance man James Barton.

Nils Thor Granlund, known by his initials as NTG, or as "Granny" to his friends, had a long career working in many different jobs in the New York legitimate theater and motion picture worlds. Back in the teens he was hired by theater owner Marcus Loew to help with advertising, and is credited with inventing the motion picture trailer. Granlund was the stage manager for *The Passing Show of 1924*, a job for which he was well suited given his rich theatrical background, and the fact that he seemed to know everyone in show business. As a member of the chorus Crawford got to know Granlund, who seems to have been something of a father confessor to the chorus "boys" and "girls" under his care. It would be

PLAN FOR TO-MORROW A TRIP ON THE

SIGHTSEEING YACHT
"TOURIST" CAPACITY 500

BATTERY PARK PIER

Every Day 10.30 a.m. --- 2.30 p.m. Sharp

TELS. BROAD 6854-3373 LECTURER

"A Panorama of 40 Miles --- Around New York"

PROGRAM CONTINUED

SCENE 8—MOOCHING ALONG
James Barton and Plantation Girls

SCENE 9—THE HOLIDAY NUMBER
Allan Prior, Olga Cook, Dorothy Janice and Holiday Girls

Holiday Girls

New Year's	HARRIET GUSTINE
St. Valentine's	DOROTHY BRUCE
St. Patrick's	CAROL MILLER
Easter	DORIS DOWNES
May Day	NANCY CARROLL
Fourth of July	CHARLOTTE SPRAGUE
Labor Day	LUCILLE LE SUER
Halloween	MADELON SMITH
Thanksgiving	BONNIE O'DEAR
Christmas	ROSE VELOUR

PROGRAM CONTINUED ON SECOND PAGE FOLLOWING

DINE - DANCE - AND - BE - MERRY

UNUSUALLY GOOD FOOD & SERVICE
Open 5.30 to Closing
Phone Spring 0772

THE GREENWICH VILLAGE INN
NO 5 & 6 SHERIDAN SQUARE

LARGEST DANCE FLOOR IN THE VILLAGE
5th Ave Subway at the Door

Crawford's first important professional credit was when she appeared in *The Passing Show of 1924* at the Winter Garden Theatre, New York. Working as Lucille Le Sueur, her name is misspelled in the program.

Crawford in costume for *The Passing Show of 1924*. Photo by White Studios, New York. John Kobal Foundation.

through his influence that she would move from the back row of the Broadway stage to Hollywood. "Granny," like "Daddy" Cassin and "Daddy" Wood, became the next in a series of men who helped Crawford, and she always spoke about him with regard and affection.

Female dancers in top-line Broadway shows fit in one of two categories, the distinction often determined by height. The most coveted jobs were as showgirls, and these places were claimed by the tallest dancers. Otherwise you were a "pony."

Conformity in looks, body type, and dancing style was a hallmark of the Shubert or Ziegfeld shows. Dancers were not supposed to stand out unless they were solo artists. Crawford was petite, so she was a pony. Ponies generally danced in the back line and had secondary roles supporting the action on stage.

Crawford appeared in two vignettes and is credited in the program. In the first act, she appears in Scene 7, "The Beaded Bag," as one of the Beaded Bag Girls; her name is slightly misspelled as "Lucille LeSuer." She returns in the second act, Scene 9, "The Holiday Number," as "Labor Day," one of the "Holiday Girls." Her name is again misspelled: "Lucille Le Suer" (this time with a space). At the back of the program the "Young Women of the Ensemble" are listed; Crawford's name is printed as "Lucille Le Seuer." Three chances to get it right, and three misses. Even before she got to Hollywood, Lucile (or Lucille) Le Sueur was too complicated a name for show business.

Most Broadway shows and revues of this era were photographed, even if it was only a full cast shot taken on stage. Performers, whether stars or aspirants, needed a constant supply of new images, which were a vital currency for enhancing a career or promoting a new one. White Studios and Florence Vandamm were the two leading photographers covering shows and players. Crawford was photographed by White Studios during the run of *The Passing Show*, dressed in an elaborately beaded costume, wearing a tall headdress and looked the epitome of 1920s Broadway glamour. The photographer was probably George Lucas, who took most of the shots for White Studios. This image, and perhaps others like it buried in theater archives, along with the de Mirjian photo, provides the first glimpse of the emerging performer.

Closing night for *The Passing Show of 1924* was November 22, 1924, and Crawford was out of work. Somewhere along the way Granlund introduced her to Harry Richman, the owner of a nightclub, Club Richman, which occupied a former stable east of Carnegie Hall on Fifty-sixth Street near Seventh Avenue. Richman, who was also a popular entertainer and stage star (he later introduced Irving Berlin's "Puttin' on the Ritz"), hired Crawford. His newly established club was getting the reputation as one of the hottest spots in town. She remembers working there even while she was appearing in *The Passing Show*, rushing up six blocks from the Winter Garden to West Fifty-sixth Street: "After 'The Passing Show' rang down its last curtain, I went to work at Richman's nightclub. I was now working at the Garden three afternoons and six nights a week, and at the club from twelve midnight until 7 a.m. daily except Monday."[38]

Crawford remembered well the grueling schedule of performing for the Shuberts six nights a week, then matinees on Tuesdays, Thursdays, and Saturdays, followed by late nights working in a nightclub. Not much time for sleep, which is why only youngsters can endure such an intense schedule. During her six months in New York, she "shared one room in an old Brownstone on West Fiftieth Street off Fifth Avenue," with four other women in the chorus.[39] Crawford had little time

to enjoy nightlife or socializing in New York, given her frantic schedule with only Sunday off to recuperate.

Sometime during the month that followed the Broadway closing of *The Passing Show of 1924*, the transformative event in Crawford's life occurred, but the details are almost lost to time, and no one involved ever gave a complete account of what happened. This is what we know. Through Granlund Crawford met Richman who gave her a job working as a dancer at his club, and she might also have waited tables and served drinks. "After she did her dance," Richman wrote in 1966, "she would sit on my miniature piano and I would sing to her."[40] His club attracted an important clientele that included performers, producers, and society folks. Granlund was well connected to Marcus Loew, the owner of the Loew's theater chain who earlier that year had put together, through a series of mergers, a new motion picture studio, first named Metro-Goldwyn, and soon rechristened Metro-Goldwyn-Mayer.

Loew was among the club's regulars, as was Nicholas Schenck, who ran his New York operations, and J. Robert Rubin, the studio's top lawyer. Loew's West Coast colleagues, the triumvirate in charge of the studio, were Louis B. Mayer, vice president in charge of production, and Irving Thalberg and Harry Rapf, who were responsible for providing the constant stream of new films needed to fill seats at the Loew's theater chain. The goal was to release a new feature every week, which put tremendous pressure on Thalberg and Rapf to shepherd fifty-two films annually from idea to finished work. The two were constantly on the lookout for new talent to work behind the cameras and for performers who might have a shot on the big screen. Where better to look than the New York stage, where not only did the world's finest entertainers perform but a steady stream of newcomers chased their dreams and hoped lightning would strike to ignite a new career. The Loew's team of Schenck, Rubin, Mayer, Thalberg, and Rapf would have known Richman well since the upper echelons of the theater and motion picture worlds was relatively small and tightly intertwined.

Harry Rapf left Los Angeles in late November, traveling with Loew who was returning home to New York, to scout "photoplay material in books and plays, and review current Broadway successes with a view to securing possible purchases."[41] Mayer was in Italy checking up on *Ben-Hur*, and also looking for talent (he found Garbo), and was scheduled to arrive in New York in mid-December. Rapf was also on call to sail to Italy if Mayer thought it necessary.[42]

One evening in December 1924, Rapf met Crawford at Club Richman. Speculation as to the nature of their relationship shadowed Crawford, but she always spoke highly of Rapf and acknowledged that it was he who first saw her promise as a screen actress. Rapf's son, Maurice, who was a documentary filmmaker and college professor, believed they were romantically involved although he could not speculate on the duration of the relationship.[43] Rapf was a terrific judge of talent, and by the time he was brought into MGM by Mayer in 1924, he already

had spent two decades working both in theater and the movies, most recently with the Warner brothers in Hollywood. The story goes that Rapf asked Crawford if she would like a screen test. Apparently her initial response was no since she wanted to be a Broadway dancer. "Granny" intervened and insisted, "Listen you little fool, ... Katherine McDonald, Nita Nalda [sic], and a flock of others have left the chorus of Winter Garden shows after having made motion picture tests and have been successful."[44] He recognized an important opportunity that Crawford might not have seen herself.

Typically, those aspiring to work in film would be photographed in a portrait studio before getting a chance in front of a movie camera. Whether or not Crawford professed a desire to go to Hollywood, she nevertheless would have had a portfolio ready. Rapf reviewed her pictures and found her properly photogenic. From there it would have been as simple as picking up the telephone for him to arrange a screen test. As one of the top bosses who ran the studio, he had immediate access to MGM's ample motion picture production facilities in New York City. Crawford was tested. "It was all over in fifteen minutes, but I was called back the next day to make a second test."[45]

At this point a shadowy story gets even more complicated. Crawford claimed no interest in the movies. "Would I like to be an actress [Rapf and Rubin] asked. No, I said candidly, I'd like to be a dancer. I wasn't interested in acting."[46] If so, as a cast member of *The Passing Show of 1924*, why was she not offered the chance to stay with the production when it moved on to Boston that fall? Or did she believe that working at Club Richman, with a couple of Broadway chorus credits, meant that she could easily have found work in another show? In any case, there is no evidence that Crawford sought additional work in New York, and, in fact, left a good job at a club. In every version of her biography she recounted that sometime around the middle of December she traveled back to Kansas City. Why would she have made this trip? To visit her family, as she claimed? This seems unlikely as she disliked both her mother and brother. To connect again with Ray Sterling? Again, this seems far-fetched as there is no evidence that there was the slightest romantic spark between them, and they had a lively correspondence by mail. Train travel would have been expensive, and such a vacation a luxury; her meager earnings from Richman would have given her little more than money to cover rent and the basic expenses of living in New York.

Rapf proposed, sometime in December, that Crawford accept an acting contract at MGM in Culver City. The open question is: when did she agree to MGM's offer of employment? She enjoyed describing the shock at finding herself on a Christmas vacation in Kansas City when suddenly, and unexpectedly, a telegram arrived offering her a movie contract. But, it is doubtful that she would have made the trip home without the promise of a contract. MGM would have paid her travel expenses, and the reason for the stop in Kansas City must have been to pack up her few belongings. When she left for Chicago the previous spring in

Photographer Orval Hixon made the first proper glamour photograph of Crawford in his Kansas City studio in December 1924.

quest of Katherine Emerine, she would have traveled lightly, leaving most of her possessions with her mother. For two months, she lived a gypsy life stopping in many different cities before arriving in New York where she had a single bed in a one room apartment with four roommates. A contract, even for a paltry ten weeks, presented more security than Crawford had ever before been offered. There was no risk, and she must have assumed that there were plenty of nightclubs in Los Angeles if the movies didn't work out. It is probable that Rapf and Crawford journeyed west together. Traveling between New York and Los Angeles necessitated a change in Chicago, and most trains heading to Los Angeles stopped in Kansas

City, where Crawford would have disembarked. Crawford assuredly did receive a telegram in Kansas City, but it was from Rapf telling her when she was expected at the studio. Travel details would have been provided as well as a summary of the contract she would sign upon arrival.

The terms of Crawford's contract were standard for any prospective player with no experience: $75 a week, and the deal could be canceled by MGM after ten weeks for any reason. MGM then had the option of extending the contract for an additional six months, and if the option was picked up her weekly salary would be increased to $125. At the end of that period, and again it was up to the studio, the contract might be extended for another six months with a slight pay raise. This could go on for seven years, always at the discretion of the studio. Of course, if a performer suddenly found favor with audiences, more generous renewal terms would be offered along the way.

There is another bit of evidence that suggests Crawford was under contract to MGM before she departed from New York. Kansas City was an important stop on the vaudeville circuit and thus could support two photography studios that catered to theater and movie folks: Strauss-Peyton and Orval Hixon. When movies came to the theaters, the newly minted cinema actors also took advantage of the local talent. Strauss-Peyton and Hixon both did superb work, and they photographed many of the legends of the era: Mary Pickford and Gloria Swanson were among the famous clients of Strauss-Peyton, and Theda Bara and Al Jolson of Orval Hixon.

Crawford had her first proper portrait session with Orval Hixon in December 1924. His studio was located downtown at the Hotel Baltimore, the site of Crawford's audition for Emerine earlier that year. She had been photographed by White Studios and de Mirjian in New York, but Rapf would have told her that many more images would be needed to promote a motion picture career, especially the glamorous close-ups coveted by magazines and newspapers. Crawford could not have afforded a photo session with Hixon without support. Rapf would have given her an allowance for travel, added funds for a portrait session, and allocated a few dollars for new clothing as well. It is unlikely, the way Crawford enjoyed remembering the story, that a surprise Christmas morning telegram offering a contract would have sent Crawford scurrying to Hixon to have some photos snapped, developed, and printed, in time for her to hop on the train bound for Los Angeles. Rather, the appointment with Hixon was a further step in the studio's star-making process. MGM was a business, and every move was carefully considered. First, talent was identified, screen tests were made, more portraits were taken, and then the hard work began. Crawford passed each stage of the process. And, in addition to her other successes, the results of her portrait session with Hixon were excellent. With a thick mane of hair—stylishly coiffed, and draped with a piece of fabric, suggestive, but not vulgar—Crawford was an evident movie star in the making. She was ready for Hollywood.

1925, Arrival in Hollywood

CRAWFORD ARRIVED IN HOLLYWOOD ON OR ABOUT THE FIRST OF January 1925. She was met at the station by Larry Barbier, a junior member of MGM's press department. He whistled when he saw her, or so she later claimed, and said, "Why you must be Lucille [*sic*] Le Sueur.... Honey, I'm looking for you,"[1] Barbier, then twenty-one, would go on to have a long career at the studio working in the publicity department, and became one of MGM's "fixers," someone who could get a star out of trouble and thus avoid bad publicity. Over the coming years, he would work with Crawford setting up portrait sessions, arranging interviews with fan magazine writers, and occasionally helping her out with more sensitive issues. As she disembarked, Barbier, tall, dark, and handsome, must have been a delightful sight, but he had a wife and infant son at home. He drove her to the Washington Hotel in Culver City, a short walk from MGM. It wasn't much of a hotel, but better than the places she knew from her time on the road. Barbier would have made sure Crawford's accommodations were set; shortly after, he or one of his colleagues would have picked up Crawford and escorted her to the studio to meet with a payroll clerk to sign-on officially as a new MGM employee.

Lucile Le Sueur officially joined MGM on January 2 and signed a ten-week contract that terminated on March 13. Crawford's registration card gave her basic information; she was 5'3", weighed 145 lbs., and had blue eyes and light brunette hair. Her appearance was described as "plain," but her carriage as "good." Under notes at the bottom: "No picture experience. From New York stage." Weekly salary, $75.[2]

MGM must have been an exciting place that winter. It was born of an amalgamation of four businesses the previous April and was operated under the watchful eye of Louis B. Mayer. His studio, Louis B. Mayer Productions, had been acquired by Marcus Loew, along with Goldwyn Pictures, and merged with Loew's Metro Pictures into the Metro-Goldwyn Studio. William Randolph Hearst's Cosmopolitan Pictures was part of the deal. Cosmopolitan would use the new studio's production facilities and release films exclusively through Metro-Goldwyn, but

Hearst never gave up ownership of his studio that was created primarily to make Marion Davies's pictures. Mayer, as head of production, exercised nearly complete authority over the studio's product. Given this role, a decision was made in 1925, for the sake of simplicity, to change the studio's name to Metro-Goldwyn-Mayer, or MGM. Working under Mayer were producers Irving Thalberg and Harry Rapf.

Four studios combined offered moviegoers an amazing array of stars. Along with Davies, the new studio boasted Mae Murray, Norma Shearer, Renee Adorée, Aileen Pringle, and Eleanor Boardman, among the women. In the male ranks could be found Ramon Novarro, Ronald Colman, John Gilbert, Conrad Nagel, and Buster Keaton. Child star Jackie Coogan had his own production company, but his films were made and released under the MGM banner. This rich trove of talent was the fodder that fed an ambitious schedule of making a new feature every week to supply the Loew's theater chain with a continual stream of films. Even if a top player could make three or four films a year, and in the silent era it was typical, an enormous roster of actors was necessary to cast so many films. As such MGM was constantly on the lookout for new prospects, and Lucile Le Sueur was one of the many that passed through the studio gates in early 1925.

Motion picture studios were busy places, time was money, and everyone was expected to be working all day, six days a week. Crawford had the zeal and determination and was ready to get straight to work. Her first task was to be photographed in the portrait studio. Clarence Sinclair Bull ran the still-photography department. Under his watch, a photographer was assigned to each film in production to take scene-stills recording the action. He also commanded the portrait studio, the place where the glamorous shots were taken of the gorgeous performers. These images would be widely distributed to magazines and newspapers to ensure that the faces of MGM's leading lights would be imprinted in the minds of fans.

Crawford was photographed extensively during her first months at the studio. Along with hours in the portrait studio, she made additional screen tests. The results of all this work gave Rapf, his associates, and the studio's cinematographers a sense of how she recorded on film. When she arrived in Los Angeles, Crawford wore her hair long and with a center part. Although it is fairly easy to distinguish her early portrait sessions, it is hard to establish an exact chronological order. This would change when her photographs were connected to specific films. Orval Hixon's photographs taken in Kansas City were sexy, and she showed youth and fire befitting a former Shubert showgirl. At MGM, the women were mighty glamorous, but they projected a cool elegance rather than a more overt carnality. Crawford's earliest MGM photographs were tame, and the photographers asked her to be coy rather than obvious. Crawford learned fast how important portraits were to a film career. She was extraordinarily photogenic, that was obvious from the start, but she needed to learn how to convey moods and emotions. During her first two or three years at MGM she hardly looked like the Joan Crawford

of her glory years of the 1930s or '40s. Still, she was an excellent portrait subject, and it is a pleasure to watch her face evolve as she transformed herself into an actress and later a star.

Without any acting experience, and with a limited background as a dancer, Crawford had a lot to learn. MGM did not have acting school—performers were expected to learn on the job, and to learn fast—but there was ample opportunity to train as a dancer. This might seem ironic since films were silent and there was limited use for performers whose skills were singing or dancing. Looking over the films MGM released in 1924, 1925, and 1926, few "musicals" were among the offerings, but of those made, several included a part for Crawford. The great exception was *The Merry Widow*, starring Mae Murray and released in the summer of 1925. This was a first-class production and would have had a specially composed score to accompany the film that in the big city theaters would be played by an orchestra. Murray was a huge star, and the film was based on an operetta that was famous worldwide, two factors almost certainly guaranteeing big box-office returns. Crawford seems to have had an uncredited role among the large cast supporting Murray on the dance floor.

As a protégée of Rapf, Crawford's first screen appearances were in films that he produced. Within weeks of starting work, she served as a double for Norma Shearer in the film, *Lady of the Night*. Shearer plays two parts: young women who are close friends, one from the right and one from the wrong side of the tracks, who love the same man. Of course, he must end up with the right partner. At the climactic moment the women meet in the back of a taxi. Although the double-exposure photography is excellent, when Shearer's two characters embrace—all former tensions between them resolved, and the opportunity for two close-ups—another actress was required. Crawford stands-in for both versions of Shearer's characters and thus is given her first few seconds on the screen. She is seen twice, only from the back, and did not receive screen credit. As far as motion picture debuts go, it did not predict a distinguished career.

The second role Rapf assigned Crawford was well-suited to her brief background working in New York. Lucille Le Sueur (the spelling of her first name was changed to include a double "l") played a showgirl in *Pretty Ladies*, a backstage drama based vaguely on the Ziegfeld Follies, and, this time, she would be featured in a minor role. Directed by Monta Bell, the film starred Zasu Pitts and Tom Moore. Crawford appears early in the action in the ladies' dressing room sitting in front of one, of several long shared mirrors, readying herself to go on stage. Bell, or perhaps Rapf, saw to it that hers was one of the few faces picked out by the camera. In her first real screen scene, Crawford, dressed in an elaborate eighteenth-century-style gown, visits Pitts in her private dressing room. The young ingénue and the older veteran comic share thoughts about life. When Crawford speaks, an inter-title reveals her words: "Men are all alike . . . if they ain't fresh, they're rotten!" While speaking these words she also gets her first screen close-up.

Crawford's first significant screen appearance was in *Pretty Ladies*, 1925, starring Zasu Pitts.

She is revealed as an attractive woman comfortable in her new profession, but no sparks fly heralding a brilliant career (as they did the first moment Garbo appeared on film at MGM later that year).

Pretty Ladies was filmed in the spring of 1925, and released in the late summer. Although Crawford's name did not appear in the cast list on screen, *Variety*'s review was more generous, and Lucille Le Sueur is listed tenth of nineteen who had leading or featured parts.[3] Myrna Loy and Carole Lombard also had uncredited small roles as chorus members. The film was well received, but as Crawford had such a minor part its success or failure was not on her shoulders. Her job was to learn how to work with the camera.

A film based on a play by W. Somerset Maugham, *The Circle*, provided Crawford's second significant appearance again without screen credit. As Lady Catherine, she performs in a long scene at the beginning, playing an adulterous wife who leaves her husband for true love. Most of the film's action takes place a generation later when the now long married couple return to visit Lady Catherine's former husband and the child she left behind. Eugenie Besserer plays the older Catherine. As in *Pretty Ladies*, Crawford is at ease before the camera. And, in both films, she is heavier than she would ever again be on film.

While *Pretty Ladies* and *The Circle* were in production, Carey Wilson, who enjoyed a long career at MGM as a writer and producer (and occasionally facto-tum for Mayer), was working on a documentary film, *1925 Studio Tour.*[4] Thirty minutes in length, the film is an extraordinary record of a day in the life of MGM in mid-1925. It must have been intended to serve as a promotional film that would introduce the MGM product to the distributors and theater owners who were essential to the studio's revenue stream. The film takes viewers on a backlot visit where we meet a wide array of the men and women who worked behind the scenes to make the movies: writers, directors, electricians, producers, among others. So, too, we meet the stars and leading players who populate MGM's films. In one sequence, about twenty-five are lined up and the camera pans slowly to reveal, among those gathered, John Gilbert, Norma Shearer, Lon Chaney, Claire Windsor, and Billy Haines. Crawford stands next to Haines. A list follows announcing the players who will be featured in forthcoming films. Lucille Le Sueur is named, surprising since she had yet to appear in a released film (other than as a double or extra), and those currently in production would not even include her name in the credits. Still, Wilson gives her more screen time than anyone else. In addition to her standing among the stars, a clip from *Pretty Ladies* is included showing Crawford smiling broadly. A bit later she is the model for the costume designer Erté who fits her for a gown. An inter-title follows and for the first time she is named: "He drapes the beautiful figure of Lucille Le Sueur, an M-G-M 'find' of 1925." Writing fifty years later, Erté recalled the moment: "Miss Crawford cut quite a different figure, in those days, from the sleek and sophisticated image she later acquired. Her beautiful face was set off by long, dark hair which she wore parted in the middle. She reminded me of a luscious Italian Madonna."[5]

The studio's publicity department had designated Crawford "Miss MGM," and for a short time she served as a sort of studio mascot, an attractive young woman who would be paraded out to meet the exhibitors—almost always men—who visited the studio to learn about the new releases. Crawford claimed that she was always available to do any sort of publicity chores: "I probably had more pictures taken than any girl who'd ever been signed at the studio."[6] As for Cary Wilson, "He became another of my self-appointed guardian angels."[7]

During those first months Crawford was continually used as an extra, one of the actors providing background in crowd scenes. She can be spotted in a surviving scene-still for *The Only Thing*, starring Conrad Nagel and Eleanor Boardman, as one of the elegantly gowned dancers working behind the principals.

Rapf elected to renew Crawford's contract when it expired on March 13. With the new contract came an important change: Rapf and MGM publicity chief Pete Smith decided that they wanted to rename her. This was not uncommon in Hollywood: Mary Pickford was born Gladys Marie Smith; Mae Murray started life as Marie Adrienne Koenig. Rapf and Smith already had two sets of names from which to choose, but they mustn't have liked Billie Cassin, or even Lucile

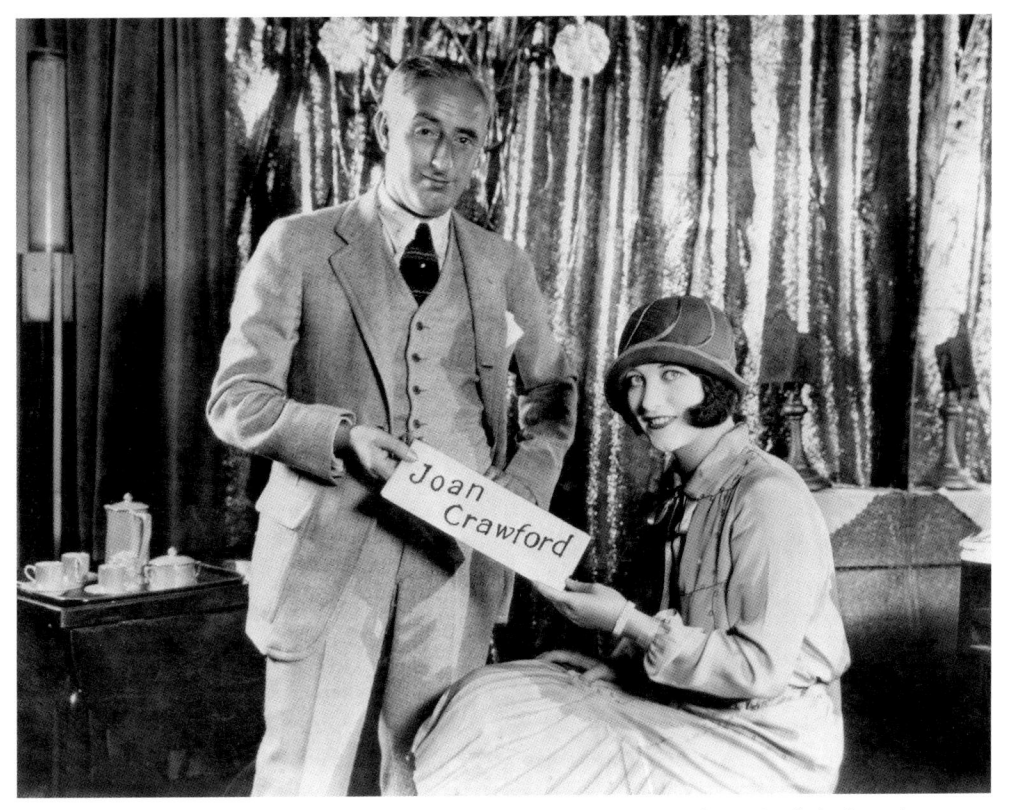

Producer Harry Rapf held a contest to rename his new find. In the summer of 1925, Lucile LeSueur became Joan Crawford. Collection of Joanna Rapf.

(or Lucille) Cassin any better. Instead of picking a name a random, Rapf gave his protégée an enormous publicity boost, one unique in Hollywood for an unknown player. *Movie Weekly*, one of the top movie magazines, hosted a contest asking fans across America to submit names for the budding actress. On March 28, 1925, the promotion began with a headline: "Introducing Lucille Le Sueur who needs another name for her screen career. . . . Name her and win $1,000." In fact, the winner would receive $500, with "ten other prizes of $50 each for the sponsors of the next ten best names." "I know she will be a remarkably clever motion picture artiste," Rapf told readers, "but her name is unsuitable for the screen, because it is difficult to remember, hard to spell and still harder to pronounce."[8] Crawford later suggested it was because Le Sueur sounded too much like Le "Sewer."

The contest lasted for six weeks; entries needed to be postmarked by midnight, May 2. Most weeks there were articles reminding readers to send in suggestions, "There's still time to enter" (April 11), "This is the last chance" (May 2). A panel of luminaries headed by Adele Whitely Fletcher, the magazine's editor, chose the winning name. Others were Florence Lawrence from the *Los Angeles Examiner*; Edwin Schallert from the *Los Angeles Times*; and Harry Rapf.

On September 19, the winning name was announced in *Movie Weekly*. But Joan Crawford was not the name selected by the committee the previous June. "Please note," Pete Smith wrote to the studio's head of contracts, "the judges in the Lucille Se Sueur contest have decided on the following name for her: Joan Arden."[9] The following month his assistant, Howard Strickling, cabled from New York, "We are in a jam." Seems even before all the names mailed in had been counted, "Joan Arden" had been submitted three times. Postal regulations were clear, "prizes equal to the stipulated value of the main prize ($500) had to be given to *all* entrants who came up with the same winning name." The jam was all winners would be entitled to a $500 prize. "Joan Arden" was out. Perhaps the bigger bosses as at MGM were not as enthusiastic about the untested Crawford's film prospects as Mr. Rapf, at least they were not willing to spend more than the agreed upon $1,000.

You can't keep a secret in Hollywood, and by July the *Exhibiter's Herald* reported, "Joan Arden is the new name of Lucille Le Sueur, playing in 'I'll Tell the World,' following a contest in the east." *Motion Picture News* announced "Joan Arden" as a member of the cast of Rapf's upcoming film, *I'll Tell the World*, to be directed by William Wellman. "Joan Arden" was not the only name to be changed. When the movie opened in 1926 it was retitled as *The Boob*.

Adele Whitely Fletcher was still writing for fan magazines more than a half century later. After Crawford's death in 1977, she penned a tribute in the August issue of *Modern Screen*. Fletcher told readers that it was she who selected the name Joan Crawford when the other members of the team, perhaps wary of gathering a second time, left the decision to her. "Joan Crawford" was announced to the world in a *Movie Weekly* article on September 19, 1925. Mrs. Louis Artisdale of Rochester, New York, won the $500 prize, and ten others received $50 runner-up awards. Mrs. Artisdale refused to send a photo to run in the magazine, but the other ten—seven women and three men—are proudly illustrated. Rapf was happy with Fletcher's decision, but not the newly christened actress.

"I hated the name," she told biographer Roy Newquist.[10] Her dislike of "Crawford" became part of her later mythology. "It sounds like Crawfish," she complained to Billy Haines, an up-and-coming actor who befriended Crawford early in her MGM tenure. He responded with the wit that became his screen trademark, "Crawford's not so bad . . . they might have called you Cranberry and served you every Thanksgiving with turkey."[11]

Rapf intended to renew Crawford's contract in September (for another six months with a slight raise) or he would never have gone to the trouble and expense of organizing a name change contest. She had passed the first tests, recorded well on camera and in portraits. She did not cause her bosses any trouble, and may have continued a romantic relationship with Rapf. Any assignment offered was gratefully accepted. She experimented with hairstyles and makeup, lost weight, and visited sets whenever she could, observing the stars perform before the

Clarence Sinclair Bull made this portrait of Crawford in mid-1925.

camera. Crawford admired Mae Murray "for the measure of her tremendous discipline over her body." One day she was furtively watching Marion Davies when a prop man saw her hiding in the shadows. He asked Davies if she might allow Crawford to watch her work and the actress agreed.[12] Crawford never had anything nice to say about Norma Shearer, but admitted that she learned a lot about being an actress from watching her on the set.[13]

After the excellent publicity generated in the spring, it is surprising that Rapf decided not to give Crawford a big push and cast her as lead in an important picture following the contest. Instead, he managed her career with care. The fast pace of the good fortune she had enjoyed over the past eighteen months might have yielded, in one version of the Hollywood fantasy, the next "overnight sensation"; instead, she returned to the ranks of newcomers yet to find a secure place in the movies.

With a new name, Crawford set out to forge a brand-new identity. It was easy to cast off Lucile Le Sueur, the uneducated, untrained, gauche young woman, who still managed to catch the eye of a series of important men. Billie Cassin was her first invention, the brash, enthusiastic, would-be dancer and party girl, but this was not the image she desired to present to the world. Joan Crawford was a name and nothing more. She could become whatever the former Lucile wanted to make of her.

Screenwriter Frederica Sagor, who worked at MGM in 1925 and 1926, recalled one afternoon when there was a knock at her office door. It was Crawford. "I like the way you dress," she told Sagor. "You dress like a lady. I need that." Sagor agreed to take her shopping. She noticed the transformation that took place as Crawford tried on elegant outfits, "the image in the mirror bespoke a new personality—a personality you could not ignore. Her head was high, her carriage straight and tall. She had class, even if it only showed in her wardrobe." New clothing was another step forward. "She had only two interests," Sagor later wrote, "two obsessions: her goals of stardom and of becoming a good actress."[14]

Neither Lucile Le Sueur nor Billie Cassin had the chance to be either. Crawford looked around and saw firsthand Shearer, Murray, Davies, and Boardman. She didn't want to imitate any one of them, but she wanted their success. What quality did they share that made them movie stars? No other performer calculated so strategically what it took to excel. If Crawford was uneducated, she was nevertheless a brilliant study of character. It would take her more than three years to figure out Joan Crawford, but when she exploded on the screen, she was a star like no other.

Child star Jackie Coogan had a big hit with *Rag Man*. The film was produced by Jackie's father John, who also served as his manager, and the family lived high off the young star's impressive earnings. It was released by Metro-Goldwyn in early 1925, and later that year John Coogan moved his operation to the studio. Anxious to capitalize quickly on his son's latest success, he planned a sequel titled, *Old Clothes*. Rapf proposed Crawford to play the featured female role, and John Coogan agreed. It was a small part as Jackie was the attraction and he would dominate nearly every scene, but since the youngster was a popular attraction, *Old Clothes* was sure to be widely distributed and thus provide good exposure for Crawford. It did, although the film had its best business at matinees with audiences dominated by children. Still, it is the film that introduced Joan Crawford.

She received her first screen credit, was often mentioned in reviews including her first in *Photoplay*: "Joan Crawford, a newcomer, is interesting."[15] Her face also appeared on lobby cards, and in some of the promotional still-photographs sent to magazines. Given Jackie's stature the movie was novelized, and Crawford's picture appeared on the book's back cover among the other main cast members. These were small but important steps toward getting her name and face out before the public.

On the heels of *Old Clothes*, Rapf cast Crawford in another small role in a film originally titled, "I'll Tell the World," but released as *The Boob*. "The Boob" was played by comic actor George K. Arthur, and his leading lady was Gertrude Olmsted. Crawford played a Prohibition agent, and she appears primarily at the film's conclusion. In *Old Clothes*, she had a significant supporting role, but Crawford's part is small in *The Boob*, although her name is on the film's title card. It was completed by August, but was held back for more than six months before being released in the spring of 1926. Rapf made a year-end trip to Europe so the film was delayed until his return. The film has the dubious distinction of being MGM's cheapest picture for the 1925–26 season; it also had the lowest box-office returns and ended up with a $30,000 loss to the studio.[16]

Crawford's reward for all her hard work in small parts was to be featured in *Sally, Irene and Mary*. It would be her third film in a row with hardly a day off. Based on a successful and long-running 1922 Broadway musical, it was another role ideally suited to Crawford as she played (once again) a Broadway chorus girl. Edmund Goulding wrote the screenplay and directed. The cast announced back in June included Sally O'Neil, Eleanor Boardman, and Rénee Adorée. Rapf decided to retain O'Neil, who he was positioning for stardom (she too had arrived at MGM in early 1925) and replaced the others with Constance Bennett and Crawford.

Casting films was part of the art of career building. No studio would waste valuable screen time placing two (or more) successful actresses in the same film. *Sally, Irene and Mary* would be a competition among O'Neil, Bennett, and Crawford to find out who, if any, would find favor with audiences. Bennett had been working in New York, most recently at Universal. She was starting to get attention, so was snapped up by MGM. This cast change made sense as Boardman had scored several successes on her own that year. Adorée had completed *The Big Parade* opposite John Gilbert, a film that was sure to be popular. The studio now had bigger plans for her and reunited Adorée with Gilbert for his upcoming film, *La Bohème*.

In the new cast, Bennett played Sally, Crawford, Irene, and O'Neil, Mary, three Broadway dancers who sought love in the wrong places. Fate treats each differently: O'Neil gets a happy ending, Bennett sticks to her old ways, and Crawford's character is killed in an automobile accident. The film was shot in October and November, marking the beginning of what would become a friendship between Crawford and her director. "Eddie Goulding started teaching me to act," Crawford

Crawford at the time of *Sally, Irene and Mary*, 1925, her first important screen role. John Kobal Foundation.

remarked, and the film was a needed boost to her confidence. "That picture told me I was doing the right thing." Goulding, a veteran of dozens of films, knew he was working with a neophyte who "had a habit of overacting to compensate for her lack of dramatic training," but one who showed tremendous promise.[17]

Reviews were mixed, but the box office returned a respectable profit of $141,000 to the studio. The best notices went to Sally O'Neil, although *Film Daily* called the cast "splendid" and a delightful trio of chorus girls."[18] Less enthusiastically, *Variety* proclaimed, "It's not a good picture," and landed hard on Crawford who "makes a silly girl of Irene."[19] The *New York Times* was neutral on the acting and described the film as "a tawdry preachment concerned with the night life of gold-digging chorus girls." Had Crawford paid close attention to the *Times*, to the right of Mordaunt Hall's review, advertisements for current plays on Broadway were listed and included were *12 Miles Out* and *Rose-Marie*. In two years' time,

Crawford would play opposite John Gilbert in the film version of *12 Miles Out*, and the following year she would play the title role in *Rose-Marie*.[20]

The critics might not have been excited, but Louise Brooks recounted a story of Goulding's enthusiasm for Crawford. Louise was staying in New York with producer Walter Wanger when Goulding visited. *Sally, Irene and Mary* was playing in theaters, "but he didn't want to talk about that, nor did he talk about Constance Bennett and Sally O'Neil . . . he talked exclusively about Joan Crawford. 'She's the find of the year, Walter. . . . Beautiful, wonderful emotional quality—bound for stardom.'" Brooks resented these comments. She noted, "Nobody ever talked that way about me. . . . As I listened to Eddie rave on," Brooks decided, "that Joan Crawford must really be something."[21]

If Crawford didn't become a movie star after twelve months in Hollywood, she was nonetheless awarded a high honor when in December she was named a WAMPAS Baby Star of 1926. Starting back in 1922, the Western Association of Motion Picture Advertisers (WAMPAS) selected each year thirteen young women who they believed had a chance at movie stardom. Colleen Moore was a member of the class of 1922, Eleanor Boardman the next year, and Clara Bow in 1924. MGM publicity chief Pete Smith was the president in 1925 and would have had a hand in choosing three promising women from his studio, all thought to have the prospect of stardom. Along with Crawford, Sally O'Neil, and Marceline Day were selected. Being named to this sorority bestowed substantial free publicity for the winner (and her studio). "My nomination," Crawford wrote, "gave Pete Smith and his assistant Howard Strickling, a chance to flood the country with publicity art." The other WAMPAS stars for 1926 were Mary Astor, Mary Brian, Joyce Compton, Dolores Costello, Dolores del Rio, Sally Long, Janet Gaynor, Edna Marian, Vera Reynolds, and Fay Wray. Gaynor would go on to become a star rivaling Crawford; Astor, Brian, del Rio, and Wray would have significant careers. Each February, a lavish ball was held in Los Angeles celebrating the year's selections, and in 1926, the "WAMPAS Frolic" attracted some 6,400 who crowded into the brand-new Shrine Auditorium.

Another actress arrived at MGM that fall who would go on to have more than a significant career, Greta Garbo. She joined the studio in September and was making *The Torrent* at the same time Crawford was filming *Sally, Irene and Mary*. Although they were almost the same age, and both new to MGM, Garbo would have a meteoric ascent to stardom. Crawford would have been aware of the attention the Swedish newcomer was getting, and followed Garbo's upward progression in 1926 and 1927. They were complete opposites in personality and screen type. Yet, each deliberately and strategically planned her path to stardom. Garbo rejected the studio's publicity apparatus, and by becoming invisible, except on screen, created a demand for any personal tidbit or image the studio was willing to leak. Crawford embraced the public with a frenzy that soon became legendary—and put old-timers like Gloria Swanson and Mary Pickford to shame.

In late 1925 Crawford was named a WAMPAS star heralding the prospect of motion picture stardom.

MGM had announced an ambitious production schedule for the 1925–26 season, "The Quality 52," and, in a series of ads taken out in trade journals, was ready to give titles to more than 40. Crawford had parts in six, demonstrating that in slightly over a year she was fully a member of the MGM family. None were starring roles, but it augured well for the future.

Leading Lady, 1926–27

WITH A NEW NAME, A WAMPAS HONOR, SEVERAL SCREEN CREDITS, and the reputation of being good natured and willing to take any part ungrudgingly, Crawford's contract was renewed for twelve months on March 13, 1926. She would no longer work under six-month renewal periods. Her pay was increased to $250 per week.

Over the previous twelve months, Rapf had methodically managed Crawford's screen appearances, and her work in *Sally, Irene and Mary* showed that she was beginning to emerge as a motion picture actress. The film was playing in theaters to decent if not exceptional box-office returns, attracting mostly the young women who would continue as her mainstay over the next three decades. She was given parts in five films in 1926, different sorts of projects that would provide her a variety of experiences before the camera. Contract renewals and modest raises didn't necessarily mean that the studio had great future plans for Crawford. MGM needed young and attractive actresses to fill cast lists. Plenty of successful careers were had by performers who completed three-, five-, or even seven-year contracts at the studio but who were never given the chance at movie stardom.

As a young woman, Crawford enjoyed nightlife, and long days at the studio hadn't diminished her passion for dancing at clubs. "I worked all day and danced all night. Tuesday and Wednesdays at the Montmartre, Fridays at the Cocoanut Grove, the beach clubs, the Saturday tea-dance kid. . . . There was no lack of dancing partners—this town was filled with gay young men"[1] She became renowned for her Charleston and Black Bottom. Many of the clubs offered dancing contests that awarded loving cups to the winners, and Crawford collected many. Along with her enthusiasm and skill, she recognized the key to becoming well-known in a city filled with the famous: "My skirts had to be a trifle shorter, my heels a little higher, my hair a tint brighter, my dancing faster."[2]

"At the Wednesday and Friday night dancing contests," wrote Hollywood columnist Margaret Reid, " . . . if your luck is good, you happen in on a night when Metro-Goldwyn's Joan Crawford is strutting her Charleston with one Jerry

Chrysler. The cheering and yelling, of quite collegiate abandon, always awards them the cup."[3] Chrysler was one of Crawford's first and best dancing partners,

> One evening at the old Montmartre we won the dancing contest after an hour of hectic whirling. It was an exceptionally warm café, but when we got into Jerry's open car it was chilly. I begged him to keep his overcoat around his shoulders, even tried to hold it there for him, but he was so over-heated from the exertion that he refused. . . . Two days later, the resulting cold had developed into pneumonia.[4]

Pneumonia proved fatal to the young man.

Among those in her long line of dancing partners, she found romance. "Joan Crawford Engaged!" was the headline over a spot in February's *Variety* that informed readers of the news: "Michael Cudahy, the son of Mrs. Jack Cudahy, is reported engaged to marry Joan Crawford, Metro-Goldwyn featured player who was recruited from the ranks of a Shubert musical in New York by Harry Rapf."[5] Cudahy was the seventeen-year-old son of a wealthy Chicago meat packer, and the young man had a substantial monthly income from a trust fund.[6] He was also more than three years younger than Crawford. Writing for *Photoplay*, Cal York described "The Real Hell Raisers in Hollywood," the story of the rich young men who descended on Hollywood in the 1920s with the goal of bedding, or perhaps even marrying, actresses. Cudahy was one of his targets.[7] Cudahy charmed Crawford, and she agreed to become his wife. But there was a formidable obstacle, his mother was firmly set against the union.

That did not prevent Cudahy from escorting Crawford to the best clubs in Los Angeles "You never found me dating a boy who couldn't dance," Crawford later wrote. "I met and fell in love with Mike Cudahy . . . startlingly handsome, tall, dark, gallant, a graceful dancer." He was also a drunk. He lived with his mother in a "great old mansion . . . with at least thirty-five rooms . . . on a hill above Hollywood and Sunset."[8] Crawford tried to keep him sober, but without success. Drinking notwithstanding, the relationship was doomed. In May, Mrs. Cudahy commented on the purported engagement to the *Los Angeles Times*: "My son is 18 years of age and I am his legal guardian, so I can say that this marriage would be annulled if he ever decided to marry this girl."[9] The next month, the paper reported that the engagement was called off noting, "Neither young Cudahy nor Miss Crawford is of age."[10] She was, having turned twenty-one that March, but such a report contributed to shaping her later claim of 1908 as her birth year. Cudahy continued to chase after actresses, among them Clara Bow, and married Muriel Evans in 1929 (they divorced the next year).

Cudahy's mother wasn't Crawford's only family problem that year. Now that she was rewarded with a substantial raise, she moved out of the Washington Hotel and rented a small house on Argyle Drive in Hollywood. This was the catalyst

A champion Charleston dancer, Crawford won many cups at competitions in Los Angeles throughout 1925 and 1926.

for Crawford's mother to move to Los Angeles. Her brother Hal had appeared, uninvited, the summer before with dreams of either his sister's support or a career in the movies, or perhaps both. He insisted that she arrange a screen test for him; after all, how much talent did his sister have and she was being paid $250 a week? Crawford did as her brother asked, and he was tested for a part in *The Midshipman*, a Novarro picture that was filmed in the late summer of 1925. Ruth Harriet Louise photographed Hal and also made double portraits with his sister. These portraits were picked up by the fan magazines, with captions that focused on Crawford. He did not get a part in *The Midshipman*. Hal was luckier the next year when he landed a role in *Night Bride*, starring Marie Prevost, for Metropolitan Pictures, a Poverty Row studio. Gone was the name Hal Le Sueur;

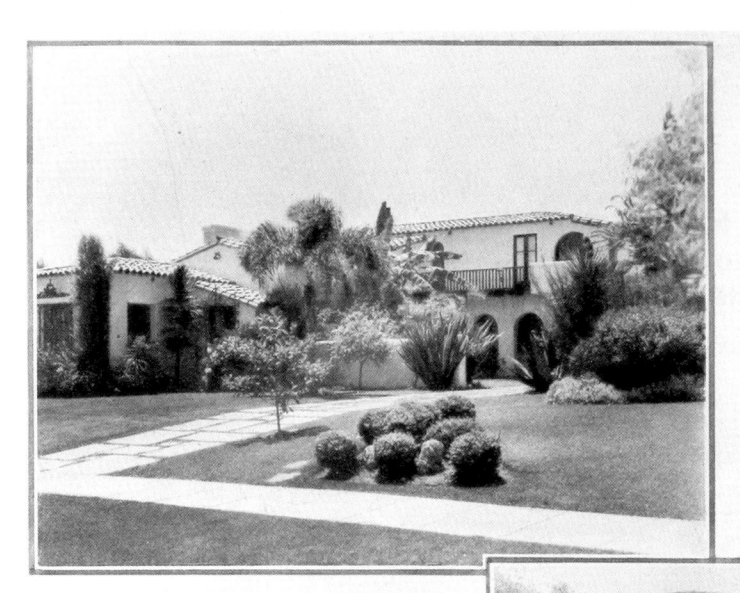

Then and Now

Top, Robert Montgomery's present home on Palm Drive, Beverly Hills. Right, the house in which he lived up Beechwood Drive, Hollywood, back in 1928 when he first came to movieland. Montgomery took a bus to work in those days.

Left, the house where Joan Crawford first lived in Hollywood. It is on Argyle Drive. Below, the present residence of Joan Crawford and her husband, Doug Fairbanks, Jr., in Brentwood Heights, near Santa Monica. Quite a contrast!

When Crawford's contract was renewed a second time in late 1925, she moved out of the Washington Hotel into a rental house on Argyle Drive in Los Angeles. [*New Movie Magazine*, November 1931, 50.]

Hal LeSueur followed his sister to Hollywood and had an early success in the movies (as Richard Crawford). He is seen here with Constance Howard in *Night Bride*, 1927.

he had rechristened himself Richard Crawford. The studio liked his work and announced in April 1927 that he was being signed to a long-term contract.[11] Later that year, Metropolitan was acquired by Pathé, and Richard Crawford was never heard from again. Hal Le Sueur did work at MGM in the 1930s in uncredited bit parts. Mayer would soon predict a grand future for Crawford, but there would be only one movie star in the Le Sueur family. When Crawford rose in the studio ranks, Anna adopted the manner of a leading lady's mother, and eventually, like her son, co-opted her daughter's new last name as well.

Crawford was lent out by MGM to work with comedian Harry Langdon in *Tramp, Tramp, Tramp*, 1926.

Rapf's first project for Crawford in 1926 was working with Harry Langdon, who had been a top comic for Mack Sennett: not quite in the Charlie Chaplin and Buster Keaton league, but successful, first in vaudeville, and later in films. He left Sennett in the mid-1920s, and joined First National Pictures, where he planned to start making feature films. His first effort was *Tramp, Tramp, Tramp*, and he looked to Rapf for suggestions for a young actress who could play his love interest. Rapf suggested Crawford, and Langdon approved. A deal was made to loan her to the competition at a premium fee paid to MGM but with nothing extra for Crawford. It was, however, a chance to work with a well-loved comedian, and an opportunity to get further exposure as Langdon's debut in a feature film would generate a great deal of attention.

Whether it was working with Jackie Coogan or Harry Langdon, these fellows were the stars so there wasn't much room on screen for anyone else. Langdon played a character named Harry, a hobo who entered a cross-country walking event—Boston to Los Angeles—in order to win the heart of his beloved, Betty, played by Crawford. *Variety* summed it up well: "Joan Crawford is borrowed from Metro to be a nice leading lady with little to do."[12] Another critic called her "a vivaciously pretty Betty."[13] Langdon got most of the attention, but an Indianapolis

newspaper gave her a boost: "Joan Crawford, one of the most beautiful of the screen's younger actresses, plays opposite Langdon, and makes a brilliant part of the role she plays."[14]

As filming on *Tramp, Tramp, Tramp* was wrapping up, Crawford was announced as the lead in *There You Are*, which was to have been directed by Jess Robbins. He never worked at MGM, and when the film was made in late 1926, Edward Sedgwick was director and Gwen Lee played the part originally intended for Crawford. Instead, her next job would be working again with Edmund Goulding.

Goulding had signed an agreement with Rapf in January 1925 to direct of series of films for MGM. This was not an exclusive arrangement, but over the next three years he would make five films for the studio. The first released was *Sun-Up*, followed by *Sally, Irene and Mary*. He owed a picture to Paramount so left for two months to make *Dancing Mothers*, starring Clara Bow. He was back in the winter of 1926 and ready for a project. Rapf offered him *Paris*, a film that had become a "hot potato" for the producer. *Paris* was meant to be the first of two pictures designed by the French artist Erté. He was hired by Mayer in March 1925, bringing him to Los Angeles at great expense and fanfare. Erté was to work with Rapf, and to provide sets and costumes for two films that would be built around his signature modernist extravagance, *Paris* and its sequel, *Monte Carlo*. Both films started as titles without scripts. In July, full-page advertisements appeared in the trade magazines announcing that Robert Z. Leonard was directing *Paris* from a script by Carey Wilson, and starring Pauline Starke and Lew Cody. The next month, *Monte Carlo* was promoted also promising Erté's fashions, and to be presented in Technicolor.

For reasons never ascertained, this iteration of *Paris* fell apart, if in fact it had ever successfully come together. In November, *Paris* had a new director, Paul Bern, later well-known as a producer and as a husband of Jean Harlow. He had directed a couple of features for Paramount, and recently signed a contract with MGM "to make one picture with an option for two more."[15] Carey Wilson's script had survived the shuffle but now Eleanor Boardman and Charles Ray were to play the leads. To keep him busy, Erté had been asked to provide costumes for a variety of films such as *Ben-Hur* and *La Bohéme*. When he discovered that Wilson's script was not a contemporary story but an historical drama, Erté quit and fled back to France. Two weeks later, Bern walked out on his contract. Rapf was left without a director, and had on his hands a heavily advertised film that was signaled to feature dazzling sets and costumes by the renowned Erté.

Goulding needed a job and was happy to salvage *Paris*. His condition was that he wanted to direct his own script. Whatever Rapf, Wilson, and Erté had envisioned, it was buried when Goulding came up with a fascinating though brutal story of the contemporary Paris *demi-monde*. It told the story of members of Les Apaches, an underworld gang of criminals who encountered a wealthy American at a seedy café. Goulding's biographer wrote that it "revealed Eddie's

interest in tawdry, subterranean meeting places," and that "he handpicked his star, Joan Crawford."[16] Charles Ray portrayed the millionaire, Douglas Gilmore was the apache, and Crawford played his moll. The reimagined project was ready to start filming in March 1926.

Crawford was now the female lead in a film that had received tremendous build-up but had sunk to become a middle-of-the road program picture. With all the expenses that had been charged to *Paris*, Rapf knew it could never be a success at the box office, and he was satisfied to get a film in theaters under the title *Paris*. *Monte Carlo*, the planned sequel, came out first. Like *Paris*, it was released without sets and costumes by Erté, nor were there any Technicolor sequences.

For the first time, Crawford's name was used to publicize one of her films. Stardom was still a long way off, but she was now a leading lady albeit at the bottom rung of that designation. Posters carried her name, below the title and after Charles Ray, but she was credited above Douglas Gilmore. An equally good barometer of rising success was being awarded a full-page portrait in one of the top fan magazines. Crawford's first was in the June 1926 issue of *Motion Picture*, where she was featured as photographed by Ruth Harriet Louise in a sitting arranged while *Paris* was in production. Wearing a white collared shirt and sweater, with her hair parted at the side and combed back, she is the personification of cool elegance. The following month, *Cinema Art* also gave her a full-page reproducing another portrait from the same session.

Reviews for *Paris* were mixed. "Her acting is commendable" was the best the *New York Times* could do.[17] *Film Daily* was more enthusiastic, noting, "Crawford gets her first real chance as the Apache girl and does splendidly."[18] Others acknowledged that she still had a long path to travel. "Advance information on Miss Crawford among the 'picture mob' had her strongly heralded as a 'comer,'" wrote the critic for *Variety*. "Undoubtedly a 'looker' . . . Crawford will nevertheless have to show more talent than in this instance to make that billing entirely unanimous."[19] Still, there were little clues that success was coming. In a June issue of *Moving Picture World*, one page was devoted to the reviews of *Tramp, Tramp, Tramp* and *Paris*.[20] This was an example of subtle market saturation. Joan Crawford was becoming known to the motion picture public.

Speaking at a trade luncheon for exhibitors in New York in May as *Paris* was about to open in theaters, Mayer discussed his studio's upcoming releases. He also tipped his hand, deliberately, revealing that MGM "had four new stars in the making and named Sally O'Neil, Renée Adorée, Joan Crawford, and William Haines as those being groomed for stellar honors."[21] His words were meant to be captured in the press so that public opinion might have a voice in deciding whether or not any of the aforementioned had a shot. Mayer knew who really made stars, he was simply the fellow who paid their salaries.

William Randolph Hearst's Cosmopolitan Productions was part of the MGM family, and although it is best remembered today as the producing agency for

Crawford with Louis Mercier, Pat Somerset, and Charles Ray on the set of *Paris*, 1926.

Marion Davies, they also financed many other films. For the 1926–27 season, Cosmopolitan announced nine pictures, three of which would feature Davies including *The Red Mill*. Irving Thalberg would supervise the Davies pictures. Among the six others were *The Temptress*, with Garbo, and *The Understanding Heart*.[22] *The Understanding Heart* began its life as a story by Peter D. Kyne, which had been serialized in Hearst's *Cosmopolitan Magazine*. The publisher had approval over director and cast; he okayed Jack Conway to direct and a cast headed by Crawford, Rockliffe Fellowes, and Francis X. Bushman Jr.

Cast and crew left Culver City in late July to film on location in Yosemite during August and September. "There are forest fires, fugitives in flight, airplane rescues and twists of various kinds to provide the thrill" was how *Film Daily* described the action, calling "Crawford good as the mountain lookout girl."[23] If the film did not prove to be her breakout, it still provided her best notices yet. "'The Understanding Heart,' which is concerned with the fighting of forest fires, depends chiefly for its entertainment on the charming presence of Joan Crawford," wrote Mordaunt Hall in the *New York Times*. "Miss Crawford is exceptionally good. She is attractive, but at the same time she is clever enough to impress one with the idea that she is not quite aware of it."[24]

Back in Culver City, producer Bernard Hyman assigned Crawford a leading part in *The Taxi Dancer*. Crawford's character is unable to get work on stage so has to settle for a job in a seedy dance parlor, serving as a 10 cents-a-dance girl. Young and attractive, she meets many men, some good and some bad. At the end, she finds a good one. Neither Crawford nor the critics liked the picture. "My only fond memory of *Taxi Dancer* is the fact that I was better than the picture."[25] The *New York Times* agreed: "Joan Crawford could evidently do better under more inspiring direction or in a well-knit story."

Up next was an historic drama set in the American frontier during the French and Indian War. Mayer decided that there was money to be made with "Westerns" and set up a special production unit with Hyman at the helm. *Winners of the Wilderness* wasn't a typical Western—the action took place in and around Pittsburgh—but there were men on horseback and battles with the indigenous population, so it qualified as far as the studio was concerned. Originally called "Braddock's Defeat," before release it was given a more upbeat title. Crawford played the daughter of a British general who falls in love with a Yankee soldier. Tim McCoy, who played the soldier, was beginning a career that saw him become one of cinema's top cowboy stars. He joined MGM in 1926, and his first film, *War Paint*, was a huge hit. Woody Van Dyke directed, and the studio wanted to capitalize on the film's success so ordered three more Tim McCoy "Westerns," with Van Dyke at the helm, but with a different leading lady for each picture. The first was *Winners of the Wilderness*, with Joan Crawford. Dorothy Sebastian and Marjorie Daw supported McCoy in the following two films, which, in the spirit of economy were made simultaneously; McCoy would work with one cast in the morning and the other in the afternoon (or vice versa).[26] *Winners of the Wilderness* was released in the winter of 1927.

The ultimate accolade awarded an ingénue with dreams of movie stardom was appearing on the cover of a top fan magazine. *Screenland* was Crawford's first, and she made the cover of the May 1927 issue as her new film was playing in theaters. Most fan magazines used paintings as the sources of cover art, which, in turn, were derived from official studio portraits. Among the best of these illustrators was New York-based Jay Weaver, who had a contract providing covers to *Screenland*. He painted Crawford in a costume from *Winners of the Wilderness* that was derived from a photograph by Ruth Harriet Louise. Crawford must have been excited the first time she saw her face at newsstands around Los Angeles. Soon it would be a regular sight as she became one of the movie industry's most frequent cover subjects.

Crawford was beginning to get noticed but in modest films that did not get much attention. She had made ten pictures in which she had some sort of featured role, from chorus girl in *Pretty Ladies* to the female lead in *The Taxi Dancer*. "There seems to be a rather vague and experimental regard for Joan Crawford on the part of Metro-Goldwyn-Mayer," wrote columnist Fred W. Fox. "It may be that

they are allowing her to run the gamut from semi-farcical drama to dyed-in-the-wool melodrama to determine her fitness for certain vehicles."[27] If her career was going to move forward she needed to be offered better and less scattershot roles.

Her studio was also sending out conflicting images. Mayer, as reported by Ann Sylvester, told Crawford that she "had an interesting future . . . but that she was jeopardizing it with frivolous publicity . . . he wanted to see less jazz notices about her."[28] Yet, could Mayer have minded that fan magazines were showing interest in one of his up-and-coming leading ladies and following her exploits on and off the screen? Some mentions were items announcing upcoming projects: "Joan Crawford, whose rapid rise with M-G-M reads like a film romance, appeared with considerable success in 'The Taxi Dancer.' 'The Unknown' will be next."[29] Others appealed to her growing coterie of fans. *Motion Picture* gave her a full page in March 1927, demonstrating in ten photographs how to dance the Black Bottom. "Oh Boy! But it's Good" was the tag line for Chapman's Fancy Ice Creams in a series of print ads appearing throughout that year. Crawford was photographed about to take a bite out of a temping looking ice cream cone.

There was also the issue of billing:

> Joan Crawford, although listed as an M.-G.-M. featured player, was practically starred in her least two releases, *The Taxi Dancer* and *The Understanding Heart*, both of which stood up remarkably well at the box office considering there was no special merit to either production. Since she is Harry Rapf's protégé, we hear that he has big plans for her and will star her ere long.[30]

Her career turned upward with the flurry of attention generated by the almost simultaneous release of three Crawford pictures in February 1927: *The Understanding Heart*, *The Taxi Dancer*, and *Winners of the Wilderness*. Harry Rapf had managed her early appearances, but her successes brought Crawford to the attention of the studio's other producers. She had graduated from Bernard Hyman's Western unit, so the looming question was: was she ready to take on more prestigious projects? Mayer decided yes, and had her cast in two films working opposite the two biggest male stars in Hollywood, Lon Chaney and John Gilbert. Both would be quirky films, but her roles would force her to expand her range. How successful she was in sharing the screen with Chaney and Gilbert might determine her future.

Fan mail was reckoned to be one of the best indicators of stardom, and in 1927, Lon Chaney received more letters than any other player.[31] Since moving to MGM from Universal in 1924, he had a series of hits playing the widest variety of roles of any actor in town (maybe ever). Chaney could seemingly do anything (except perhaps be a romantic lead), and his rich variety of characters—clowns, criminals, old ladies, military men—won him acting's highest praises. "The star has a way of attracting movie fans," wrote journalist Laurence Reid, "who come

A portrait for *The Unknown* attributed to Clarence Sinclair Bull. John Kobal Foundation.

to see what next will be served up in the way of original characterization. Lon is a man who never fails them."[32] For *The Unknown*, he played Alonzo, a circus performer, an armless knife-thrower, who used his feet to perform his daring act. Crawford played Nanon, his partner, who had the unenviable role of standing on a revolving platform against a board while knives were tossed in her direction, landing in an arc barely tracing her body. Todd Browning directed this peculiar story of obsession. Looking back at the actresses working at MGM, who else but

Crawford could have played this Nanon? Not Garbo; possibly Shearer before Thalberg decided that she was suited only to portray elegant ladies. The role was out of the question for Davies or Lillian Gish. Here was the first great opportunity for Crawford: a terrific part, working with the industry's biggest draw, demanded an actress who could convey steadiness, bravery, perseverance, and a working-class sexiness, all characteristics that would soon come to define the Crawford brand.

"When he worked, it was as if God were working, he had such profound concentration," Crawford wrote of her experience with Chaney. "It was then I became aware of the difference between standing in front of the camera, and acting."[33] She was singled out in reviews. "Miss Crawford is not only beautiful but she gives a most competent performance," wrote the *New York Times*. She got terrific, and rather gushing, praise in the *Film Spectator*:

> Joan Crawford is very satisfactory in this picture and to me her characterization is the only meritorious feature of the production. . . . Elaborate care is taken to acquaint the audience with the fact that she has a fine figure. . . . I feel grateful to Browning for demonstrating to me that she has beautiful legs. . . . I also was glad to note, when my mind was not occupied with its reaction to her legs and the rest of her physical self, that she is coming on as an actress.

Working with Lon Chaney gave Crawford the opportunity to work with the movies' greatest actor. Next she would support Tinseltown's number one romantic lead, John Gilbert, in *Twelve Miles Out*. He had completed, in succession, three of what became the silent era's most notable films: *The Big Parade* was a financial blockbuster, giving MGM a profit of nearly three and a half million dollars; *Flesh and the Devil* brought Garbo stardom and further long lines at the box office; and *La Bohème*, costarring Lillian Gish, was a prestige project that also scored well with the public. It seemed he could do no wrong, although he did have couple of problems, namely, liquor and Garbo. Gilbert was obsessed by his Swedish leading lady who was living in a small guest house on his property while she negotiated a new contract following her dazzling performance in *Flesh and the Devil*. He was desperate to marry Garbo but she toyed with him, leaving him anxious about their future. After a spat with her in April, he went off and got drunk; the details are murky, but whatever happened, he got arrested and was sentenced to ten days in jail. This was poorly timed as he was expected at the studio to shoot *Twelve Miles Out*. The bosses intervened, and his sentence was reduced to the one day served.[34]

Prohibition began in the United States in 1920, and the restrictions against the manufacture, sale, or transportation of beer, wine or liquor provided the movies with an inexhaustible number of plots during the following decade. *Twelve Miles Out* was a contemporary story, and the title refers to the distance off shore that law enforcement could monitor. Beyond the twelve miles, a boat loaded with liquor

Crawford and John Gilbert on the set of *Twelve Miles Out*, 1927.

was safe. The trick was getting the cargo to shore. Gilbert plays a bootlegger who has scored a load of liquor. While being chased by coast guard agents, he returns to land and docks at Crawford's Long Island home. Seeking refuge, he breaks into her house. Since she can identify him, he abducts her and brings her aboard his vessel where, predictably, they fall in love. As he is not a good man, the censors made sure he paid for his crimes, and he dies beautifully in Crawford's arms.

This was the first of Crawford's films that got the censors' fingers wagging. It wasn't over sex—there wasn't any—but rather alcohol and violence. "I think it is quite delightful to have a picture about bootlegging and high-jacking," wrote the critic in *Film Spectator*, who clearly enjoyed a drink. "Bootleggers play such an intimate part in the lives of all of us that we have personal interest in the worries that beset them." James Quirk, editor of *Photoplay*, had different thoughts:

Mr. Mayer is holier than none. No hotter screening of 100 per cent sex than "Flesh and the Devil" has appeared in years. The "Callahans and the Murphys" aroused the ire of the Irish and the Catholics all over the country.

Exhibitors who had paid for it feared to run it. "Twelve Miles Out" violated so many of the rules he smugly set up for other producers and offended theater patrons to the extent that many exhibitors regretted showing it.[35]

Film Spectator was a trade publication that had a strong industry following but little influence with the public. *Photoplay*, on the other hand, was a publishing juggernaut, and Quirk offered one of the most influential voices in the industry. Censorship was coming.

Bootlegging, kidnapping, and murder notwithstanding, *Twelve Miles Out* was popular with the public and made money for MGM. Both Gilbert and Crawford got good notices. "Joan Crawford is a riot, registering like a classic for form, appearance, looks and ability," said *Variety*. "Two more pictures like this for Miss Crawford and she's set.[36]

Among Crawford's many early supporters (or at least enthusiasts) was F. Scott Fitzgerald. It is often stated that he considered her the epitome of 1920s vitality, but, in truth, she shared the honor. His book, *The Great Gatsby*, was published in 1925. It was an immediate sensation, and for a century has helped define our understanding of the Jazz Age. Considered his era's authority on the topic, Fitzgerald was often asked his opinion about the flapper. Margaret Reid interviewed him in 1927 for *Motion Picture* magazine. He placed flappers into one of four categories. Clara Bow was the "quintessence of what the term 'flapper' signifies"; Colleen Moore, the "young collegiate"; Constance Talmadge, "the epitome of young sophistication" and "Joan Crawford is doubtless the best example of the dramatic flapper. The girl you see at the smartest nightclubs—groomed to the apex of sophistication—toying iced glasses, with a remote, faintly bitter expression—dancing deliciously—laughing a great deal with her wide hurt eyes."[37]

Another early fan was young Salvatore Ferragamo, who opened a shoe shop in Hollywood in 1925. He quickly became a darling of the Los Angeles elite and the studios' leading ladies. Among his favorites was Crawford, who, he believed, had the most beautiful legs in Hollywood. Ferragamo returned to Italy in 1927 and went on to become one his industry's legends. Crawford remained a devoted client for the rest of her life. [38]

Two and a half years after stepping off the train from Kansas City, critics were about ready to anoint Crawford with the stardom she had worked so painstakingly to achieve. Mayer and the producers had other ideas. She had been tested in big-budget films with the best actors working, and had succeeded admirably. Instead of casting her in increasingly prestigious films, however, she found herself in a pair of films supporting William Haines. Like Crawford, Haines had been moving up steadily. Also like Crawford, he proved his real worth to MGM costarring with Chaney, and got great notices in the successful military story, *Tell It to the Marines*. Over-the-title stardom was awarded him in mid-1927. This achievement was well deserved; he was a fine actor, popular in Hollywood, and

always remained relatively down-to-earth, although in a nod to the Hollywood high life, he built a magnificent house that was splendidly decorated and furnished. Although Crawford and Haines were close friends, and would remain so, she may have felt a bit of pique at his success.

The studio did not offer her a star's contract but did show appreciation for her good work and that summer helped her purchase a house. Her salary in 1927 had risen to $500 a week, a hefty raise from the year before, but Crawford did not have the capital for a down payment. Frank Lloyd Wright's son, Lloyd Wright, was establishing himself as a Los Angeles architect. Two years earlier, he had built a house at 513 Roxbury Drive in Beverly Hills for writer Herbert Howe, who had a romantic and professional relationship with Ramon Novarro.[39] Howe decided to sell the house, pricing it at $28,000. Crawford bought the house with a $6,000 loan from MGM for the down payment, and took out a mortgage for the balance.[40]

The first of the Billy Haines movies was *Spring Fever*. It tells the story of a factory worker who has the good fortune to be a superb golfer. His wealthy boss is a committed player but terrible at the game. Thus, the young man is invited to play at the fancy country club in the hope that his skill will rub off on his employer. At the club, he meets a beautiful young woman. A romance develops, on one minute, off the next. In the end, the young lovers are united. Crawford has little to do except wear smart sporty outfits and watch Haines mug amusingly for the camera. The second was *West Point*, filmed on location, about a well-heeled young man—Haines playing his trademark wisecracker—admitted to the famous military academy. It is a coming-of-age story, the obnoxious fellow who grows up, with plenty of scenes showing cadet life, but it is also a football picture with Haines becoming the team's star player. The scenes of the game are excellent, and the editing so fine that it appears he is playing in the Army-Navy game. The studio cast Haines as an athlete in both films to promote him as a red-blooded leading man although he was living openly with a male partner. He also hated sports. Crawford was the right leading lady with her appealingly down-to-earth sexiness: if she liked him, he must be okay.

They met soon after Crawford arrived in Los Angeles, and Haines had a part in *Sally, Irene and Mary*. By 1927, they were best friends off-screen as well as attractive and well-suited costars. Filming at West Point, less than sixty miles north of New York City, gave Crawford the chance to visit friends she had made back when she was dancing at the Winter Garden. On one of their jaunts in late August both were hurt in an automobile accident, but not badly enough to delay filming. Both *Spring Fever* and *West Point* hold up well today though neither can be described as a classic of the silent screen. The appeal is the leads. Haines is a physical actor and holds the audience's attention with his charm and sure command of his gestures. Because Crawford arrived untrained and had her entire apprenticeship at MGM, she lacks the mannerisms often associated with silent acting, and reads on screen as fresh and modern.

Crawford made two films in 1927 with her best friend William Haines, *Spring Fever* and *West Point*. Portrait by Ruth Harriet Louise. John Kobal Foundation.

Returning back from the East Coast Crawford found herself assigned to another Tim McCoy Western. Was this punishment, or simply the studio's way of informing Crawford that good work and reviews notwithstanding, not to mention a mountain of publicity, she wasn't going to move any further up the ladder? *The Law of the Range* was not only low-budget, but at less than an hour, it wasn't really even a feature, and made to be shown at either the front or back end of a Saturday afternoon double bill. It wasn't Crawford's style to complain about the choice of films she was being offered although in this case she might have taken a lesson from Garbo. *The Law of the Range* passed hardly noticed, intended for kids at the matinees, and it is among the silent era's many lost films.

Why was stardom withheld from Crawford? Money was one factor, influence was another. MGM was paying huge salaries to Garbo, Shearer, Davies, and Lillian Gish. Crawford, and another successful leading lady, Renée Adorée, were kept at a peg below. They were inexpensive, and could be put in a wide variety of films, from Westerns to romances. These sorts of actresses were the workhorses, making one film after the next to fill exhibitors' expectations of a new MGM feature coming out almost every week. Since so few films were blockbusters, the studio economized whenever possible. Rapf and Mayer took the gamble that Crawford would remain content with her secondary status. She said many times how grateful she was that MGM gave her a chance—and paid her a weekly salary.

But was she content? Crawford worked diligently to rise in the MGM star factory, but she was shrewd enough to recognize that her talent and professional ambition were not sufficient to gain a top perch at the studio. At least not without assistance. She watched with awe, as did almost everyone in Hollywood (including the MGM executives), as Garbo finessed the bosses and won for herself, after only eighteen months in America, an extraordinary star contract, promising her, to start, $2,000 a week, four times what Crawford was being paid. Like everyone else in Hollywood, Crawford understood that Garbo was the exception, and that hers was a game no one else would likely play and win again. She respected Garbo's acting and admired the screen image that was being promoted. She had no such regard for Shearer although she coveted the roles Shearer was offered. Crawford knew that Shearer's ascent had been carefully managed by Irving Thalberg. Whether anyone liked it or not, Thalberg had the most clout of any MGM producer, and could dole out the best roles as he pleased. Most went to Shearer, and Crawford knew she got the crumbs. On September 29, 1927, Shearer married Thalberg. Any chance that Crawford might successfully compete for good parts vanished. It wasn't just Garbo and Shearer who were in Crawford's way. Eleanor Boardman married director King Vidor in the fall of 1926. Lillian Gish had a million-dollar contract, and pretty much choice of script. Marion Davies's relationship with Hearst promised her whatever roles she wanted. While Crawford was paying the mortgage on a small house and supporting her family, Davies was building a 100-room mansion on the beach at Santa Monica.

Not having the exalted positions of Garbo, Shearer, Gish, and Davies did allow Crawford the freedom to enjoy the fun of being a motion picture leading lady. Whether or not Mayer wanted her associated with "frivolous publicity," MGM's publicity department had other ideas. Offered the opportunity, she enthusiastically volunteered to pose for any sort of promotional shots they could imagine. Celebrating the 4th of July, Clarence Sinclair Bull photographed her exploding out of a firecracker. With Christmas coming she posed for Ruth Harriet Louise wearing only Santa's jacket and hat, thus exposing her beautiful long legs. Legs were once again in evidence in a pictorial in *Screen Secrets* titled, "He Who Gets Socked"; readers saw Crawford sparring with Gene Alsace, MGM's leading trainer

Clarence Sinclair Bull created this image of Crawford appearing to be exploding out of a firecracker. John Kobal Foundation.

Crawford and Dorothy Sebastian at the beach in Malibu, 1927. Photo by Don Gillum. John Kobal Foundation.

and stunt double. Action specialist Don Gillum was one of her favorite photographers, and they regularly went off to places around Los Angeles that provided scenic backdrops. One late winter day Gillum photographed Crawford with Dorothy Sebastian at the beach with a portable Victrola to keep them entertained. Shots showing the two friends sitting under an umbrella enjoying the ocean view, exercising, tossing a football, and jumping hurdles, appeared in newspapers and magazines throughout 1927. In November, she wielded the shovel for the ground breaking ceremony for the new Golden Gate Theater on Whittier Blvd.[41] The next month she was featured at the *Los Angeles Examiner*'s Christmas benefit dancing with one of her old Charleston partners, Danny Dowling, performing a new routine.

Aside from the frivolity and the random assortment of films offered, Crawford was demonstrably rising in the matrix that mattered the most in Hollywood: the box office. The *Film Spectator* put out a series of articles in late 1927, *Story of the Box Office*, which measured the financial value to the studios of writers, producers, directors, stars, and featured players. As the year drew to a close Norma Talmadge occupied the top spot among female stars with Garbo second. Among featured players, Crawford was number one, with Adorée a close third. How could Harry Rapf or Bernie Hyman or even Mr. Mayer himself continue casting Crawford in low-budget Tim McCoy Westerns?

Leading Lady, 1928

THE ROMANCE BETWEEN CRAWFORD AND DOUGLAS FAIRBANKS JR., as the story goes, ignited when, in October 1927, she saw him appearing on stage in the play *Young Woodley* at the Majestic Theater in Los Angeles. Crawford attended the opening accompanied by Paul Bern; others in the audience were screen luminaries such as Charlie Chaplin, and young Fairbanks's father and stepmother, Mary Pickford. She claims to have been besotted by him, and, as Fairbanks remembers it, the next day sent him a "note of congratulations, hand-written and hand-delivered, asking for a signed photograph, and, if I had the time and was so inclined, a telephone call."[1] Crawford claimed it was a telegram that she called in in the middle of the night, but whether note or telegram, it set in motion a romance that soon had Hollywood gossip columnists in atwitter. Gallant Fairbanks "answered in person, dropping by at teatime the next day." He signed the picture and from that moment on, the two were inseparable. Crawford described him as "the epitome of suaveness . . . he could write, paint, had a gay delicious wit, exquisite manners, and so much knowledge that it was hard for me to reconcile his conversation with his youth."[2] Youth, yes—in fact, he was seventeen, and Crawford, twenty-two.

Fairbanks had been working steadily since he was fourteen, and by the opening night of *Young Woodley* he had more than a dozen screen credits. He claimed to be "the sole support of seven or eight people. . . . I had absolutely no say about the disposition of anything I earned . . . my job was to make the money and turn it over to Mother."[3] He and Crawford had met before as he was a close friend of Mike Cudahy; she claims to have broken up with Cudahy two weeks before attending opening night of *Young Woodley*. Fairbanks also had worked at MGM the year before having a featured role in *Women Love Diamonds*, which was in production at the same time Crawford was filming *The Taxi Dancer*.

During her first two years in Hollywood, Crawford had a series of romances with wealthy young men. None proved to be successful or lasting. As Harry Rapf's protégée, her career had been well launched, but she may have understood that

Crawford and Douglas Fairbanks Jr. in a portrait by Ruth Harriet Louise.

he could do little more. Paul Bern, Thalberg's chief production assistant, had an influential voice at MGM, and he had become an ally. Although there is no indication they had a romance—both Crawford and Fairbanks claim the Bern relationship was strictly professional—he was "one of my guiding lights and best friends." He was also a frequent escort, and in her 1971 memoir she described one of the many ways he influenced her.

> In one of my first houses, a rented one, I had portraits of dancing girls done in black velvet with blond hair (real hair!) and rhinestones and pearls (not real). I guess they were typical of the twenties. I thought them beautiful. Paul Bern . . . came to pick me up one night, gazed at my "art" displayed, and gulped. I got rid of them fast.[4]
>
> "He helped hundreds of unhappy, baffled, ambitious boys and girls. . . . Poor Paul—the sob stories that man was told. But he gave each person who came to him courage, hope, new life. . . . Paul was the only real saint I ever knew."[5]

Fairbanks was in a different category. Handsome, charming, showing promise as an actor, he must have appealed to many young women in Hollywood. But his trump card was his family. His famous father and stepmother were mythical figures in Hollywood. Crawford may well have fallen madly in love with young Douglas watching him perform on stage, but she was equally as enamored of his pedigree. She may not have been as strategic as Garbo about managing what films she would accept, but Crawford maneuvered through Los Angeles society with an equal sense of purpose. Marriage to Mike Cudahy and his millions would have given her wealth and significant social status. But Crawford does not seem to have been interested in money except where it could be used to support her ambition. When that relationship soured, once and for all, suddenly a handsome young prince appeared before her under the bright lights on stage at the Majestic Theater. Fairbanks's father was rich, almost as famous as Chaplin, a peer to Mayer and Hearst, and, along with his wife, sat at the pinnacle of the Hollywood social order.

Crawford is convincing when describing herself as a woman in love: "There is a certain spontaneous combustion that happens once in a lifetime, when two very young people fall very passionately in love and nothing else matters. Even another Tim McCoy didn't matter, I galloped through it, dreaming of Douglas."[6] It might also have been because she was cast in "another Tim McCoy" Western that she felt her professional worth slipping. Working with Chaney and Gilbert established her acting skills; with Haines, that she was a good sport supporting her best friend. But back in Westerns? Beginning a relationship with young Fairbanks might give her career the final boost that MGM producers thus far had been withholding.

Spring Fever was released the same month that *Young Woodley* opened. *West Point* had been completed in August, and then Crawford began work on *Law on the Range*. If she wasn't given top productions, she was nonetheless busy working every minute. Next up was a picture for Harry Rapf, the sixth film she made in 1927, *Rose-Marie*, based on a successful Broadway musical. Renée Adorée had been announced for the role and had started filming (scene-stills survive showing her at work), but as MGM's leading ladies were interchangeable, after a few days of shooting, Adorée was taken off the picture and replaced by Crawford.

She wasn't prepared for the sudden schedule change, especially as it came so quickly after of *Law of the Range*. *Rose-Marie* was being filmed in Yosemite, and Crawford had to set off right away. The director was also replaced, and Lucien Hubbard followed William Nigh; James Murray continued as the male lead. Writer Katherine Reid, who was going to tag along and cover the production for *Picture-Play*, visited Crawford the afternoon before they departed "and found her wailing that it had come unexpectedly, that she had a dozen social engagements to break." Reid later wrote about the splendid scenery which served as double for the Canadian landscape of the original story. "We were housed in little cabins,

Crawford in costume for *Rose-Marie*, 1928. Portrait by Ruth Harriet Louise.

tucked away in a deep forest, and our very living quarters became part of the set." After a quick stop back at MGM to film interiors, Hubbard brought the cast and crew up to Las Turas Lake (now Lake Sherwood) for further location work. "It's her reward of merit," Reid wrote. "She's been one of the most popular leading women in the M.-G.-M lot. . . . now it is her turn for a title role."[7]

Rose-Marie was Crawford's biggest project yet. Playing the principal character, she was accorded top billing, but her name was, once again, listed below the title, although her face was featured on most posters. Her costar, James Murray, for a

moment seemed to have great screen potential based on an excellent performance in King Vidor's *The Crowd*. Drink proved to be his downfall, and after a few good films at MGM, Murray worked at increasingly less prestigious studios before his death at thirty-five. There is no way to judge Murray or Crawford's performances in *Rose-Marie* since it is a lost film; so too is Crawford's last Tim McCoy Western, *Law of the Range*.

Although we cannot watch *Rose-Marie*, the abundant publicity generated gives a clear picture as to Crawford's escalating status. Like all featured performers, she had been photographed by Ruth Harriet Louise in the portrait studio. These images, however, were markedly different from those of the MGM star actresses. For Garbo and Shearer, hours, sometimes an entire day, would be devoted to long sessions in which the photographer worked to capture moods that reflected the actress's newly minted star persona. Davies and Gish, both veteran players, were photographed in a narrow range of moods reinforcing their well cultivated screen images. Sessions were typically arranged following the conclusion of a film. Newspapers and magazines were greedy to publish brand-new portraits especially if the actress was costumed for the upcoming release. While Crawford sat (or stood, or jumped) for more photos taken than any of the reigning queens of the lot, they were a disparate mix, taken first to introduce her to the public, but now, and more importantly, to add spice to the fan magazines. At the conclusion of *Rose-Marie*, back from all the location work, Crawford had a portrait session with Louise. It is an attractive body of work, but there is no glamour. MGM still hadn't figured out that side of Crawford.

What they had figured out is that she was willing to work from one project to the next without letup. Fresh from Yosemite and Lake Turas, her next project was to support Ramon Novarro in *China Bound*, which was released as *Across to Singapore*. On location again, this time much of the filming would take place on a boat out in the Pacific Ocean. Novarro was the last of MGM's top male stars with whom she had yet to work. If she had a moment to read the trade papers good news appeared to be on the horizon: "M-G-M is reported planning to elevate Joan Crawford to stardom."[8] Bad news was that cast and crew had to depart just before Christmas; off-shore filming would last for three weeks. Fairbanks, who had spent the late fall touring with *Young Woodley* in San Francisco, did not get back in time to say farewell. He did, however, arrange to have Novarro deliver a gift to Crawford on Christmas morning, a pair of jade earrings.

Nineteen twenty-eight was the year that Crawford took the final stride forward towards the long-awaited goal of becoming a movie star. She finished *Across to Singapore* in January, and after three years and eighteen films, was a popular, though poorly paid, leading lady. It was also when she emerged as a darling of the readers of the fan magazines. Since joining MGM she had courted writers and photographers, befriending many, and made herself available at a moment's notice for an interview or photo shoot. Her strategy paid off. Typically stars and

featured players let the studio's in-house publicity department handle these sorts of requests. Not Crawford. She made sure anyone who could help promote her career had her telephone number. Her new relationship with Fairbanks Jr. gave the writers additional copy to feed to the anxious public.

One of MGM's big films intended for 1928 was the historic drama *Tide of Empire*, a Cosmopolitan production produced by Hunt Stromberg. Crawford had been cast to play the female lead back in the fall, before either *Rose-Marie* or *Across to Singapore* went into production. It was based on a Western novel by Peter B. Kyne, and in January, James Murray was announced as the leading man; this was MGM's second pairing of the two. The Novarro film wrapped up in late January, and by mid-February work began on *Tide of Empire*. When filming started, Murray was out, replaced by Norman Kerry. Cast and crew went on location up to San Fernando Rey to film against a majestic mountain backdrop. Hardly had any film been exposed before *Tide of Empire* was halted.

> Running afoul of censorship conditions, M.-G.-M., after putting three days on "Tide of Empire" . . . suspended production after expenditure of around $15,000. Before the picture was put into production Al Rogell, directing, informed the M.-G.-M. officials that the story might be distasteful to the Spaniards and Mexicans, as it was a yarn dealing with the hate of these two countries for the Americans.[9]

MGM had run afoul of the censors before, and the bosses felt it best to abort rather than having an expensive film that could not be released. The decision was taken to rewrite the script; Rogell would not be available later in the year so he would be replaced. Crawford was taken off the film, and the trades reported that instead she would start, "The Dancing Girl." When *Tide of Empire* started anew in the summer, Renée Adorée had the Crawford role.

Crawford had only a brief session with Louise after completing *Across to Singapore*, and most publicity images promoting the film were taken from scene-stills. Louise did meet with members of the cast taking photographs that would be translated into poster art. Novarro and Ernest Torrence, who played Novarro's older brother, worked with Louise on February 10, posing for a wide range of dramatic tableaus mimicking the film's dramatic action. Crawford was missing. Publicity director Pete Smith determined that Crawford's time could be better spent elsewhere. When her character was needed, a double filled in. She had gotten her start serving as Shearer's double, and now—another indicator of Crawford's improved standing—she was deemed too busy to engage in this sort of publicity work, and a stand-in took her place. As posters and lobby cards were nearly always made from paintings (created from photographs) so that they could be lithographed in brilliant colors, it would have been easy for an artist to paint-in Crawford's face.

Crawford with Ramon Novarro for *Across to Singapore*, 1928. John Kobal Foundation.

Just before leaving Los Angeles to start work on *Tide of Empire*, Crawford sat for Ruth Harriet Louise to model outfits for that film. As an upper-tier leading lady, Crawford was now being accorded the perks associated with her new rank. Pete Smith had been monitoring Crawford's rise and saw that this was the moment to flood the press with new images. Poster art could be handled by a stand-in. Portraits, on the other hand, were an important currency of stardom. She had been photographed often—and had accumulated a huge portfolio of images showing her to be lively, sporty, and attractive. But so far, few photographs revealed a star in the making. Smith, looking forward to what the studio had planned for Crawford in 1928, sought to present Crawford to the movie going public in a new, and enhanced, fashion.

For *Across to Singapore*, Crawford sat for Louise posing in a plain dress. For *Tide of Empire*, Smith wanted something radically different. Crawford had played the year before a hodgepodge of roles: contemporary young women in *Spring Fever* and *West Point*, out west in *Law of the Range*, in the Rockies for *Rose-Marie*, and out to sea in *Across to Singapore*. None of her characters had worn interesting or especially attractive costumes. This was about to change.

Crawford in costume for *Tide of Empire*, 1928. Portrait by Ruth Harriet Louise. John Kobal Foundation.

During MGM's early years, a trio of designers were responsible for most of the studio's costumes: Andre-Ani, Gilbert Clark, and David Cox. All had prepared wardrobes for Crawford. For *Tide of Empire*, she was to play a Spanish senorita costumed by Cox in a wide array of splendid outfits.

Nominally, she was modeling costumes, but that day ended up taking on greater significance. Although Crawford had always been keen to pose in the past, she had yet to provide the studio a unique image around which they could promote a star in the making. Her youthful vitality and frantic gusto had been captured by many lenses. What was missing was the inner life (or the acting out of such) that registered well in portraits of Garbo and Gish. Louise was one of Hollywood's masters of recording thought in photography. Crawford needed to learn how to be quiet before the still camera and to convey an endless variety of moods through subtle changes of her expressions.

Louise was her instructor. And, as so often before, Crawford was the diligent student, who with proper tutelage mastered the tricks of becoming a superb subject. Louise's portraits for *Tide of Empire* mark the first sighting of what soon would become the thrilling beauty of the 1930s. Before Louise's lens Crawford transformed: vigor morphed into glamour. The magazines picked up on this change. "Joan is Hollywood's best photographic subject," read the caption under a full-page portrait in *Photoplay* that summer. "Not only has she an almost perfect figure . . . but she has a camera proof face."[10] This is not to say that Crawford gave up her playful and energetic personality when being photographed, but henceforth she would select the proper mood to fit the circumstance.

Tide of Empire might have been the film that solidified her reputation and forced MGM's bosses to acknowledge her value at the box office. Instead, the fates conspired in Crawford's favor that winter, and one production's delay pushed forward the film that was meant to be her second outing for 1928, *The Dancing Girl*.

That project, soon renamed *Our Dancing Daughters*, was one of Cosmopolitan's releases for the 1928–29 season. Crawford would be the featured of the three "dancing daughters," sharing the screen with newcomer Anita Page, and her MGM pal, Dorothy Sebastian, who was stalled in second leads. Putting three young and attractive women in the same film was unusual—although three years earlier the strategy worked in *Sally, Irene and Mary*. Supporting the ladies were three young handsome men, Johnny Mack Brown, Nils Asther, and Eddie Nugent. Veteran writer Josephine Lovett wrote an original screenplay, and the story's narrative was announced in its title. *Our Dancing Daughters* followed the exploits of these vivacious young women, archetypes of the Roaring Twenties, who played hard and suffered the consequences. Mayer, Hearst, producer Hunt Stromberg, and director Harry Beaumont, took a gamble that youthful audiences were ready for films that reflected contemporary morality, and would support them at the box office. It was a good gamble. *Our Dancing Daughters* was a huge success, propelled forward many careers, most notably Crawford's, and a century later remains a signal example of the best of Hollywood's silent cinema.

Underway in March, *Our Dancing Daughters* was completed in a month but held until the fall for release. That gave time for the publicity department to market it aggressively (with the enthusiastic assistance of Hearst's chain of national newspapers). When it was released, *Our Dancing Daughters* was a bonanza. Critics were enthusiastic, and the ticket-buying public even more so. "Entertaining, lively, richly produced, and at times well-acted," wrote *Picture-Play*. "To this are added sound effects, wild parties among the younger set, and considerable jazz dancing on the part of Joan Crawford, who is a spangled dart of pure light, and as such, is a joy to behold."[11] One critic may have intended to be judgmental when writing, "This picture seems to be a sample of how much a producer can show of a woman's legs and how far he can allow her to flirt with men before bringing the censor's wrath upon him," but skin and sex was what the audiences wanted.[12] "The young folks about me in the theater," wrote T. O. Service, in *Exhibitor's Herald*, and reflecting views of theater operators nationwide, "... loved every inch of the film."[13] *Screenland* got right to the point: "This is the Last Word on that Younger Generation."[14] *Our Dancing Daughters* became an emblem of youth in America in those glorious few months before the Depression would rock the world. "It is exactly the atmosphere on the screen," wrote the critic for *Time*, "that F. Scott Fitzgerald's books have when you read them."[15]

Crawford was the dynamic firecracker that heralded this youthful screen revolution. She was not the first actress to claim the new morality of the decade—Clara Bow at Paramount played freewheeling characters in films such as *The Plastic Age* (1925) and *It* (1927). But Bow's characters, vivacious and exciting though they were, had a tawdry quality that was burnished out of the roles offered MGM's top leading ladies. As Crawford was on the verge of becoming a star, henceforth her characters had to be carefully presented on screen. No longer could she portray vaguely (or explicitly) immoral women as she had in films like *Paris* and *The Taxi Dancer*. "On screen for some time I had specialized in carefree, blithe young girls," Crawford later described that period, "and like them I have been sure of myself in a brash juvenile way."[16] A writer for *Screenland* commented on the change, and "preferred Joan as the arrogant alarmer, and not as the humble heroine" (and didn't like the "Sears Roebuck" costumes either).[17] Anita Page played the bad girl, a role that might have better suited Crawford. But Crawford was not going to end up dead at the bottom of a flight of stairs. Roles like that were for actresses who had few prospects for stardom.

Our Dancing Daughters was hardly radical, but like many films that challenged conventional mores, it had its detractors. The film was banned by the mayor of Lynn, Massachusetts, on the grounds that the local censors found it "objectionable." North of the border in Canada trouble was brewing. "I saw this before the censors got in their work and thought it the B.O. natural of the year," commented an exhibitor from Manitoba, "but when it came on my screen there was very little left, and a complete failure at the box office."[18] The United States had become such

Crawford on the set of *Our Dancing Daughters*, 1928. Photo by Clarence Sinclair Bull. John Kobal Foundation.

an important cultural influence internationally that voices could be heard decrying the lessening of moral standards. A London correspondent for *Film Mercury* believed that films such as *Our Dancing Daughters*, even if financially successful abroad, will "do immense harm to American prestige." The Hollywood product, "is not only a sort of animated catalogue of American goods, but an ambassador." Thus, the studios had a responsibility to provide wholesome entertainment—if for no other reason than to prop up the balance of trade![19]

The provocative subject matter was a boon to the film's prospects, but it faced another hurdle indicative of what was simmering in Hollywood that spring: the coming of talking pictures. *The Jazz Singer*, which had opened the previous October, wasn't a real talking picture but had sound sequences that announced the coming technological revolution. Audiences flocked to it, and immediately some studios rushed to copy Warner Bros. MGM moved unhurriedly trying to figure out whether it was a fad or a new business model. Holding it for release until the fall of 1928 put the film in competition with the first generation of talkies. With so much riding on *Our Dancing Daughters*, the decision was made to release it with sound effects—"ping-pong balls, door knocks, sobbing saxophones and wild waves,"[20]—but without any dialogue. How would the public react?

Crawford posing with Ruth Harriet Louise in a photograph taken by Clarence Sinclair Bull. John Kobal Foundation.

Audiences and critics answered loudly: "*Our Dancing Daughters* suddenly arises as a tempestuous box office grosser, to dissipate the fear, if it has existed, that no silent or plain sound effect film can stand up against the talkers." This from *Variety*, and the writer continued, "This M-G-M sensational drawer seems to stand up very well against any talker." And that included *The Jazz Singer*.[21] In the end, a relatively inexpensive film brought in more than a million dollars at the box office—which was outstanding business—and returned a profit to MGM of more than $300,000. How much of this could be attributed to Crawford is

difficult to gauge, but even so, these are the sorts of figures associated with hits starring Garbo and Gilbert.

She had another session with Louise when *Our Dancing Daughters* was completed. If the portraits for *Tide of Empire* revealed a new Crawford, photographs made that spring refined that image further. On the one hand, they acknowledged the film's youthful, energetic accent. Louise photographs Crawford costumed as the fall harvest, wearing a gently revealing costume, decorated with grapes, and holding a horn of plenty. Some shots show Crawford dancing. These widely distributed photographs—the fan magazines loved them—fuse masterfully the two sides of Crawford that were simultaneously being presented, the "dancing girl" and the star in the making. She also posed in costumes from the film and on the spectacular art deco sets designed by Cedric Gibbons whose work would be among the best showing inter-war Parisian chic on the American screen. These carefully rendered photographs present her as an elegant beauty rivaling Shearer, if not quite yet Garbo. In mid-May, the two met again, and Crawford modeled a smart tennis outfit. By chance, Louise was to be the subject of an article for *Screenland*, so Clarence Sinclair Bull visited Louise's studio and photographed the two women at work with Crawford sitting before Louise's large-format 11 x 14 camera. The negatives exposed are rare surviving documents showing the portrait process. "She Bosses the Stars," *Screenland's* tribute to Louise, was published that September with one of Bull's photographs leading the article.

As had been typical for Crawford over the past two years, finishing one picture meant getting ready for another. MGM had acquired the rights to the play *Four Walls* in January 1928 as a vehicle for Gilbert. Much had been made at the studio that winter about whether or not he would be paired again with Garbo after their second huge success *Love* based on Tolstoy's *Anna Karenina*. Many new Garbo-Gilbert films were proposed, some even announced, including *The Son of St. Moritz*, later called *Carnival of Life*, which wasn't made under either title. With *Love* still playing in theaters, it was decided to divide up Hollywood's number one romantic team holding off a reunion a little bit longer before they were reunited in *A Woman of Affairs*. In the meantime, Garbo was given *The Mysterious Lady*, and Gilbert began *Four Walls*. William Nigh was assigned to direct the Gilbert picture, and having worked with Crawford recently on two films, *Law of the Range* and *Across to Singapore*, was enthusiastic about a rematch with Gilbert.

Gilbert was so successful, famous, and profitable, that he had the final say over his costars and he agreed with Nigh's choice. Although he solidified his stardom in *The Big Parade*, a war picture, it was romances that kept Gilbert number one at the box office. Watching him work with Mae Murray, Renée Adorée, Garbo, and Crawford, he was always the ideal partner, generously sharing the screen and never upstaging his leading ladies. Gilbert and Garbo might have been the hottest ticket in town, but Gilbert and Crawford could work up plenty of steam on the screen "For getting down to earth with the practical sort of love-making

that folks like," wrote the reviewer for *Photoplay*, "our hat is off to John Gilbert and Joan Crawford. John certainly takes that gel in hand, and, boy, how she likes to be taken."[22] Sex meant good box office. A second success costarring with Gilbert solidified her perch on the cusp of stardom. *Four Walls* came out a month before *Our Dancing Daughters* hit theater screens. Welford Beaton, who edited and wrote most of the copy for the *Film Spectator*, had been following Crawford's ascent, and after nearly four years was among those in her cheering section.

> I have urged Metro to feature Joan's brain instead of her legs, and in this picture this is done. She takes her place now among our leading dramatic actresses, and her work should impress her employers with the fact that they need not be hesitant about assigning big parts for her. She has youth, good looks and intelligence.[23]

As Crawford was now all but anointed a star, MGM used her to gauge the viability of prospective leading men (the way she had been tested earlier). Swedish-born Nils Asther had joined MGM that year, and was one of the dashing trio who supported the dancing daughters. He was also given a good part in *The Cardboard Lover*, with Marion Davies. The studio thought he had the prospect of stardom and cast him as the male lead in *Dream of Love*, based on a French play, *Adrienne Lecouvreur*. As soon as Crawford finished *Four Walls*, she was back to work, playing Adrienne opposite Asther. In August, Crawford was announced in the trade papers as having the "title role." Typically, it was stars, not leading ladies, who portrayed "title" characters. Rapf had made an exception for *Rose-Marie*. This time, so there wasn't any mistake, the front office renamed *Adrienne Lecouvreur* as *Dream of Love*, indicating that Crawford hadn't officially joined MGM's star roster and further rationalizing that a French title might put off domestic audiences. *Dream of Love* was a neutral title that promised a romantic story with two attractive leads but did not give Crawford the authority of headlining the film.

In the midst of her busy schedule she continued to find time for Fairbanks Jr. He made six films in 1928, and by happy chance one was at MGM, *A Woman of Affairs*, where he played Garbo's younger brother, and it was filmed more or less concurrently with *Dream of Love*. Smitten, as were so many others, he decided that he would attempt a romance with the great Swedish star: "How my deceitful heart bubbled when for a few days I thought I was well on the way to an underhanded conquest." Of course, Garbo would have none of his youthful pining. Fairbanks claimed he escorted her to parties, and if this is true it would be unique in Garbo's relationships with members of her films' casts. Still, he is a reliable chronicler, so maybe his memories are true, though it seems fanciful that hawk-eyed Crawford would permit him to look more than casually in Garbo's direction. More than a half century later, his youthful ardor remained present and he recalled those weeks working on *A Woman of Affairs* as "a muffed opportunity."[24]

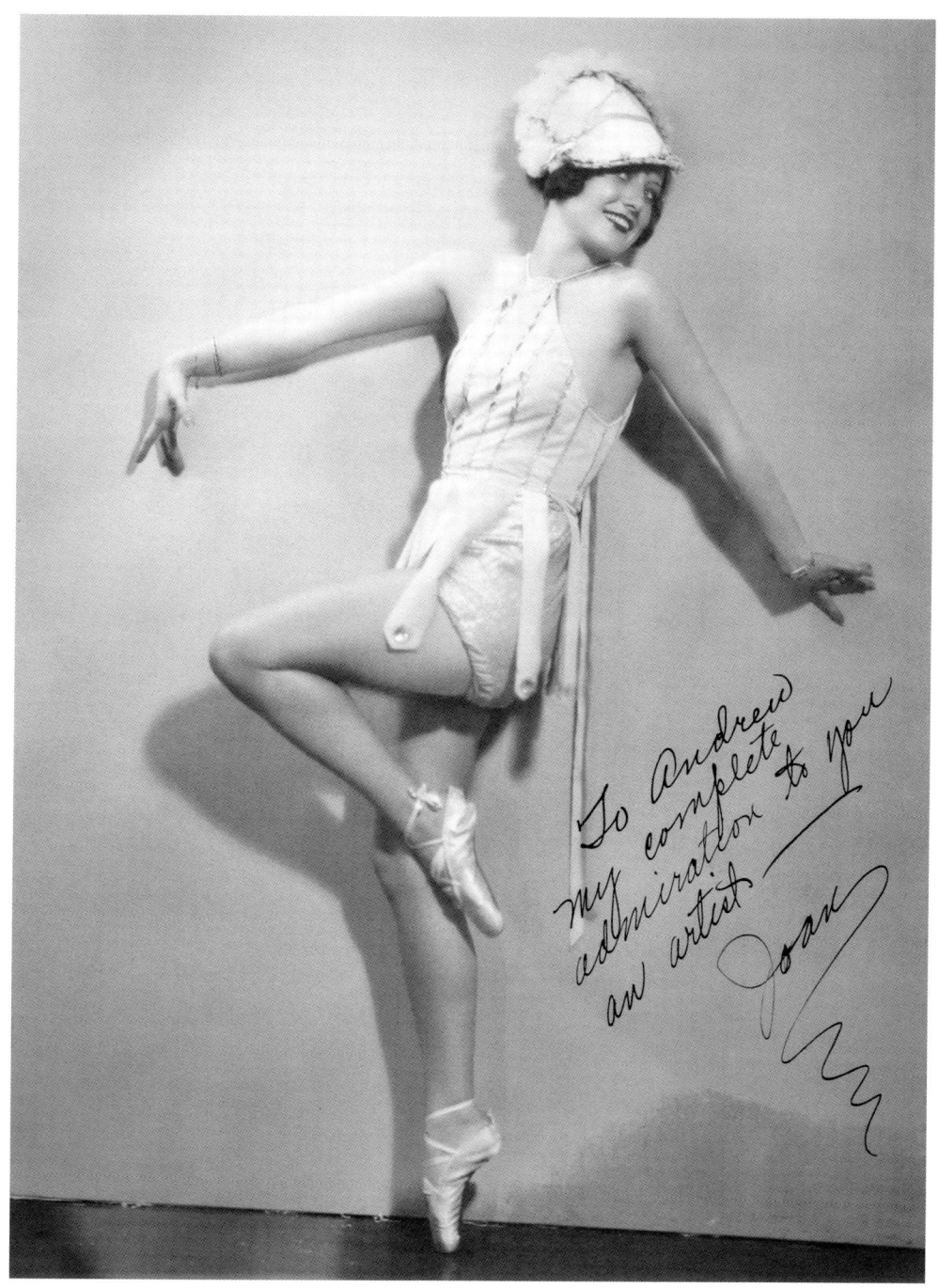

Crawford posing for Ruth Harriet Louise. The photograph is autographed by Crawford to Louise's (and later Hurrell's) re-touch artist Andrew Korf. Collection of David Huss.

For Crawford, there would be one more film in 1928 before she was offered the crown she had so diligently worked to achieve. Had she been Garbo, Shearer, Davies, or Gish, after the successes of *Our Dancing Daughters* and *Four Walls* MGM's producers would have held her back from making any further films until an appropriate vehicle could be prepared to showcase a brand-new star. But why do that when she could be worked relentlessly for the bargain price of $500 per week? Her contract was up for renewal in late November, so Crawford was cast in *The Duke Steps Out*. She supported, once again, Billy Haines. Getting the production going before the new contract was signed saved MGM money—not much, but the point was to work performers as much and as cheaply as possible, letting the big bosses garner lavish bonuses when revenues were high.

Based on a *Saturday Evening Post* story, *The Duke Steps Out* tells of a prize fighter (Haines) who goes to college. Advertised as "an M-G-M sound Picture with dialogue," it included the usual sound effect gimmicks, but also had a radio announcement at a critical moment that added background to the story. The public loved it and it was a substantial money-maker, heading the 1929 list of MGM's most profitable films exhibited at the Capitol, Loew's flagship theater in New York. "Give us more like this, Metro," wrote a theater owner in Texas, "and we should fret about sound."[25] The reviewer for *Variety* liked the picture, but like so many critics (and fans) was wary of the way Crawford was being treated by her studio.

> What this picture will do for Miss Crawford is questionable, because she has nothing to do. . . . Following "Dancing Daughters," this girl looked to be well on her way. . . . But the sidewalk Don Juans and kitchen Cleos are going to be disappointed with their Joan. She doesn't even get much chance to predominate on looks. . . . It's a reverse step for Miss Crawford, and she'll have to make up on the next one if she going anywhere in a fast moving field that's now moving faster.[26]

She did make it up on her next one.

The transformation of Lucile LeSueur into Joan Crawford was almost complete. Along the way, she saved a bit of Billie Cassin, but revealed her only to close friends. "Practically nothing of the first Joan remains," writer Margaret Reid wrote of Crawford in late 1928. "The memory of her has already a legendary quality. It lingers faintly along the night-clubs and cafes and those habitués whose idol she was."[27] Harry Rapf and Pete Smith arranged a new name, but it was Crawford herself who imagined a new personality. The invented woman grew in lockstep with the actress who was being molded by MGM's star factory. She might yet not have given a great performance on screen, but Crawford had excelled at creating the perfect framework for the ideal movie star.

This hard work was rewarded by increased devotion among moviegoers. "Fan letters were pouring in," Crawford remembered decades later. "The studio gave

me bundles of them every day and I read every word. . . . I answered every letter personally, addressed and stamped the envelopes and took them to the post office . . . no bedtime for me until every letter was answered."[28] No other star is known to have served his or her fan base with such affection and diligence. It was not a ploy Crawford used to excite the public during her rise; she continued this practice throughout her career, and there were still letters waiting to be answered the morning she died.

Of the five films Crawford made in 1928, the three she made after *Our Dancing Daughters* are considered lost: *Four Walls*, *Dream of Love*, and *The Duke Steps Out*. Losing any silent film headed by an important figure is significant, but in this case we cannot view the movies she made following her breakthrough performance. Only scene stills, publicity materials, and reviews give even a vague sense of these later films. Without these three works we miss witnessing Crawford's final ascent from leading lady to star, and we are left with a jump in time of a full year from *Our Dancing Daughters*, completed in April 1928, to its sequel, *Our Modern Maidens*, filmed twelve months later. This is also the moment when Hollywood was in the midst of the sound revolution. None of these lost films were talkies, but the last one had synchronized sound effects, as did *Our Dancing Daughters*. *Our Modern Maidens* would be Crawford's last silent film, and among the last released by MGM. The revolution ended fast and talking pictures were victorious. She was among those who moved seamlessly from silence to sound, and there is nary a word in the press wondering if she would be able to make the transition to the new medium. Crawford saw to it that she had a terrific voice for talking pictures.

Reports of Crawford's apotheosis started appearing in the trade papers in October. "JOAN CRAWFORD TO BE STARRED," headlined the *Exhibitor's Daily Review*, with the writer telling readers, "Coming on the heels of Joan's great performance in 'Our Dancing Daughters' this announcement will probably surprise no one."[29] It was official on November 29, 1928, and her salary was doubled to $1,000 weekly. Garbo would be making $4,000 in 1929; Crawford had her stardom but she still had a long way to go. She had overcome the odds and in four years landed near the top of MGM's acting summit, but she must have been aware that the real race was only now beginning. Crawford had proven herself as an actress and now sought to claim her place among cinema's giants. "Now you know as well as I do what Joan can do when she wants to," wrote a critic for *Screenland*. "She is one of the most devastating girls in pictures."[30]

1929, Stardom

A KEY INDICATOR OF SCREEN STATUS WAS THE AMOUNT OF PUBLICITY a studio lavished on a star. Posters and lobby cards were obvious for marketing, and status was apparent by who was featured. The studio also used other promotional tools. MGM distributed to exhibitors, for example, full-color, over-sized promotional books heralding the studio's biggest stars and advertising the most important of the upcoming year's releases. Crawford took her place for the first time in *A New Era, 1929–1930*, and was awarded a double-page spread featuring her portrait, a brief biography, and a mention of her future films. *Our Modern Maidens* was listed first followed by *Jungle* (noting: "title to be changed") and "Two All-Talking pictures suited to her dashing and radiant personality." The studio was stingy in awarding stardom to players, and the top roster had changed little over the years from the mid-1920s to the early 1930s. Garbo, Novarro, Shearer, Chaney, Davies, and Gilbert were the familiar names; the addition of Crawford to the ranks of those accorded over-the-title credit was momentous.

She had a few months off prior to starting *Our Modern Maidens* in late February 1929. No longer would Crawford be rushed from project to project. Leading ladies might work nonstop, but stars had a more dignified schedule. Motion picture studios, like many other businesses, figured that one success predicted another. "*Our Dancing Daughters* with its imperial salons and moonswept amours," wrote *Time*, "caused such a flutter in nationwide breasts and box-offices that the Metro people repeated the formula with practically the same players involved."[1] *Our Modern Maidens* reunited Anita Page and Crawford, as well as Eddie Nugent, in a cast that now included Rod La Rocque and Josephine Dunn. The most significant addition, however, was Douglas Fairbanks Jr. to the lineup in order to capitalize on the famous romance.

How much did Crawford's relationship with Fairbanks Jr. contribute to her being awarded movie stardom? It was a brilliant strategical tactic as it placed her alongside the most powerful family in Hollywood. She became the darling of the press and the fan magazines in 1928 in no small part because of this alliance. It

was neither as big as the Garbo-Gilbert frenzy of 1927 (which soon died down when it became clear that the Swedish actress was not going to marry the world's great screen lover, regardless of the fans' expectations); nor as explosive as the Liz and Dick story that dominated international headlines for several years in the 1960s.[2] But is was still a huge story. The public loves romance, and the tale of the dashing young son of the great Fairbanks falling in love with Hollywood's new princess was potent fodder for gossip and generated seemingly endless lines in the magazines. Crawford also intuited correctly that the fascination for the engaged couple might diminish if they got married. She announced their engagement in the fall but was coy about setting a date. Without Fairbanks Jr., Crawford likely would have become a star. With him, she became the biggest story in town.

Our Modern Maidens has a complicated plot of love gained and lost with Crawford and Fairbanks's characters at the center. In a further instance of art imitating life, they are united on screen in a formal wedding. "It is hard to recall," one critic wrote, "a more pretentious or elaborate wedding ever staged in pictures."[3] If the public couldn't get enough reading about the young lovers, MGM was going to give them an eyeful on screen. The marriage doesn't stick, and by the final reel they are no longer together. Still, fans got to see a fictional version of the anticipated wedding of the year on the big screen.

There was the additional problem, hinted at in the press, that Fairbanks Jr.'s father and stepmother, Mary Pickford, might not approve of him marrying an actress who had the reputation of being something of a wild woman during her first years in Hollywood (not to mention in New York and before). Fairbanks Jr. addressed this in his 1988 autobiography and stated explicitly that "our marriage was psychologically hastened by the quiet, unpublicized but vehement opposition of my parents."[4] His age was also a factor. Women could shave off a couple of years to convince themselves and the fans that they were still young. But in those chauvinistic days, men were still expected to be older and established. Fairbanks Jr. was born in November 1909, so for most of 1928, as the press speculated about the Crawford–Fairbanks Jr. romance, he was only eighteen and she (though never admitted) was four and a half years older. Although officially he was residing with his mother in Los Angeles, the young couple lived together openly at Crawford's house, and one fan magazine told readers, "Through Douglas, Joan has found the world of books and many of their evenings are spent at her home, with Douglas reading to her."[5] This could have caused a scandal, but seems to have been accepted as the couple were engaged. His parents may have thought this a more desired arrangement to their marrying.

Joan Crawford, the leading lady who had a reputation for high living, might have been able to keep up a public live-in romance with her famous beau, but Joan Crawford, the star, could not be so casual about her domestic arrangements. All contracts of Hollywood performers contained morality clauses that were enforced (when necessary) by the studios. The Fairbanks seniors did not want Crawford

to become part of the family, but Mayer would have encouraged this marriage, although he would have preferred that his new star stay single.

There was a sticking point; Fairbanks Jr. was underage, and his father refused to give permission for the couple to wed. As soon as filming was completed on *Our Modern Maidens*, Crawford and Fairbanks Jr. traveled to New York, where his mother, Anna Beth Sully, was living. Whatever misgivings she may have had earlier, she relented, and allowed the marriage to go forward. "He was nineteen, but supposed to be twenty-one," Sully stated, "so he asked me to confirm the later age."[6] She agreed. Sully was in a similar situation. She had taken up with Jack Whiting, a popular musical star who was twenty-eight—and thus fifteen years younger: "[Mother] and Jack accompanied us to New York's City Hall where, ducking in by back and side doors to avoid the press and the curious, we applied for our license." They were married on June 3, 1929, at St. Malachy's Roman Catholic Church. "Mother and Jack were the witnesses . . . at that time Billie professed to be Roman Catholic and therefore wanted to marry in the church."[7] Four and a half years after arriving at MGM she had accomplished her two goals: motion picture stardom and a prestigious marriage. All the earlier press coverage, magazine covers, and fan attention paled against the accolade she received on June 4, 1929, when her marriage was announced on the front page of the *New York Times*: "Fairbanks, Jr., 19, Weds Joan Crawford Here; Pair Too Busy in Films for Honeymoon Now."[8] Crawford's age was never mentioned in the accompanying article. A telegram was sent to Fairbanks and Pickford, who, officially, were delighted by the news. Legally married, and without the possibility of a forced annulment, the young couple returned to Los Angeles to continue their busy careers.

She bought a new house for them to share. After almost a year in Beverly Hills, in the summer of 1928 she acquired a bigger place on North Bristol Avenue in Brentwood, a home she would live in for the next three decades. They named it "Cielito Lindo" although it was more commonly referred to as El JoDo. An imbalance between the newlyweds was obvious from the beginning. "I couldn't yet afford to buy it myself," remembered Fairbanks Jr., "or even to pay an equal share." She might not have minded—"What's wrong? It's only money!"—but he did, and "the business of her buying the house became the first snag in our relationship."[9] There was another snag. At nineteen, he would not have been old enough to purchase a house under his name, thus his wife, at twenty-four, would have been obligated to make the down payment and sign for the mortgage.

"Welcoming a new star to the film firmament: Joan Crawford" was the headline of a series of full-page ads that MGM took out in all the top fan magazines announcing her new status as *Our Modern Maidens* hit theaters. "Joan Crawford . . . the girl of the hour, vibrant with the spirit of youth . . . write Joan and tell her how happy you are that she's joined the Hall of Fame of stardom."[10] MGM was happy, too. In her debut as a star she brought in a profit of nearly a quarter of a

Crawford and Douglas Fairbanks Jr. pose for Ruth Harriet Louise in front of their new house in Brentwood.

million dollars, a nice return on investment from an actress Mayer was paying just one thousand dollars a week.

She was worth a lot more than that to MGM; it turned out that the studio was relying on a small list of performers to deliver audiences into theaters. "Nine Stars are scheduled to appear in 22 MGM films" was a headline in *Exhibitor's Herald-World* in June. Along with Crawford, the list included Garbo, Shearer, Davies, Gilbert, Novarro, Chaney, Haines, and Keaton. They were the undisputed "money-getting stars." Some 40 percent of MGM's output, and an even higher percentage of its revenue, rested on the shoulders of this elite group. The public "now say John Gilbert, Greta Garbo or Lon Chaney is at the cinema today, let's hurry down and see the picture."

Our Modern Maidens inaugurated one of motion picture's great partnerships. It was not a screen team, but the beginning of Crawford's collaboration with costume designer Adrian. New to MGM in 1928, one of his first projects was *Dream of Love*. As the film is lost, only stills survive to give us a sense of the costumes. For most of the film, Crawford is simply dressed although in a later scene she wears a luxurious white fur coat. The best wardrobe was saved for Aileen Pringle,

To announce Crawford's elevation as a star, MGM took out full-page advertisements in the fan magazines.

who asked Adrian to design something spectacular for her. He did: a sequined coat and matching cap that stands among his finest designs.[11]

As the star of *Our Modern Maidens*, Crawford would wear the most elegant dresses, and it is the film in which we get a first sight of the sorts of garments Adrian would create for her famous films of the 1930s. He dressed Garbo, Shearer, and the other stars beautifully but seems to have saved his best for Crawford. From the start, the two clicked professionally, and the actress took an active role in selecting the sorts of dresses she wore on screen. Well before *Our Modern Maidens* reached theaters, he wrote an article for *Screenland*, "The Modern Maid's Clothes," in which he promoted the film's wardrobe. "The Crawford type," said Adrian, "is either a rocket or a fascinating and continuous eruption of scintillating lava." The article introduces the film's most extraordinary gown, the zebra dress, "a costume designed to make movie audience's gasp!"[12] It would be the first of many such utterances from audiences over the next decade.

Concurrent with filming *Our Modern Maidens*, Crawford had a small role in a gigantic musical production, *Hollywood Revue of 1929*, conceived and produced by Rapf. It was a two-hour talkie extravaganza, mostly singing and dancing, with a couple of dramatic pieces thrown in to add variety. The gimmick was that almost every MGM star would appear, and most would sing (and some would dance). Two were exempted: Garbo and Chaney, although Chaney had a strong presence in a musical skit that gently parodied his sinister side. The film was rolled out slowly, playing exclusively in Los Angeles in the early summer before moving to New York in August. The ticket price was two dollars, which put it on par with Broadway musicals. Jack Benny and Conrad Nagel served as hosts and introduced the stars. Crawford appears towards the beginning and sings "I've Got a Feeling for You." She also dances, but neither her voice nor her dancing show much aptitude. Still, this was Crawford's sound debut, and her speaking voice is pleasing; what she lacks in musical skill she makes up for with enthusiasm and charm. The entire cast assembles for the big finale, "Singin' in the Rain," the first appearance of the Nacio Herb Brown and Arthur Freed song that would become a standard and inspire (and name) one of Hollywood greatest films. *Hollywood Revue of 1929* was a box-office bonanza taking in nearly two and a half million dollars, half of which was profit to the studio.

Having made a successful talkie debut in *Hollywood Revue of 1929*, it was time for Crawford to prove her worth in the new medium. Rapf assigned her to *Untamed*, taken from a story called "Jungle" that had been published the year before in the *Saturday Evening Post*. It was a perfect vehicle: the tale of a young woman named "Bingo" who was raised in the South American jungle, inherits a fortune, and is brought to New York City where she confronts urban mores and etiquettes. "Box Office Check-up and Ad Tips," a regular column in *Motion Picture News*, told readers, "Joan Crawford in her first talking picture is enough billing to bring in big business. . . . Add to this . . . the title, made for Miss Crawford and

Crawford models the famous zebra dress designed by Adrian. Photo by Ruth Harriet Louise. John Kobal Foundation.

Crawford's talkie debut was in *Hollywood Revue of 1929*. She is shown with Charles King, Conrad Nagel, and Cliff Edwards.

the exhibitor's troubles are over."[13] Her reputation, first as an unrelenting party girl and later as kinetic exemplar of the modern generation, was being used to sell the picture. From the first moments of her stardom, the Crawford personality became integral to selecting the sorts of pictures in which she would appear. That is why "Joan Crawford in *Jungle*" might have been a good title, but "Joan Crawford in *Untamed*" was a great title.

Now that she was a star, the studio would cast promising young male actors to appear opposite her. The first was Robert Montgomery, who had completed a leading role in a modest film, *So This is College*, and was one of the many stage actors who had passed through MGM's front gates when the studio was searching for the next crop of performers whose voices would record well on screen. Working with Crawford in *Untamed*, he is ideal as the handsome, suave, sophisticated suiter who wins Bingo's hand. Montgomery's rise to stardom was rapid, and he was anointed top honors in 1931. He and Crawford made many movies together in the 1930s, and he proved to be a good leading man for nearly all MGM's female stars.

Even the most diligently plotted careers take time to register well with critics. A regular columnist for *Exhibitor's Herald World*, T. O. Service, wrote in late 1929,

"Miss Crawford has seemed to me, as I believe I've made plain, as about as bad an actress as we've had before us. Her silent pictures have been a tremendous bore. When they were not merely dull, they were offensive (intellectually if not morally). And when they were neither, they were just plain awful."

But he began to see the light after attending a screening of *Untamed*: "The reason for Miss Crawford's employment is more to be heard than seen. Seen *and* heard, the lady promptly becomes one of the good reasons why I'm going to keep on going to picture shows and writing about them."[14]

Audiences as well were pleased with her voice, and rewarded at the box of-fice—where it mattered most—MGM's decision to elevate Crawford to stardom. As a sequel *Our Modern Maidens* had a head start as fans were anxious to see the further exploits of the "dancing daughters." But, more tickets were sold to *Untamed*, and it made twice as much money, adding more than a half-a-million dollars to the studio's bottom line.

Crawford sang and danced in *Untamed*, but her untrained singing voice and frenetic Charleston must have been as wearing to contemporary audiences as it is to us today. Even poor Robert Montgomery was forced to warble a couple of songs. The film's theme song "Chant of the Jungle," however, sold well as sheet music. But it was not musical aptitude that reinforced her newly won stardom. *Untamed* treats us to the first real sight of the Crawford who would emerge in the 1930s.

Garbo, Swanson, and Talmadge were riveting silent performers. Crawford was not. She was popular, attractive, and became the screen's symbol of pre-Depression-era youthful exuberance. When she began to speak on screen an integrated per-sonality emerged. This was aided by her directors and cinematographers, most notably Jack Conway and Oliver T. Marsh, with whom she worked on both *Our Modern Maidens* and *Untamed*. In the latter film, she is at her best not when dancing, but in the later scenes, beautifully dressed sitting or standing in elegant drawing rooms, where her director and cinematographer taught her how to be still and let the camera come to her. It is the first time Crawford acts with her face rather than depending on her body.

Untamed continued the important collaboration with Adrian. Unlike the dra-matic outfits he had designed for *Our Modern Maidens*, Adrian created simpler costumes including a cocktail dress finished with ostrich features. In the earlier film, she brandished the magnificent zebra coat with a youthful enthusiasm; this time she wears her clothing as though it is a second skin, and with the confidence of an experienced fashion model. Soon Crawford would be launched as a perpet-ual candidate for Hollywood's most glamorously dressed star. Kay Francis and Constance Bennett were worthy rivals for this acclaim, but throughout the 1930s the Adrian–Crawford collaboration populated her films with one extraordinary wardrobe after the next. Beginning with *Untamed*, Crawford was never merely a mannequin for beautiful dresses; rather, clothing became integral to her screen personality.

Crawford and Robert Montgomery in a portrait by Ruth Harriet Louise for *Untamed*, 1929.

"To wed, or not to wed," asked *Photoplay* in 1929 just as Crawford was preparing to marry Douglas Fairbanks Jr. Photo by Ruth Harriet Louise. John Kobal Foundation.

As a new star who proved popular with fans, Crawford was photographed more extensively than ever before. Nickolas Muray visited Los Angeles on assignment from *Vanity Fair*, and the newlyweds were on his list of those to be photographed for the magazine. Appearing in *Vanity Fair* was among the highest accolades a performer could achieve. He accompanied the pair to the beach at Santa Monica one morning and made a series of photographs. The one selected for the October issue shows Crawford in profile, seated in the sand, eyes closed, resting her head and shoulders against her husband's back. Through Muray's lens, the radiant couple seem the epitome of carefree young love.

What had been sequential publicity department arranged sessions with Ruth Harriet Louise promoting each new Crawford film, now became a nonstop photographic binge. Along with the required shots documenting outfits for *Our Modern Maidens* and *Untamed*, she modeled new dresses by Adrian and other designers, posed in costumes for upcoming holidays, and invited the camera into her home. One day she put on Hamlet's smock and black tights and acted out scenes from Shakespeare's play, giving *Photoplay* the inevitable tag line: "To wed, or not to wed." The two-page spread came out in June, so the magazine's timing was perfect. The partnership between Crawford and Louise that had first recorded her as a gauche beginner in Hollywood, followed her rise to stardom, and resulted in many superb portraits of the actress, was about to end. Norma Shearer, now married to Thalberg, insisted on not only having the best scripts but on her choice of photographer. Louise took magnificent career defining portraits of Garbo, and she was instrumental in shaping Crawford's image. But Shearer did not believe that Louise was serving her well, and looked to photographers working beyond the protective walls of the MGM publicity department. Ramon Novarro introduced her to George Hurrell, working from a studio on South La Fayette Park Place in downtown Los Angeles. After an initial session with him, Shearer believed she found the camera artist who could best present her to the public. By the end of 1929, Louise was out of a job, and in January, Hurrell took over the MGM portrait studio. Shearer was right, he did present her in a more modern spirit. But it would not be Shearer who benefited most from Hurrell's genius, but Crawford.

One of motion pictures' most potent totems of stardom was an invitation from Sid Grauman to have hand and foot prints memorialized in the courtyard of his Chinese Theater on Hollywood Blvd. Crawford's turn came on September 14, 1929. Accompanied by Fairbanks Jr. and a crowd of fans, she first signed her name and then placed her hands in the wet cement. After cleaning her hands, her husband held her arm as she followed with her high heels. The inscription above, not in Crawford's hand, but likely her sentiment reads: "May this cement our friendship." Although Fairbanks Jr. was present for the ceremony, he was not invited to share the honors. Two years earlier his father, celebrating the opening of the theater, inaugurated the tradition.

Another of stardom's many perks was a moderate working schedule. Crawford was accustomed to making as many as five films a year often without a break. Now the studio was careful not to overexpose her. Films henceforth would be paced to build up excitement about the opening of the next Crawford picture. Along with *Our Modern Maidens* and the featured bit in *Hollywood Revue of 1929*, Crawford worked on only one more film in 1929, *Montana Moon*, but it did not start until December, and most of the filming would take place the next year.

Montana Moon was another Western, but unlike those she had made before, it would have a big budget, was a musical, and Crawford was the star. Johnny Mack Brown, another of the young actors MGM was grooming for stardom, would play the male lead. Adrian lent his talents, here asked to glamorize the American west. In the opening sequence, Crawford, on a train heading to her family's Montana ranch, wears a sharp dress and an extravagant fur coat. The cinematographer was William Daniels, who had shot most of Garbo's pictures and was claimed by Shearer whenever possible due to his well-deserved reputation for making ladies even more beautiful. Crawford and Daniels had worked together the year before on *Dream of Love*, but as it is lost so too is evidence of their initial collaboration. In any event, MGM hadn't yet promoted Crawford as a glamorous figure on screen, although there are moments in *Untamed* where she comes close. This second outing with Daniels gave the producers an opportunity to consider new ways to present her. Without interfering with the proven cinematic personality, Daniels lights her more elegantly than she has ever been seen before, and what emerges is the face we would come to know well in her 1930s dramas. It took five years and more than twenty-five films for the final transformation to begin. We witness in *Montana Moon* Crawford on the cusp of revealing the style and glamour that would delight her fans for the next decade.

Number 1 at the Box Office

DETERMINING A PERFORMER'S BOX-OFFICE STATUS DURING THE silent and early talkie periods was not based on an objective set of criteria. Film journals, in particular those issued by Quigley Publishing Company, such as *Exhibitors Herald* (later known as *Exhibitors Herald World*), announced annual rankings that relied on feedback from theater owners across the country. The measures included profitability, but also relied on the perceived popularity of individual stars. In later years, dollars alone determined the top place and, for example, at the beginning of the twenty-first century Tom Cruise and Tom Hanks dominated the yearly lists because their films made the most money. In the teens, Douglas Fairbanks was often in first place, and in the twenties, Mary Pickford and Clara Bow both had a turn in the top position.

Joan Crawford was awarded the designation number one at the box office for 1930. The lists were gender neutral and did not attempt to divide honors equally between women and men. In the years before 1930 it was typical that only three or four women made the cut. Five women were, however, among the top ten in 1930, and Clara Bow, Janet Gaynor, Colleen Moore, and Greta Garbo joined Crawford. Among the male stars, four were designated: William Haines, Al Jolson, Richard Barthelmess, and Tom Mix. The tenth spot was saved for Rin Tin Tin.

Crawford made three films in 1930, *Our Blushing Brides*, *Paid*, and *Dance, Fools, Dance*, and began work on a fourth, *Great Day*, which was never completed. It was also the year that she began two of her most important professional collaborations. Photographer George Hurrell would not only create dazzling portraits but transform her appearance and create the most potent archetype for 1930s motion picture glamour. Clark Gable, beginning his motion picture career, would have a small part in a Crawford picture, but soon became her greatest screen partner.

Our Blushing Brides was the third (and last) of the "Our" series following *Our Dancing Daughters* and *Our Modern Maidens*. They were not sequels but had common casts with Anita Page and Dorothy Sebastian back again to support Crawford, and each film followed the travails of three women trying to find love

in the big city. This time the three handsome men were played by Robert Montgomery, Raymond Hackett, and John Miljan. Once again, Anita Page's character comes to a bad end, this time by way of a spectacular wardrobe and a Cedric Gibbons designed modernist apartment. When the man of her dreams betrays her she dies after taking poison. Once a promising newcomer, Page's career slumped after *Our Blushing Brides*. She continued in second leads, sometimes supporting comics Marie Dressler and Polly Moran, before MGM let her contract expire after five years.

It took almost thirty films for Crawford to be cast for the first time as a working-class young woman who through grit and determination rises in the world, often as a result of a successful marriage. Variations on this theme would be repeated time and again over the next decade. In *Our Blushing Brides*, she plays Gerry who is employed as a model in a department store. Robert Montgomery is the son of the owner, who after ninety minutes of steamy drama, takes Crawford as his wife. Early in the film she is shown among a chorus of lingerie models (read underwear), and the best and most revealing outfit is saved for the new star. It is an elegant two-piece ensemble, a bra and short slip that must have been startling to audiences even in the pre-Motion Picture Production Code era. Not only do the models wear abbreviated clothing, but each walks up a short flight of modernist stairs to stand conspicuously before a glossy circular black backdrop underscoring the revealing nature of the lingerie. Even though it is the women's fitting room, Robert Montgomery is present, watching the parade of beautiful woman. "Where did you learn to wear clothes so well?" he asks Crawford, reminding audiences, as if they needed to be, that she was becoming one of cinema's totems of style. A spot in *Variety* mentioned that "it is a picture made for women," but added, "There are so many half-dressed girls in the picture that maybe men would like it, after all."[1] A second fashion show in the middle of the film features the models wearing Adrian designed dresses, swimwear, and evening gowns. Crawford's dress and fur coat stand out among an array of dazzling outfits.

Our Blushing Brides is the film in which she casts off, once and for all, the youthful energetic persona of the previous five years and reveals the advent of first stage of the mature Crawford face and personality. The transition from *Untamed*, made a few months earlier, is startling, and she used her first two talking pictures to learn how to work with the sound camera. Never before had she been so natural as in *Our Blushing Brides*, or in full grasp of her craft. Director Harry Beaumont, who also helmed *Our Dancing Daughters*, deserves credit for his elegant touch, as does cinematographer Merritt Gerstad. Both had the difficult task of keeping Crawford squarely at the center of the film in which her plain-spoken and dowdily dressed character is surrounded by glamorous supporting players living in sumptuous settings. But it is Crawford, with her wit and magnificent speaking voice, who takes control of the film from start to finish. At MGM, she now had one rival for command of the screen, Garbo.

Crawford on the set of *Our Blushing Brides*, 1930. Photo attributed to C. A. Pollack. John Kobal Foundation.

What makes *Our Blushing Brides* enjoyable ninety years after it was made is its sexual frankness. An unmarried couple lives together, and the woman (Page) is being kept financially by the man. When the relationship sours the woman commits suicide. The film also shows Crawford and a half-dozen of MGM's most attractive second leads and contract players (including Gwen Lee and Mary Doran) parading in their underwear (with men watching). While the film was shooting a bomb dropped on Hollywood—the Motion Picture Production Code, which attempted to regulate content. This would be the most radical change to the movies since the introduction of the talkies. Martin Quigley was the publisher of the *Exhibitors Herald* and *Motion Picture World*, two of the most influential trade journals in the industry. He was also a staunch Roman Catholic and believed that movies were becoming increasing indecent. Enlisting the aid of a priest, Daniel A. Lord, SJ, he authored "A Code Regulating Production of Motion Pictures," which he presented to the Motion Picture Producers and Distributors of America (MP-PDA) headed by Will Hays.[2] Film censorship had become an enormous problem as each state determined what was acceptable and what was not. The result was that some films were not exhibited in more conservative communities or were edited locally by simply snipping out offending bits. Hays had been looking for a policy that the studio executives would accept so that a national standard could be applied to all Hollywood films released. Quigley's Code was published in his magazines and *Variety* in February and March 1930. Producers agreed in principle to follow the guidelines. But the ticket-buying public was not interested in this sanitization of movie content. As Quigley's Code was perceived not as dogma but as a series of recommendations, producers continued to push the limits of propriety. This worked well for four years until 1934, when the MPPDA, in part resulting from Mae West's obvious screen carnality, required pictures to have a certificate testifying to decency before they could be released. *Our Blushing Brides* would not have received a certificate, nor would many of the films Crawford would make over the next three years.

Great Day was to have been based on a musical that flopped on Broadway in the fall of 1929. Critics and audiences condemned the show but liked some of the songs, and MGM bought the rights as a starring vehicle for Crawford. Irving Thalberg served as producer, Harry Pollard directed and Johnny Mack Brown was signed as the male lead. For a prestigious Thalberg production meant to be one of MGM's big releases for the 1930–31 season, little information survives documenting the film. A handful of scene-stills show Crawford at work, and sheet music was released with her name emblazoned on the cover. By mid-June, *Great Day* was underway, and Brown was off with the location crew shooting background scenes in New Orleans. *Variety* reported that Crawford was "due shortly," but no other evidence supports the trip.[3] She was at the studio filming in July, and *Great Day* was still underway a month later.

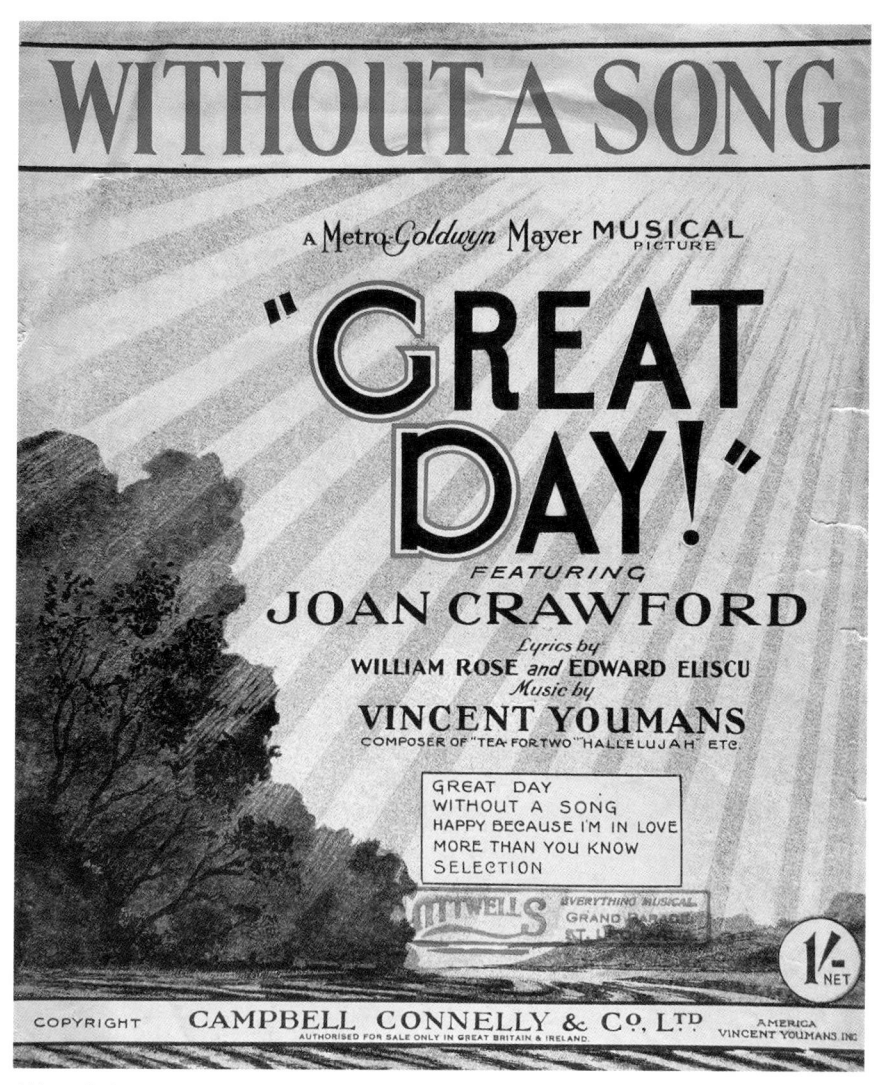

Although *Great Day* was never completed, a British firm published sheet music featuring songs form the musical.

"Joan plays a fourteen-year-old girl at the start of the story," wrote Harriet Parsons in *Photoplay* of this "musical comedy laid in the old south. . . . We saw her taking a test the other day in a blue-checked gingham dress and socks, looking young enough to be in 'Our Gang.'" The Crawford role was originated on Broadway by Mayo Methot, and the one song from *Great Day* that has become a standard is *More Than You Know*. Parsons was on the set and heard a playback of Crawford's version: "Joan sings 'More Than You Know' in a low pleasing voice. Her eyes have a far-away look. Probably thinking about that good-looking husband of hers."[4]

"The part wasn't well defined," Crawford wrote in her memoirs. "I had never played an ingénue and I went into the picture with grave misgivings." She was also concerned about playing such a young character, finally telling Mayer, "I just can't talk baby talk." Anxious to exorcise an unpleasant period, she claimed that she spent only ten days working on *Great Day*, when it was more likely two months. Star power does have its rewards, and it seems that Crawford convinced Mayer to bring this expensive Thalberg production to a halt. "Well, I'm dreadful," she said. Mayer must have thought so too: he took a loss of $280,000. [5]

Crawford and MGM forfeited a big-budget musical spectacle about the old South that had failed on Broadway, and with Crawford's limited singing ability was hardly a sure-fire path to box-office riches had it been completed. Also, Mayer must have been aware that his new star was shining in different types of roles; she was becoming simultaneously a dramatic actress and a sophisticated glamour girl. Next up for Crawford was a film that perfectly suited her, a talkie version of a popular stage play *Within the Law*, which had been previously filmed in 1923 with Norma Talmadge. Now titled, *Paid*, it tells of a young woman, Mary Turner, wrongly convicted of a crime, who is sent to prison and upon her release exacts vengeance upon her accusers.

Conviction and jail time are dealt with hastily, and after about fifteen minutes Mary is free and planning her revenge. The conceit of the film is that criminals can get away with a great deal if they stay "within the law," and Crawford masterminds a series of clever schemes that enrich her newly formed gang. The endgame is to snare the son of the tycoon who sent her to prison, which she does draped in Adrian-designed gowns and furs. The old story, even after more than a century, remains fresh, and Crawford, along with all her screen cohorts provided superb entertainment. "It will get a load of money anywhere and will help Joan Crawford," wrote *Variety*. "Advancing beyond the strictly s[ex] a[appeal] and dud wearing years, here she histrionically impresses as about ready to stand up under any sort of dramatic assignment." [6]

Mayer and his top producers—with the exception of Thalberg, who seems to have little involvement with Crawford's films—now had a new star who could thrive both in heavy drama and was also a proven commodity for lighter fare. To keep the fans entertained who had flocked to *Our Dancing Daughters*, the follow-up to *Paid* was a drama that included a significant dancing component. *Dance, Fools, Dance* appealed to the legions of followers who still liked to see her cut loose. It was unusual for an MGM star to be presented in more than one guise, but her box office returns showed that audiences were enthusiastic about both Crawfords. *Our Blushing Brides* and *Paid* each took in about $1,200,000 and returned slightly over $400,000 in profit. *Dance, Fools, Dance* was a slight variation on what was becoming the standard Crawford story. But this time she starts off as an heiress whose father loses the family fortune so she must go to

Crawford with Douglas Montgomery on the set of *Paid*, 1930. Photo attributed to George Hommel. 1930.

Warner Bros. photographer Elmer Fryer visited Crawford and Fairbanks Jr. shown with their Scotty Woggles at home in Brentwood.

work—as a newspaper reporter who goes undercover as a nightclub dancer—and her exploits provide the film's narrative.

One of her adventures is with a mobster played by Clark Gable. Top credited among the supporting cast were Lester Vail and William Bakewell, but it was Gable, in one of his first film roles, who scored with the audience as well as the star. He had spent several years in Hollywood working as an extra and can be spotted in silents such as *The Merry Widow* and *The Plastic Age.* He had better luck on stage in New York before trying again for the movies in 1930. He was signed by Pathé for a role in *The Painted Desert*, then Warners for a small part in *Night Nurse.* MGM hired him for *The Easiest Way* with a cast headed by Constance Bennett, Robert Montgomery, and Anita Page. Although the role was small, Thalberg liked him, and, as the studio was in need of leading men with stage experience, Gable was hired for a year at the hefty newcomer salary of $650 per week. *Dance, Fools, Dance* was the break he needed. As a murderous gangster, his role is not sympathetic, but, nevertheless, in a long scene with Crawford sparks fly. He first notices her heading the chorus line at a club, and his reaction launches a professional and personal relationship that endured for decades. "In the one

scene where he grabbed me . . . his nearness had such impact, my knees buckled. If he hadn't held me by both shoulders, I'd have dropped," Crawford later wrote.[7]

Crawford and Gable would make eight films together; they wouldn't always be her best, but invariably they burned up at the box office. He became the star partner she needed. Although she would work with most of MGM's leading men, and he with the studio's leading women, they had a dynamic partnership that enhanced and reinforced both careers. He was listed at the back of the pack in *Dance, Fools, Dance*, but the producers discovered they took a good gamble with Gable, and renewed his contract. Her next film would be recast well after filming had commenced when Gable replaced one of the leads in order to accommodate the Crawford–Gable enthusiasm. The next year in Crawford's *Possessed* he would be first below the title; after that he was a star.

He also became her lover. Crawford was always candid about the nature of the relationship but it is not certain when it turned to romance. She was, after all, still married to Fairbanks Jr. When the marriage began, the two were crazy about each other, although there was a sense of doom right from the start. His age might not have been as much of a problem as her ambition. The final split, which didn't occur until 1933, was provoked by differences in temperament and interests, and her steadily upward ascent. And, whether or not the Fairbanks Jr.-Crawfords and the Fairbanks-Pickfords reached an accord, marriage into that famous family seems to have enhanced her insecurities, chiefly social, and Hollywood's young prince was never able to establish Crawford as his princess consort. The fan magazines promoted the young couple as the epitome of Hollywood youth, success, and happiness, but behind the endless pages and the photographs of the beautiful couple the truth was that Crawford wanted a star career more than a marriage. It is possible as early as 1931 that she believed her brand might one day overtake that of her famous in-laws. If she did, she was correct.

"I'm sick of this royal family stuff," Crawford told a reporter for *Photoplay* in late 1929, which might have been true but she was, nevertheless, faced with in-laws who relished being at the center of a dazzling social whirl. "Doug, Sr., laid the gifts of the world at Mary's little feet. He brought kings and queens and ambassadors to her door."[8] Her lack of education and working-class background colored every encounter with the grand couple. Crawford had taken control of her professional life and succeeded mightily, and had made a brilliant marriage. But she was still Lucile and Billie.

> Pickfair was a formal and sumptuous house . . . going there was an ordeal for me but it became an essential part of our life . . . we went to Pickfair every Sunday. All day. It was a ritual. . . . I never selected a fork until I'd checked to see which one Miss Pickford used. . . . Mary would descend, beautifully gowned for the evening . . . and there I sat . . . feeling anything but chic, anything but poised, in fact gruesome.[9]

She had ambivalent feelings about her father-in-law, sometimes appreciating his sense of humor and kindness but worried about when she might become the object of teasing. "He enjoyed kidding me. In front of people like Lord and Lady Mountbatten he'd say, 'Billie, you tell them which of my pictures you like best.' Knowing I'd seen none of them . . . knowing that I didn't dare open my mouth in front of his distinguished guests."[10]

Her husband shared his father's love of high society. While Joan preferred quiet evenings at El JoDo, Fairbanks Jr. wanted to move with Hollywood's top echelon, seeking invitations from the Thalbergs, Constance Bennett and her marquis husband, and Broadway stage greats Fredric March and Florence Eldridge. And, of course, he fitted in with the illustrious crowd that populated dinners and dances at Pickfair. "Gradually our entertaining increased. 'Cielito Lindo' we called the house now, 'Little Heaven,' and to it Douglas invited a rush of celebrities, young sophisticated and literary lights. We acquired a domestic staff. . . . Saturday nights were usually formal." Hollywood's leading lights were not the company she wanted to keep, rather old friends like Billy Haines and Dorothy Sebastian. While her husband sought out intellectuals and the high-born, Crawford "constantly made other friends, too, script clerks and publicity people such as able Jerry Asher."[11]

Fairbanks Jr. had become a published author when he wrote series of profiles for *Vanity Fair* to which he also contributed a caricature. The first was published in May 1930 and the subject was his father: "Being an actor primarily, he is a series of masks." The next month he wrote about his stepmother: "She is always the dominating force of any meeting or consultation." And in July he was brave enough to send in "a portrait of Joan Crawford." "She has," he began, "the most remarkable power of concentration of anyone I have ever known."

> She is not easily influenced, and must be thoroughly convinced before she will waver in her opinion on any point. . . . She is intolerant of people's weakness. . . . She never drinks but smokes like a cowboy on his last cigarette. . . . She is a ten-year-old girl who has put on her mother's dress—and has done it convincingly.[12]

For Christmas 1930, the Fairbanks Jrs. treated themselves to a trip to New York City. It was their first vacation since they married eighteen months earlier, and they stayed at the brand-new St. Moritz hotel on Central Park South. The grand suite they rented became the site of a breakfast interview with Rowley Trench writing for *Screenland*. They greeted their guest wearing pajamas, which was duly noted, as was Crawford's breakfast of Bran Flakes and skimmed milk. "She calls him darling, and he calls her Billie and Baby!" And they often addressed each other in baby talk. They spoke of places they had been, and seeing luminaries such as Peggy Joyce, Texas Guinan, Fannie Ward, and Walter Winchell. Fairbanks Jr. was "a trifle dour" about his film career noting that "he had been promised big

Douglas Fairbanks Jr. and William Haines join Crawford at a party at Marion Davies house. The theme was to come dressed as children. John Kobal Foundation.

things," not small roles in a Billie Dove film, and little more than a bit in *Little Caesar*." Crawford was also beginning to create in earnest the Crawford myth fudging places and dates to suit her invented persona. "I left New York when I was sixteen," she told Trench. "I'd been there just six months, fresh from the convent when Hollywood got me." At least the part about her being in New York for six months was true. After returning home, she was interviewed by Radie Harris for *Silver Screen*. Harris's last line to readers noted: "And, oh yes, her one complaint is that no one ever gives her correct age. It is March 23, 1908." Henceforth, that was her "official" birthday, and she stuck to it for the rest of her life.

George Hurrell

BACK IN THE WINTER OF 1924, CRAWFORD MADE THE STRATEGIC decision to take advantage of those who could help her achieve her goals. At first she dreamed of a career as a dancer, which, given her lack of any formal training, was at best a fantasy, but she managed through determination to get a series of jobs that landed her on the stage of the Winter Garden that summer. By year's end, she had a motion picture contract. Unschooled in acting, by right she should have been dropped at the end of her first six months. Crawford had a protector in producer Harry Rapf who guided her early days at MGM. Resolute in succeeding at the studio, which meant landing small parts and perhaps one day joining the ranks of leading ladies, she befriended anyone who could assist her ambition. She made friends with Billy Haines and Dorothy Sebastian, watched Norma Shearer and Marion Davies at work, and refined her meager skills as a dancer. And, most importantly, she learned how to act in front of the silent camera, crediting her success to the men and women who worked behind the scene, including camera operators, technicians, screenwriters, costumers—in fact, anyone who could teach her something about the movie craft. As she advanced to better parts, she developed good relationships with directors such as Harry Beaumont and Jack Conway, and cinematographers like Oliver T. Marsh and Charles Rosher. Adrian took command of the costume department in late 1928 and oversaw the designs for nearly all of MGM's films. His primary focus was on the wardrobe for the female stars and he served Garbo and Shearer brilliantly, but his most lasting contribution to film history might be the succession of dresses be created for Crawford during the 1930s, many of which were so popular they were quickly copied and produced by the thousands. There is no evidence that either Crawford or her producers were looking to find her a dynamic screen partner as her personality was so dominant that fans flocked to see her films regardless of costar. But, Clark Gable appeared in 1930, and they formed a team that rivaled Garbo and Gilbert or Astaire and Rogers. Adrian's gowns and regular appearances with Gable helped keep the Crawford brand at full blast during that decade. There

George Hurrell, Joan Crawford, September 1930. John Kobal Foundation.

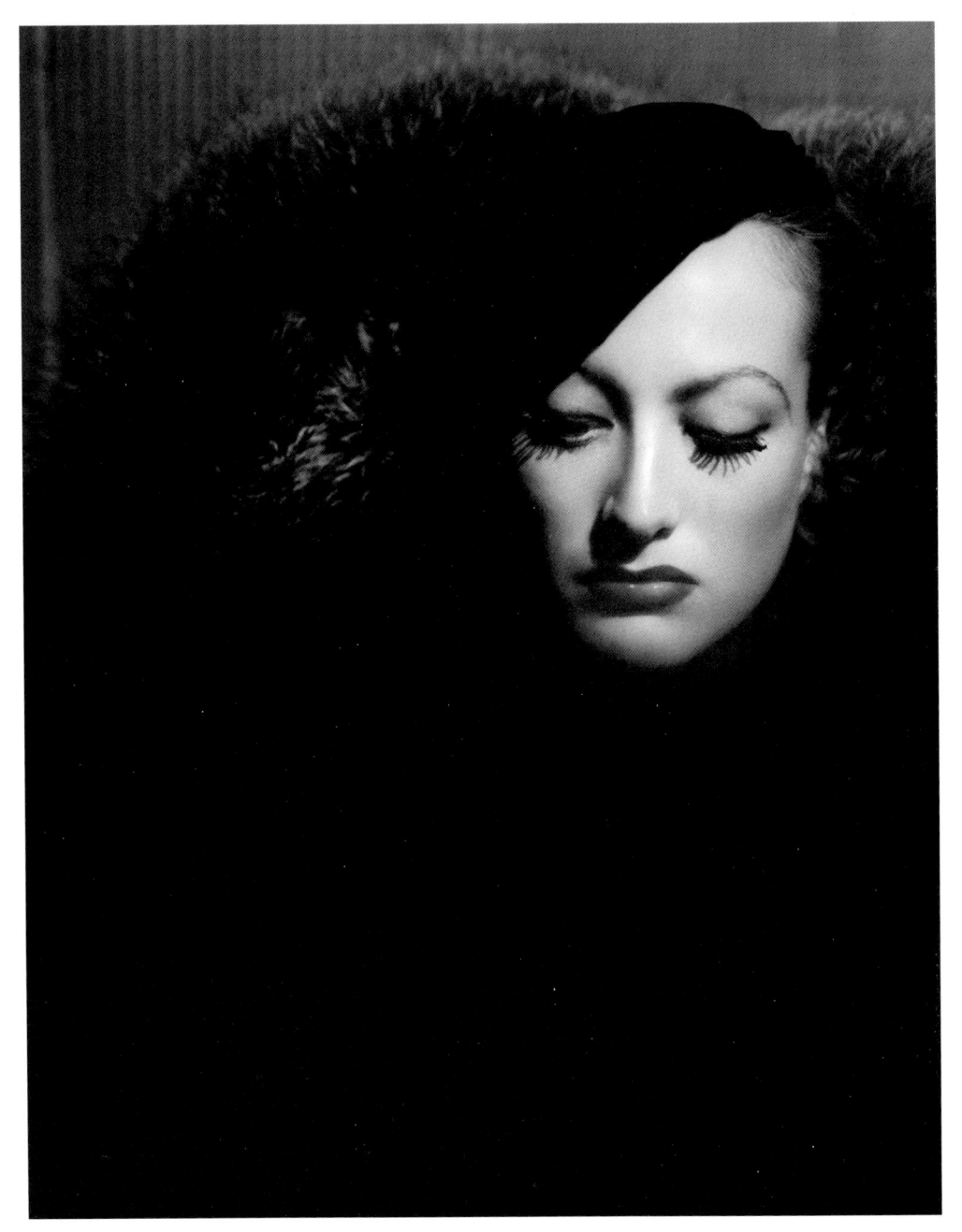

George Hurrell, Joan Crawford, *Letty Lynton*, 1932. John Kobal Foundation.

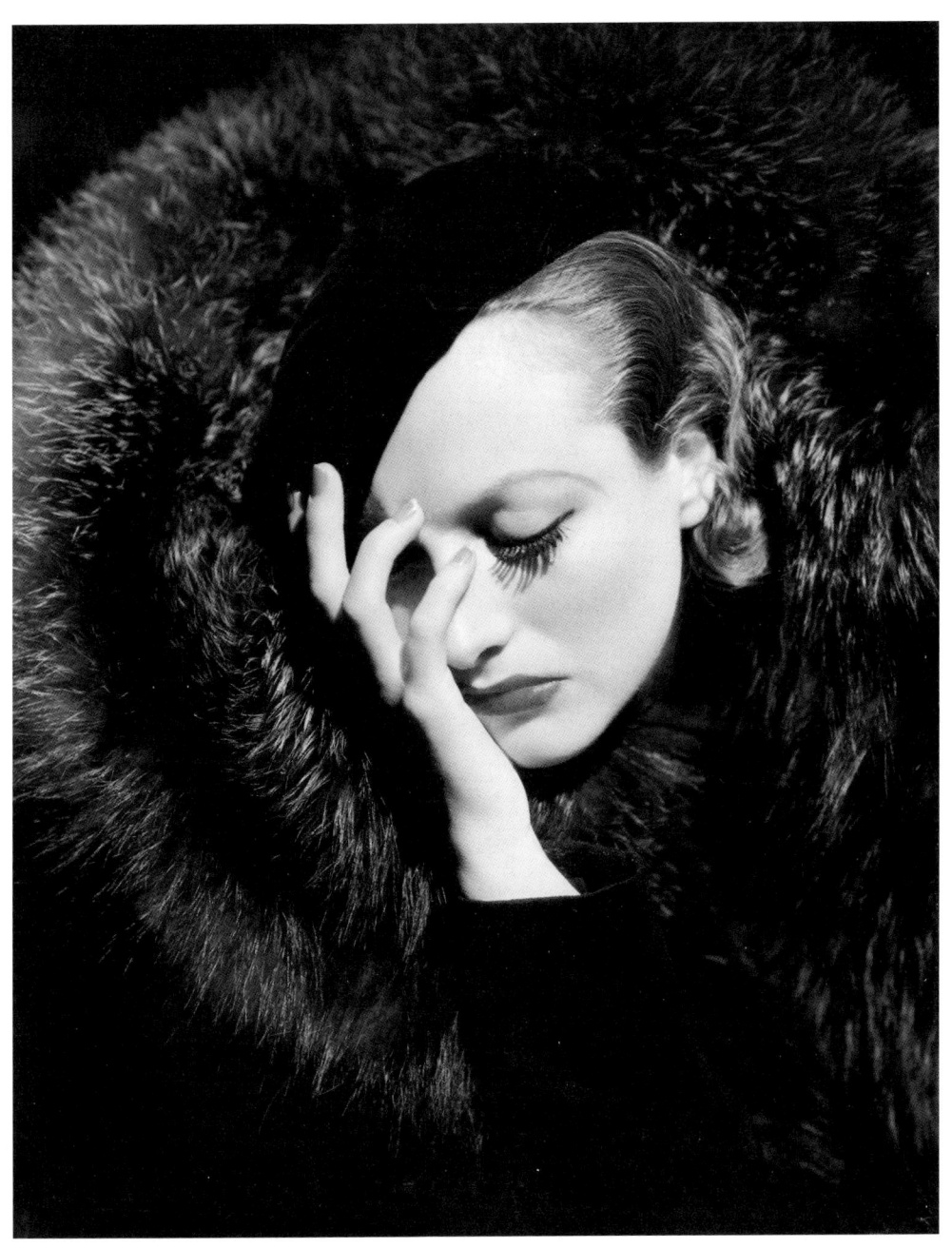

George Hurrell, Joan Crawford, *Letty Lynton*, 1932. John Kobal Foundation.

George Hurrell, Joan Crawford, *Letty Lynton*, 1932. John Kobal Foundation.

was another newcomer to MGM in 1930 who, in the end, contributed more to Crawford's enduring legend than any other who supported her screen career: George Hurrell.

Hurrell replaced Ruth Harriet Louise as MGM's chief portrait photographer in January 1930. Shearer asked her husband to bring Hurrell to the studio, and the result was that Louise was out of a job. Louise had married director Leigh Jason in 1927, had her first child in 1932, and continued to accept occasional private commissions, but for the most part her career was finished at the end of 1929. She died in childbirth in 1940, and until John Kobal resurrected her career in the 1980s she was little more than a footnote in Hollywood's photographic history.[1]

Hurrell, on the other hand, had a long career working into the 1990s, and from the moment he began at MGM, until the present day, he is regarded as Hollywood's premier photographic artist. Discovered, at least as far as motion picture stars are concerned, by Ramon Novarro in 1929, when he asked Hurrell to make a series of portraits that the actor might use in promoting a potential operatic career in Europe, Novarro showed the prints to Norma Shearer, who had been anxious to change her screen image. Shearer wanted to become a screen sex-goddess like Garbo, in the face of her husband's pressure to present her always

George Hurrell, Joan Crawford, c. 1933. John Kobal Foundation.

George Hurrell, Joan Crawford, 1933. John Kobal Foundation.

as a cultivated and elegant lady. The portraits Louise made of Shearer reflected perfectly Thalberg's vision. Secretly, Shearer decided to take her business to Hurrell in the hopes that he would find the smoldering glamour she felt was missing from her MGM portraits. She told him what she wanted. He gave her what she asked for, transforming Shearer. Hurrell used tricks that Louise never employed. She posed her subjects carefully, photographed them in soft focus, and retouched her negatives as sparingly as possible. Hurrell used sharp focus, removed as many mid-range tones as possible, and printed his negatives so that the blacks were

pure and the whites were brilliant. His negatives might be heavily retouched. To glamorize Shearer he made her legs long and thin by painting out the edges of her calves to give them the contour she requested. He asked his female subjects to wear little makeup save lipstick and mascara, providing an almost blank slate on which to burnish the negatives, giving skin a flawless and radiant appearance.

No matter how much we thrill to Louise's best portraits today, in late 1929 her work would have seemed retardataire. She had served Crawford well and made elegant portraits for *Untamed*, the last film on which they worked together. In these photographs—close-up, full-face, three-quarter, and profile—she observed her subject more acutely than she ever had before. Still, these images are a record of Crawford at the moment of transformation. Hurrell was the herald of portraiture, the nod to the future, and the ideal colleague at MGM to Cedric Gibbons whose magnificent modernist sets adorned many of the studio's contemporary stories.

MGM had made Crawford a star as a result of a well-defined personality and audience approval. It would not be until 1930, however, that Crawford would begin to earn her place among cinema's elite with films such as *Paid*, *Possessed*, and finally *Grand Hotel*. At her side was Hurrell. After a rough start together they developed into the ideal artist and muse.

"I photographed her literally thousands of times," Hurrell wrote in 1976, meaning that he captured her image on thousands of sheets of 8x10 inch film. "Each sitting was a new experience for both of us. For one thing, she constantly altered her appearance, the color of her hair, eye makeup, eyebrows, and mouth. Yet, with all the changes, there was a classic beauty, a weird kind of spirituality, if you will, that was always there." It is difficult to know what Hurrell meant by "spirituality." As the man who brought glamour photography to its fullest expression, he understood that part of his duty was making his subjects magical. For Crawford, and for at least one male subject as well, Ramon Novarro, he created portraits that presented the fantasy of other-worldliness. Hurrell leads us to believe that he saw this magical, dreamlike quality in Crawford's face even before he took her photograph or manipulated her image in the darkroom.

> Joan Crawford was, for many years, the most photogenic of the Hollywood group of actresses. . . . When we first met, she swept into the gallery full of energy and drama. I reacted immediately to her warmth and her dazzle. She had a perfectly proportioned figure, and her one defect—broad shoulders— was turned into an asset by Adrian's costume designs. . . . When I caught my first glimpse of her in my lens, I felt an emotional tug of excitement and knew that I had a unique subject. Her reddish-brown hair, large wide eyes, and strongly molded features were perfect in the camera.[2]

Crawford was an ideal subject for Hurrell during the dozen years they worked together while she was at MGM. As she became middle-aged, and older, her

George Hurrell, Joan Crawford, January 1934. John Kobal Foundation.

features hardened, and as she continued her career well into her sixties, the image of Crawford that endures is not always the ethereal beauty, but of a handsome— but hardly "spiritual"—face. And, Faye Dunaway's brutal caricature has, for some, come to define the face and personality of Crawford. But to understand Crawford's motion picture stardom is to watch her face evolve from 1930 throughout that decade under the scrutiny of Hurrell's camera lens. It is those images that continue to define her even to a generation that might never have seen one of her films.

Their first meeting was in January 1930 soon after Crawford completed *Montana Moon*. It didn't go well. The brash young photographer, oozing talent, had leapt into the top position under the patronage of Shearer and Novarro. Louise, whose tenure at the studio almost mirrored its history, was out, and this could have created hard feelings as she was well-liked and had recorded her subjects beautifully. And, being perceived as Shearer's protégé would not have endeared Hurrell to Crawford. Grudges aside, the newly minted star had carefully crafted the veneer she presented to the public. Would the new photographer understand what she wanted?

> I kept telling her how to pose. She finally got so upset about it that she went into the dressing room and said, "I'm not going to pose any more."... So the publicity gal came out and said, "You can't talk to her like that."... "What the hell am I doing here then? She doesn't want me to tell her how to pose? Pack it up Al [St. Hilaire]. Let's get out of here." So he had the camera packed and we were going out the door and she came running after us.[3]

Crawford may have possessed one the strongest egos in Hollywood, but more important was her now refined instinct to discern who could help support her stardom. Whether or not she "came running after" Hurrell, she did wait anxiously to see the results of his work. She approved, and they met regularly thereafter, in the portrait studio, occasionally on set, and she also invited him to photograph her at home. "If it was the first time to shoot a star at home, my assistant and I would go in and search through the house to see what would make the best-designed backdrop: some architectural detail like a column or a case or maybe decoration on the wall."[4] Hurrell made regular trips to Brentwood, and these domestic photographs stand in fascinating contrast to the studio portraits. At home, Crawford is alive with the enthusiasm of a young woman in the midst of a brilliant career. In the studio, the goal was glamour with the focus on the face. Crawford was the perfect subject in any guise, and she could change her personality at will, one moment interpreting a character on the set, the next cheerfully posing at home, and most successfully allowing Hurrell's penetrating eye to make dazzling portraits.

Over a day-long portrait session with Hurrell for *Dance, Fools, Dance* Crawford was interviewed for *Screen Mirror*, and the article provides a peek into this

slice of her working schedule. They met at 10 o'clock, with an hour off for lunch, and by mid-afternoon Crawford was in need of a cup of coffee. "'Just a moment, Joan, please, I want to get a few more shots in that outfit.' [Hurrell] changed a light a fraction of an inch and disappeared under the black velvet hood which covered the camera." When the shots were taken, "Joan slipped out of the black velvet dress she was wearing and into a blue satin negligee. A boy in a white coat came up the three flights of stairs from the commissary to the portrait studio on the roof of a three story building, carrying a tray with pots of coffee." After the team enjoyed a short break, Crawford dashed behind a screen and changed into the afternoon's final costume. "Then Joan returned wearing a cloth of silver dancing costume, daringly abbreviated, glittering under the glare of the lights. . . . Joan drifted from one graceful, natural dancing posture into another while the camera clicked and an electrician moved the battery of lights this way and that."

"Four-thirty, she said," ending the session. She wasn't tired of posing, but still had much to do that day. "[Dancing] lesson from five to six, shower and dress and home by seven. I guess Doug and I can make the theatre tonight." Crawford was well known for subsisting on coffee, and that day's schedule is a good indication why. As she prepared to leave Hurrell's studio, she spoke to the reporter for a few minutes. "I don't want to be branded as a definite type. . . . I want even my portraits to be different. I don't believe there is anything more tiring than seeing the same thing over and over again."[5]

Her insistence on variety meshed perfectly with Hurrell's desire to create radically imaginative portraits. He set her skin and hair against contrasts of mezzotint black and blinding white. Heavy mascara and thick lipstick became props. She reveled in his kinetic working manner and was pliant when he suggested new poses. "[Hurrell] worked to catch you off guard. He'd talk to you constantly and his camera would go click . . . while I was saying 'Nooowwww,' or 'Reeeeeaaaallly.' And he'd get pictures while I was talking, asking for a cup of coffee."[6]

Hurrell's Crawford endures, and forty-five years after *Mommie Dearest*, his images have overtaken the caricatures and the drag queen impersonations to provide once again our principal understanding of her face and legacy. She was his favorite subject, "beautiful in herself, in any angle, in any light."[7] She could go on posing endlessly; "she never wanted to stop. She loved being looked at."[8] Ninety years later the Crawford–Hurrell portraits continue to enthrall. "There is a strength and vitality about her," he wrote in 1941, "that gets across and prevails even in the finished print. If I were a sculptor I would be satisfied with just doing Joan Crawford all the time."[9]

George Hurrell, Joan Crawford, 1934. John Kobal Foundation.

Grand Hotel

FOR HER GOOD WORK IN 1930 (AND EXCELLENT BOX OFFICE), CRAWFORD received a bonus of $10,000.[1] Aware of the strong returns her films were taking in, she exercised one of the prerogatives of stardom and asked for a new contract with a raise in pay. She didn't need to employ Garbo-like tactics and threaten to go back to Kansas City, or stay home and not show up for work. She asked to be paid a star's salary. In April 1931, a new deal was reached, seemingly without rancor, giving her $3,000 per week with annual options adding $500 to that figure topping after four years at $5,000.[2] It wasn't as much as Garbo and Shearer, but it was plenty, and an acknowledgment that she was now near the pinnacle of her field.

Another indication of her status was a public feud she was having with Shearer. From her earliest days as a leading lady, she resented that Shearer had her pick of parts. Back in the late twenties Crawford understood that Shearer's marriage to Thalberg gave her rival preferred treatment. But now that Crawford was on equal footing at the studio, she demanded better scripts. She wasn't the only MGM star that resented Shearer. Marion Davies was bruised time and again when Shearer took parts she thought rightfully hers. Crawford's ire peaked in April 1931. "It's a studio secret that Miss Crawford wasn't especially wild about the way her stories were being treated. Better breaks for Miss Shearer were alleged," wrote *Variety* that month. The details surrounding the rapprochement have never been revealed but the paper noted in a headline "Crawford–Shearer truce after favoritism charge." Along with giving her more say over her stories, Crawford's new contract sweetened the bitterness between MGM's rival star actresses. The *Variety* article promised that the Shearer-Thalbergs and Crawford-Fairbanks were so happily reconciled that they were about to head off on a European vacation together. It was a lot of bunk, but a carrot the MGM publicity office gave the reporter so as to make the public airing of MGM business appear less unseemly.[3]

Crawford joined many of her colleagues and appeared in a comedic short film, *The Stolen Jools*, made by the Masquers Club in Hollywood to benefit the National Vaudeville Artists Tuberculosis Sanitarium. The twenty-minute film is a

lark about the "theft" of Norma Shearer's jewels (the so-called "stolen jools"), and Crawford, along with Buster Keaton, Cary Cooper, Irene Dunne, and dozens of others, donated their time to this worthy project. Crawford's short scene shows her with Billy Haines, defending themselves as possible culprits. The film was distributed by Paramount as a short subject and played in theaters in the spring of 1931.

While contract negotiations and spirited competition for the best scripts were occupying Crawford's time, that spring she was also in the midst of working on a film that had run up against difficulties. Originally titled *Torch Song*, later *Complete Surrender*, before it was released as *Laughing Sinners*, Crawford played a nightclub dancer in love with a bad guy, but who is saved by a Salvation Army worker. When it went into production the good fellow was played by Johnny Mack Brown, Crawford's leading man in *Montana Moon*. Depending on whose story you believe, when the rushes were shown (or perhaps after the first preview) either the star or Mayer did not like the on-screen chemistry between the pair. Years later, after Brown had become a legendary cowboy star, Crawford wrote, "Johnny's performance was excellent," but she didn't feel that way in the late winter of 1931, and he was fired from the picture; his scenes were reshot with a new actor, Clark Gable.[4] Brown never worked at MGM again.

Was Gable brought into the film as a favor to Crawford, or was there something wrong with Brown's performance? It was an expensive and time-consuming decision on the part of the producers to reimagine *Laughing Sinners* in the midst or at the conclusion of filming. It didn't fare well with the public generating a paltry $150,000 profit, one-third of what her last three films had made, and one theater owner even went so far as to write that it was "a big let down from the usually good pictures Crawford has made."[5] Critics thought Gable was miscast, but they still liked him. As Gable rose to become one of the giants at the studio, Crawford and Mayer could look back at the decision (whoever made it) with the certainty that it was correct.

Following *Laughing Sinners*, Crawford starred in *This Modern Age*. Like her previous film, it was delayed, this time due to a change in director, and its release postponed from May 30 until August 29. Directing credit was given to Nicholas Grinde, who had begun making features after many years specializing in short subjects. His first for MGM was *Remote Control* with Billy Haines, and *This Modern Age* was the follow-up. There has been speculation, however, as to how much of the film was directed by Grinde; at some point during the production, he took a leave from the studio. Director Clarence Brown's biographer states that after an unsuccessful preview he was brought in to complete, or perhaps entirely reshoot, the film.[6] A photograph reproduced in *Motion Picture Herald* (May 9) shows Crawford with members of the cast, among them Marjorie Rambeau, who was slated to play her mother. Rambeau, after filming had started, was replaced with another stage and screen veteran, Pauline Frederick. Why this change was made is unknown, but Frederick almost steals the film playing the mother who

abandoned her daughter as a child. Are Frederick's scenes with Crawford the work of Brown? The film takes place in Paris with Gibbons's art deco sets providing a glittering backdrop to the action. It is another story of Crawford getting the right man after a series of misadventures—including possibly sharing a lover with her mother! This time, she dyed her hair blonde, an experiment that wasn't bad, though it didn't enhance either her appearance or personality. Grinde did receive sole directing credit, but he did not make any more films at the studio. Even with two directors and cast changes, *This Modern Age* was relatively inexpensive to produce and brought in respectable receipts and good reviews. It was the last of the films Crawford made before demanding input into her scripts (and perhaps costars and directors as well).

Possessed was the first in a series of artistic and box-office successes that have come to define Crawford's MGM stardom. There was plenty of good work before, but beginning with *Possessed* we find films that are regularly screened on TCM or exhibited in revival houses: *Grand Hotel, Dancing Lady, Sadie McKee*, and *Forsaking All Others*. *Grand Hotel* was an all-star feature where she worked aside many of her illustrious colleagues. The others were starring vehicles in which she was supported by actors such as Clark Gable, Franchot Tone, or Robert Montgomery. Later in the 1930s, now designated stars themselves, Gable and Montgomery would be among the relatively few actors who shared above-the-title credit with Crawford.

For *Possessed*, Crawford was surrounded by her most trusted colleagues starting with Harry Rapf, who produced. Her costar, now accorded solid second billing, was Gable. The film was directed by Clarence Brown, who would work with her again four more times during the 1930s. Oliver T. Marsh, who had photographed Crawford exquisitely in films such as *Untamed* and *Our Modern Maidens*, was the cinematographer. Still photographer James Manatt worked on a set designed by Cedric Gibbons, Adrian designed her wardrobe, and Hurrell made portraits. With this team, nothing could go wrong as long as she had a good script.

If you are looking for a film that defines what is meant by "pre-Code," *Possessed* is not a bad place to start. Like so many of MGM's dramas of the 1930s, it found its source in a Broadway play, *The Mirage* by Edgar Selwyn, that was updated for the screen. Rapf's son Maurice, then a Stanford student, came up with the title *Possessed* and received $50 for his contribution.[7] Crawford plays the first in what would become a series of working-class young woman with dreams of a glamorous life in the big city. In *Possessed* she succeeds and the fact that she becomes a mistress to wealthy Clark Gable doesn't bother her a bit. Early in the film, she declares, "I left school at the eighth grade; I never learned how to spell regret." Today it probably does not startle audiences watching Crawford scoring a fancy Park Avenue apartment, but the candor with which her character sought and attained her goals was pretty frisky back in 1931.

Crawford with Clark Gable (pre-mustache) in portrait for *Possessed*, 1931. Photo by George Hurrell. John Kobal Foundation.

The set of *Grand Hotel*; Crawford stands on the counter (center) next to director Edmund Goulding (in white).

Pre-Code films are now considered a subset of early Depression-era studio releases. Gangster pictures were scrutinized for violence, and romantic dramas for presenting what was considered moral impropriety. We watch these films with pleasure, enjoying the nods and winks from screenwriters and actors pushing the limits in ways that rely on clever dialogue and sharp editing. Pictures with big stars coming from major studios should have been examined carefully, and some were, but others largely escaped the censors' scissors. Garbo was considered virtually censor-proof, although her scripts were rewritten over and over again before and during shooting. Her continental attitude to sex and romance might have been shocking, but the average movie goer didn't identify with Garbo. Crawford's influence over American women, on the other hand, was significant. How her characters behaved on the screen, what she wore, and even how her life was presented in the fan magazines, were closely followed, and imitated.

Studios were meant to send completed scripts to the MPPDA for review, and then invite a committee member to view a film's rough cut. Somehow the folks at MGM slipped *Possessed* into production without a cleared script. When the film was screened, the response was harsh: too much sex, too much immorality. In other words, it was an excellent picture. "This picture worries me more than any I have seen since [my] arrival," wrote Lamarr Trotti to his boss, Jason Joy, at

the Hays office. Will Hays went over the heads of Rapf and Mayer and protested to Nicholas Schenck, Loew's boss in New York. Although MGM was forced to make some slight cuts of offending dialogue (such as, "All they got is their brains and bodies and they are not afraid to use them"),[8] *Possessed* is an example of MGM's successful strategy in ignoring censorship concerns as much as possible and then asking for forgiveness in the form of minor cuts in order to keep the spirit of the original script.

Crawford and Gable had clicked in *Dance, Fools, Dance* and *Laughing Sinners*, but this time they sizzled on-screen together. She admitted to having been in love with Gable, and this film was likely the moment when their affair started. Hurrell noticed it too when photographing them together. "Most of the time they forgot that I was there."[9] One of his best sessions of the pair was his photographing them both dressed in black. Their screen scenes together suggest the nature of the relationship, but Hurrell's photographs—ignoring censorship—deliberately convey either a pre- or postcoital moment.

The motion picture rights to a popular 1929 novel by the German author Vicki Baum, *Menschen im Hotel*, were purchased by MGM. The studio also invested in the stage production, rechristened *Grand Hotel*, which was presented on Broadway for thirteen months beginning in November of 1930. It closed in New York as cast and crew began to gather in Culver City to film MGM's first all-star dramatic feature. The film follows twenty-four hours at a luxurious middle European hotel populated by the rich and famous, and the not-so-rich and notorious. Among the bustle, actor Lewis Stone gives us one of the film's most oft-quoted lines, "Grand Hotel. Always the same. People come and go. Nothing ever happens." In fact, quite a lot happened, and happened so beautifully that the film received the Academy Award for Best Picture of 1932. Edmund Goulding directed and was given the extraordinary budget of $750,000, and it returned a profit of nearly a million dollars, a huge sum in those Depression days.

"What do you think about this for a cast", wrote Dorothy Manners in *Movie Classic*. "Greta Garbo . . . John Gilbert . . . Joan Crawford . . . Clark Gable in 'Grand Hotel.' Irving Thalberg thinks so much of it that it is practically set."[10] This news titillated fans at the beginning of December, but by the time rehearsals started after Christmas the lineup had changed. Garbo and Crawford remained, but Gilbert was replaced by John Barrymore, and Gable by Wallace Beery. Quite the dizzying fantasy imagining Garbo and Gilbert along with Crawford and Gable all in the same film, but the final cast was so good that Thalberg and his team can be forgiven for not giving audiences, then and now, the highest wattage over-the-title billing ever. One more top star was also announced, Buster Keaton, but when cameras started to roll, the late addition was Lionel Barrymore.

Months earlier, Crawford had been engaged in a battle of wills with her producers over the perceived favoritism of Norma Shearer for the best parts. When cast in *Grand Hotel*, as Flaemmchen, the stenographer, she sought to decline

the part believing it to be minor compared to the roles assigned to Garbo, John Barrymore, and Wallace Beery, and that she would be little more than a supporting member to an illustrious cast. There was even a rumor that she sought legal advice as to whether or not she would be compelled to play a role she thought unworthy: "Though Joan's rebellion was intense—it was short-lived. Several conferences with the tactful and persuasive Edmund Goulding convinced her that the screen Flaemmchen enjoyed greater opportunity than the play and novel gave to the part, and that the role for the screen had been built up so that it took second place to none."[11]

Not quite second place to none. When the screen credits were negotiated, Garbo, to no one's surprise came out on top, with John Barrymore second. Crawford was listed third. She was followed by Beery and Lionel Barrymore. All five would be placed over the title, which gave poster designers plenty of room to be creative. Crawford and Garbo never appeared together, and it is doubtful they crossed paths while the film was in production.

Whether or not a British writer in early 1932 had inside information, he suggested that Shearer was upset at not having got the part of Flaemmchen. He wrote that Crawford also beat out both Marion Davies and Constance Bennett.[12] All of this underscored the importance of *Grand Hotel* as MGM's biggest film of the year. It was accorded one of Hollywood's biggest opening-night extravaganzas ever, and premiered as a road show attraction charging ticket-buyers a hefty $1.50 during its first run.

Rehearsals began in late December. Goulding assembled his cast and invited a still photographer to record the beginning of the momentous film. All the principals showed up except Garbo who was vacationing in New York. One camera negative dated the 30th marks the day they gathered to read the script together. Pictured are Crawford and Beery, neither looking happy, along with other of the film's supporting players. Crawford wears jodhpurs, not a fashion statement, but an indication of where she was headed later in the day. Also invited was a reporter from *Photoplay* who dutifully told readers about the sniping of the stars each of whom felt it was beneath him or herself to read or rehearse.

Star temperament was noticed on the set, and most bolted for their dressing rooms when the director said "cut." Crawford behaved differently. "Upon completing a scene," Goulding remembered, "Joan stayed behind. She would be talking with William Daniels . . . or sharing a coke with the overworked script girl. She was interested in everything that happened around her."[13] Similar reports survive from other Crawford films. Anything she could learn about filmmaking she considered supportive of her craft. Never satisfied to walk on the set and stand in the place where directed by Goulding or lighting technicians, she wanted to understand the technology and why certain camera angles or position of lights worked better for her than others. These would be lessons learned on the sets of *Grand Hotel* and other films, and she remembered them throughout her career.

Crawford with John and Lionel Barrymore on the set of *Grand Hotel*. Photo by George Hurrell.

Crawford had scenes with the three male leads, the two Barrymores and Beery, but shared the most screen time with Beery and Lionel Barrymore. She had the chance to play a full array of Crawford types: attractive working-class woman who caught the attention of a prominent man (John Barrymore); secretary to a boorish businessman who wanted to trade sexual favors for promotion (Beery); and a woman with the heart of gold who sets out to help a dying man recover (Lionel Barrymore). Crawford may not have wanted the role of Flaemmchen, but when the film was completed it was her character that was the most fully realized, and she nearly walked away with the acting honors. *Grand Hotel* proved what had long been suspected: Crawford was a first-rate dramatic actress. Films such as *Paid* and *Possessed* provided testimony that she was worth MGM's investment; *Grand Hotel* that she might find a place among the screen's immortals. Lucile LeSueur took the name Joan Crawford, and over six years of diligence imagined her first as an actress and then as a movie star. The premiere of *Grand Hotel* showed her task completed. Two and a half years after MGM made Crawford a star, now she was one.

Always the avid correspondent, in a letter to her close friend actor Clifton Webb (whom she addressed as "Poopsie") from April 1932, Crawford let loose

Crawford poses for George Hurrell on the set of *Grand Hotel* wearing one of her costumes for *Letty Lynton*.
John Kobal Foundation.

about her experience working on her recent film: "Clifton dearest I was working on 'Grand Hotel' and I've never been so miserable in all my life." One reason was her busy schedule, "before I completed that I started on my last film, which I have just finished [*Letty Lynton*]." She signed the letter, "Love from your Puss."[14] Vicki Baum was interviewed the same month in New York and she spoke about the tribulations of the motion picture business: "Hollywood means the picture industry, and the picture industry means suffering. Everyone in it, great and small, is tortured by the same gnawing thought, 'Shall I fail this time?'"[15] Crawford possessed an ego commensurate with her stardom, but also the insecurity that at any moment she might let down her audience. So far her fans had stayed firm, one of whom was the book's author.

"She was predestined for the role," wrote Baum for *Modern Screen* about the casting of Crawford. Although she had praise for all, with regard to Crawford's portrayal of Flaemmchen, "I was thrilled and amazed." Baum commented on the cuts necessary to make a movie out of her book, "I think that censorship . . . robbed Joan of one of her greatest scenes: the bedroom scene with Preysing which appeared in the stage play but not in the picture."[16] Censorship won that battle, but Crawford's films would continue to push the limits, particularly her next two, *Letty Lynton* and *Rain*.

Among film buffs and Crawford fans, *Letty Lynton* has become enveloped in a mythology as it is almost impossible to view. Until the advent of the internet where fuzzy pirated copies can be located by those willing to burrow deep, the film was, practically speaking, lost. It is not screened in film festivals or on TCM. A few lucky collectors have 16mm copies that survive from the 1930s, and it might exist in foreign film archives. It is a pity that *Letty Lynton* is scarcely available to study for it is one of the best examples of pre-Code films. It also has the best costumes Crawford wore on screen.

Less than a month after *Letty Lynton* opened in theaters in late April 1932, authors Edward Sheldon and Margaret Ayers Barnes leveled a charge of plagiarism against MGM asserting that the film was taken from their 1930 play *Dishonored Lady*. By the end of July, the US District Court in New York had ruled in the studio's favor accepting MGM's claim that the plot instead derived from a 1931 novel by Marie Belloc Lowndes "based on an actual occurrence published in the newspapers."[17] And thus began an eight-year legal drama that was finally settled in 1940 with a decision by the United States Supreme Court ruling against MGM. Along the way the studio offered to purchase the rights to *Dishonored Lady* for $30,000, a deal which looked promising but was rejected by the lower courts. Instead, the authors asserted a claim to all of the profit *Letty Lynton* generated. A district court agreed, awarding $587,604 to Sheldon and Barnes. Box-office returns exceeded $1.5 million, but $922,141 was considered a legitimately deductible studio expense. On appeal, the appellate court reduced the damages to one-fifth of the profits, or $117,520. This ruling was upheld unanimously by the Supreme Court. The film has been withheld from distribution ever since.[18]

Even this protracted eight-year legal battle wasn't as interesting as the film's plot. Clarence Brown directed, and the blurry prints available reveal a fast-paced, engaging story. Crawford played the title character, and *Letty Lynton* opens with her living in South America with a brutish fellow played by Nils Asther. In order to escape, she secretly booked passage on a liner back to America. There she met suave Robert Montgomery, but her dreams of happily-ever-after were dashed when she found Asther waiting on the pier having flown by plane ahead of the boat. Asther insisted their affair continue, as did his physical abuse, and he blackmailed her with letters of an erotic nature she had written to him earlier. For revenge she poisoned him, was arrested, but spared conviction when those around her agree to perjure themselves. This film has it all: sex outside of wedlock (with more than one man!), beatings, lying to the police, and, surprisingly, a happy ending with no moral consequence—except the prospect that Crawford and Montgomery will end up married.

Letty Lynton marks the first time since Crawford was promoted to stardom with *This Modern Age* that her leading man shared equal over-the-title billing (all-star *Grand Hotel* doesn't count). Robert Montgomery became a star in mid-1931 after only two years at MGM, at a moment when the female roster was strong but there were an insufficient number of men to support the great ladies, Crawford, Garbo, and Shearer. He and Crawford had first worked together on *Untamed*, and they would costar three more times during the 1930s.

Letty Lynton might not be best known for its scarcity, or the lawsuit, but for Crawford's Adrian-designed outfits. Not merely stylish, they were popular with audiences. By the end of 1932, his dresses for the film were "copied by several wholesalers—and proved to be the biggest sellers they ever had."[19] "When the clothes Joan Crawford wore were seen for the first time, it sent a shockwave through the ready-to-wear industry. Puff-sleeved models flooded the market, and within a week fifty thousand potential Letty Lyntons were seen on the streets of New York City."[20] Almost as fast as ticket-sellers could get audiences into the theaters, Seventh Avenue manufacturers worked over-time to turn out affordably priced knockoffs to sell to the fan who figured with the right sort of dress Hollywood glamour could be hers. Sure, film stars influenced clothing before *Letty Lynton* but never with such a frenzy. Adrian predicted the puff sleeves would be popular and told as much to "the editor of a great fashion magazine." Her response was to pronounce the "impudent pretensions" of the Hollywood "gown designers." He was right, and later the editor acknowledged his prescience. Adrian believed that studio fashion had a democratizing effect on fashion:

> She can see a picture which stars a woman of her type. Let us assume that she is the general size and shape of Joan Crawford. She sees carefully made clothes on which hours have been expended. She sees perfect accessories to go with these clothes. She can sit back in her chair and make an easy decision as to how that sort of grooming might suit her. [21]

Crawford posing in a gown for *Letty Lynton* that became one of the most copied dresses of the 1930s.
John Kobal Foundation.

MGM didn't license these dress designs—that would come later—but every time a copy was sold in a department store, it cemented further Crawford's reputation as a paradigm of glamour, and added to the anticipation of her next picture.

Many of Hurrell's best portraits depict Crawford costumed for *Letty Lynton*, and they continue to be widely reproduced. He photographed her in the "puff-sleeve" dress, but it was other outfits that registered even better. One fashion trend that emerged from *Letty Lynton* was a sleek tight cap worn slightly on one side of the head. Hurrell made many portraits of Crawford modeling the cap, and luxurious furs featured in the film. She also posed in a black and white dress that is especially dramatic given his technique of making whites brilliant and blacks as deep as the darkest night. *Letty Lynton* began filming as *Grand Hotel* wrapped so Hurrell was able to take advantage of the chic hotel lobby interior as a backdrop. Photographed by Hurrell, Crawford gowned in Adrian's costumes was an unbeatable recipe for the most glamorous photographs produced in 1930s Hollywood.

Rain

W. SOMERSET MAUGHAM'S SHORT STORY "MISS THOMPSON" WAS published in *Smart Set* in April 1921. Based loosely on a trip the author had made to Pago Pago, it told the story of Sadie Thompson, a prostitute, and her interaction with a missionary couple who are bent on her reform. The next year it was adapted for the stage with the new title *Rain*, starring Jeanne Eagels, and had a successful run on Broadway. Gloria Swanson claimed the role for the screen in 1928 and called her film *Sadie Thompson*. United Artists owned the rights, and it was only a matter of time before one lucky actress got the chance to portray Sadie in a talking version.

When news of *Rain* started appearing in the Hollywood trade papers in early 1932, it was reported with a director assigned but no star. Joseph Schenck brought Lewis Milestone to United Artists to produce and direct several pictures for the studio, beginning with *Rain*. Milestone was riding high having directed *All Quiet on the Western Front* in 1930 and *The Front Page* the next year. In February, Tallulah Bankhead was considered for the role of Sadie.

Crawford wanted the role, but with a closed-end MGM contract, which paid her well but prevented her from working elsewhere without permission, it was Mayer's decision whether or not she could play Sadie. He agreed, asking United Artists to pay a $12,500 commission on top of covering Crawford's $3,500 weekly salary. In addition, both studios would share any profits.[1] It didn't hurt that the heads of MGM and United Artists were brothers, Nicholas and Joseph Schenck; a bit of nepotism often assisted deal-making in Hollywood.

Included in the package was cinematographer Oliver T. Marsh who had photographed *Possessed*, *Untamed*, and *Our Modern Maidens* (as well as Swanson's 1928 film). Mayer wasn't going to let another studio's cameraman shoot one of his most valuable stars. *Rain* was filmed on Catalina Island; a mini-studio was created so that both exteriors and interiors could be shot on location, and a camera track was constructed that went up from the beach and circled the "island village."[2] Actors and crew stayed on Catalina for about six weeks during the late

Crawford as Sadie Thompson in *Rain*, 1931. Portrait by John Miehle.

Crawford and Walter Huston on the set of *Rain*, 1931. Photo by John Miehle.

spring and early summer, and any reshoots necessary had to be done there before the set was struck.

Playing the minister who tries to convert Sadie was Walter Huston, and Beulah Bondi, his wife. The role of the young man in love with Crawford, regardless of her past, was given to William Gargan, and was his first significant screen role. The narrative was simple, showing its source as a short story. Passengers on a ship are forced to disembark on Pago Pago, and while there Huston attempts to convince Crawford to change her ways. She has a flirtation with Gargan but manages to keep his enthusiasm under control. Falling spell to the minister's good words, Crawford repents, and all seems well until the night he rapes her. Guilty, he commits suicide. Discovering Huston's death the next morning, Crawford decides that Gargan is the right man for her after all. After learning of her husband's death the minister's wife approaches Crawford and says, "I'm sorry for you." "I'm sorry for everybody in the world, I guess," Crawford responds as the credits roll.

Crawford's wardrobe, hair, and makeup have been discussed since the day *Rain* premiered. She was photographed on the set by John Miehle, and his stills, rarely credited, continue to be widely circulated among devotees. Miehle and Crawford must have enjoyed working together for he captures both the strong and soft Sadies with style and elegance, and always insures his subject, while often

tough, never appears tawdry. The simple checked dress that she wore for most of the film was purchased at a Los Angeles department store for $17.50. Her hair was shoulder-length and tightly curled at the end. It was her makeup, however, that got the most attention, and heavy lipstick and mascara were meant to identify Sadie's line of work. Ninety years later, all her decisions seem right although back in 1932 reviewers and fans wondered about her choices. "Joan Crawford's getup as the light lady is extremely bizarre," wrote the critic for *Variety*. "Pavement pounders don't quite trick themselves up as fantastically as all that."[3] It got worse. "Miss Crawford's exaggerations of costume and make-up are, as they say, a matter of taste," wrote Norbert Lusk of *Picture-Play*. "So I shall say nothing about them."[4] *Photoplay* gave her a subtle scold in a caption under a photograph of her costumed as Sadie, "at the height of her shady dame period," and then asked, "will she return to peppy, lovable roles again?"[5] The writer had every right to dismiss Crawford's performance in *Rain* but his memory was stretching back a few years as she had not played in "peppy" or "lovable" roles in her recent films *Grand Hotel*, *Possessed*, and *Paid*.

Crawford's hoped-for triumph fizzled at the box office. Even a star-filled premiere at Grauman's Chinese Theatre failed to ignite audience interest as United Artists had expected. For a while, box-office returns looked hopeful. "*Rain* stepped in Friday to Loew's State and Orpheum to crowded houses," wrote *Variety* after the film opened in New York. "Queues formed for Joan Crawford, women predominating. Although every critic in town rapped the pic plenty. Yet Saturday both houses again jammed them in, the Orpheum registering a record for that week-day." *Rain* proved a loss for United Artists even though it brought in more than $700,000. MGM was wise to ask for $12,500 up front.

Rain should be included among those movies that were critical failures and garnered a tepid audience, but which have weathered well over the decades. Although Crawford was blasted by many critics, she did have a few defenders including Delight Evans, editor of *Screenland*, who wrote, "Sadie Thompson is her greatest performance." This was a minority opinion in 1932 but one shared by many today who see the film as a fitting follow-up to her fine work earlier that year in *Grand Hotel*. She was compared unfavorably to Jeanne Eagels, who had portrayed Sadie on stage, but, alas, none of us are able to comment on that judgment. It is hard to imagine any of Crawford's contemporaries giving a more compelling performance. Sadie is a strident character, confident, reckless, and, at heart, tender. Over the course of ninety minutes, Crawford takes Sadie from tough, to soft and back again without ever losing credibility. She was embarrassed by what she considered a terrible performance. Sometimes it is better not to read the critics and let history be the judge.

Another bit of history began after the film's premiere. At a Los Angeles "night spot a female impersonator holds forth with his impression of Joan Crawford in 'Rain.' Joan went around to see the show the other night, but she didn't say what

she really thought."[6] In time, she would become one of the most imitated figures from the world of entertainment. Her exaggerated features and mannerisms in *Rain* set the tone for the future parody. In the late twentieth century, most drag queens were parroting not Crawford but Faye Dunaway's wildly exaggerated performance in *Mommie Dearest*. Nevertheless, beginning with *Rain*, and continuing for the next four decades, Crawford provided plenty of material for her impersonators who continue to this day.[7]

The Fairbanks Jrs. celebrated their third wedding anniversary while Crawford was on Catalina. Douglas took a day off from work and hired a plane to fly him over to celebrate the occasion. Crawford hosted a picnic for the cast and crew. He gave her a diamond necklace, emerald bracelet, and leather handbag, and she unwrapped a gold cigarette lighter. The plane trip, picnic, and expensive gifts proclaimed marital happiness to the press corps, but the marriage was in the midst of breaking up. Clark Gable was one reason, as were Fairbanks Jr.'s many affairs. Another was their working schedule that often kept the couple apart. Her husband's old friend, Frank Case, who owned the Algonquin Hotel and was a witness at their wedding, lent Crawford his cottage in Malibu where she could be alone, or at least not be with Fairbanks Jr.

A long delayed European honeymoon was scheduled to begin as soon as *Rain* was completed. As the pair would be representing their respective studios, MGM and Warners, the bosses agreed to cover most of the traveling expenses. Mayer, aware of the Crawford–Gable affair, hoped the distance would cool one ardor and reignite another. The year before he had insisted Gable marry Ria Langham with whom he had been living. Mayer wanted to avoid the bad publicity that would ensue if two of his biggest stars went through pubic divorces.

This would be Crawford's first vacation outside the United States. "I reveled in every detail of planning the trip," wrote Fairbanks, "the friends and plays we would see in New York, the cabin on the ship to reserve, what to do in London and Paris." Stopping first in New York, they stayed at the St. Moritz, and visited Fairbanks Jr.'s mother and stepfather, and other old friends. "On the night before sailing, we went to a huge and memorable party given by my old acquaintance Barbara Hutton. It was held at the Casino in Central Park and Paul Whitman's huge orchestra, the best dance band in the world at the time, had been engaged to play." They received a lavish send-off. "Eight motorcycles" were provided by the mayor, "to escort us to the pier, a wild careening ride, the sirens shrieking." When they reached the ship, "crowds at the pier tore at our clothes, women fainted scrambling over each other to see what I was wearing." Passage had been booked on the SS *Bremen*, and they would disembark in Southampton and make their way to London. Later, a side trip to Paris was planned. Laurence Olivier and his wife Jill Esmond were also on board.[8]

London admirers mirrored their American counterparts. "Everywhere we went, crowds followed us, flashbulbs exploded, the press kept pace." The day after

she arrived, Crawford was fêted at a special luncheon in her honor at the Savoy Hotel. Fairbanks Jr. introduced Crawford to his circle of London friends, including Ivor Novello, the Duke of Kent, and Noel Coward. One evening they attended a performance of Coward's play *Cavalcade*: "They tore my evening coat off my back and I basked in their fond attention. Noel, Douglas and a corps of bobbies carried me into the theater on their shoulders. This is the public without which an actress cannot exist, and I had a ball."[9] Once inside the theater the fans calmed down. "The audience rose to its feet," Fairbanks Jr. later recalled, "and applauded two absolutely numb and unprepared youngsters." They visited the typical tourist sites by day, and in the evening, "mingled with Mayfair's playboys and girls . . . the aristocracy . . . the plutocracy and politicians." Both Novello and Coward hosted them at their country houses. Crawford, however, became increasingly uncomfortable among the swells. When the aristocrat Margot Asquith, widow of a former British prime minister, arranged for them to attend a garden party at Buckingham Palace, Crawford refused the invitation.[10]

After two weeks in London they traveled to France where they were entertained by, among others, Maurice Chevalier. Another perk of wealth and social status was being memorialized in oil. "Billie and I had our portraits painted—two huge, larger-than-life pictures by the then most fashionable artist, the Spanish [Federico] Be[l]tran-Masses." None of this impressed Crawford although press photographs from the trip showed her seeming to enjoy the attention, and showing off the spectacular wardrobe she brought along. Fairbanks Jr. was in his element, but Crawford "hated it all."[11]

They departed Europe sooner than planned. The trip revealed the irreparable gulf that divided the couple. He thrived in the exhilarating whirl of high society, cultivated the most interesting friends, read poetry, and listened to music. Crawford pretended to enjoy the sophisticated world Fairbanks Jr. was anxious to lay at her feet. What she preferred, however, was the enthusiastic attention of her fans; they stimulated her better than any elegant soirée she might attend. Stardom had been her ultimate goal, and it provided all the assurances she required. What she wanted more than anything else was to return to the safety of the MGM cocoon. A photograph taken on the train as they arrived back home shows a beaming Crawford surrounded by her best friends, actors Billy Haines, Robert Young, Alexander Kirkland, and press agent Jerry Asher. They were her intimate circle, not the snobs she met in Europe. Fairbanks Jr. sits next to her, but he might as well not have been in the picture. He wasn't going to be for much longer.

Fairbanks Jr. had work awaiting his return, a part in *Parachute Jumper* at Warners teamed with a still largely unknown Bette Davis. Nothing was scheduled for Crawford, although in early September, *Rain* opened with its gala premiere at Grauman's Chinese Theatre, and the star attended with her husband at her side (along with pals Robert Young and Alexander Kirkland).

Crawford and Fairbanks Jr. greeted on their return from France by her pals (from left) William Haines, Robert Young, Jerry Asher, and Alexander Kirkland.

The event was shadowed by tragedy as a couple of days earlier Crawford's friend and early Hollywood confidant Paul Bern had died of a probable suicide. He had married Jean Harlow eight weeks before. Bern had commissioned from artist Alexander Ignatiev a large mural for his house depicting Hollywood luminaries seated in costume at an Elizabethan banquet. At Harlow's left, he had the artist depict Crawford, with Norma Shearer seated next around the table.[12]After her husband's death, Harlow had the mural removed.

Two months passed before a Crawford project was identified, a script based on a William Faulkner short story "Turnabout," set during World War I that did not have a central female character. Howard Hawks had signed a three-picture producing-directing deal with MGM in 1932, and he held an option on the Faulkner story that he was anxious to turn into a film. He also had an affair with Crawford back in 1925 when she was new to Hollywood. Thalberg decided "Turnabout" should be reimagined as a Crawford picture, and a committee of writers, including Faulkner, worked on a new script. Renamed *Today We Live*, the story, set in England, follows two upper-class school friends, played by Robert Young and Franchot Tone, who go off to war together. Tone was Crawford's brother, and Young her fiancé. Several leading men were considered for the third

Gary Cooper was borrowed from Paramount to costar with Crawford in *Today We Live*, 1933.

Crawford on the set of *Today We Live*, 1933, with Franchot Tone, Robert Young, and (at right) director Howard Hawks. Photo by James Manatt.

male lead including Gable, but Hawks settled on Gary Cooper, who would have to be borrowed from Paramount. Cooper asked for a $20,000 bonus and got it. He played an American who had enlisted to serve with the British, and it is his character that provides the romantic tension, finally winning Crawford's heart. Costarring Cooper and Crawford was big news for the fans, but there was little on-screen chemistry. The film received mixed reviews, did modestly at the box office, and showed a small loss, a first for a Crawford picture at MGM since she had been made a star.

"I thought some of it wasn't bad," Hawks later said, and felt his star "had her limitations. She was a personality more than an actress, and there were things she just couldn't do. How are you going to explain . . . that the addition of the biggest star in pictures is going to spoil your movie?"[13] Hawks was too harsh, not about his film, but about Crawford. Watching it we see that her role was carved out of an existing narrative. Had she and Cooper worked well together the result might have been different. *Today We Live* didn't help Cooper either, nor did his second film on loan-out to MGM the next year, another stinker named *Operator 13*, with Marion Davies. But, on a positive note, working with Clarence Sinclair Bull during that production gave Cooper the best portrait session he had over his entire career. Crawford agreed with the critics who claimed she was miscast. Tone and Young, on the other hand, were terrific. This was Tone's second film following many years

working on the stage in New York. Critics liked his performance. Crawford liked Tone; soon they began an affair that ended up in marriage.

While Crawford was traveling in Europe, one of her favorite studio allies, Hurrell, left MGM. Trouble had been in the air. Hurrell's personality was not suited for a six-day-a-week job, and he was challenged by a demand that he use photographic papers not to his liking, and a request that he reduce or eliminate the dramatic black backgrounds that he favored, and which suited many of his subjects.[14] The final straw was when he photographed Lilyan Tashman, who was working at RKO, on his day off from the studio. When Howard Strickling, head of the publicity department, confronted Hurrell about this infraction, the photographer resigned. It was not Crawford but Shearer who got Hurrell back working at MGM, but now on a contract basis. Shearer asked for his services so Strickling was forced to negotiate. "Twenty negs for two hundred dollars," Hurrell demanded. "That's highway robbery!" his former boss responded. "If that's going to break the studio, then I suggest you get someone else."[15] Hurrell won the round, and made many trips back to MGM. Crawford often requested that he visit her at home in Brentwood, and it became the site of many of her later portrait sessions.

Bull photographed Crawford in the late fall as she was getting ready to film *Today We Live*, and worked with all the film's stars in January as filming was underway. Hurrell and Crawford would join forces again for her next film, *Dancing Lady*. The remarkable collaboration witnessed in portraits from *Letty Lynton* would continue spectacularly when they met again.

The frost between Crawford and Fairbanks Jr. that was apparent before the European vacation grew stronger upon their return. They continued to share the Brentwood house but lived as though they occupied separate apartments. Crawford still made use of the Malibu cottage, sometimes for weeks at a time. When marriages end, each of the parties usually seeks to find blame in the other, and close friends often provide the incriminating evidence. Irving Asher, Phil Holmes, and Allen Vincent dropped the news about Crawford's infidelities. "For almost two years Billie had been having an intense and fully requited love affair with Clark Gable, one of our friends and frequent dinner guests." What seemed to bother Fairbanks Jr. as much as the affair itself was that a favorite trysting place was "the charmingly decorated, very comfortable portable dressing room I had given her as a wedding present—and had only recently finished paying for."[16] He was probably unaware of the new man in his wife's life.

Crawford had been carrying on discreetly, but her husband found his love life announced in newspaper headlines. "Fairbanks Jr. sued for alienation," read the bold type on March 17, 1933. "Fairbanks is accused by [Jorgen] Dietz of stealing the 'love and affection' of his wife, Mrs. Solveig Dietz."[17] Fairbanks Jr. denied the charges and responded that he was a victim of extortion. He even suggested that his dresser borrowed his car and was the actual culprit. Nevertheless, in his autobiography, he wrote that Mrs. Dietz, "had been one of the group of regular

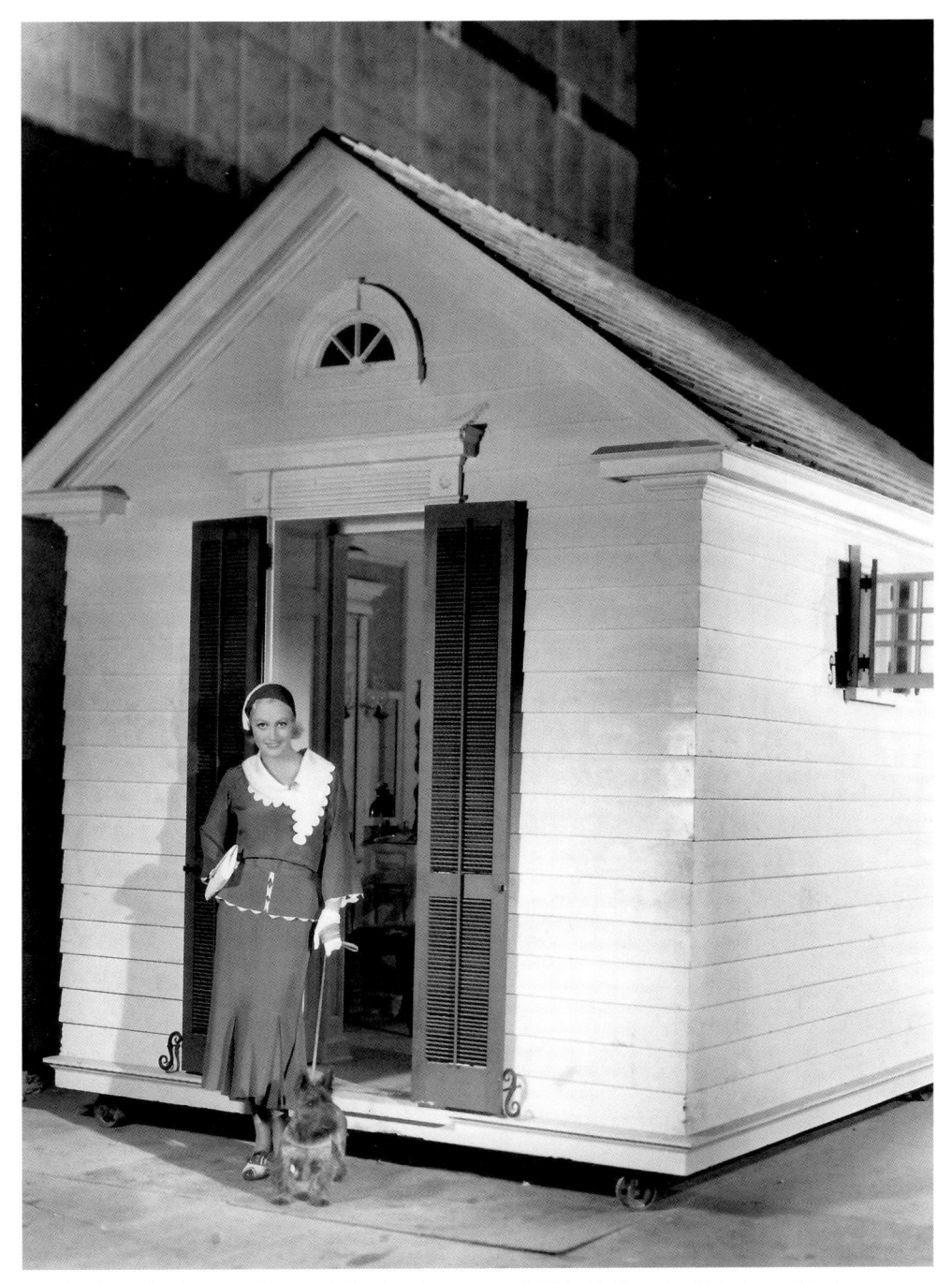

Crawford standing in front of her portable dressing room at MGM with Woggles. Both were gifts from her husband, Douglas Fairbanks Jr.

'dress extras' the studio favored for certain kinds of background atmosphere. She had been one of the more conspicuous types on the lot."[18] Solveig Dietz was not around to comment as when the lawsuit was filed she had returned home to Denmark. There was an initial flurry of press but nothing further reported suggesting that the charges were dropped, or that a settlement was reached. The bigger story dropped the next day.

Crawford was quoted that she and her husband "have discussed these flagrant charges together. It is an outrageous injustice, and there is no truth whatever in the charges."[19] Still, she knew it was time to act. Crawford hoped to manage the split in a dignified manner by giving the story to old friend Katherine Albert who had written it up for *Modern Screen*. "The Separation of Joan and Doug" would appear in the May issue, which arrived on the newsstands about April 6. With coast-to-coast headlines about Fairbanks Jr.'s purported infidelity, she needed to get ahead of her own story. Like many stars before and after, Crawford called Louella Parsons. With no time to waste, Parsons wrote up the scoop in Crawford's living room, and the next day, March 18, the news flash was carried in the *Los Angeles Examiner* (and just about every other newspaper in America). The last anyone heard from Solveig Dietz was a line published in *Time* in late March, "Mrs. Dietz in Copenhagen said Fairbanks would get a Paris divorce and marry her."[20] Crawford was granted her divorce on May 13.

$7,500 Per Week

WHILE CRAWFORD WAS MAKING *TODAY WE LIVE*, MGM WAS IN TURMOIL. Thalberg suffered a heart attack in December; in February 1933, along with his wife, Norma Shearer, he left on an extended trip to Europe to consult with German physicians and to recuperate. Just before Thalberg's illness, Mayer sprung the news that he had appointed David O. Selznick, his son-in-law, as a producer, and he would be accountable to Mayer. This appointment threatened Thalberg's authority as he relished his position as "generalissimo," overseeing a "highly diversified production cabinet."[1] He had little direct supervision over Crawford's films, but as she was one of the studio's top earners, he followed her progress through his team known inside MGM as Thalberg's "shock absorbers." Rapf also had a heart attack in 1932, and he too made a prolonged European trip that fall. His absence might have been one reason that it took so long to find a script for Crawford, and when one was identified, it turned out to be an expensive mistake. While Thalberg was in Germany, Mayer made the decision to reimagine radically the structure of MGM's senior management. He cabled Thalberg that his team was being disbanded. Two of Thalberg's top lieutenants, Larry Weingarten and Bernie Hyman, were named independent producers. So angry was Thalberg that, had he been able to break his contract, he would have left MGM.

Other factors contributed to the unrest. Franklin Roosevelt had been elected president, which troubled Mayer, a staunch Herbert Hoover supporter. There was an earthquake in Los Angeles that damaged the studio. Paul Bern had committed suicide the previous fall, which left the studio without a popular producer but also put in jeopardy the career of his wife and rising star, Jean Harlow. Garbo had left for Europe the previous summer, and although she had a secret contract to return in mid-1933, the studio would be without any Garbo revenue for eighteen months. So too was Shearer absent from filmmaking, and likewise, more than a year and a half would pass before her next film was released. The only two reliably profitable female stars were Crawford and Marie Dressler, who had scored triumphs in *Min and Bill* and *Emma*, and was named number one at the box office for 1933. The

Crawford enjoyed signing portraits for her fans. This lucky fellow received an original George Hurrell photograph taken for *Dancing Lady*, 1933.

revenue dollars generated by their films were critical to the studio's bottom line as the Depression was at last seriously affecting movie revenues.

Following big successes in *Grand Hotel* and *Letty Lynton*, Crawford's next two films hadn't done well at the box office. *Rain*, however, was United Artists' loss, and *Today We Live* nearly broke even. In the latter, fans were happy to see their favorite back playing a dignified role, and no actress ever lost ground costarring with Gary Cooper. Still, Crawford needed a hit to solidify her status and justify her hefty weekly wage. For her next film, the studio evaluated what had made Crawford a star, and packaged for her a film that looked to be a surefire winner. It was.

Dancing Lady was based on a popular novel that had come out in 1932. The title alone made it ideal for Crawford. The film was announced in January, but in March it was delayed as the script wasn't ready. *The Prizefighter and the Lady*, from an original story by Frances Marion, was on the back burner as a script earmarked for Shearer and Gable. With Shearer's long absence in Europe, and still no script for *Dancing Lady*, Crawford was substituted. Two months later, Crawford and Gable were still set to star in *The Prizefighter and the Lady*, with Josef von Sternberg directing. Gable was taking daily boxing lessons in preparation. Hunt Stromberg was producer, and he decided he needed the services of a real boxer so he hired Max Baer who had shot to international fame by defeating Max Schmeling at Yankee Stadium. Gable and Crawford were out. Baer was supported by Myrna Loy.

With David O. Selznick producing, Robert Z. Leonard directing, and Oliver T. Marsh as cinematographer, *Dancing Lady* was finally underway. The story was the tried-and-true tale of the young woman who wants to break into show business, and, after a series of mishaps becomes a Broadway star. Along with Gable the other male lead was Franchot Tone—rivals on screen, as well as in real life, for Crawford's affections. The supporting cast was worthy of the ticket price. The Three Stooges appeared as did Nelson Eddy, May Robson, and Robert Benchley. But most noteworthy was Fred Astaire in his motion picture debut. Now Crawford would have a proper partner, a Broadway star on the verge of becoming a motion picture legend. In the past she had typically been seen as the leading member of a female chorus or featured dancing the Charleston.

Dancing Lady wasn't really a musical, although it did have an extravaganza at the end. Astaire was introduced early in the film and did a brief number with Crawford. Through most of it we see the top of her head as she resorted to the bad habit of watching her feet while she danced. In the final musical spectacle, she is better, although it was choreographed such that her dancing was limited, and audiences often watched Crawford and Astaire standing as the chorus moved around them. Nelson Eddy, making his motion picture debut, has a song in the final sequence. It would take MGM eighteen months to pair him with Jeanette MacDonald. Selznick hired Astaire for two weeks of work but neglected to offer him a long-term contract. By the time Astaire got to MGM to start on *Dancing*

Fred Astaire was Crawford's partner in *Dancing Lady*, 1933, just before he moved to RKO and became a dancing legend. John Kobal Foundation.

Lady, he had signed with RKO, and before it was completed, he was at work on *Flying Down to Rio*.

It took over four months for *Dancing Lady* to be finished. Gable was ill much of the time, and on the occasions when he attempted to work in the late summer, often he found himself too weak. Selznick was prepared to replace him with Robert Montgomery, but Mayer said no. Fans were expecting a Crawford–Gable picture for Christmas, and that is what the boss intended to deliver. Crawford, too, injured her leg and that also contributed to the slow pace. Expensive stars causing months of delays pushed *Dancing Lady*'s cost to $923,000, $150,000 more than budgeted.[2]

The screenwriters calculated the fans' wishes perfectly. Crawford got to choose between two dashing men, one to the manor born, the other self-made. She sang and danced—well enough—partnered with Astaire, who seems at ease working with Crawford although her limitations are apparent. And there were comic turns (sadly not enough) from Ted Healy and the Three Stooges. A bang-up finale, populated by a large chorus and spectacular sets, was followed by a concluding short scene in which Crawford and Gable decided they were meant for each other. All of this meant almost $2,500,000 at the box office, about equaling *Grand Hotel*. Even with the production overages it brought back $750,000 in profit. Crawford was still at the top.

Crawford poses with Clark Gable for *Dancing Lady*, 1933. John Kobal Foundation.

Still at the top, yes, but her days as a dancer and singer were about over. In silent films, her infectious ebullience charmed audiences, but when movies started to talk it was apparent that her talent was sufficient to entertain, but it was not of professional caliber, as her experience with Astaire had shown. Soon professional singers and dancers would find their way to Hollywood. Astaire at RKO would set the standard for dance, and MGM was about to engage Eleanor Powell who became the decade's greatest female tap dancer. Nelson Eddy would soon be paired with Jeanette MacDonald, and real singing would be heard at the movies. It is not evident how aware Crawford was of her musical limitations, but her producers undoubtedly were, and with the exception of a song here or there, in the future music and dance would be left to others. She had demonstrated that she could hold her own against Garbo and Shearer as a dramatic actress. Over the next ten years at MGM, appearing in more than twenty films, she would solidify her position as one of the studio's and Hollywood's greatest dramatic stars.

Although Gable captured Crawford's heart at the end of *Dancing Lady*, his illness worked well for Tone who was courting her off screen. With the competition sidelined, Tone could claim the position of official suitor. And, as Gable was married, happily or not, it was difficult for him to make demands on Crawford's time. In the Gable–Tone competition, Crawford had made her choice. "Much as I cared for Clark, the deep conviction that it could last was lacking with me."[3]

"Franchot," on the other hand, had caught her eye; he "was of a different fiber from anyone in Hollywood. He'd been to the manor born . . . the son of society . . . of wealth . . . he'd been graduated from Cornell with a Phi Beta Kappa key . . . and he had and has a truly golden talent."[4] Surprising that she described him as "different," for aside from the college degree, he sounds like her first husband. Whether it was Mike Cudahy, Fairbanks Jr., or now Franchot Tone, Crawford was attracted to men who came from wealth and privilege. Cudahy had the most money, Fairbanks Jr., had impeccable connections to Hollywood and international society, and Tone was the best educated with the manners of the East Coast elite. She may have been in love with Gable, but given the sort of men she married, he was an unlikely candidate.

Before coming to MGM, Tone had been a member of New York's Group Theatre. He planned to travel east for the opening night of an upcoming production, *Men in White*, in which Crawford's old friend Alexander Kirkland had a part. Since it coincided with the New York opening of *Dancing Lady*, Crawford agreed to accompany him. It would also be an opportunity to meet Tone's parents who came down from Niagara Falls to meet their son's new flame. Tone also wanted to introduce Crawford to his New York theater friends as he hoped to convince her to appear on stage and radio.

Fan magazines were in a quandary about what to do about Crawford's on/ off screen love lives. Should portraits be published of Crawford and Gable, or Crawford and Tone? The admirers may have preferred Crawford and Gable, but, if she was considering marrying her new leading man, publishers needed to be ready. MGM's publicity department saw to it that the portraits distributed to the magazines and newspapers split evenly—plenty pairing her with Gable and lots with Tone.

Crawford requested that Hurrell make those portraits. For *Possessed* in 1931, and *Letty Lynton* the next year, most of his worked focused on Crawford alone. This changed for *Dancing Lady*, and she posed extensively (in separate sessions) with Tone and Gable, as well as working alone with Hurrell. They would continue their collaboration, and have many more excellent sessions, but he would never better the work he did for *Possessed*, *Letty Lynton*, and *Dancing Lady*. These remain signal examples of the finest Hollywood portraits, and remain the bedrock of Crawford's glamorous persona almost a century later.

Few of us get to be our own Pygmalion, and for those who have managed to do so, none have done it better than Crawford. By the time of the release of *Dancing Lady*, the creation of "Joan Crawford" was completed, the image and screen persona were fixed, and she would rigorously adhere to her invention for the balance of her career and life. On screen, she could be a working-class young woman who makes her way up in the world or the wealthy heiress who confronts a series of problems before ending up with the right man. Her films had to be romances, typically with two or more contenders for her hand. There was always a happy

On a warn day in 1928 some of Crawford's best friends gathered on a boat for a picture. From left: Tommy Shugrue, Larry Barbier, Fay Webb, the boat's captain, Gwen Lee, and still photographer William Grimes.

ending, and she had to be spectacularly gowned. The formula was working well, and neither Crawford nor her studio was going to jinx success.

Having achieved stardom Crawford embarked on a quiet mission of charity that she continued for decades. In the days before health insurance, working- and middle-class folks were often unable to afford health care, especially hospital care. One of Crawford's closest friends since her earliest day at MGM was Tommy Shugrue, who worked for the studio's publicity department as an electrician and general handyman. He was a former vaudeville dancer, and practiced with Crawford before her first screen test at the studio. Later, she arranged a small part for him in *Dance, Fools, Dance*. When she named her ten best friends in 1934, he was on the list.[5] He became ill, and she paid his hospital bills. Shugrue died in January 1934. "The doctor did everything he could but he couldn't save Tommy."[6] From that time forward, Crawford maintained "two rooms at the Hollywood Hospital all year around—mostly for use by those she sees through their illnesses."[7] She worked in partnership with Dr. William Branch, who "donates his services; Joan pays all the hospital expense."[8] She also paid to educate children, some of whom don't seem to have had a significant connection to the actress. "The Donaldson boys," wrote a columnist in *Hollywood Reporter* in 1934, "being educated by Joan Crawford, have finished junior college—and will be at U.S.C. in the fall."[9]

In June 1934, Crawford joined the Screen Actors Guild (SAG). The organization had been formed the year before to represent the interest of actors, including negotiating the previously unregulated number of hours in a workday, and challenging the salary cuts that were industry-wide during the Depression. For the guild's Second Annual Ball in November, Crawford was a member of the supper committee. At the gala, Crawford, wearing a "sequined cocktail jacket" that was described as "spectacular," joined the grand march alongside her new beau Franchot Tone.[10]

That year she made three films in quick succession: *Sadie McKee*, *Chained*, and *Forsaking All Others*. In the first two she played working women who through determination ascend socially. *Forsaking All Others* casts Crawford as a member of the upper class whose strife is being pursued by Robert Montgomery and Gable. A small circle of leading men was circulating through her films—Montgomery (*Forsaking All Others*), Tone (*Sadie McKee*), and Gable (*Chained*, *Forsaking All Others*)—but audiences like her best when partnering with Gable. *Sadie McKee* and *Chained* told basically the same story. Crawford marries a wealthy older man out of devotion, not love, but then the decent older fellow sees what is going on and releases her to find true love and happiness. *Forsaking All Others*, which should be counted among the best and earliest screwball comedies, shows Crawford chasing the caddish Montgomery for most of the film before realizing, in the final moments, that Gable has been patiently waiting for her all along. Playing the courteous gentleman was a slight departure from Gable's usual characterizations, and he plays a type that Cary Grant would perfect during the 1930s.

The Motion Picture Production Code was finally enforced in 1934. Crawford took on the censors by playing Sadie McKee as a virtuous woman who happened to be unmarried and staying with her boyfriend in a rooming house bedsit. And, after all, she intended to get married. Later, she does marry a nice (older, wealthy) drunk, whose life she saves by getting him on the wagon. Leaving him, with no hard feelings on either side, she pursues her first love who is now dying of tuberculous. After his death, she ends up with Tone, who, also, has been patiently waiting for her all along. *Sadie McKee* is a good movie, but it is packaged with such moral righteousness that it is deprived of much of its fun. Esther Ralston, playing a small role of a nightclub singer, gets all the daring lines and abbreviated clothing, the sort of part that Crawford might have been assigned in the 1920s. *Chained* has little sex to worry about, and the adultery with an older man is taken care of when they marry. After another happy divorce, she gets the man of her dreams, and going off into the Argentine sunset with Gable was all the sex Crawford's fans needed.

Part of the fun of viewing screwball comedies today is observing how writers substituted humor for sex. *Forsaking All Others* opens with Crawford, her face lathered in cold cream, getting an intense massage in her bedroom. Soon the room is populated by her friends, including Billie Burke and Rosalind Russell, and her

Crawford watches the filming of a dramatic scene from *Sadie McKee*, 1934. From left: Edward Arnold, director Clarence Brown, and cinematographer Oliver T. Marsh. Photo by Frank Tanner. John Kobal Foundation.

groom-to-be, Robert Montgomery, shaking a silver cocktail shaker. Bedrooms might be off limits for sex, but not for comedy. Chaste Crawford and Gable circle the others who jump in and out of matrimony while biding time for the inevitable conclusion. Audience response was enthusiastic, and the film not only took in over $2 million in ticket sales, but gave MGM a profit of more than a million, the first of Crawford's films to break that barrier.

Contract renewal came at the end of the year, and Crawford was rewarded for all the revenue she registered at the box office with a three-year deal, beginning in December 1934, that raised her pay to $7,500 per week based on a forty-four-week working schedule. The following year her salary would jump to $8,500, and in 1937 would cap at $9,500 weekly. She was expected to make three films a year, and if she managed to make ten in thirty-six months, a bonus of $50,000 would be paid.[11] This put her near the top of star salaries. Garbo remained untouchable at the summit and, beginning in 1933, she made only a single film a year and collected $250,000 for her trouble based on a twelve-week shooting schedule. Overtime typically brought Garbo's pay to something closer to $400,000 a film. Crawford would be getting $330,000 a year but that worked out to $110,000 per film (in the third year the total would be $418,000 or almost $140,000 per film).

Crawford and Clark Gable in a clinch for *Chained*, 1934. Photo attributed to Frank Tanner.

She was allowed a voice about her upcoming films, but, unlike Garbo who could veto projects she didn't like, the final decision on scripts was Mayer's alone.

Clarence Brown directed *Sadie McKee* and *Chained*, and Woody Van Dyke directed *Forsaking All Others*, but it had gotten to the point with Crawford's films that the director was largely irrelevant, or at least they were interchangeable as her films seemed to be produced on an assembly line. In fact, Van Dyke was called off *Forsaking All Others* just before it was completed to start work on a new version of *Rose-Marie*. Jack Conway stepped in to finish up. MGM was a studio that insisted on a corporate brand rather than allowing director personalities to dominate. What MGM was selling, and the public greedily consuming, was Crawford, Garbo or Shearer, not Brown, Van Dyke, or Hawks. The essential elements for Crawford's films were sympathetic cinematographers such as Oliver T. Marsh or George Fosley—along with Adrian, (preferably) Gable, and a continuing supply of new portraits (preferably) taken by Hurrell.

It was those portraits that continually reinforced the Crawford brand between her pictures. When her first film made under the new contract, *No More Ladies*, was about to open in the summer of 1935, almost every fan magazine ran a full-page photograph of Crawford modeling one of the spectacular outfits worn by

her character. Only fans counted. Critics mattered almost as little as directors; what could they write that would make a difference? "Again Joan Crawford plays her familiar role, again the minority who think her capable of a new one are overwhelmed by demand of the majority," opined Norbert Lusk for *Picture-Play*. "Her pictures are standardized and apparently incapable of variation." With her million-dollar deal—and Mayer hoping to realize another $2 or $3 million in profits after paying her salary and accounting for all the costs to make Crawford films—they were disinclined to take risks with new projects. Lusk hoped otherwise, and understood that fickle audiences would make the ultimate decision. "Miss Crawford has outgrown this glittering, superficial stuff. When will her public do likewise?"[12]

Garbo successfully took on the studio in the late 1920s and demanded better roles. Before leaving for her year-long vacation in Sweden in mid-1932, she completed *As You Desire Me*, based on a Pirandello play. Her first film back at the studio was *Queen Christina*, and that was followed by *The Painted Veil* taken from a W. Somerset Maugham story, and then *Anna Karenina* and *Camille*. Shearer was making *The Barretts of Wimpole Street* and *Romeo and Juliet*. Hearst, furious that Marion Davies was overlooked for all the good scripts, moved Cosmopolitan Pictures to Warner Bros. in 1934. Crawford was floating through light romances that were box-office winners but contributed nothing to her reputation as an actress. Her excellent work in *Grand Hotel*—and, whether she recognized it or not, in *Rain*—demonstrated her dramatic ability, but Mayer preferred to keep her as a profitable clothes horse.

That's what she was in *No More Ladies*, and once again she flitted between Montgomery and Tone. Montgomery shared above-the-title credit, so it was inevitable that he would win her in the end. *Modern Screen* called it a "Three-Corner Romance," and *Photoplay*, "Threes a Crowd"—quips for a hackneyed movie. But how could the studio argue with success? Crawford's films in the 1930s were like the novels by Danielle Steele: predictable entertainment that asked little of readers (or, in Crawford's case, moviegoers). Edward Griffith directed most of the film but he became ill with pneumonia late in the production. George Cukor was brought in to shoot retakes. "Did I get it?" she asked Cukor after completing a scene. "You've remembered the words," he replied, "let's put some meaning into them."[13] As Crawford always strived to improve, she took Cukor's suggestions. They became lifelong friends, and later he directed two of her best remembered films, *The Women* and *A Woman's Face*.

The producers and screenwriters changed tack for Crawford's second movie for 1935, *I Live My Life*. This time she would portray a wealthy young woman who falls for a fellow played not by Tone, Montgomery, or Gable, but Brian Aherne. Aherne was a British stage actor who had worked on Broadway with Katherine Cornell, and in pictures with Helen Hayes in *What Every Woman Knows* and Marlene Dietrich in *Song of Songs*. And the "other man" in the love triangle—there's

always one in Crawford's pictures—was an off-screen fiancé who was dispatched quickly. Aherne plays an archeologist who Crawford met on a vacation in Greece. The rocky California coast line populated with papier-mâché columns made for a convincing Aegean landscape. She wants him to give up his career and live with her in New York where he can assume the life of a lazy, well-paid executive in her family's business empire. The romantic tension is whether he will give up his academic ambitions for her, or will she give up nothing for him. In an ending that anticipates the sort of antics that became a mainstay of Preston Sturges's films, the two negotiate a future together. It is worth watching *I Live My Life* for the sterling comic performances of four character actors: Jesse Ralph, Frank Morgan, Eric Blore, and Arthur Treacher.

As soon as Crawford completed *I Live My Life*, and Tone, *Mutiny on the Bounty*, which were filmed at MGM simultaneously, the pair departed for New York. Commotion followed the couple wherever they went in New York. The press demanded to know if they were engaged or already married. Out on the town, the "film couple nearly broke up a performance of *Children's Hour* when the audience demanded they take a bow. In other theatres crowds have jammed the lobbies to see them at intermission making it difficult to seat patrons at curtain time."[14] They attended the premiere of Warner Bros.' *Midsummer's Night Dream*, which even by New York standards was a momentous event. "When Miss Crawford and Tone drove up, the crowds broke the windows in their car." After the film concluded, they were asked to remain in one of the theatre's offices until the crowd thinned.[15]

Tone might always have had second billing to Gable and Montgomery, but he won her off-screen. While Crawford told reporters after her divorce from Fairbanks Jr. that she was finished with marriage and claimed that actresses should not wed, it was only a matter of time before they stood before a judge as they did on October 11, 1935, in Englewood Cliffs, New Jersey, a quick drive from New York City across the George Washington Bridge. Nicholas Schenck, who made the arrangements for the secret nuptial, was one of the witnesses. They managed to keep their marriage from the public for three days before calling a press conference at their suite at the Waldorf Astoria. Tone's parents came down from Niagara to celebrate with the newlyweds. After a month's vacation in New York they returned to Hollywood.

Although Crawford had agreed to three films a year, only two were made in 1935. Others were announced: *The Sport of Queens*, from a script by Anita Loos, and *Elegance*, a musical to have costarred Broadway actor Clifton Webb with Tone in a supporting role.[16] As it was the studio and not Crawford that wasn't able to move forward with a third film, she was paid her full salary. The two pictures she made, *No More Ladies* and *I Live My Life*, generated over a half-a-million dollars in profit so she remained a good value.

In 1936, Crawford began working with Joseph Mankiewicz, a writer who that year was elevated to producer. Although Irving Thalberg is often called Hollywood's boy wonder, Mankiewicz was another relative youngster, only twenty-eight

when he produced the first of seven Crawford pictures. *The Gorgeous Hussy* was their first collaboration. It was the same old Crawford story but with entirely new packaging. It would be her first historical drama since the silent films *Winners of the Wilderness* and *Dream of Love*. Set in Washington, DC, in the early nineteenth century, it is a fictionalized account of the "Petticoat Affair," a scandal in which a woman with a past, Peggy O'Neal, marries John Eaton, a United States senator who later joins President Andrew Jackson's cabinet. Mankiewicz, director Clarence Brown, and Crawford all agreed it was time to forego asking Crawford to portray another contemporary woman, chicly coiffed and dressed, in favor of her playing a saloon-keeper's daughter wearing old-fashioned gowns and curly haired wigs. She was sensitive to the criticism that her previous roles were similar, and wanted to try something different. After all, Garbo and Shearer were successful in historical dramas.

Perks of movie stardom may be as rich and varied as the imagination allows. In lieu of a typical dressing room, Crawford ordered "a perfect facsimile of a New England house . . . complete with a picket fence, grass mats and a steeply sloping roof." On the first day of shooting, cast and crew were called to the set to witness Crawford making "a grand entrance in costume through one of the doors." Melvyn Douglas recalled that he was greeted "in a gracious and distinctly southern manner, less as if I was a fellow player than a guest in her home."[17]

Even without custom designed dressing rooms, this genre is expensive to produce. *The Gorgeous Hussy* was no exception, costing over a million dollars, about double the average cost of recent Crawford films. Along with the elaborate period sets and costumes, it was populated by a large supporting cast headed by Crawford's costar Robert Taylor. Typically Crawford's films had two competing love interests, but this time, in addition to Taylor, she was wooed by Melvyn Douglas, James Stewart, Franchot Tone (playing Eaton), and even Lionel Barrymore (playing Jackson). Adrian designed period-style outfits that did little to flatter Crawford. Unlike Garbo and Shearer who could rotate easily between contemporary and historical dramas, and wear the requisite gowns with ease, Crawford seems out of place portraying Peggy O'Neal. As a jazz baby or an art deco totem, she had no equal on screen. And, after all her experience of playing self-sufficient and independent women, when she took a crack at a nineteenth-century figure, she lost her courage and gave fans plenty of gorgeous but hardly any hussy.

Given the connection to American politics, MGM decided to premiere the film in Washington, DC. "Society editors and Washington social registerites evidenced more excitement and interest in regard to the premiere than any previous cinema event ever held in the capital." Even without the stars appearing in person, "so many Washington officials requested seats for the opening that the management was forced . . . to show the picture twice in succession, at 8:30 P.M. and at midnight."[18] Critics were kind, and the film did brisk box-office business, taking in over $2 million, but the high front-end costs kept profits modest in the end returning slightly over $100,000.

Crawford was happy with her performance and felt it gave her "another big boost in dramatic prestige."[19] But the production was marred by dissent from one cast member, Tone. "He really objected violently to having to do it," wrote a columnist for *Picture-Play*.[20] Crawford claimed he hated the role in part because it was too small. He would show up on the set late, and sometimes not come home in the evening. He may also have bristled at being overshadowed by Taylor and Douglas. Though Tone relished being married to the glamorous actress, and enjoyed perks and the salary MGM paid him as a leading man, he nevertheless resented Hollywood, considering himself primarily a stage actor. "It was the breaking point in his career and the breaking point in our marriage."[21]

Tone may well have been aggravated by the studio's decision to cast him in *The Gorgeous Hussy*, but it was a plum part in a prestigious film. His ego might have swelled a bit when he discovered before filming began that he had been nominated for a Best Actor Academy Award for his performance in *Mutiny on the Bounty*; costars Charles Laughton and Clark Gable also were nominated (Victor McLaglen won for *The Informer*). With this accolade, he may have expected a better selection of roles, but soon discovered that under the studio system an actor took what he was assigned or risked suspension. Though tensions on the set were a first sign that the Tones' marriage was in trouble, in fact he was thriving professionally—not as a star, but as a leading man often working in top productions. Mayer rewarded him for his Oscar nomination by granting him over-the-title credit in several lesser films he made in the late 1930s. He may have wished to be credited alongside his wife but, as she was a star of the highest order, those precious slots were saved for the likes of Montgomery and Gable.

Two weeks after *The Gorgeous Hussy* premiered in Washington, Irving Thalberg died at home in Los Angeles on September 14, 1936, of the heart condition that had plagued him all his life. Although he had taken little active role in promoting Crawford's career—that was left to Rapf and Mayer—his sudden death was felt throughout the studio. Mayer had insured, expecting the inevitable, that business would continue. Already a new generation of producers were claiming top properties, as witnessed by the elevation of Mankiewicz, and he would guide Crawford though most of the films she made during her later years at MGM. Crawford's tenure mirrored but for eight months the history of the studio. Starting at the bottom she prevailed against impossible odds, proved Rapf right, endured the transition from silents to talkies, and in 1936 was MGM's most profitable female star. The death of Thalberg may not have changed the day-to-day operation at MGM but it symbolized the end of the first great era of the studio's history. Crawford believed *The Gorgeous Hussy* to be a high water mark in her career. Would she continue to thrive within Mayer's new regime as she entered middle age and a new generation of youthful, ambitious Lucile Le Sueurs sought her place and her fame?

George Hurrell, Joan Crawford, circa 1932. John Kobal Foundation.

Ruth Harriet Louise, Joan Crawford, 1927.

Ruth Harriet Louise, Crawford in a costume for the Christmas holiday, 1927.

Joan Crawford and Robert Montgomery on the cover *True Romances*, October 1932. The painting is derived from a portrait taken by Ruth Harriet Louise in 1929.

Poster for *Grand Hotel*, 1932.

Clarence Sinclair Bull, Joan Crawford, circa 1933.

George Hurrell, Joan Crawford, and Clark Gable for *Possessed*, 1932.

Clarence Sinclair Bull, *Joan Crawford*, 1933. The label on the back of the photo describes this Adrian design as black velvet with white accordion pleating of white organdie forming a ruffle trimming.

Frank Tanner, Joan Crawford for *Forsaking All Others*, 1934.

Clarence Sinclair Bull, Joan Crawford, 1931.

George Hurrell, Joan Crawford, 1930.

Clarence Sinclair Bull, Joan Crawford, 1932.

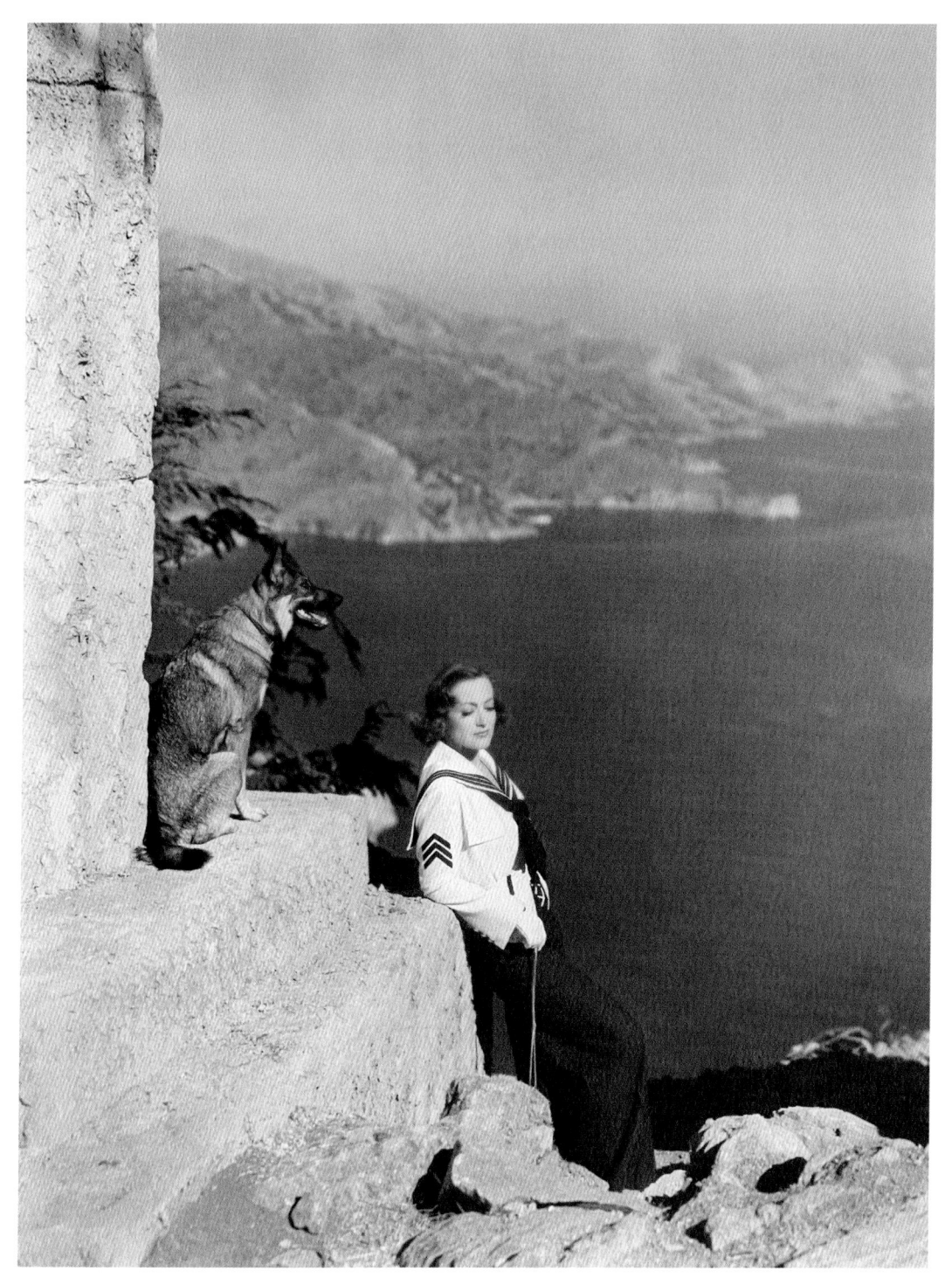

Frank Tanner, Joan Crawford for *I Live My Life*, 1935.

movie MIRROR

APRIL

10¢

A MACFADDEN PUBLICATION

JOAN CRAWFORD

The REAL REASON WHY Ross Alexander KILLED HIMSELF

Joan Crawford photographed in color by James N. Doolittle for the cover of *Movie Mirror*, April 1937.

Natural color photograph
by PAUL HESSE—Hollywood

To Maybelline —
The eye make-up
I would never be
without —
Sincerely
Joan Crawford

Crawford photographed in color by Paul Hesse for an advertisement for Maybelline (back cover of *Modern Screen*, January 1946).

Laszlo Willinger, Joan Crawford for *The Women*, 1939. John Kobal Foundation.

Queen of the Movies

CRAWFORD WAS AT HER ZENITH. POPULAR WITH HER BOSSES, IN THE three years from *Dancing Lady* (1933) to *The Gorgeous Hussy* (1936), her films brought $3,500,000 in profit to MGM. Reviews didn't matter as, for the moment, she was largely immune from critical judgment. Banal films were fine as long as they produced lines at box offices across the country and featured her in beautiful dresses. *Motion Picture* called her "the most-copied girl in the world."[1] Earning more than $300,000 annually, she was able to live like a movie star in her Brentwood home, expanding, updating, and re-furnishing it as her mood changed, Spanish-style one year, colonial the next. Old friend Billy Haines, now one of Los Angeles's premier decorators, was always available to assist his first and most loyal client. Her house boasted a magnificent swimming pool, a movie theater, and a staff of servants. When not working, the couple entertained lavishly, sumptuous intimate dinners for twelve, or large parties populated by Hollywood's brightest stars: "We had a cook, butler and upstairs maid and could accommodate forty for a buffet dinner, or even more for a garden buffet."[2] Keeping Crawford and Tone company were three dachshunds.

Thinking back to the evenings when her former in-laws hosted gala parties honoring notable visitors, Crawford decided to plant her stake on the Hollywood social scene. When conductor Leopold Stokowski came to town to star as himself in Paramount's *The Big Broadcast of 1937*, Crawford decided to host a welcoming party at the Ambassador Hotel. On the first Sunday in March 1936, at 4 p.m. sharp, 200 guests began arriving to meet the famed musician. Wearing a navy-colored suit and a matching wide brimmed hat, Crawford, with Tone standing at her side, greeted each guest and made introductions. As she had not met Stokowski before, this scheme seems as much a social ploy as an opportunity to ingratiate herself to the famous classical musician at the moment when she was thinking that her voice might be suitable for an operatic career. Costars such as Robert Montgomery and Jimmy Stewart attended, along with friends Claudette Colbert and Adrian. Louis B. Mayer was among the guests as was Dorothy Arzner. Given Crawford's

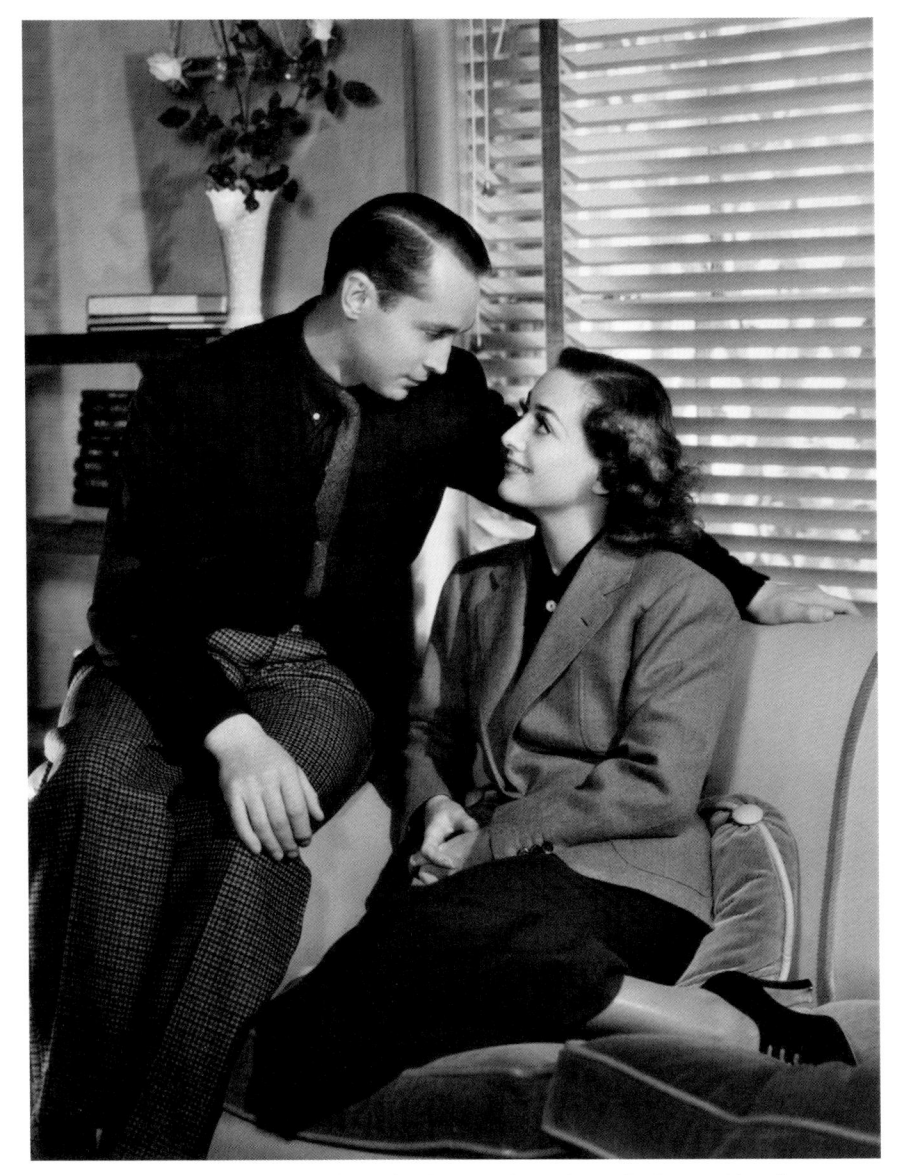

Crawford and her second husband Franchot Tone posing at home for George Hurrell, 1937.

new enthusiasm for classical music, the most notable among those invited was Madame Ernestine Schumann-Heink, the legendary contralto.

Tone encouraged his wife to consider a theatrical career. He was never happy working in the movies although he enjoyed the reliable paycheck and his wife's fame. Crawford spoke often about her ambition to appear on stage, perhaps an honest goal, or more likely an attempt to mollify her husband. More interested in music, Crawford vigorously studied singing throughout 1935 and 1936 with Otto Mormando, a European tenor and Hollywood's best regarded classical vocal coach.

Lessons lasted two hours each day, even when she was working, which sometimes had Mormando coming to her house at midnight, she told a reporter.[3] During her house redecoration in 1935, Haines added a music room. There is plenty of evidence to the quality of her voice as she sang in many of her pictures. It was light and pleasing, but never suggests suitability for a professional singing career. For a moment, teachers and friends supported the fantasy, and "fortunate" guests were treated to at home musicales. "Piece-de-resistance of the entertainment Joan and hubby provided at their parties is usually either a solo by either, or a duet by both and invariably grand opera."[4] Crawford may have approached singing with the same determination she had used to build her motion picture career, but in the end it was in vain. MGM was determined to have a brilliant musical star and found one in Jeanette MacDonald. MacDonald had a smash hit *Naughty Marietta* in 1935, her first teaming with Nelson Eddy. Did Crawford imagine she could compete with MacDonald much less find a place on the opera stage? She was fortunate to avoid the sort of humiliation that Orson Welles savagely described in *Citizen Kane*. Even stronger than Crawford's will to master this new endeavor was her razor-sharp calculation as how best to present herself to the public.

Crawford never acted on stage with Tone or anyone else. And, all those singing lessons were for naught. But she did perform on the radio. "To anyone who had known me," Crawford later wrote, "the fact that I was going to appear on radio was a dead giveaway that I was completely under Franchot's spell."[5] One of the most popular radio programs of the thirties was the *Lux Radio Theater*, sponsored by Lever Brothers to promote their soap. The *Lux* programs debuted in the summer of 1935, were broadcast live from New York City, and ran sixty minutes. Each week a different radio play was prepared with a leading stage or screen performer as the draw. $5,000 was the star's pay which wasn't bad for an hour's work. Crawford made her radio debut for *Lux* in *Within the Law*, the story behind the film she had made back in 1930 as *Paid*. Her leading man was not Tone but Raymond Bramley, once a well-known Broadway actor. With most famous names now based in Los Angeles, in the spring of 1936 Lever moved the program to Hollywood and engaged Cecil B. De Mille as the weekly host. In July 1936, Crawford and Tone appeared together in *Chained*, based on the film she had made two years earlier with Gable. Tone took Gable's part. Their second *Lux* program was the next year, *Mary of Scotland*, along with Judith Anderson. Crawford and Tone also performed a skit on the *Shell Chateau*. *Shell Chateau*, sponsored by the oil company, was a variety show produced in New York that ran for two years in the mid-1930s. Crawford and Tone selected a scene from *Let Us Be Gay*, taken from a London play starring Tallulah Bankhead that was made as a MGM film with Norma Shearer.[6]

Once Tone had convinced Crawford to appear on radio, he set out to persuade her to act on the stage. While in New York he arranged dinner with Alfred Lunt and Lynn Fontaine. "Seeing how happy they were," Crawford wrote, "I was ready

to believe two careers could blend."[6] If MGM would not make him a screen star, Tone intended that the couple could conquer the stage together becoming a youthful version of Lunt and Fontaine.

Movies always came first, and whatever other professional dreams she harbored, when the bell sounded to start a new film project she gave all her attention to preparing for the role. To the delight of fans, in late 1936, a new Crawford–Gable picture opened at theaters. *Love on the Run* was a screwball comedy about a runaway heiress being pursued by rival reporters. Tone again competed for Crawford's affections but, as always, lost out to the more famous star. It was a huge success and one of her most profitable pictures. But, it was not a film first intended for Crawford, and its path forward demonstrates that although she was a star of the top echelon and a steadfast moneymaker, she never had Shearer's or Garbo's clout over selecting scripts. Shearer and Garbo were the product of judiciously developed and unique screen images. Although fans might have disagreed, her employers felt that of the three Crawford had the least defined screen persona, and she was always considered by the top brass a notch below her two MGM rivals. This was most evident in the scripts selected. No one but Garbo was going to play Queen Christina or Anna Karenina; only Norma Shearer would portray Elizabeth Barrett Browning and Marie Antoinette.

Like so many Crawford properties, *Love on the Run* began its life as a story in *Cosmopolitan Magazine*. MGM bought the property, and in February 1936, announced it as an upcoming vehicle for Robert Montgomery and Myrna Loy. In June, the trade papers reported a cast change and now it would to star Montgomery with Jean Harlow. By August Crawford was in, but she was to work with Robert Taylor and Robert Young. Later in the month, the final cast was set: Crawford would costar with Gable (above the title) and Tone (below). Mayer and his producers regarded Loy, Harlow, and Crawford as interchangeable. Assignments were made as much to conform with schedules as to fit an actress's personality. Looking back almost ninety years, it is hard to imagine that Crawford and Harlow were at one time considered for many of the same parts. Harlow's last film, *Saratoga*, filmed in early 1937, had been slated for Crawford, but two Crawford–Gable pictures in a row would have been a poor marketing strategy for the studio, so Harlow got the part. For the same reason, Crawford was removed from *Parnell* with Gable, which she had been scheduled to film following *Love on the Run*. The role went to Loy.

Joseph Mankiewicz produced *Love on the Run* as he had *The Gorgeous Hussy* earlier in 1936. Woody Van Dyke directed for eighteen days, but was called off to shoot *After the Thin Man*, the second film in the popular series. Clarence Brown stepped in, and although Van Dyke received directing credit, most of the film presumably was the work of Brown. "That was a sporting gesture on the part of 'Woody' Van Dyke for unstintingly giving credit to Clarence Brown for what he did for 'Love on the Run,'" wrote a columnist for *Film Daily*, "no one outside

At Franchot Tone's urging, Crawford appeared on radio several times during the mid-1930s.

Franchot Tone and Clark Gable competed for Crawford's affections both on-screen and off. In *Love on the Run*, 1936, Gable seems to be winning, but off-screen she married Tone. The woman is Mona Barrie.

Hollywood would ever have known of Brown's contribution, since he declined to take any credit on the screen."[7]

Crawford, Gable, and Tone gave audiences a fast-paced caper that borrowed from other popular films, including *It Happened One Night*. Crawford bolts from the altar on the run from the prospect of a bad marriage, and newsmen Gable and Tone are in pursuit after her story. If Tone had been annoyed by his part in *The Gorgeous Hussy*, he should have been furious with his role in the next film. Playing Clark Gable's rival mustn't have been easy for any actor, but here the script so favored Gable that Tone often comes off as a buffoon. Comedic scenes such as Tone being tied up, or dressed in frivolous eighteenth-century costumes, seem today a little embarrassing for the husband of the star. Better comedy comes from Donald Meek, a character actor in a small role who steals his scenes. Overall, the action is lively, and even without scarcely an original moment, *Love on the Run* continues to entertain. Critics yawned, but the public was satisfied, and after all the expenses were accounted for, it brought MGM another $677,000 in profit.

After two films together, Mankiewicz and Crawford's professional relationship turned intimate. "I was madly in love with him and it was lovely. . . . He gave me

such a feeling of security I felt I could do anything in the world. . . . He relaxed me, teaching me to have fun in my work."[8] Born in 1909, he was four years younger than Crawford, but "both allowed Joe to play Pygmalion, a role he relished."[9] Of his time with Crawford, Mankiewicz recalled, "You'd have to watch the way she came in. If Joan was wearing a pair of slacks, that meant you'd go over and slap her right on the ass . . . she'd be as raucous as Billie Cassin." On the other hand, if she came "back the next day wearing black sables and incredible sapphires . . . you'd better be on your feet and click your heels, kiss her hand, and talk with the best British accent you had." Those were but two of her interchangeable personas; another day she might "come in in a dirndl or pinafore, and you'd be on the floor playing jacks with her." And what did the young beau think of this capricious behavior? "I loved it."[10]

It was not Mankiewicz but Lawrence Weingarten who produced her next film, *The Last of Mrs. Cheyney*. First made in 1929 with Norma Shearer as her second talkie, the new version was intended for Myna Loy, but when she was substituted for Crawford in *Parnell*, Crawford took over. The story is similar to *Paid* in that both feature Crawford as a thief working with her posse of crooks. This time she plans to steal a magnificent pearl necklace during a weekend stay at a grand English country house. In *Paid*, she convincingly played a gangster masterminding criminal activity. Six years later, she seems unable to break free from the elegant lady mold. It works fine at the beginning of the film as she ingratiates herself with the upper crust, but her character rings false when she negotiates the jewel heist with her gang. Maybe Loy would have been the better choice. An underused William Powell plays one of her accomplices, and Robert Montgomery is cast as an aristocrat who falls for Crawford and then tries to blackmail her into a sexual relationship, and in a weird twist, ends up proposing marriage in the final fadeout. *The Last of Mrs. Cheyney* has plenty of sexual innuendo, especially for a film made under the constraints of the Production Code, but instead of being adult and provocative, it plays as sophomoric and coarse. The director, Richard Boleslawski, died before he completed the film and was replaced by George Fitzmaurice; he didn't last long, and it was Dorothy Arzner who finished the film. She had recently completed *Craig's Wife* for Columbia and was scheduled to direct Luise Rainer under Mankiewicz's supervision. Knowing that Arzner was available and about to begin work at MGM, Mankiewicz suggested she complete the Crawford picture.

The Last of Mrs. Cheyney did almost the same box office as *Love on the Run*— the Crawford fans remained a faithful and consistent community—and, as it cost a little more to make, it returned a bit less to MGM, but still showed a profit of $460,000. Since she had been anointed a star in 1929 only one of Crawford's films for MGM had lost money (and it was a tiny loss). Underscoring her lofty position, *Life* gave the film and the star a big push in March 1937. One page is given to nine descriptive frames recording the film's principal narrative. Over two

pages, the Tones are shown at home in Brentwood with their three dachshunds. A magnificent almost full-page portrait by Martin Munkásci is captioned: "By the almighty standard of the box-office, [Crawford] is the first queen of the movies."[11]

"'Once There Was A Lady,' an adaption of the Ferenc Molnar stage play, 'The Girl from Trieste' will be Luise Rainer's next production at Metro," *Variety* reported in February 1937.[12] That month Rainer received an Academy Award nomination for her work in *The Great Ziegfeld* (she would win). Bolstered by this accolade, and not liking the script, she asked to be taken off the film. When Crawford expressed interest in the part, Mankiewicz cast her instead. Swapping roles with Loy and Harlow was one thing, but with Rainer was something else. Austrian-born Rainer had a quiet, introspective personality. She made a big splash at MGM for a few years in the mid-1930s, making eight films most notably *The Good Earth*. She and Crawford were nothing alike. Molnar's play was set in middle Europe, and told the story of Jessie, a prostitute who captures the attention of an aristocrat who believes, with a new name, proper clothing, and introductions, he can pass her off as a lady. The film was re-drawn for Crawford. Instead of a prostitute, Jessie was now a café singer working in the "lowest dive in Trieste." This gave her the chance to sing a few bars, revealing that all those lessons had not helped with her upper range. This sounds like a better role for Crawford than Rainer—another version of rags to riches—and it might have succeeded had the locations been changed to Atlantic City with Crawford heading to Newport, instead of beginning in Trieste and moving to a swank mountain top resort in the Tirol. Crawford had so wholly come to define American brash, smart and chic, that she was unable to play the part as written. Rather than being outgunned by the European swells, she comes off as confident and should, by the sheer force of her will, be able to take her place among their ranks.

Arzner was retained as director even with the shift in star. No problems between director and star were reported on the set of *The Last of Mrs. Cheyney*, but on the next film the two didn't get along. "By the end of filming," wrote Crawford biographer Bob Thomas, "Crawford and Arzner communicated only through written messages carried by the studio publicist, Maxine Thomas."[13] She never mentioned Arzner in her memoir, and nary a word about the film. The collaboration between two strong-willed and talented women resulted in neither a friendship nor a particularly successful film. Arzner was a lesbian, and there are hints that the actress might have been put off by her overt behavior.

For Crawford, the story was not only reimagined but retitled as *The Bride Wore Red*, a reference to the red dress Crawford's character demands as part of her new wardrobe, but inappropriate at any of the fancy parties she attends. She received sole billing above the title with Tone and Robert Young listed below. This time her husband captured her hand at the end. But in a twist, that may have worked for Rainer, instead of moving up socially as was typical in her films, Crawford ends up with Tone who portrays an Alpine postman. This is not what audiences wanted.

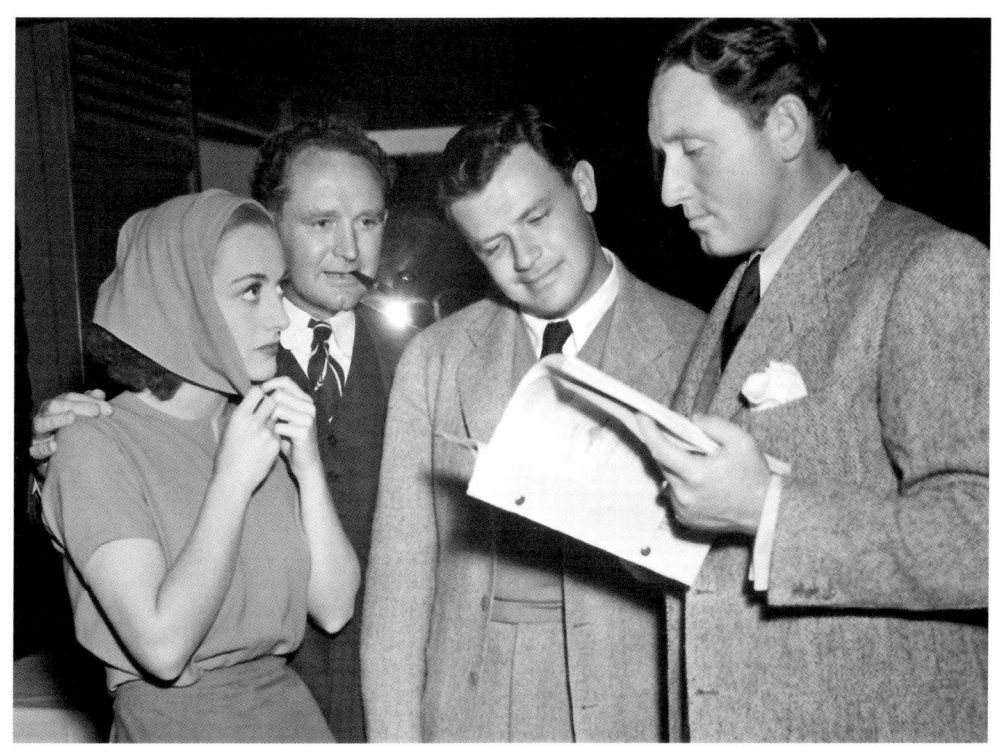

Crawford on the set of *Mannequin*, 1937, with (from left) director Frank Borzage, producer Joseph Mankiewicz, and Spencer Tracy.

Most critics were severe. "'The Bride Wore Red' is a mixture of Molnar and Hollywood, mostly Hollywood,"[14] wrote *The Sun. Variety* called it "a jolt to those loyal Joan Crawford fans,"[15] And most damning of all was the *New York World Telegram*: "[It] is one of the least entertaining of the current films—ponderous in movement, pedestrian in speech, hackneyed in situation, unimaginative in treatment and altogether unworthy of its fine cast."[16] Crawford later wrote, "When *The Bride Wore Red* opened at the Capitol, it was ushered in with an enthusiastic demonstration by my fans. But that picture laid the proverbial bomb."[17] Bringing in a mere $1,200,000, it was the lowest return of her last ten films—and, the only one to lose money. The first crack appeared in what for years had seemed an impervious shell protecting the Crawford brand.

Unhappy that a Crawford film had gone into the red, Mayer and Mankiewicz came up with a new strategy. Henceforth, with one notable exception, she would be costarred with a top male player. *Mannequin* went into production right on the heels of *The Bride Wore Red*. It was too soon to costar her again with Gable (he was busy squiring other leading ladies, Harlow, Loy, and Shearer), and fans probably had had enough of Montgomery, so Crawford was cast alongside Spencer Tracy. An up-and-coming MGM star, Tracy had made the successful *Captains Courageous* (for which he won an Oscar). *Mannequin* provided Crawford

Crawford and Spencer Tracy in a portrait for *Mannequin*, 1937. Photo by George Hurrell.

a perfectly tailored role. A young woman growing up in poverty on the Lower East Side of New York has dreams of riches, and Spencer Tracy, playing a gruff self-made millionaire, is able to satisfy her desires (a part that could have been equally well played by Gable). "His is such simplicity of performance, such naturalness and humor," Crawford wrote about Tracy. "He walks through a scene just as he walks through life. He makes it seem so easy, and working with him I had to learn to underplay."[18] But Tracy's skills as an actor did not always endear him to Crawford on the set. "At first I felt honored working with Spence . . . but he turned out to be a real bastard. When he drank he was mean, and he drank all through production."[19]

Frank Borzage, with whom Crawford worked in her first significant film role, *The Circle*, in 1925, directed *Mannequin*. He and Tracy were accomplished polo players, and during filming they enticed Crawford to give the sport a try. She had enjoyed watching matches from the stands at the polo field in Santa Monica, but it was Tracy who taught her to play the game. He even gave her a horse named Secret. She remembered him as a "real bastard," but photographs of the two of them at the stables and riding together suggest something more than a professional relationship, and some Crawford biographers claim they were romantically involved for a short time. "Secret threw me one day," recalled Crawford. "No horse

could do that to me." And thus polo ended as quickly as it began. Her "enthusiasm for polo" was a short-lived as her infatuation with Tracy.[20]

They appeared together to promote the new film. Maxwell House coffee sponsored a nationally broadcast radio program, *Good News of 1938*, which debuted in November 1937. Radio provided a new, and successful, form of advertising for the motion picture studios. MGM sent Robert Young to host the show's second program, which featured Crawford and Tracy reading scenes from *Mannequin* and giving audiences a "sneak" preview seven weeks before the film hit theaters. Then in March 1938, they took the leads in *Anna Christie* for the Lux Radio Theater. It was the last of the Crawford–Tracy collaborations.

Along with pairing her with a big-name costar, the producers drastically cut back the film's budget to about half that of her last film. This economy, and Tracy's popularity, brought the revenue almost in line with her last few successful pictures, and studio profit to a respectable $475,000. *Variety* called it "one of the best Joan Crawford starring vehicles in several seasons."[21] Frank Nugent in the *New York Times* thought the film only "fair," nevertheless, he understood the star's box-office appeal; "'Mannequin' . . . restores Miss Joan Crawford as the queen of the woiking goils."[22]

This boost came at an opportune moment as the three-year contract she signed at the end of 1934 was up for renewal in early 1938 (time had been added for days off). The returns for *Mannequin* were strong, like most of her films except *The Bride Wore Red* (loss) and *The Gorgeous Hussy* (slight profit), encouraging Mayer's generosity even though overall studio revenues were down. Crawford was offered a five-year contract at a healthy $330,000 per year (for forty weeks of work) with three pictures owed annually to the studio. In addition, the studio promised up to twelve weeks off to perform in a play if she desired. This contract committed her to making fifteen pictures and staying at MGM until early 1943. Where many veteran performers would have balked at such a schedule, the hard-working Crawford signed with gratitude.

What sort of pictures should she make? Continue the well-trodden but successful path as "queen of the woiking goils," or try something new? Critics complained when her films were too similar, then yelled even louder when she ventured too far afield. Crawford and Mankiewicz had set up an informal production unit, and since beginning this association, he had made only one film, *Double Wedding*, without her as star. Thus far she had taken his advice, but in late 1937, she turned down two projects he proposed. The first was a World War I drama, *Three Comrades*, based on a novel by Erich Maria Remarque about three German soldiers, played by Robert Taylor, Robert Young, and Tone. Crawford felt that her character would be lost in the story.[23] Margaret Sullavan was assigned the part, and although it would be many months before Crawford discovered her error, the film turned out to be a hit bringing in over $2 million in revenue. Mankiewicz then offered her *Shopworn Angel*, and again she refused. As soon as *Three Comrades* finished

DRAWING BY ROBINSON

"My dear, did you hear? We're being cast for the next Joan Crawford picture!"

Crawford was so famous in the mid-1930s that even goldfish wanted parts in her pictures.
[*Photoplay*, June 1936, 76.]

shooting, Sullavan stepped into that part as well. Not as big a success, but still it brought in over a million dollars, and added real luster to Sullavan's movie credits.

While Crawford was considering scripts and watching the financial results of *Mannequin*, a firecracker was set off in Hollywood. "Poison at the box office" declared Harry Brandt in an advertisement placed in *Hollywood Reporter* (May 1938) on behalf of the Independent Theater Owners Association (IOTA), directing his venom at a small group of stars whose, in his opinion, "box office draw is nil." Crawford, along with Garbo, Katharine Hepburn, Mae West, and Edward Arnold were named, along with Kay Francis and Marlene Dietrich. Brandt and the theater owners he represented were frustrated at having to exhibit so many films that did poorly and consequently affected exhibitor's revenues. History has shown us that "box office poison," as it became known, was as much a product of declining returns due to the lingering Depression as the viability of stars. Brandt made reference to the $5,000 a week star salary which may have galled theater owners who watched their weekly incomes dropping. There was surprisingly little response to the ad in the trade papers, and almost none in the fan magazines. Most performers did see a drop in salaries in the late 1930s, but not because of Brandt. In 1938, Garbo was paid $250,000 for *Conquest*, plus another $150,000 for overtime. The next year, for *Ninotchka*, her base was reduced to $150,000. This reflected poor box office of the former, and the overall decline of studio revenues. After being a top draw, Mae West lost her top spot, left Paramount in 1937, and didn't make another film for three years. Crawford was at the end of a five-year contract, and for the most part, her films were doing well at theaters, just not generating the previous level of profits for MGM. Perhaps the biggest influence of Brandt's article was how it affected the egos of individual performers. No successful person likes to be described as "poison" in his or her industry's leading trade paper. Crawford claimed not to have been bothered, but as she was acutely aware of everything written about her, this poison dart must have stung, and made her all the more careful as she considered her next move.

She was looking for a prestigious dramatic project, one that would elevate her to an even higher stature in filmland. Having passed on two films, she looked to Broadway and convinced Mayer to purchase the 1934 play *The Shining Hour*. It told the story of a woman who falls in love with her brother-in-law, and when the two decide to run off together his wife commits suicide. This was not going to work as a Crawford film. The story was reimagined and tailored to fit the image audiences expected. Her character was now a successful ballroom dancer, which allowed a musical sequence in a nightclub giving Crawford another opportunity to show off her skills. Wealthy Melvyn Douglas falls in love with her, but in a twist for a Crawford film she resists his marriage proposal. When she finally agrees and they marry—not for love, but because she likes him—they move to his family's magnificent estate, shared with Douglas's brother played by Robert Young, and Young's wife, played by (predictably, given that she was now a Mankiewicz

protégée) Margaret Sullavan. Young falls in love with Crawford, and thus the drama unfolds. But there is no suicide, and all spouses return, sensibly, to the ones they married in the first place.

Mankiewicz was riding high, but Crawford was lumbering along. She needed *The Shining Hour* to be a triumph. It wasn't. As rewritten for Crawford the story was so anemic as to have little real drama. Borzage directed, Ogden Nash transferred the original Yorkshire location to Wisconsin, and Fay Bainter was added to give spice to the otherwise banal story. Here is an example of an excellent cast and superb behind-the-scenes talent not able to produce a successful product. The main culprit might have been the Production Code, which demanded that anything stimulating in the play be eliminated. Sometimes writers could outmaneuver the censors, but it didn't work this time. As Crawford's films always had to be aimed at a relatively unsophisticated middle-class, largely female audience, she would have been better served not to have selected a property that needed such judicious reshaping. She wanted to try something new, but, alas, *The Shining Hour* proved a mistake. It lost money. "I think this was about the time my loyal public began dwindling," Crawford later wrote. "You can't keep 'em coming to bad films."[24]

After two years, the Tone marriage was on the rocks. Neither seemed committed. He had many affairs, and she was seeing Mankiewicz and of course Gable (and perhaps Tracy and others). Having separated in the summer of 1938, Crawford confided to Mayer that she would soon file for divorce, but he asked that she wait until after the release of *The Shining Hour*. In November, Tone learned that MGM would not be renewing his contract. Had he wondered whether or not he was wanted for his talent or his marital connection, he discovered the truth when his marriage dissolved. After good parts in prestigious films, often supporting his wife, he was relegated to roles in "B" pictures (or programmers, or second features) such as *The Girl Downstairs*, with Franciska Gaal, and *Fast and Furious*, with Ann Sothern. His name was above the title in both, which may have soothed his pride a bit. After his contract expired MGM offered him a decent supporting part in a Wallace Beery film but at a reduced fee (and below-the-title credit), but years of excessive drinking had so damaged his health that he wasn't able to accept.[25] "I am sorry we married," she told a reporter covering her divorce proceedings in April 1939. "Marriage was a mistake for me."[26]

Crawford had agreed to star in three films in 1938 but she made only one, and it was not successful. What was Mayer (and his producing team) thinking when he offered her a million-and-a-half-dollar, fifteen-picture deal, without having suitable properties waiting? Most of 1938 was spent getting the rights to *The Shinning Hour*, which both star and studio, with its million-dollar budget, expected to be a brilliant success. With 1939 approaching, MGM producers again seemed to be without viable Crawford properties. It was her old friend Harry Rapf who came to the rescue and cast her in a film that turned out to be, perhaps, the most

The posters for *Ice Follies of 1939* suggested that Crawford would leap through the air on skates but in actuality she hardly stepped a foot on the ice.

unsuitable of any she had made to date. Her second film for 1939 turned out to be a masterpiece, but it too initially lost money, and only later was recognized for its outstanding quality.

Rapf needed a successful film. At MGM since its founding in 1924, he continued as a producer, although by the mid-1930s he was making mostly "B" pictures. He had two successes with *Whipsaw* (1935), starring Myrna Loy and William Powell, and *Piccadilly Jim* (1936), with Robert Montgomery, but his recent films had been disappointments. In 1938, he decided to return to a model that had been successful in the past, the musical spectacle. The International Ice Follies, a skating revue, had been touring America and came to Los Angeles in the spring of 1938. Rapf decided they would make a good subject for a film and engaged the company to be featured in a MGM extravaganza. Borrowing in part a title he had used profitably in the past, *Hollywood Revue of 1929*, he titled his new project *Ice Follies of 1939*. The main attraction would be a thrilling ice spectacle filmed in Technicolor. What he needed was a story around which to build his film.

Did Crawford sign on to the film to help out an old friend, or was it Rapf who cast his former protégée at a moment when her stock was low? Either way, what was Crawford doing starring in an ice skating movie? Jimmy Stewart, who had won his starring stripes in *The Shopworn Angel*, was costar; Lew Ayres, hot off his first Dr. Kildare movie and Lewis Stone had featured parts. Rapf found himself with four superb dramatic actors, plus the Ice Follies. How would the two worlds mesh?

Rapf engaged his writers to produce a story that might bring the disparate pieces together. What he got was the basic Crawford scenario, not updated a bit. Young woman, in love, down on her luck, loses her fellow, gets a break, becomes a star (and gets her man back). Instead of being a singer, or dancer, or actress, this time she is an ice skater. One problem. Crawford couldn't skate (neither could Stewart or Ayres). The three put on ice skates, went out onto the rink, and posed gamely for a still photographer one day. Some posters for the film even show Crawford leaping through the air, although aside from a split second at the film's start, none of the leads stepped foot on the ice. "Did they ever stop to think that a lot of the cash customers around the country, paying their money to see a picture billed as 'Joan Crawford in Ice Follies,'" wrote one trade paper, "would faintly expect that Miss Crawford was going to skate during the picture?"[27]

What MGM promised was that she would sing. "Headed straight for the hit parades of the country are three songs sung by Joan Crawford in 'Ice Follies of 1939,'" was the ballyhoo promoted in *Studio News*, MGM's in-house weekly paper. "Preview performances of the numbers by Miss Crawford have already clicked."[28] Aside from accompanying the chorus for a few bars at the film's end, all the songs were dropped. Rapf, king of the cornball, who happily incorporated nods back to vaudeville, drew the line at letting Crawford sing on screen. For a spectacle, the film had a short running time of eighty-two minutes suggesting that her songs were cut shortly before the release. "There are a lot of customers,"

wrote one critic after the film opened in theaters, "who will probably be happy because Joan Crawford neither sings [n]or skates."[29]

Ice Follies of 1939 remains an entertaining film although lost among the great masterpieces released in 1939. The ice skating sequences are superb, and the male leads are excellent. Crawford was miscast because, while she was nominally the star, she was swallowed up in a production that found no place for her to be one. Even swanning in the final Technicolor sequences, she is nothing more than decoration. Had she been flying high with audiences and critics, this bauble could have been passed off as a lark. Instead, it was perceived as a gross misstep. Audiences who were expected to flock to the amazing ice show exhibited tepid enthusiasm. Rapf's comeback lost money.

The queen of the movies was in trouble. Perhaps Harry Brandt was right after all. Crawford had had two duds in a row. MGM also had a big financial loss with Garbo's *Conquest* in 1938. The same year, Norma Shearer brought in strong audience numbers to *Marie Antoinette*, but still the studio lost nearly three-quarters of a million dollars on the film. Top-line stars were no longer a promise of success. In spite of this new reality facing Hollywood, Hunt Stromberg was casting *The Women*, based on Clare Boothe Luce's successful Broadway play, which would feature many of MGM's leading ladies with Norma Shearer scheduled to headline. One plum role remained to be cast, Crystal Allen, the unsympathetic rival who steals Shearer's husband. Crawford wanted the part. Mayer and Stromberg hesitated; would audiences accept her portraying such an unsavory character? Moreover, it was not the leading role, and MGM never put two female stars of the magnitude of Shearer and Crawford in the same film. The one exception, *Grand Hotel*, had been made seven years before, and Garbo and Crawford didn't appear in a single scene together. Crawford was willing to take the risk, figuring that the part was so good that she could make it work. Her producers wondered if she was up to the task. Was Crawford, once again, being pigeon-holed by the studio? After fifteen years, did they still wonder whether or not she could really act. She had always been the diligent employee, and watched while other actresses won the acting honors. A showdown was brewing, although it would not come for another four years.

The End of Her Reign at MGM

SHE WAS STILL QUEEN OF THE MOVIES—BUT BARELY.

Before audiences had a chance to react to *Ice Follies of 1939*, *The Women*, was underway. Crawford prevailed, and won the part of Crystal, although for the first time since becoming a star another performer would precede her name on screen credits. Shearer and Crawford shared above title billing for *The Women*, but Shearer was accorded the first position. As both women were contractually entitled to precedence, it was Crawford who backed down in order to take the part she desired. Shearer, too, was in a slump. Two big-budget spectacles, *Romeo and Juliet* and *Marie Antoinette*, had suffered tremendous losses, as did her first film in 1939, *Idiot's Delight*, with Clark Gable. From the old-timer's crowd, Garbo was the exception and redeemed herself that year with the huge hit *Ninotchka*. The newer generation of female performers, relatively inexpensive, including Sullavan, Rainer, and Rosalind Russell, and the musical stars, Eleanor Powell and Jeanette MacDonald, were more reliable income producers. Russell, a five-year veteran of Hollywood, was third-billed in *The Women*, also above the title, but in smaller letters. Over the title or not, large or small letters, who comes first, these may seem small matters, but the egos of stars, and the perks of stardom, were such that every tiny detail needed to be worked out, and agreed upon.

George Cukor was among the most talented and successful directors working in Hollywood when his career hit turbulence in late 1939. Beginning with *Dinner at Eight* and continuing with films such as *David Copperfield* and *Camille*, his stock was so high that he was a natural to be hired to direct *Gone with the Wind* for independent producer David O. Selznick. For reasons never well explained, he was fired in February. The most consistent gossip, and never countered, was that he fell victim to Clark Gable, who did not want to work with him. Apparently the memory of an earlier dalliance between the two men irked the star. Losing a job is never good for one's career, but being taken off the most publicized production in Hollywood was a serious blow to his ego and professional stature. Mayer and

The main cast of *The Women*, 1930, from left (rear): Phyllis Povah, Paulette Goddard, Crawford, Rosalind Russell, Norma Shearer; (front): Mary Boland, Florence Nash.

Stromberg, who was producing *The Women*, remembered Cukor's great MGM successes, and within a month he was engaged to direct.

When Cukor first developed the reputation as being a "woman's director," isn't known, but that is what he became when he took the helm of the all-female cast. Along with Shearer, Crawford, and Russell, the leads were played by Paulette Goddard, Joan Fontaine, Mary Boland, Phyllis Povah, and Virginia Weidler. Secondary roles were given to Marjorie Main, Lucile Watson, Virginia Grey, Hedda Hopper, and Ruth Hussey. Given Mayer's loyalty to performers from bygone days, bits were played by former leading ladies, Dorothy Sebastian, Aileen Pringle, Betty Blythe, Peggy Shannon, and Natalie Moorhead, all uncredited. All told, eighty-five women had speaking parts.

A love triangle is at the center of *The Women*, but the man is never seen. Society leader Shearer loses her husband to a sales clerk, played by Crawford, but gets him back at the end, with eighty-five voices providing good and bad advice along the way. Crawford's common, working-class character shines in comparison to Shearer's sanctimonious portrayal of the abandoned spouse. When Crystal learns that her husband is going back to his former wife, she accepts the loss

stoically. Although she is heading back to the perfume counter, the scriptwriters, keeping a semblance of balance between the two stars, give Crawford the film's best line: "There's a name for you ladies, but it isn't used in high society—outside of a kennel."

Competition between the leads continued off-the-set. Photographer Laszlo Willinger who had been assigned the task of making a group photograph of the stars, remembered well the day:

> The call was for 10:00 a.m. Nobody. 10:30, nobody. 11:00, nobody still. Finally Roz Russell walked in and said, "Sorry I'm late." I said, "You're not late, you're the first one here." . . . I walked outside the stage, and I saw Norma Shearer driving by, looking out of her car window and then driving on; and right behind her was Joan Crawford, also driving by the stage, looking out then driving on . . . I called Strickling . . . He said, "Don't you know what they're doing? . . . Shearer is not going to come in before Crawford comes in, and Crawford is not going to come in before Shearer does." I asked him what he could do and he said, "The only thing I can do is to stand in the middle of the street and stop them." Which he did.

But that didn't solve anything. Once inside, the ladies played the game again, with neither willing to come out of her dressing room until the other appeared first. Russell was ready first wearing an evening gown and a hat with feathers. Willinger commented that the hat wasn't flattering, but not willing to be upstaged by her glamorous costars, Russell told him, "Maybe not, but I sure as hell am going to wear it." One out of three wasn't enough, so the photographer called Strickling to action again. He got the stars on the set, and enabled Willinger to begin work. Of the photographs taken, one had Crawford at the left, another had Shearer with Russell always at the right. "Don't you think it's about time you started working with the stars and sent Miss Russell home?" Shearer asked. Thus ended the abbreviated portrait session. "Crawford sort of enjoyed this thing between Shearer and Russell," noted Willinger, who was aware, as was Crawford, that it was Shearer who lost out the most when merely a small handful of portraits were taken.[1] Willinger also made portraits of both Crawford and Shearer separately.

A gala premiere was held at Grauman's Chinese Theatre. Keeping with the film's theme, as first-night patrons entered the theater's forecourt they were entertained with "a live fashion exhibit [that] was staged on specially built platforms . . . with models wearing dresses designed by Adrian. A group of M-G-M stock actresses, selected by a studio committee for their pulchritude, functioned as part of the theatre staff, serving as curb attendants, lobby escorts and ticket-takers."[2] Crawford brought as her date her current beau, Charles Martin, a writer and later a director. The two were photographed together often at restaurants and attending movie openings from mid-1939 well into 1940, when the ardor cooled.

Crawford, Norma Shearer, and Rosalind Russell in a portrait for *The Women*, 1939, by Laszlo Willinger. John Kobal Foundation.

Calling it "rough, tough and wise-cracking," *Cue* summed up the film well.[3] "The tonic effect of 'The Women' is so marvelous," wrote the *New York Times*, "we believe every studio in Hollywood should make at least one thoroughly nasty picture a year."[4] Taken as satire, the film plays beautifully eight decades after it was made. See *The Women* for the hilarious fight between Goddard and Russell at the divorce ranch in Nevada. Plenty of paying customers did, and it brought in almost $1,700,000, but the expensive cast, an unnecessary Technicolor fashion sequence, and all those clothes contributed to the film losing money. A later release brought it to break-even.

Shearer got first place in the billing, and is the film's principal player, but MGM's publicity department decided to favor Crawford in the press they released. Did this mean that the bigwigs felt Shearer's career was coming to a close, but that Crawford's still had a stretch to run? A long story in *Screenland*, "George's Women," barely mentioned Shearer:

Why this picture is definitely so important is because of the New Joan Crawford. This time she really *is* New. It's goodbye to the old Crawford of glamorous days, of gigantic close-ups with parted lips and batting long

eyelashes; it's Crawford the actress, and a very good actress too, who is going to be grateful to Cukor for putting her onto a different plane, a plane among the screen's great performers."[5]

Or was it noticed at the first previews that Crawford almost walked off with the movie, and would have had Russell not given so brilliant a performance. Critics largely ignored Shearer. So, too did the public. After *The Women*, Shearer made *Escape*, which was good, followed by two duds, *We Were Dancing* and *Her Cardboard Lover*. Without Thalberg to guide her career, it ambled along until she retired in 1942.

The Women gave Crawford the recharge she needed, but what consumed her time that summer (aside from Charles Martin) was the adoption of a baby girl. This was Christina, who thirty-nine years later would write *Mommie Dearest*, the book that would devastate Crawford's reputation. On June 11, 1939, two months after she divorced Tone, Christina was born to unwed parents. At some point, much earlier, and when Crawford and Tone were still married, she started the adoption process through a baby-broker. "Unknown to the mother," Crawford later wrote, "I paid for her confinement and hospital bills."[6] She kept her plan a secret, and the child's impending birth was likely the reason she was anxious to be divorced, as Crawford did not intend to share this child with her soon to be ex-husband. Adoption by a single parent was illegal in California, but somehow the authorities ignored that she magically became mother to an infant child. At the time of the adoption, Christina was named Joan Crawford.

One reason for the adoption, Crawford claimed, was that she had raised her brother's daughter, also named Joan (Joan Crawford Le Sueur), from the time of the child's birth in 1934. She had been long estranged from Hal, especially after he was involved in a deadly automobile accident in late 1935 in which a passenger in the other vehicle was killed. The court that examined the evidence of the crash exonerated him of responsibility, but the driver of the other car later sued Hal for $86,000. This was later settled out-of-court for $8,500, presumably paid by Crawford. In 1938, Hal and his wife Kasha divorced, and mother and daughter moved to New York, leaving Crawford without her beloved "Joanie-Pants."[7] This seems a thin reason to adopt a child, and whatever it really was, she made the decision without any input from the studio, who saw to it that no mention was made in the press of the blessed event. Aside from the idea of a single woman, much less one of the world's most famous movie stars, adopting a child, MGM's publicity department had other reasons to be concerned as Crawford had been quoted about her thoughts on domestic life. "I'm through with marriage. . . . I am through with trusting my happiness to another human being," she told all who would listen at the time of her divorce from Tone.[8] These words made it difficult for the studio to present Crawford, idol to millions, as a joyous young mother. Thus it was decided that nothing at all would be said.

Crawford and Clark Gable in a portrait for *Strange Cargo*, 1940, by Laszlo Willinger. John Kobal Foundation.

After getting her new baby settled in Brentwood, Crawford went back to work. Her fans, who breathlessly awaited every new tidbit about the star, were kept in the dark about the adoption. They were, however, aware of her stellar work in *The Women*, and what better way to reward the star and her followers than for MGM to announce an upcoming Crawford–Gable film. It was the eighth time the pair costarred, and although it would be their last, *Strange Cargo* was their finest collaboration. Filmed at and around Pismo Beach, 175 miles north of Los Angeles, it is the story of an escape from Devil's Island, the French penal colony off the northeast coast of South America. Crawford works in a café (read prostitute), and one day encounters a convict, Gable, when he is out on a work detail. Gable takes flight with a small band of cohorts, and coming upon Crawford, entices her to go on the lam with them. Most of the film covers the escape, first a trek through the jungle and then sailing in a small boat to the mainland. Neither actor wears much if any makeup and Gable is usually bearded. In what might be a first for a film starring Crawford, Adrian's name does not appear on the credits. Although he must have designed the two stylish dresses she wore for the opening scenes, for most of the film Crawford's character wears a simple dress that becomes increasingly tattered and dirty. What must contemporary audiences have thought

of a bearded Gable and an unmade up Crawford, but viewed today the pair look sensational. Freed of swanky gowns, tuxedos, long eyelashes, and close shaves, the stars can concentrate on delivering a highly charged erotic love story although the couple rarely even kiss.

This was the sixth time Mankiewicz produced a Crawford film, and he brought together another top-flight team. Frank Borzage was back directing, and studio newcomer Robert H. Planck served as cinematographer. Planck had been working for the past decade at smaller studios, for independent producers, and occasionally made short subjects. It must have been Mankiewicz who saw his potential and hired him to shoot his first MGM film. The results were terrific; he stayed at the studio for the next fifteen years, where he photographed all of Crawford's upcoming films. The supporting cast included Ian Hunter, as a mystical character who has the power to see the future, Peter Lorre, and Paul Lukas.

This little-remembered film has flickers of greatness. Crawford and Gable give among their best performances, the cinematography is superb, and each supporting actor beautifully plays his part. Willinger made marvelous portraits of the leading couple that should be added to the stack of Crawford's best. Had the story focused on the escape, *Strange Cargo* would have endured better. Ian Hunter's Christ-like character (if that is what it is) pervades the film in a fascinating but ultimately unsatisfying manner. His role is redemptive—most of the escapees find peace and pardon before dying as only Crawford, Gable, and Hunter reach the shore. It might make sense in a story about a group of criminals, but this sort of spiritualism is out of place in what is fundamentally a sex drama, although Gable does see the light and returns to prison, with Crawford loyally awaiting his release.

Critics were mixed on the film, recognizing its flaws, although it was popular with audiences taking in almost $2 million. Not so with the Catholic Church. In what might be a first for a major Hollywood studio, in March 1940, *Strange Cargo* was condemned by the Catholic Legion of Decency, the church's arm that policed motion picture content, noting it "presents a naturalistic concept of religion contrary to the teachings of Christ and the Catholic Church,"[9] No studio release could play in theaters with a Condemned, or "C," rating. The film was withdrawn, and cuts were made to make it palatable to the Legion of Decency. Since no prints of the original film survive in circulation, it is impossible to know what offended the censors. The picture's future was held in abeyance until October when the original ruling was reversed. "Legion of Decency's total ban on M-G-M's 'Strange Cargo' has been modified and pix has been removed from the 'C' classification to 'Class A, Section 2,' meaning that it is unobjectionable for adults."[10] The next year, *Two-Faced Woman* starring Garbo would suffer similarly, and require not only edits but the addition of a corrective scene.

Crawford and Gable's on-again, off-again relationship may have been "off" during the making of *Strange Cargo* as Gable had married Carole Lombard in

March 1939 while he was making *Gone with the Wind*, and Crawford was busy taking care of her infant daughter. Although they were always the best of pals, even during times when they were not lovers, a *contretemps* flared when filming completed. For their previous seven films, Crawford's name had preceded Gable's in the credits. This time, Mankiewicz was under pressure to reverse the order given Gable's increased post-*Gone with the Wind* popularity and box-office clout. Crawford objected and notified her agent Mike Levee that she was challenging the decision. This resulted in many of the studio's top brass getting involved to settle the dispute. Eddie Mannix, Mayer's right hand, cabled Levee, "Know of no promises regarding billing on *Strange Cargo*. However, Mr. Mayer returning to Los Angeles tomorrow and will discuss it with him." His next line must have made Crawford livid: "Know of no better billing that 'Gable and Crawford' especially taking into consideration Gable's tremendous hit and publicity after *Gone with the Wind*."[11] When Mayer returned, Crawford was waiting for him. The astute mogul made a decision worthy of King Solomon. Crawford's name would precede Gable's on the film's credits, and her name would come first in the cast list. For the posters, and other print publicity, Gable would be listed first. Whether or not any contemporary fans of the two noticed this subtle sleight-of-hand, it satisfied the egos and contracts of the two stars.

Crawford had signed up for three pictures a year, but properties were hard to come by, and at best she made two. *Susan and God* followed *Strange Cargo*, and once again it was a script passed among MGM leading ladies before ultimately resting with Crawford. Based on a successful 1937 Broadway play starring Gertrude Lawrence, MGM bought the rights with Greer Garson in mind. Garson had come to MGM in 1938, one of the new faces Mayer discovered on a trip to England. Her film debut the next year, in *Goodbye Mr. Chips*, was a critical triumph (and big money-maker) and launched an important motion picture career. Mayer was smitten by Garson, seeing her as the potential replacement for the old guard of actresses. Although she was older than either Crawford or Garbo, she was a fresh face on the screen. Her second film, *Remember?*, with Robert Taylor, wasn't very good. Nevertheless, Mayer saw great potential in Garson and carefully oversaw the selection of her next films. *Susan and God* had worked well on stage and was a hit for Gertrude Lawrence, but translated poorly to the screen in large part because, like *The Shining Hour*, it was subjected to rigorous censorship. Sophisticated stories that played well in New York had to be sanitized before they could reach the American screen. Katharine Hepburn had a double triumph with *The Philadelphia Story*, both stage and screen, because divorce was presented as being gently comedic, and the warring spouses got back together in the end. *Susan and God* went through countless rewrites, and at every stage must have become a less and less interesting script. Whether this influenced Mayer or not, he decided that it wouldn't suit Garson, casting her instead in *Pride and Prejudice*.[12] It didn't make much money but it added to her professional stature.

Crawford with Rita Hayworth and John Carroll on the set of *Susan and God*, 1940. Photo by Laszlo Willinger.

With Garson out, the studio announced *Susan and God* would be made starring Shearer, but by January 1940, that too changed.

Crawford claimed that she "craved the role of Susan" but understood Shearer was set to play the part. Shearer, however, was resisting as she did not want to portray a woman with an almost grown daughter. Cukor was directing and asked if Crawford could take her place. "Would you be willing to play a mother?" Mayer asked. She famously retorted, "I'd play Wally Beery's grandmother if it's a good part." Crawford had no such vanity when it came to a good role.[13]

The title, *Susan and God*, gives a broad hint to the story: a Long Island society lady, Susan, estranged from her alcoholic husband, visits England and falls under the thrall of a religious fundamentalist whom she invites to accompany her back home. Brandishing her new friend, Lady Wigstaff, she tries to convert her family and friends to the newfound faith. The beginning is played as mild comedy and works well as Crawford annoys all her friends and especially her daughter and husband. But then it turns into ponderous drama, and "the whole picture drifts away in a cloud of sentiment and melancholy," as reviewed in the *New York Times*.[14] Crawford could play satire well, and of course was a specialist

in "sentiment and melancholy," but not in the same picture. Fredric March played her husband and Rita Quigley, her daughter, but film buffs today tune in to see an excellent early performance by Rita Hayworth in a supporting role.

"That's my best part so far," Crawford said of playing Susan.[15] Fan magazine writers largely agreed and were enthusiastic about the new role. "Having struggled for years to get herself loved for her acting ability as well as her good-looking legs," wrote *Modern Screen*, "Joan Crawford has at last come through with a perfect performance as Susan, the rattle-brained, rattle-tongued, religion-struck wife."[16] And in *Photoplay*, "the most important thing about this picture is that it points a great star back to the high road from which she has lately wavered."[17] Fans who weren't concerned with her career trajectory could be satisfied with her smart Adrian-designed wardrobe. Willinger made Crawford's portraits as well as camera studies with other cast members on the set that were abundantly published in the magazines. Even with a slightly rocky story, it had all the makings of a hit. It wasn't. Barely cracking $1 million in ticket sales (the cost of the picture), it was a flop, losing even more money than *Ice Follies of 1939*.

One well-regarded columnist, Ed Sullivan, knocked both Crawford and the film. Working as a syndicated columnist for the *Daily News* in New York, Sullivan had a devoted national audience who followed his pronouncements on show business, and they were the same folks who dutifully tuned in to his popular television program that debuted in 1948 and lasted for almost a quarter of a century. In a column from October 1940, he went on the attack:

> Goodness knows that I don't often rap people, or performers but it's about time to crack down on wide-eyed Joan Crawford. . . . For some years, I've tried to like her, but she certainly strains friendship to a point where something has to give, and it GAVE. . . . I don't know, really, anyone who has gone so far in this business with so little talent as La Crawford.

What did she do to Sullivan that incurred such wrath? He had interviewed her years before, and after her marriage to Tone she invited him to her suite at the Waldorf Astoria where they had a long conversation that became the basis for an article in *Silver Screen*. That time, not only did she chat about her recent nuptials, she discussed the sometimes rocky road she had with reporters. "After what has happened to Franchot and myself on this wedding trip," he quoted her as saying, "I've come to the conclusion that Garbo and Hepburn are right. Run away from the newspapermen and photographers—thumb your nose at them—because the best a celebrity can get from the ladies and gentlemen of the press (most of them) is the worst of it." She got the worst of it from Ed Sullivan.

It seems that Sullivan was angry at Crawford for refusing his invitation to attend the Harvest Moon Ball at Madison Square Garden (or perhaps she backed out at the last minute). An annual event since 1935, it was sponsored by the *Daily*

News, and had grown to be one of the country's biggest amateur competitive dance contests. Given Crawford's well-known history as a contestant at such evenings more than a decade earlier in New York and Los Angeles, Sullivan hoped to deliver Crawford as a special guest. In a surprising move, Crawford answered this and other criticisms in an article published in *Hollywood* magazine. As for his claim that she had ignored the invitation, she told readers that it has been delivered through "MGM publicity men," and not Sullivan personally, and whether or not she intended to appear or not, "I was in the country with my infant child who was ill." Responding to the nasty crack about her talent, Crawford took the ironic position. "Aw, Ed, how could you? As long as I was getting away with murder why turn stool pigeon and snitch on me?"

"If Joan wonders why her latest flicker, *Susan and God*, was such a terrific box-office flop," Sullivan continued his tirade, "it is not alone that the part was unsuited to her talents; it was also because the contract with her public has been broken." He was wrong that taking on Susan was a poor choice, but his comments about her public must have stung hard. In her response, Crawford admitted that newspapers and magazines helped develop her career, but she nevertheless acknowledged years of "doing everything from lolling around in pajamas to jumping through a hoop," all for the "benefit of a photographer." Even for Crawford, who seemed to enjoy posing, at least when she was younger, it could become exhausting and intrusive. Speaking for herself, and the myriad of other actresses forced to play the game, there "comes an occasion when she does not leap through the hoop. Then annihilation." For Crawford, there would never be "annihilation," but Sullivan's boldness revealed fissures in the bedrock of her stardom.[18]

Susan and God marked a moment when Crawford, famously proud of her self-reliance and resilience, was noticed to be drinking excessively. She was a heavy smoker but had been known as a light drinker; it was likely the stress of her second divorce that provoked her dependence on the 100-proof vodka that became her constant companion for the rest of her life. Critic Alexander Walker details the list of absences recorded in the MGM studio files in 1940 and 1941, suggesting that her "illnesses" might have been the reason why she was able to film only a single picture in 1940 although she was contractually obligated to make three.[19]

When *Susan and God* was completed, Crawford set off with baby in tow to New York where the actress rented an apartment on East End Avenue, overlooking an attractive park and the river (upstairs, Irving Berlin had the penthouse).[20] Two months later, eleven months after receiving her child from the baby broker, and likely on the advice of her lawyers, Crawford took her daughter to Las Vegas where she was able to secure a legal Nevada adoption. After first calling her Joan, Crawford changed her mind and began calling her Cynthia.[21] By the time of the Nevada trip, the baby's name was Christina.[22] Where the baby had come from, and the circumstances under which Crawford came to have the child, were apparently ignored by the Nevada court that was convinced (or bribed) that all was in accord.

After the official adoption was finalized, Crawford and her daughter returned to New York. "Crawford bares her newish plans," wrote one New York-based fan magazine writer interviewing her about the visit, and commenting that surprisingly she was staying in town for the summer. "She goes on frequent rides in Westchester and Southern New England. The greenery of Connecticut especially enchants her."[23] As previously, there was no mention of the now one-year-old baby occupying the nursery of the East End Avenue apartment. There was, however, a long feature in *Motion Picture* about Crawford and her now six-year-old niece "Joanie pants."[24] Was the article in *Motion Picture* planted to direct readers away from the real story by providing a red herring that nonetheless revealed Crawford's maternal instincts? How much the movie press knew is an open question, but as Crawford counted among her closest friends writers like Katherine Albert and Jerry Asher, it must have been that year's best-kept "secret" in Hollywood.[25]

Crawford spent nine months in New York, and while there the studio continued to offer her scripts. One, *Bombay Nights*, had been proposed as her third film for 1940, but it was never made. Her disappearance from Hollywood was picked up by the press who angled for any bits about what she was doing. Although she had spoken often of appearing on stage in New York, there is no indication that she considered any projects. Motherhood must have kept her busy, but other things did as well. "In New York I had met a marvelously mature man, one of the best people I have ever known. This man must be nameless because he was never able to get a divorce. . . . He is a business executive. . . . He taught me to hunt and fish, we used to go on these expeditions with a whole group of men. . . . I carried my own gun and camera . . . [he] introduced me to politics, to banking, big business and public affairs."[26] It might be the same fellow about whom *Motion Picture* titillated fans when writing, "She is still keeping that secret romance very secret."[27] "Women need the stimulus of a masculine point of view," Crawford wrote in the late 1950s, and although this is not a sentiment shared by all women, it was for her, and between marriages photographs routinely depict her in the company with one man or another.[28]

Although she was without question one of the biggest movie stars in the world, and one of the most successful women in any industry, she could feel the sting of being associated with the movie business. Unimaginable today when show business celebrities occupy the highest stratum of society, in the 1940s there was still the lingering sense that movie people were second class, or even lower. "When I was in New York last Autumn," Crawford told top movie writer Gladys Hall soon after she returned to Hollywood, "I went to a charity thing at one of the smart cafes. During the evening, a very uppity socialite was asked to pose with me for some pictures which could be sold for the charity. She refused, saying she couldn't, she r'ally couldn't, you know, pose with 'an actress.'"[29]

While Crawford was summering in and around New York, she told her fans that she would return to Hollywood in the fall to make *A Woman's Face*. Insisting

that only Cukor would do as director, she was placed on suspension for ten weeks while he completed his work on *The Philadelphia Story*.[30] When first announced in the press, her costar was slated to be Jimmy Stewart. By the time she returned to Hollywood in November, Stewart was replaced by Melvyn Douglas, with Conrad Veidt in the key supporting role. After a long hiatus, nearly a year away from the camera, Crawford was back to work in December.

The play upon which *A Woman's Face* is based, *Il était un fois* by Francis de Croisset, was filmed first in France, then in Sweden with Ingrid Bergman in 1938, the year before she came to America. Following closely the Swedish version, the film tells the story of a woman, Anna Holm, who suffered terrible burns as a child that left her with a badly scarred face. She and a gang of accomplices work as blackmailers, and one of her marks turns out to be a plastic surgeon who becomes fascinated by her disfigurement and proposes a radical series of procedures to remove her scars. This might seem a strange choice of scripts for a glamorous MGM star, but Crawford, having played a glamour-defying part in *Strange Cargo* and an unsympathetic one in *The Women*, knew she could handle the role. Mayer and team agreed that audiences would accept her in an unsavory part. British producer Victor Saville, relatively new to MGM, produced, George Cukor directed, and Robert Planck was behind the camera for a third time in a row with Crawford. Melvyn Douglas played the doctor, and Conrad Veidt portrayed the evil aristocrat who is Crawford's partner-in-crime. Marjorie Main, one of MGM's most vivid character actors, is superb in a pivotal supporting role.

"Secrecy was the rule throughout the filming," wrote *Hollywood* magazine as the film was opening in theaters. "The set was closed to all visitors while Joan had the scar on her face. No stills were taken of Joan with the scar."[31] Cukor, working with Crawford for the third time in two years, understood how carefully she needed to be directed. "Just say the lines as if you're saying the multiplication table," he told her when directing a particularly sensitive scene, aware of her natural inclination to dominate the screen. Recalling the film decades later, he told writer Gavin Lambert, "In *A Woman's Face* the idea is how physical ugliness distorts you. . . . The second part has nothing to do with the first. You see her as a monster, then plastic surgery makes her beautiful and she just wants to live down the past." Cukor was aware of the excellent acting she had done although he also acknowledged in the later part of the film a weakness in both his direction and her performance. "In the first part she's really a complete character, not the actress who's playing it. Then, when she becomes pretty, she becomes . . . Joan Crawford."[32] Viewing the film fifty years after Cukor's comments were made, it holds together better than he suggested. Yes, when the transformation is complete she looks like a movie star, although in fairness to her performance, Crawford managed to keep her character in focus. A deftly rewritten script might well have produced a better movie as was suggested in the *New York Times'* largely negative review of the film: "Miss Crawford, however brave she is to face her fan clubs in such a role,

also seems to lack the ability to project more than a superficial harshness of the character of Anna Holm . . . although the fault in her performance lies more with the script that with herself." Now, with the hindsight of eighty years, *A Woman's Face* must be considered one of her finest films, and along with *Strange Cargo* reveals that Crawford was, in fact, a top dramatic screen actress. With a gross approaching $2 million, her fans thought so too.

Melvyn Douglas, who had worked with her on *The Gorgeous Hussy*, noticed a change from the glamorous persona he had encountered on the earlier set. This time, she was reveling in her new maternal role, and he recalled "a little girl who would be led on to the set at about three-thirty or four every afternoon by a real English nanny. The arrival of this child, dressed in a pinafore, patent leather shoes, peek-a-boo gloves, ribbons in her hair, and bonnet, would stop production for about a half hour while everyone gathered in a circle and Joan made a great show of being a mother."[33] Ingrid Bergman, who had played the Crawford part earlier in Sweden, was filming *Dr. Jekyll and Mr. Hyde* at MGM at the same time that *A Woman's Face* was in production. She visited the set, and although we might wish to know her thoughts about another actress taking her earlier role, what was reported was that the two young mothers chatted about their children who it seems were playmates.[34]

Aside from the *New York Times*, reviews were mostly good, some great. "Miss Crawford has a strong dramatic and sympathetic role, despite her hardened attitude, which she handles in topnotch fashion," wrote the critic for *Variety*. "Picture can assist in reviving her b.o. standing, which dropped noticeably two years ago."[35] "While we are not concerned here with entertainment merits," wrote *Showmen's Trade Review*, "credence must be given to the reports syndicated by columnists, following the picture's sneak preview on the coast, to the effect that it 'is Joan Crawford's greatest personal triumph.'"[36] "She is simply magnificent," gushed *Photoplay*.[37]

Next up was a bit of typical MGM froth. "Metro goes to the plate with a heavy batting order in 'When Ladies Meet,' directed by Robert Z. Leonard," wrote *Variety*. "Cast toppers are Joan Crawford, Robert Taylor, Greer Garson, Herbert Marshall and Spring Byington." Crawford didn't want the part but agreed (with top billing) as a favor to Mayer who wanted a star studded vehicle to offer to moviegoers. It was a remake of a successful film the studio had made in 1933 with the leads played by Ann Harding, Robert Montgomery, Myrna Loy, and Frank Morgan. It's a trite tale of mismatched lovers who straighten things out at the end. Garson is married to Marshall who is having an affair with Crawford. Taylor is in love with Crawford. They all convene, unexpectedly, at a weekend house party hosted by Byington. By the final credits order has been restored, Garson and Marshall are reunited and Crawford and Taylor sail off into the sunset together.

When Ladies Meet turned out to be the final collaboration between Crawford and Adrian at MGM. Each had helped build the other's career, and her magnificent

Crawford and Melvyn Douglas pose for Columbia photographer A. L. "Whitey" Schafer during the production of *They All Kissed the Bride*, 1942.

triumphs of the early and mid-1930s owe as much to Adrian as fine scripts and directors. After thirty-one films together, tastes had changed, and the mature Crawford no longer relied on gowns or glamour. The sumptuous MGM style was on the wane, as were the ladies who helped define it in the years since the studio opened in 1924. Adrian knew his time was up, and he retired in September 1941.[38]

It is only a fair movie, but the stars look great; Adrian's costumes and Cedric Gibbons's sets are up to the studio's high standards, and audiences loved it. Relatively inexpensive to make even after paying all those salaries, *When Ladies Meet* brought in over $600,000 in profit. Mayer was right: give the public what they want and dollars will flow into the studio's coffers. It wasn't, however, what Crawford wanted. She was tired of the tried-and-true formula and was looking for more films like *Strange Cargo* and *A Woman's Face*. Unfortunately, those were the sorts of pictures that were more common at rival studios like Warner Bros.

With nothing lined up in Hollywood, she and Christina decamped for New York where they spent the late summer and fall. The journey east might have been to avoid the gossip surrounding a second adoption that June of a boy whom she named Christopher. When the birth mother discovered the infant was in

the custody of a film star, she tried to extort money. Rather than be subjected to endless blackmail, Crawford returned the child to his mother in November. Although Louella Parsons wrote about the adoption in the *Los Angeles Times*, she and other journalists were silent when the baby was returned, and the story was kept secret from fans for more than a year before *Photoplay* gave readers a condensed version in February 1943. Suffering from the stress of losing Christopher, in November Crawford requested a ten-week leave of absence that was granted at half-pay.[39]

Her first film for 1942 came up unexpectedly. Carole Lombard was among the first movie stars to answer President Roosevelt's call to aid the war effort by selling war bonds in the aftermath of the bombing at Pearl Harbor. She had completed filming Ernst Lubitsch's *To Be or Not to Be*, costarring Jack Benny, for Universal, and had agreed to make *They All Kissed the Bride* for Columbia, which would go into production as soon as she completed her bond tour. Departing Los Angeles on January 12, 1942, she flew as far as Indianapolis before heading back to California. On the evening of January 16, shortly after take-off from Las Vegas, the plane in which she was flying crashed in to the mountains. All on board were killed.

Mayer wanted Crawford to star in another retread, *Her Cardboard Lover*, based on a 1926 play that had served as the source for a silent film starring Marion Davies. She had been gracious giving in to Mayer the year before but this time took suspension rather than play in a film that she felt did not suit her. "The part," she told a reporter, "is about a beautiful girl who stands around doing nothing." Mayer then offered the role to Hedy Lamarr. "I'm not as beautiful as Hedy," Joan continued. "I can't stand around doing nothing and expect to give a good performance."[40] When the film was made it was Shearer who took the lead, and it was a disaster, critically and financially. Shearer never worked again.

There must be a good story about how Crawford landed the role intended for Lombard. Alas, no one privy every told it. As an MGM star, it would have been unthinkable that she would appear in a film for Columbia (considered second string), especially in light of her recent box-office success. She and Mayer had been squabbling over scripts, and thus far the right one had not appeared. *Bombay Nights* was still being discussed, and Crawford wanted to make a film based on the novel *Ethan Frome*. Nothing came of either project. Given Crawford's close relationship with Gable, she may have offered to take the lead in *They All Kissed the Bride* as a favor to him. Given Lombard's tragic death, her popularity in Hollywood, and the fact that she was the wife of MGM's biggest male star, Mayer could hardly refuse Crawford's request. On January 29, newspapers across the country carried the story that she would soon return to Hollywood and step in for Lombard. Crawford decided to donate her entire salary of $112,500 to charities: $50,000 to the American Red Cross; $25,000 to President Roosevelt's Infantile Paralysis Drive; $25,000 to the Motion Picture Relief Fund; and $12,500 to the Navy Relief Fund. Since there was no compensation, Mayer decided it didn't make sense to "lend" her services to

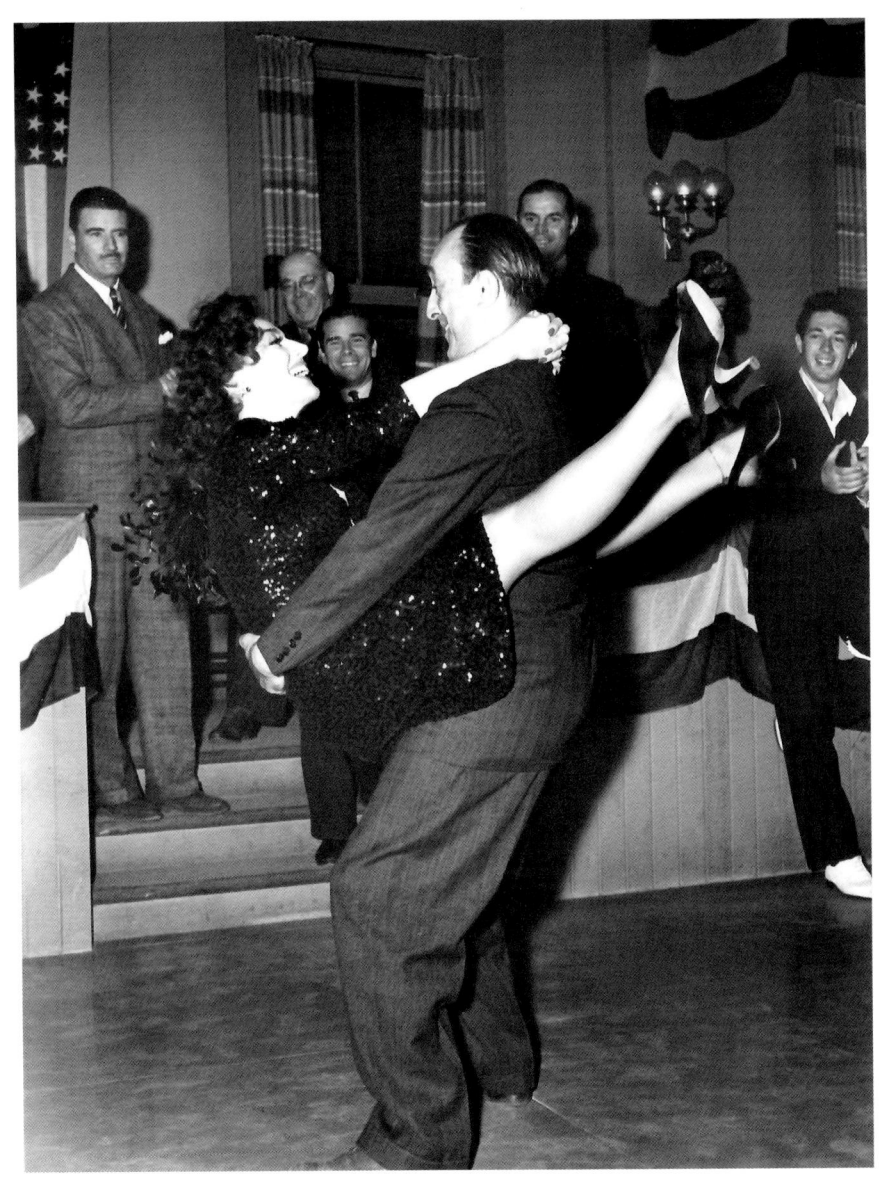

Showing her still youthful dancing vigor, Crawford dances with Allen Jenkins in *They All Kissed the Bride*, 1942.

Columbia, but rather granted Crawford a leave of absence from the studio. Those days, of course, were added to the end of her contract.[41]

Lombard had a reputation as a specialist in comedy. Her last film, *To Be or Not to Be*, is recognized as a classic, as is an earlier work, *My Man Godfrey*, so it made sense that she had turned to Columbia, which had a well-deserved reputation for screwball comedy (*The Awful Truth*, *Holiday*). Crawford, too, had shown adeptness in comedy beginning with *Forsaking All Others*, so she was a good choice to fill

in for her friend. As queen of the most glamorous Hollywood realm it must have been an adventure for Crawford to work at a rival studio known for excellent productions, but one that watched every dollar spent.

Both Alexander Hall, the director, and cinematographer Joseph Walker were riding high off Oscar nominations the year before for *Here Comes Mr. Jordan*. Melvyn Douglas costarred in this sort of *Taming of the Shrew* story of a hard-nosed business executive (Crawford) whose heart melts under reporter Douglas's charms. Crawford's fans should be grateful that she made this mediocre film for the fun of seeing her working outside the MGM cocoon at a studio that preferred fast-paced scripts over elegant surroundings. At the center of the action was Crawford, elegantly dressed by costume designer Irene (who would soon come to MGM). Although the direction and camera work were excellent, there was a slight shabbiness indicative of her temporary workplace.

Columbia gave her the opportunity to pose for a new portrait photographer, A. L. "Whitey" Schafer, one of the medium's masters, but who never worked at MGM. Schafer made two sets of portraits, one of Crawford alone and a second with Douglas. Crawford had been well-served by the MGM team, but being scrutinized by a fresh photographic eye added a new dimension to the extraordinary body of portraits taken over the previous seventeen years.

In early June 1942, a Crawford friend, "press agent Harry Mines asked if he might bring Phillip Terry to dinner."[42] Terry was the sort of fellow she liked: educated at Stanford, studied at the Royal Academy of Dramatic Arts in London, worked as a stage actor before being signed by MGM in 1937. But for the first three-year he played bit parts, almost always uncredited, including a second of screen time in *Mannequin*. By 1941, he was playing second leads at Paramount in films such as *The Parson of Panamint* and *Torpedo Boat*. Six weeks after that dinner, on July 20, they married. He didn't have the good luck that favored Tone. Terry continued in second leads and never worked with his wife, although she made a screen test with him.

Why did Crawford marry Terry? The best guess is that after two adoptions, one of which had gone terribly wrong, she decided that it made sense to be married before she tackled it again. And tackle it she did soon after her third marriage. A baby was born in October 1942, adopted by Crawford soon after, and named Phillip Terry Jr. Unbeknownst to her husband, Crawford alone adopted the child. The marriage would survive less than four years. "The easy going, unpretentious man who seemed to adore me, who was calm and absolutely uncomplicated" wasn't what she wanted.[43] Nor did she want his name to remind her of the mistake. As soon as Terry was out of the house, Crawford had the baby's name changed. She made Phillip Sr. and Jr. both disappear. The four-year-old's name was changed to Christopher.

Following the bombing of Pearl Harbor, MGM along with other studios reimagined their schedules and began releasing films reflecting the action in Europe.

"The high percentage of Metro-Goldwyn-Mayer pictures with war themes or connotation," wrote *Film Daily*," is indicated by the fact that no less than 20 Culver City feature productions with stories having a direct relationship to the war were released or being prepared between December 1941 and the end of December 1942."[44] During the few weeks when Crawford and Terry were courting, Mankiewicz proposed a script, *Reunion in France*, telling the story, set in Paris, of a woman in love with a wealthy industrialist shortly before the Nazi invasion of her country. When she learns that her lover is collaborating with the enemy, she turns from him and befriends an American pilot and works for the Resistance. Crawford agreed to make the film, and newcomer Jules Dassin was assigned to direct. He had been in Hollywood less than two years but had a success for MGM with his first feature, *Nazi Agent*. Philip Dorn played the industrialist, and John Wayne, the American.

"*Reunion in France* was the first feature set for release to deal with the dramatic undercurrent of the anti-Nazi movement in France."[45] Mankiewicz, his writers, and star must have been keen to make an important picture, but instead they created another glamorous tribute to Crawford that rang hollow in its representation of current events. The *New York Times* summed it up well as "the shallowest drama out of the pith and substance of an ironic tragedy. It is not a picture of France as it fights today in ways devious and dark; it is more simply a stale melodramatic exercise for a very popular star." After the fall of France, and with fighting continuing in Europe, audiences and critics were mixed as to whether they wanted films to reflect truthfully the war, or nod vaguely at serious contemporary events. For many it was the latter, and the box office was excellent, with grosses approaching $2 million, and a nice wartime profit for the studio over $200,000. Plenty of 1943 audience members were still happy to watch a beautifully dressed Crawford cavort among the Nazis, and flirt with young and handsome John Wayne who seems to have been set down in Paris for no other reason than to romance the star. A withering conclusion to the *Times* review must have spoken for others when the author wrote that *Reunion in France* "had the temerity to be glibly untruthful on serious matters."[46]

Philip Dorn and Crawford had little chemistry, but she and John Wayne lit up the screen in a way not seen since her work with Gable. It's a pity that the two never worked together again for Wayne was one of the few actors who had the sort of rough sexiness that with a good script or two could have helped revitalized her image as it did for Dietrich in their three films together at Universal. Crawford was not, however, looking for a new screen partner but for interesting scripts. And, as it turned out, what she wanted more than anything were the films Mayer assigned to Greer Garson.

Looming was Crawford's contract renewal, and the five-year deal she had signed back in 1938 would expire in the spring of 1943. Crawford hated *Reunion in France* and considered it one of her worst films. And among other projects

John Wayne and Philip Dorn vie for Crawford's attention in *Reunion in France*, 1942.

proposed in 1942, she hesitated taking the lead in *Cry Havoc*, the story of nurses working in Bataan (Philippines), although it had been advertised with her and Merle Oberon heading the cast. Two films made at MGM contributed more to Crawford's emotional unrest than any of her professional concerns. *Mrs. Miniver* was released in the summer of 1942, and *Random Harvest* in December. Both starred Garson. Crawford had lobbied unsuccessfully for both roles. Adding to the insult, both were financial blockbusters, each taking in over $8 million at the box office. Garson was solid gold to Mayer. Nothing mattered more than profits. Crawford may have continued her reign but her crown was heavily tarnished. Devotion continued from the many fans that continued to be her mainstay, and she could still open the pages of fan magazines and read her tributes:

Joan Crawford's like a gorgeous hunk of diamond! Glittering, many sided, fabulous. Crawford trailing maid, secretary, dachshunds. Shoveling out time and money to charity. Dashing off an autobiography. Racing home to kiss the adopted tots good night. Tossing off three model movies a year (the latest "Reunion in France" for M-G-M). Getting things done in a twinkle . . . and, bless her, doing them with DASH.[47]

It wasn't enough anymore.

The film she agreed to make in late 1942 was based on a suspense novel by Helen MacInnes, *Above Suspicion*. Set in 1939 just before England entered the war, it was meant to be another teaming of William Powell and Myrna Loy, but the actress was devoting her time to serving with the Red Cross. Crawford stepped in, and Mayer continued the policy of costarring her with a front-line leading man. Since men were in short supply at MGM (apparently Powell wasn't an option) as one after the next enlisted, Fred MacMurray, was borrowed from Paramount. They played a newly married British couple, he a university professor, who take a wedding trip on the continent. Unbeknownst to Crawford (at first), her husband is working as a government agent. Victor Saville produced, and Richard Thorpe directed this Hitchcockian thriller but without the benefit of the great master. Supporting roles were taken by Conrad Veidt (his last film) and Basil Rathbone. *Above Suspicion* is enjoyable but a slight addition to the Crawford canon. "A completely entertaining thriller," wrote the *New York Times*,[48] but the *New York Herald Tribune* was closer to the mark: "neither Joan Crawford nor Fred MacMurray look quite bright enough to unravel the tangled skeins of this screen melodrama."[49]

As days grew closer to her contract's expiration, Mayer attempted to retain Crawford at MGM. After eighteen years, she had made him plenty of money, and they felt a loyalty to one another. When she wrote or spoke publicly about Mayer, she never had anything but praise for her boss. But she was unhappy. "When you start to slide in this business," Billy Haines told Crawford, "it's like walking on nothing." Unsettled, professionally and personally, she parroted his words: "I was walking on nothing."[50] In retrospect, it is easy today to see that her last few films hadn't been bad, and most made money. But she felt she was slipping and blamed poor scripts, both the films she made and those offered that she rejected. Crawford's discord had more complicated roots. A convenient marriage to a man she didn't love must have added to her frustration and contributed to her drinking. At the core of her anxiety, however, was her new rival, and she was enraged watching Garson rise higher and higher in the studio's and the public's imagination. It was one thing to play third to Garbo and Shearer, but Garson was something altogether different, an interloper in her kingdom.

Mike Levee, Crawford's agent, had started contract negotiations back in the summer of 1942. Mayer had proposed a $1,200,000 deal over five years with twelve pictures due at $100,000 each. By the following spring, her enthusiasm

for staying at MGM was waning. In April, she asked "to take six months off and consider any offer made to her for a picture elsewhere."[51] *Film Daily* announced in May that she had withdrawn from *Cry Havoc*. She no longer came into the studio.

The queen of MGM was about to abdicate and enter another realm. That spring Levee had been in contact with Jack Warner about the possibility of Crawford signing with Warner Bros. Feeling jealous at the attention Garson received at MGM, it is surprising that she would consider joining the studio that had Bette Davis as its premier attraction. It was a risky move, but one Crawford thought worth the gamble.

Although her contract was set to expire in March, MGM claimed that she owed the studio an additional fourteen months stemming from her many suspensions, absences for health, and requested layoffs. Mayer sensed the finality of Crawford's decision and convinced Schenck that it was in the interest of all parties to terminate Crawford's employment. The mutually agreed upon date was June 30, 1943. Her last film, *Above Suspicion*, was scheduled to be released in late summer so it was prudent to retain Crawford's good will. Lawyers for both sides determined that she was owed a final payment of $100,000, which was paid on her last day as an MGM employee. "After seventeen years, I left the studio where Joan Crawford had been born. It was five o'clock in the morning when I gathered up the last of my possessions from my dressing room and left—by the back gate."[52] She claims not to have spoken to anyone, but how could she have left without saying goodbye to the man responsible for her career, Harry Rapf?

Warner Bros. and *Mildred Pierce*

THE LORE SURROUNDING CRAWFORD'S MIDCAREER MOVE IS THAT SHE made her break from MGM and suddenly, in her new home, found the perfect script and reimagined her career, bringing it to even greater heights. It wasn't that simple. She reached a deal with Jack Warner in late June 1943, one on better terms than Mayer had offered. She gave his studio a six-year option on her services, and would be paid $500,000 for three films. Although Crawford now was a middle-aged veteran of the movies, Warner needed her to help replenish the diminishing ranks of his star lineup. His studio was still the home of Bette Davis but was losing many of its most popular female stars. Olivia de Havilland's contract ended in 1943, and Miriam Hopkins made her last film at Warner Bros. that year. Crawford's timing was perfect when she let it be known that she was looking for a new studio, and Warner wasted no time in offering her attractive terms.

There was little fanfare surrounding the move, which coincided with a change in her professional management. Mike Levee was replaced by Lew Wasserman at MCA. The few press mentions suggest it was a seamless transition from her home of eighteen years to Warner Bros., although she claimed, disingenuously, that when she left MGM both she and Terry were without jobs.[1] Crawford initially agreed to join her new studio on July 15, but at her request that date was moved ahead a month, to August 15. Terry, suffering the same fate of his predecessor Tone, lost his berth at MGM, but before summer was over he found work in a Walter Wanger picture, *Ladies Courageous*, starring Loretta Young.

Warner did have a script picked out for her debut, *Night Shift*, from a novel by Maritta Wolff. It was a predictable Crawford story about a nightclub singer who falls for a recently divorced musician who can't decide whether to find happiness with his new romance or become a seafarer. Bought for Ann Sheridan and Humphrey Bogart, by mid-1943 it was targeted for Crawford, although no leading man was mentioned. She liked the story but not the script, and after several rewrites, rejected it in the fall. It languished until 1947 when, renamed *The Man I Love*, it was made with Ida Lupino and Robert Alda.

Another prospect was a story by Sinclair Lewis, *Green Eyes—A Handbook of Jealousy*, that appeared in *Cosmopolitan* (September and October 1943). The heroine, with the marvelous name of Alpha Orchard, could have been written with Crawford in mind: "I've always had too much energy, too much imagination.... I can't go on living the way women did in 1910 or even 1930 . . . so I can either go on being old fashioned and jealous . . . or new fashioned and have a job."[2] Alpha sounds a bit like Mildred Pierce, but for reasons undocumented, the project didn't move forward after being announced in the trade papers.

More promising was a "treatment," or outline, of a story titled *Never Goodbye* that Edmund Goulding had written for Crawford, and one he hoped to direct. He delivered "a ten-page synopsis" in October and was paid $50,000 for his efforts. Errol Flynn agreed to costar, Goulding signed a contract to direct, and filming was scheduled to begin in January. Warner Bros.' battery of writers tackled the story, but couldn't expand it into a finished script that would satisfy Crawford. She thought it "a rehash of the old glamour stuff she did at MGM." Goulding's contract was temporarily suspended, and at the end of November the writers were ordered to give up trying. Later, he was assigned a remake of the Bette Davis classic, *Of Human Bondage*, this time with Eleanor Parker and Paul Henreid.[3]

Was Crawford being temperamental? Since she loved to work and wanted to make good on her new contract, it is probable that she did not think the proposed scripts were suitable, or at least she had not found the project she wanted for her Warner Bros. debut.

Never willing (or able) to stay home and do nothing but review scripts, she also sat for portraits and decorated her dressing room. Even though she wasn't working in front of the motion picture camera, she decided that an offering was due to her fans and invited Hurrell to her house and posed for a new series of pictures. "Co-starring Crawford and Adrian" was the title of a four-page pictorial in *Screenland*, with the subtitle, "Great collaboration: Hurrell's photos, Adrian's dresses and Crawford's personal wardrobe."[4] Since leaving MGM, Adrian had set up a dress shop in Beverly Hills, and Crawford was one of his most loyal and enthusiastic customers. If only for a day Crawford was back working with two old friends, renewing the collaboration that helped define 1930s glamour.

She also began working with Warner Bros.' two portrait photographers. Eugene Robert Richee, who had spent two decades at Paramount before moving to the studio in 1941, was among the great artists of the high glamour era of the 1920s and early 1930s. Bert Six had been shooting stills and portraits for a decade. Crawford would sit for both, and she insisted that her portraits be more dazzling than was typical at her new studio. It is sometimes difficult to determine authorship as photographs released by the studio were rarely credited. Regardless of the photographer, Crawford maintained studiously her glamorous image.

Her legions of devoted followers still looked up to this image. At the time she left MGM, a new "official" Joan Crawford fan club was established under the

leadership of Edith Clemens in Brooklyn, New York. There had been an earlier Crawford club that began in 1931 created by Marian Donner, of The Bronx, with annual dues of 50 cents and having 450 members. *Variety* reported in a 1937 cover article about a meeting in New York at which the star made an appearance: "A type of lunacy transformed the basement of Loew's Lexington theater (N.Y.) into a combination temple of worship and violent ward of a nuthouse. . . . Hysteria of the worshipers, who range in age from teens to early 20's, grew as the magic moment approached. Suddenly, without warning, their idol appeared. . . . This was the signal for pandemonium to break loose." She only stayed a few moments, telling the assembled, "I—I'm so touched, I—can't say anything. I'm sorry. I'll-I'll have to go." As soon as she departed, "the Holy Roller effect set [in]. . . . Members screamed, wept, clutched each other's arms, knocked each other's hats off." The featured guest, once the star left, was Isidore (Dore) Freeman, a young man who met Crawford when he delivered a telegram to her at Grand Central Terminal in New York. Later she got him a job with MGM in the publicity department, and they remained friends until her death. Donner published *The Crawford News*, and counted Crawford's close friend Jerry Asher as the club's honorary vice president. At some point Donner's club folded and was replaced by Clemens club in 1943. The membership dues were $1.50 and included the *Joan Crawford Club News*, a twenty-four-page magazine, published quarterly that promised an article from the star herself in every issue. Clemens even had Crawford's secretary Bettine (Betty) Barker on the editorial staff (insuring that all the news was accurate, or at least Crawford-approved).

With the war on, Crawford's movie star lifestyle, like that of her Hollywood peers, was curtailed. Staff shortages meant closing up part of her house, and she even planted a victory garden on her front lawn. She still had time to entertain her children, and for Christina's fourth birthday in June 1943, she hosted an afternoon party for twenty of her daughter's closest friends, many the children of Hollywood stars. Pony rides were part of the fun, and guests—"the very cream of the kindergarten crowd"—included Brooke Hayward (daughter of Margaret Sullavan), Danny Milland (son of Ray), Melinda Nolan (daughter of Lloyd), Susie MacMurray (daughter of Fred), and Tarquin Olivier (son of Laurence). *Movieland* sent a writer and photographer, and featured the festivities in ten photos over two pages.[5]

Her part to aid the war effort was to establish and help underwrite a nursery for children between the ages of two and six whose mothers had entered the work force. "We found an old house near the aircraft factories [Sawtelle, CA] and the volunteer workers and I scrubbed it from top to bottom."[6] Managed by the American Women's Voluntary Services (AWVS), Crawford served as California state chair of the nursery project, spent one day a week working with the children, and was unabashed asking friends for financial help.

Crawford, wearing her American Women's Voluntary Services (AWVS) uniform, poses with her third husband, Phillip Terry.

In a cameo role for *Hollywood Canteen*, 1943, Crawford dances with Dane Clark while Robert Hutton tries to break in. Photo by Mack Elliot.

That wasn't all. "Monday nights we [Terry] worked at the Hollywood Canteen. I served behind the snack bar and wrote postcards—hundreds of postcards." The Hollywood Canteen opened in 1942 as a club exclusively for servicemen. There was good food, dancing, and entertainment, and best of all, everything was free of charge. Most Hollywood stars pitched in, including Marlene Dietrich, Gary Cooper, and Judy Garland. Only Garbo missed the opportunity to provide good cheer to soldiers on their way to fight in the Pacific, or back on leave. Other projects Crawford took on included "work for [the National] Allied Relief [Committee], for the Red Cross, and recordings for the boys overseas—'Words and Music.'"[7]

Running a house with little staff and volunteering for the war effort wasn't enough to keep Crawford satisfied: "Frankly I was bored because the actress is half of this woman and the actress had no outlet."[8] Though bored, she continued to refuse scripts. Whether pride or pressure from Jack Warner, she agreed temporarily to go off salary.

While waiting for the right part she accepted an extended cameo in *Hollywood Canteen*, Warner Bros.' star-studded salute to the military and the scores

of Hollywood stars who gave their time to entertain troops passing through Los Angeles. The story was slight: two soldiers on leave find romance and meet stars at the Hollywood Canteen. Robert Hutton and Dane Clark, two lesser players from the studio's stock company, play the leads. What makes the movie fun to watch are the appearances by dozens of Hollywood royalty: Bette Davis (president of the Canteen), Barbara Stanwyck, Eddie Cantor, Ida Lupino, Jack Benny, and many others. Crawford has an amusing bit; she asks Dane Clark to dance, and he asks whether or not she knows she looks like Joan Crawford. When he realizes that his partner is, in fact, Joan Crawford, he faints. Crawford was shrewd to make her first Warner Bros.' appearance in this brief and humorous scene rather than claiming the prerogatives of stardom and waiting for an important dramatic part. *Hollywood Canteen* presents her as a member of the Warner Bros.' family, and a good sport willing to lend a hand both to the studio and in support of the war effort.

Filming of *Hollywood Canteen* began in late 1943, but was halted when the Screen Actors Guild demanded that all players be paid their usual "full picture rates" regardless of how much screen time they were accorded. For stars that meant huge paychecks were due. The studio in turn sued the guild for half-a-million dollars. A compromise was reached the following April that allowed filming to continue. Actors, "who usually work on a 'per picture' basis," would be paid "a week's pro-rated salary at a fair minimum." In addition, Warner Bros. would donate 40 percent of the film's profits to the Hollywood Canteen.[9] The picture's budget was $1,550,000, of which $179,000 was paid to outside artists.[10] *Hollywood Canteen* brought in $5.5 million, so both the studio and the Canteen reaped the rewards of the picture's success.

While *Hollywood Canteen* was underway, Jerry Wald, former screenwriter and now producer at Warner Bros., convinced his boss to buy the motion picture rights to *Mildred Pierce*, a 1941 bestselling novel by James M. Cain. It would become Cain's third big success following *The Postman Always Rings Twice* and *Double Indemnity*. He specialized in contemporary crime novels, all set in California, and, along with Dashiell Hammett (*The Maltese Falcon*) and Raymond Chandler (*The Big Sleep*), wrote the sort of stories that had been featured in cheap paperbacks. Now, gritty tales of contemporary Los Angeles mayhem entered into the literary mainstream and became classics. They became motion picture classics, too. *The Maltese Falcon* was the first to be made into a movie (1931), and was more famously remade in 1941 with Humphrey Bogart. Cain's *Double Indemnity* was bought by Paramount and filmed in 1944 with Barbara Stanwyck and Fred MacMurray. This inaugurated a genre of motion pictures that later would be branded film noir, sinister stories filmed in a dark and brooding style that harkened back to German Expressionism.

The right vehicle for Crawford finally came along. *Mildred Pierce* tells of a woman who sacrifices her marriage to build an independent career and then her business to win and sustain the love of an ungrateful daughter. It read like a

Crawford picture, and Wald bought it as the ideal story for her studio debut. Cain's books were popular because they were explicit stories of love and sex, revenge and murder, but they were plotted such that, as written, they would be impossible to film under the continuing heavy hand of the Production Code. Paramount had to clean up *Double Indemnity* before it could get a script past the censors. Similarly, *Mildred Pierce* would need extensive revisions before it could reach the screen.

Crawford claimed, as did some authors, that Bette Davis and Barbara Stanwyck were the first choices to play Mildred.[11] As underdog, Crawford's success as Mildred is all the more exciting if we believe that her new studio initially didn't want her for the role, and it adds drama to the famous "comeback." It's a good story, often repeated, even by Crawford herself, but the truth is different. Wald purchased the novel in March 1944, and, according to Cain, Wald had decided on Crawford even before the deal was completed.[12] He announced to the Hollywood press in June that Crawford would star in the film version, and in the dozens of spots in the 1944 trade papers only one name was ever mentioned. Jack Warner had a half-a-million-dollar deal with Crawford, and for a year she had made a single, yet to be released cameo appearance. It was time to get her to work. Davis did occupy the top notch at the studio, but wrote in a letter to film historian Albert LaValley, "I was never offered the part of Mildred Pierce. . . . [Screenwriter] Miss Turney wrote many of my scripts but this one was never intended for me."[13] Stanwyck claimed she did want the part, but her great era at Warner Bros. was in the early 1930s, and more recently she had been working at Paramount, so she was an unlikely prospect to usurp Crawford's claim on the script.

Stanwyck did have an ally with Michael Curtiz, whom Wald had engaged in July to direct the film. Curtiz was Warner Bros.' top director, having shot both *Casablanca* and *Yankee Doodle Dandy* for the studio in 1942, and two years earlier, *Virginia City* and *The Sea Hawk*. Like many directors before, he was not sure that Crawford was up to such a dramatic role, and told Wald he preferred Stanwyck as Mildred.

Again, Crawford showed her true professionalism. Rather than invoking her stardom, and demanding the part she knew had been bought for her, she told Wald that she would make a screen test. "[Curtiz] broke down and cried, watching my test scene," Crawford later wrote, and whether true or not, she convinced him she could handle the role. In order to insure that she was surrounded by the best possible talent, once her part was set, she became a strong voice within the production team. "I asked to test with each potential member of the cast—a task usually relegated to a stock actress. . . . It took six weeks of casting to elect our cast: Ann Blyth, Jack Carson, Zachary Scott and Bruce Bennett."[14] Carson and Scott would receive above-the-title credit, following Crawford.

Carson and Scott were easy to cast, Carson playing the slightly shady business partner and Scott, the sinister second husband. More difficult, however, was filling the role of Veda, Mildred's complicated daughter. Martha Vickers and

Crawford with Ann Blyth and Zachary Scott on the set of *Mildred Pierce*, 1945. Photo by Milton Gold.

Bonita Granville were tested, and at one point Wald suggested Shirley Temple, an idea that did not find favor with Curtiz. Ann Blyth had been a child actress in New York and had scored so well in *Watch on the Rhine* on Broadway that she was signed by Universal in late 1943. She made four pictures in rapid succession, only one of which had been released before she auditioned for Veda. "So it just clicked," Blyth recalled testing with Crawford. "Everything about the scene we did, it worked."[15] Warner Bros.' borrowed her from Universal, and she was a superb choice. Although she was only sixteen, Blyth was able to portray both the vulnerability of late adolescence and the nascent sophistication of early adulthood.

Eve Arden and Butterfly McQueen had important supporting roles, Arden playing her signature wisecracking best friend, and McQueen, the maid. "Film Parade," a movie feature in *Ebony*, told readers that McQueen didn't want to play these sorts of roles:

> Butterfly McQueen has been a Hollywood favorite for maid roles . . . she again dons the apron to play the part of Lottie, a kitchen employee. . . . Butterfly doesn't like servant roles, but she once was boycotted by film agents for 13 months because she balked at maid parts. . . . She gets one of the biggest laughs in the picture when she jibes Jack Carson who in a

restaurant scene has put on an apron: "You look pretty." He replies: "Thank you." Her comeback: "Likewise, I'm sure."[16]

The cast was ready but not the script.[17] Many writers, including Cain, as well as William Faulkner, attempted to turn the book into a film without success. A critical issue was the looming sword of censorship. At one point, Wald sent a treatment to Joseph Breen at the Production Code Administration (PCA), where it was rejected outright:

> The story contains so many sordid and repellent elements that we feel that the finished picture would not only be highly questionable from the stand-point of the Code, but would, likewise, meet with a great deal of difficulty in its release—not only through Censor Boards, but from other public groups as well. . . . In the face of all this, we respectfully suggest that you dismiss this story from any further consideration.[18]

Wald felt that he had invested too heavily in the project to be persuaded by the PCA to abandon *Mildred Pierce*, even though Warner was willing to cancel the film and absorb the expenses thus far charged to the production including the $15,000 payment made to the author.[19] The producer needed a script that was true to the book, would make an exciting film, and get the necessary clearance from the censors.

Writer Catherine Turney finally shaped the story to Wald's satisfaction. He had asked her to frame the film as a flashback and add a murder (not in the novel) that shadows the action. By tempering the many instances of adultery and leaving the obvious to audiences' imagination, she was able to outwit the PCA. The story of Mildred's journey from penniless waitress raising two children to successful restaurant owner took on an added excitement as moviegoers from the earliest frames knew a dramatic conclusion was coming but had a mere glimpse of who might, or might not, be the murderer. Before she could finish the script, Turney was called to work on *A Stolen Life*, a Bette Davis film that was then in preparation. Ranald MacDougall finished the script and was accorded final screenplay credit when Turney, on the advice of her agent, turned down co-authorship after being offered second position after MacDougall, a decision she regretted when the film became a hit.[20]

In November, in an attempt to skirt censorship concerns, the studio announced a name change. The new film would be called *House on the Sand*. Wardrobe test shots survive that reflect the new name.[21] Wiser heads prevailed and by the end of the month the original title was restored.

Costumes were created by one of Warner Bros.' top designers, Milo Anderson. He had worked with Crawford back in 1932, when, as a newcomer, he supervised the wardrobe for *Rain*. A dozen years later, she was the newcomer in his domain:

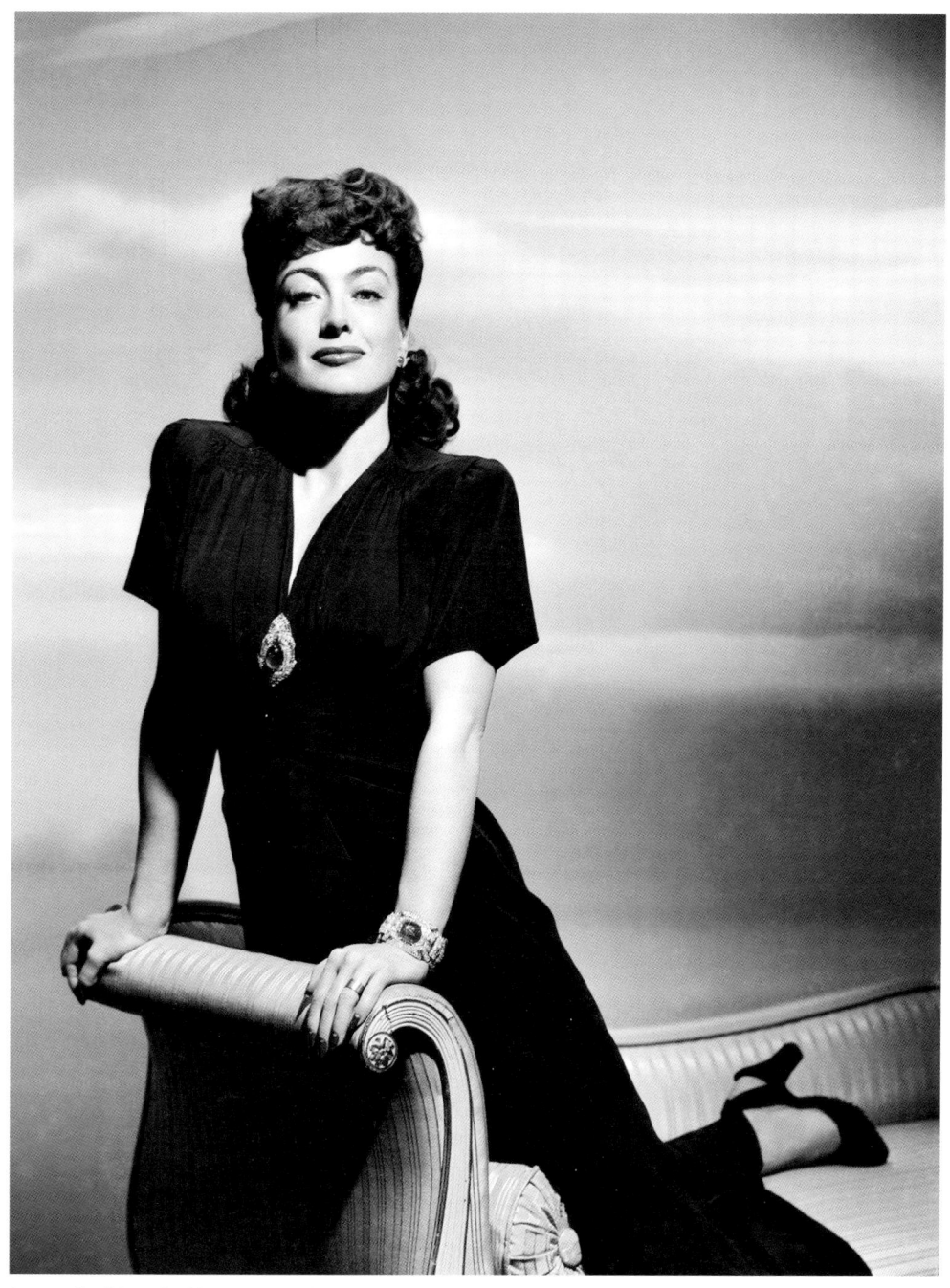

A portrait of Crawford by Bert Six taken during the production of *Mildred Pierce*, 1945. John Kobal Foundation.

"She was impossible from day one. She insisted that we go out to her house to do the fittings—something that we never did for anybody, and when we got there she didn't want to fit after all."[22] Crawford had different memories:

> For my early scenes, the studio designed some cotton frocks. Mr. Curtiz said NO, they looked too smart. I went down to Sears Roebuck on my own and bought the kind of housedresses I thought Mildred would wear. When I arrived on the set for wardrobe tests, Mr. Curtiz walked over to me shouting, "You and your damned Adrian shoulder pads. This stinks!" And he ripped the dress from neck to hem. . . . "Mr. Curtiz," I sobbed, "I bought this dress this morning for two dollars and ninety-eight cents, there are no shoulder pads," and I rushed to my dressing room in tears.[23]

Somewhere along the way, a compromise was reached. There would be no $2.98 dresses, and, in fact, many of Crawford's outfits would feature padded shoulders. In keeping with her reputation as one of the screen's best-dressed stars, even playing a Depression-era, working-class character created by James M. Cain, the studio announced to fans, "Joan Crawford will have 50 costume changes in 'Mildred Pierce.'"[24]

Filming began in mid-December, and, at last, Crawford was back at work. Curtiz, hearing that Crawford could be difficult on the set, decided to be more difficult. "Don't let him hurt you," an assistant director advised, "he'll needle you if you let him. Don't let him." The two reached a rapprochement. "I sailed into Mildred with all the gusto I'd been saving for three years, not a Crawford mannerism, not a trace of my own personality."[25]

What was different this time? Why did Crawford impress critics and studio bosses after a series of mediocre films at MGM? She was right that a good script makes all the difference. But, we also see a more skilled actress. She had spent twenty years learning how to play many different characters on screen. Jazz babies and glamour girls were followed by sophisticated women, but in nearly all those films she reminded audiences that she was Joan Crawford, first ingénue, then leading lady, and finally movie star. It was an essential marketing tool as strongly defined personalities form the basis of screen stardom. For the first time, playing Mildred, she inhabited a character, leaving aside the learned mannerisms that had contributed to her success. Now she relied on the acting skills she had honed at MGM. Make no mistake, *Mildred Pierce* is a dazzling star turn for Crawford, but gone is Cinderella's vulnerability, gone is the desperation to sing and dance and entertain, and gone is the beautiful woman who in the end just wants her man.

Working with Crawford was among Warner Bros.' best cinematographers, Ernest Haller, who had photographed many Bette Davis films (*Dark Victory*, *Jezebel*), as well as *Gone with the Wind* and *The Maltese Falcon*. His dazzling work on *Mildred Pierce* earned him an Academy Award nomination. Max Steiner wrote

the score. If not one of his legendary compositions, Steiner's plaintive score in combination with Haller's brooding camerawork created the mood that helped make the film a motion picture classic.

Before *Mildred Pierce* opened in theaters, Louella Parson wrote in *Modern Screen*, "These are the Unforgettables!" and paid tribute to Crawford's remarkable career:

> *The Most Movie—Starrish—Of—The—Movie Stars?* Mae West? Marlene Dietrich? Jean Harlow? Lana Turner? No—I say Joan Crawford gets the prize for being the girl who for the longest time has remained the popular conception of what a Hollywood star should be. . . . From the moment she came to Hollywood she was NEWS was a capital N. . . . Long before she became an official star at M-G-M she was garnering more publicity than the brightest lights on the lot.[26]

Parsons had heard rumors that Crawford's performance might well be her hoped-for successful return to the screen, but even the widely read and influential columnist could not have anticipated that "the girl who for the longest time" was launching a second (or maybe third) professional phase that would outshine even her greatest successes at MGM. Lest any actress who has passed the forty mark, as Crawford did while *Mildred Pierce* was filming, believe that her best years are behind her, *Mildred Pierce* is a dazzling example of mid-career glory. For Crawford, 1945 turned out to be not even the halfway mark of her motion picture career.

"Mildred Pierce . . . Don't ever tell anyone what she did" was the tag line a studio publicist came up with to promote the film, and created anticipation as audiences in big cities and small towns awaited the chance to find out for themselves. Fans had waited twenty-five months for a new Crawford picture. Opening night, on September 24, 1945, took place in New York at the Strand Theater on Broadway. Wald and Warner knew they had a hit. The film grossed $5 million making Crawford's salary of $166,500 seem a bargain.

Most critics agreed with the fans. "Two hours seldom have slipped by faster nor more eventfully in a movie theater,"[27] was the opinion of the *New York World Telegram*. "Crawford reaches a peak of her acting career," wrote *Variety*, and "justifies Miss Crawford's two-year wait for a proper story."[28] "Despite all kinds of chances to go berserk," said the *New Yorker*, "Crawford remains subdued and reasonable."[29] Both the *New York Times* and the *New York Herald Tribune* were tepid about the film, but that didn't matter, as *Photoplay* made clear: "Crawford fans, attention—your dream girl is back."[30]

Crawford had every right to be proud of her work, and she reveled in the seemingly endless attention she received from friends, fans, and the press now that she had climbed back to the top of the Hollywood heap. All the insecurity she had felt those past four years evaporated the second she heard the applause

Crawford accepted her Oscar for *Mildred Pierce*, 1945, at home in bed from director Michael Curtiz.

at the Strand Theater. Once again she was Joan Crawford, top movie star, and whether or not she would reign again as queen of Hollywood didn't matter, for she was something greater: a real dramatic actress. It had taken her two decades to evolve from ingénue to leading lady to fashion icon to glamorous movie star, and now she could stand up to Davis and Garson.

She desperately wanted a brilliant success as Mildred, but there was one noteworthy casualty, her marriage to Phillip Terry. Louella Parsons broke the news in mid-December that the couple had separated. When depressed and in the dumps, Crawford had needed Terry's calm stability. Now, brimming with accolades and a level of attention she hadn't felt in years, Crawford discovered she was bored with him. Ruth Waterbury, her friend and a writer for *Photoplay*, was not surprised to learn of the split: "Her days were suddenly crammed with conferences, phone calls, interviews, photographers." Terry was relegated to answering the phone and door, and looking after the children, but, of course, it was always "'her' New York apartment and 'her' Brentwood house and 'her' children." Waterbury understood the underlying truth. "Their marriage could have succeeded if Phil had achieved any outstanding success in his career."[31] Terry was the first husband she needed to pay off, and she claimed, "I was almost destroyed financially." Was changing Phillip Jr.'s name to Christopher part of the deal?

The praise of fans and critics was important, but the highest accolade possible arrived in late January when she received her first Academy Award nomination as Best Actress. The others nominated were Ingrid Bergman for *The Bells of St. Mary's*, Greer Garson for *The Valley of Decision*, Jennifer Jones for *Love Letters*, and Gene Tierney for *Leave Her to Heaven*. Bergman, favored to win, had received the New York Film Critics award earlier in the month, with Crawford and Deborah Kerr, for *The Life and Death of Colonel Blimp*, tying for second place. *Mildred Pierce* also received Best Picture and Supporting Actress nominations for Ann Blyth and Eve Arden.

Crawford's big night was March 7. Practically no one believed her story that a high fever kept her from attending the awards ceremony at Grauman's Chinese Theater. Whether it was the flu or nerves or the unwillingness to face public defeat, she took to her bed, albeit in full makeup and with a radio hookup between her house and the theater. At least one photographer was stationed downstairs—just in case. Charles Boyer announced her victory; Curtiz picked up the Oscar and immediately was driven the eleven miles west on Sunset Boulevard to Brentwood to present her with the award. By then, she had miraculously recovered, although she greeted Curtiz, guests including Van Johnson and Ann Blyth, reporters, and photographers from her bed. Morning telegrams flooded her front door including congratulations from Ingrid Bergman, Bette Davis, Louis Mayer, Harry Rapf, and Jack Warner.

Crawford had gambled a predictable, if frustrating and likely uninteresting future at MGM, for a new challenge at Warner Bros. And her new studio—home to veteran Bette Davis and newcomer Lauren Bacall—bet that she could find a place, and be worth half-a-million dollars. Both won. She had found a strong ally in producer Jerry Wald, and they would continue to work together. Warner had hoped for a prosperous collaboration, but could he and his new star have imagined the Crawford renaissance on the horizon? Maybe Crawford did when she wrote, "Oscar's not the end, he's a new beginning."[32]

Warner Bros. Star

BEFORE THE OSCAR NOMINATIONS FOR 1945 WERE ANNOUNCED, Crawford was busy at work on her follow-up to *Mildred Pierce*, *Humoresque*, advertised as a remake of a Fanny Hurst short story that had been filmed in 1920. The new version of *Humoresque* started its life not based on the Hurst story, but as part of a draft of a script for *Rhapsody in Blue*, based on the life of George Gershwin. Jerry Wald was scheduled to produce *Rhapsody in Blue*, but when writer Clifford Odets delivered a 900-page shooting script (the typical film is closer to 250 pages), Jack Warner fired Odets and the film was assigned to another producer. Wald felt Odets's script had the makings of as many as three good pictures, and asked writer Zachary Gold to fashion a story changing the pianist into a violinist and incorporating it into a property the studio already owned, *Humoresque*.[1] The newly imagined script tells the story of a working-class boy who fancies a violin as a gift, and when his mother agrees to the extravagance, he repays her by becoming a concert artist. This follows the Hurst story, but the contemporary twist is that our hero becomes the protégé of an older woman both wealthy and beautiful.

The role of the violin prodigy was played by John Garfield. It had been announced for John Dall, who was signed by Warner Bros. in 1944 to play opposite Bette Davis in *The Corn is Green*, and in his motion picture debut he was nominated for an Oscar. Garfield was nearing the end of his seven-year contract with Warner Bros. and had decided not to renew. On a loan-out to MGM, he had completed playing the lead in Cain's *The Postman Always Rings Twice*, with Lana Turner. The studio wanted one more picture before he left in February 1946, and there was time enough to squeeze in another film. Jerry Wald switched Dall for Garfield. He mentioned the script to Crawford, and she was interested. The problem was that the violinist's story dominated the action. She wanted the role of music patron so her character had to be augmented, but in a manner that would still allow a shadow of the original Hurst story to be retained. Gold now had the task of modifying the Odets script further and enhancing the female lead to a role worthy of Crawford.

Crawford and John Garfield on the set of *Humoresque*, 1946. Photo by Jack Woods.

It takes about thirty minutes for young Paul Boray to grow from boy to man, but as soon as he does, he is invited to an elegant musical soirée hosted by Helen Wright, a society lady always on the lookout for remarkable talent, especially when he is young and attractive. When we first see Crawford—in movie star close-up—she is wearing glasses, as her character is near-sighted and wants to get a good look at the newcomer to her parties. Not many actresses would allow their faces to be so covered, but Crawford bravely peers through the lenses and then removes them, revealing that even past forty she is still one of the greatest beauties in the business.

Jean Negulesco directed and immediately upset his star. "She wants to know what is behind every scene," Wald told him. "She says you don't tell her what her scenes mean, what the motivation is." This was not the director's style. "Flatter her," the producer suggested, but still Negulesco didn't know how to get through Crawford's tears. "Show her," his wife suggested. A talented amateur draftsman, he "drew a flattering portrait of her character . . . with eyes closed, but exuding an inner feeling of controlled passion. . . . It was drawn in a pleasant sanguine pastel

. . . The next day I presented it to her with a note and a single dark red rose. . . . The note read: 'Dear Joan, This is the Helen Wright I see and dream of—only you could give her to me. Jean.'" It worked. "Now I know" was her response.[2]

Ernest Haller was the cinematographer, once again providing an atmospheric background for the stars and the cast. Oscar Levant played Garfield's wisecracking best friend who often delivered his acerbic barbs while playing the piano.[3] Levant was also one of the few actors who had the temerity to criticize Crawford for her constant knitting on the set. Twenty-six-year-old Isaac Stern dubbed Garfield's violin playing and served as music advisor. It is not, however, his hands but those of another violist deftly inserted such that Garfield appears to be playing the instrument. Henry Waxman was the music director. Twenty-three pieces of classical music (often bits) were included and were played by an orchestra reported as made up of 115 musicians. Along with Dvořák's title piece, music ranged from the popular (the theme from Bizet's *Carmen*) to the melancholy (Wagner's *Liebestod*, which was used to great effect in the film's final moments).

After suffering Crawford's wrath on *Mildred Pierce*, costume designer Milo Anderson refused to work with her again. Warner Bros. then assigned Bernard Newman to prepare her *Humoresque* wardrobe, and predictably, she didn't like it. She turned to friends Adrian and Sheila O'Brien for help. O'Brien had been Irene's assistant first at Paramount and later at MGM, and had worked with Irene when she designed Crawford's dresses for *They All Kissed the Bride* at Columbia. During the mid-1940s O'Brien was not affiliated with a studio and worked as a dressmaker, often designing outfits for Crawford. O'Brien reviewed Newman's designs and agreed with Crawford that they were too matronly. She had made a beaded white dress for Crawford that they thought would be perfect for the film, and then at Crawford's request designed a complete wardrobe for her character. At least one dress made by Adrian was also used in the film and for that he was accorded top screen credit (over Newman). O'Brien was ignored.[4]

Soon after filming started in December 1945, Garfield was called back to MGM. Warner Bros. agreed to release him, but this necessitated that the production be shut down temporarily and "Metro had to pay Warners close to $50,000 for four days of retakes."[5] It was worth the money for MGM because *The Postman Always Rings Twice* was a big hit. Garfield's soaring stardom benefited *Humoresque* at the box office when it opened a few months later.

He was also an ideal partner for Crawford. Wald found in Garfield a younger actor with a strong screen presence. In *Mildred Pierce* all the men are weak: Bruce Bennett, who portrayed her first husband, and Zachary Scott, her second. Not so Garfield. He was eight years her junior with a rugged handsomeness, and his inner tough male matched perfectly her strong female. "They go together like dynamite and a lighted match," wrote Dorothy Kilgallen, "her smoothness, his roughness; her glitter, his quietness; her curried glamour, his brutal sex appeal, make an electric combination."[6] The last time anyone had written so feverishly

Drawing of Crawford made by director Jean Negulesco during the production of *Humoresque*, 1945; it became a prop used in the film.

about Crawford's connection to an actor was when she was working with Gable. It's a pity that Crawford and Garfield never had another chance to share the screen.

Many Crawford biographers and fans, then and now, consider *Humoresque* her best performance as well as the film in which she was the most radiant. She learned of her Oscar nomination in January, and the accolade must have strengthened her confidence to play the jaded and cynical character exactly as written. As she had demonstrated in *Mildred Pierce*, Crawford could play a more nuanced character than Crystal Allen (who really did have a soft side), and for the first time in her long career doesn't ask the camera or her audience to see her as sympathetic. Rather, she portrays Helen Wright as an unabashed cougar. Playing a woman "rich in worldly goods and poor in soul," wrote Kilgallen, is "a combination which it must be admitted makes richer screen fare than the vice

versa."⁷ The final scene is played mostly in extreme long shots following Crawford walking along the beach, and the motivations that led to her suicide are left to the audience to ponder. The accompanying music, Wagner's *Liebestod*, adds the pathos rather than any emoting by the star.

Garfield got good reviews, but like *Mildred Pierce* before it, the raves were saved for Crawford. She "doesn't appear until the film is well underway," wrote *Motion Picture*," but from that moment on, it's all hers."⁸ "Joan Crawford's role is an acting part, rather than a typical femme star assignment" was *Variety*'s assessment, and her "talent carries it off with top honors."⁹ "Miss Crawford has reached the zenith in her field for she has perfected her art to the point where she is not just an actress," gushed *Movieland*, "but a human being living the character she portrays."¹⁰

Praises came from most critics, but Bosley Crowther, writing for the *New York Times*, continued demonstrating his unremitting loathing for Crawford and produced another scalding review. He pronounced the film as "mawkish lamentation . . . unadulterated schmaltz . . . piteous affair," disliked both Garfield and Levant, and described Crawford as "violently emoting." His conclusion: "The music we must say is splendid—and, if you will only shut your eyes . . . you may enjoy it very much. . . . We offer no recommendation to any other part of it." This time he disliked the film as much as the star, but in later reviews would direct his spleen mostly towards Crawford.

She may have gotten used to Crowther's anti-Crawford tirades, but a new enemy was lurking nearby. "I can hardly believe that Bette Davis is being as rude to Joan Crawford as the spies on the Warner lot tell me," Louella Parson reported. "The other day, the air turned to icicles when Joan entered the commissary and seeing Bette, went up to her table with the intention of inviting her to a dinner party. While Joan stood there, Bette continue to eat with gusto and relish, barely looked up. . . . I'd hate to think such unusual conduct was because this was the first time in many years that Bette wasn't in the running for an Oscar herself."¹¹ It got worse. "Joan Crawford is quite disturbed these days and not without reason. When she went into work on 'Humoresque,' the studio promised it would be released immediately upon completion. The film was completed several months ago but there has been quite a stalling act. It seems that 'Deception,' the Bette Davis starrer, is a film of the same type and Miss Davis insisted that hers goes out first (and in time for Academy consideration) even though it was finished not more than five weeks ago."¹² Competition between the two women may have been simmering for years, but it reached a boiling point (for the first time) in 1947. Davis had won two Academy Awards (*Dangerous*, 1935; *Jezebel*, 1938) and was anxious for a third. Davis won this round as the most senior of the Warner Bros. actresses, and stalled the release of *Humoresque*, although neither received an Oscar nomination that year.

Davis might have been galled by all the attention Crawford's renaissance was getting in the press. "If we asked you who you think is the 'hottest' star in

Hollywood today—among the people of Hollywood itself—what would your answer be?" Cal York, popular *Photoplay* columnist, asked readers while *Humoresque* was being filmed. "It would probably be one of the 'younger set'—but you'd be wrong. The star is Joan Crawford, and not even at the height of her first zoom to cinema glory, has there been as much complimentary chit-chat over lunch and dinner tables as there is about Joan these days."[13]

This "chit-chat" reached the ears of the Hollywood Women's Press Club, who awarded Crawford a 1946 Golden Apple Award, her second honor in a row. The Golden Apple was given to the star thought to be the most cooperative with members of the press. In 1945, Gregory Peck was the actor acknowledged, and in 1946, it was Dana Andrews. The awards were first given out in 1941 and continued for sixty years before ending in 2001.

With *Humoresque* wrapped up, Crawford had time for a bit of unfinished business: divorcing Terry. They had been married for less than four years and separated the previous December. She filed in mid-March, and the divorce was official the next month. Almost immediately, or perhaps earlier, she took up with a dashing lawyer named Greg Bautzer. Like most of the men she fancied, he was younger and had already made a reputation as having an eye for Hollywood beauties, previously dating a sixteen-year-old Lana Turner and being engaged to Dorothy Lamour. None of this bothered Crawford, who sought him for herself, and they had a tumultuous relationship that lasted on-and off for four years. Bautzer was cut from a different cloth than Crawford's recent husbands. Handsome and charming like the others, he was not an actor, but he had achieved enormous success as one of Hollywood's most successful lawyers, counting even Howard Hughes as his client. Having been married to three actors may have encouraged her to look farther afield for romantic entanglements.

As soon as her divorce was finalized Crawford packed up her children and made a trip to La Quinta, a resort near Palm Springs. Bautzer discovered her plans and hired a plane to pursue the star—or did the two of them have this all figured out in advance? With the children back at the resort supervised by nannies, the new couple were spotted dancing at local clubs, and he showered her with gifts, daily orchids, jewelry, a gold compact, and cigarette case.[14] Before long he was her regular escort and a constant visitor to her Brentwood house. The children called him Uncle Greg. He was one in a long series of "uncles" the children would come to know.

With a new man by her side, Crawford was ready to entertain again in a grand style. Most notable was a party she gave for Noel Coward. No less an authority than Elsa Maxwell wrote about the evening declaring it "brilliant": "Joan took over the elegant Papillon, lock, stock, and barrel. And Billy Haines, in charge of the decoration, arranged for Papillon to be a bower of pink gardenias." Maxwell shared a bit of the guest list, numbering 200, a "who's who in the film colony": Irene Dunne, Ginger Rogers, Barbara Stanwyck, Robert Taylor, Marlene Dietrich,

Loretta Young, Claudette Colbert, along with Bautzer's former amour, Dorothy Lamour, and two of Crawford's ex-husbands, Fairbanks Jr. and Tone with their wives (Terry was not invited). An orchestra played all evening except when Tony Martin got up to sing or when Jack Benny rose to play the violin. Maxwell asked Coward if he participated in the entertainment. "I went to the piano and sang, 'I've Just Been to a Wonderful Party.'" All was perfect except one gaffe. Crawford seated Bautzer at her right instead of the guest of honor. Etiquette demands, of course, that the guest of honor takes that prominent position.[15]

To celebrate redecorating her house, which she did every time a husband left, she hosted a formal dinner party for forty. "Guests were seated at individual tables for four or six—and her own enlarged dining table almost sagged under the weight of the lavish buffet, to say nothing of the buckets of champagne. Each table was bedecked with masses of heather, peach blossoms, anemones, and candytuft." In keeping with the privileges of stardom, and supported by her high income, she had all the new fabrics woven in unique custom-made designs.[16]

Crawford thrived in being busy: entertaining, running a large house, starting a new romance, raising children, and making films. She even found time to pen an advice column for *Movieland*. "Would you like Joan Crawford to help solve your problems?" Her column ran from May 1947 until it concluded in December 1949, and the answers to questions have that no-nonsense, hard-bitten Crawford touch, suggesting her close involvement with the magazine. But acting always came first, no matter how persistently she tried to convince the world that her true calling was motherhood.

If you look at the newspaper columns and fans magazines in the years following Crawford's divorce from Terry, it is not only Bautzer who is mentioned as an escort but there are occasional glimpses of a rekindled (if it ever actually died out) romance with Gable. "Clark is the most wonderful guy in the world," she told reporter Robbin Coons in 1947. She needed the stability of that long-term male friendship. Christina Crawford remembered ferocious late-night rows between her adopted mother and "Uncle Greg," with screaming and slamming doors.[17] At one point, Crawford was so angry that she moved her family to the New York apartment. Bautzer followed. "It took three complete transcontinental flights," according to Ruth Waterbury, "to finally effect the reconciliation." She stayed east for four months returning when it was time to go back to work.[18]

Her third and final film due under her Warner Bros. 1943 agreement had been selected: she would make *Possessed* in the late spring and summer of 1946 even while the release of *Humoresque* was stalled. After this project, Crawford was free to look elsewhere for work. Warner wanted her to stay on at his studio, but given her spectacular box-office successes, other companies vied for her services.

Jack H. Skirball and Bruce Manning, independent producers releasing through Universal, offered Crawford a contract in May 1946, as she was preparing to begin *Possessed*, and she agreed in principle to make three pictures for them. *Portrait*

Crawford and Van Heflin on the set of *Possessed*, 1946.

in Black, to have been directed by Carol Reed, would have been the first, and it was heavily promoted during that summer as an upcoming Crawford film.[19] A second film was also promised, the romantic drama *The Barren Heart*.[20] Apparently, she never signed the contract and was toying with the fellows in order to score a better deal with Jack Warner. With two of their three pictures completed, Warner offered Crawford new and more lucrative terms. He offered her a seven-year contract at $200,000 per picture, and a Garbo-like agreement in which she would have script, director, and costar approval. No work could be scheduled for the summer so she could spend that time with her children. She would also be accommodated if she wanted to make up to three films for other studios. It was a cake-and-eat-it-too deal, and she could have made *Portrait in Black* had she wanted it. She didn't—whether it was the script or the money offered—and instead, after she finished *Possessed*, she looked elsewhere for her next project.

Possessed was based on *One Man's Secret*, a story by Rita Weiman that had appeared in *Cosmopolitan* (March 1943). After two films in which her characters dominated the men around them, Crawford was back playing a woman vulnerable to a man's attention. Her character, Louise Howell, is obsessed with David Sutton, played by Van Heflin, and when he leaves her, depression follows that turns

into schizophrenia with murderous consequences. The supporting cast includes Raymond Massey, who plays the man she marries, and Geraldine Brooks, in her screen debut, as her stepdaughter.

Wald selected as director Curtis Bernhardt who had helmed a series of successes for Warner Bros. including *Conflict*, with Humphrey Bogart, and *My Reputation*, with Stanwyck. Instead of bringing back Ernest Haller, who had photographed both *Mildred Pierce* and *Humoresque*, he engaged Sidney Hickox, but after about a month Crawford registered her displeasure with the choice and asked for Haller (there were rumors that she went home and refused to work until Hickox was replaced). He wasn't available, but Wald brought in Joseph Valentine whom Crawford liked, and he completed the picture receiving sole credit for the cinematography. Costumes were simpler this time. Sheila O'Brien and Adrian shared the duty of making Crawford's outfits, but once again only Adrian was acknowledged.

Crawford had made another film called *Possessed* back in 1931 with Gable, and she hoped that the new film could retain the title of the original story or be shortened to *The Secret*. Alas, the powers at Warner Bros. were set on *Possessed*, so in her filmography there are two films with the same title that have nothing to do with each other.

For the third time is a row, Crawford had a critical and box-office hit, and when the numbers for 1947 were reported she had two films on the list of the top 75 top grossers, *Humoresque* at number 46 ($2,600,000) and *Possessed* at number 59 ($2,200,000). The critics were enthusiastic (except, as usual, Crowther). "Miss Crawford, who's been tackling a series of difficult roles in her recent pictures," acknowledged *Variety*, "cops all thesping honors in this production with a virtuoso performance."[21] Breathlessly, the reviewer for *Movieland* tells us that "Joan Crawford proves once again that she is the finest emotional actress on the screen today. . . . She dominates every moment of the picture. . . . She carries you along on an emotional wave that will make your hands clammy . . . that will cause your heart to beat faster with genuine suspense."[22] "The film is uncommonly well acted," wrote the critic (possibly James Agee) for *Time*. "Though she is not quite up to her hardest scenes, Miss Crawford is generally excellent performing with the passion and intelligence of an actress who is not content with just one Oscar."[23] And Crowther gives us this: "Despite some classy histrionics, Miss Crawford . . . appears more a representation of a pampered actress than a truly jangled dame."[24]

Crowther is partially wrong, as Crawford gives a performance, elegantly wrought and believable, worthy of the Academy Award nomination she received. Playing an emotionally unstable character who descends into madness, she is convincing as a woman who outwardly seems in control of her emotions, when in fact she is suffering the mental illness that ultimately consumes her. But, he was right that she had become a pampered actress. Following up her success in *Mildred Pierce* with two splendid money-making performances, Crawford's career was at its peak. Always the movie star, she was behaving more regally than ever

with lavish entertainments, a revolving door of dashing escorts, and no-expense-spared hand-made fabrics. Known for her professionalism, she was now fighting with the colleagues who used to be her buddies. Crawford may not really have been everyone's best friend back in the 1920s and 1930s, but she tried to give that impression to the press and public. By the late 1940s, her head filled with a new generation of spectacular triumphs, she had stopped trying.

When the Oscars were announced, Crawford lost to Loretta Young (*The Farmer's Daughter*); the other nominees were Susan Hayward (*Smash-Up: The Story of a Woman*), Rosalind Russell, (*Mourning Becomes Electra*), and Dorothy McGuire (*Gentleman's Agreement*). All the performances were worthy of the statuette. For Crawford, this second nomination validated once and for all her decision to leave MGM and seek a different professional path. Warner was rewarded financially, and Crawford added luster to his studio, which, in the mid-1940s, must have annoyed Bette Davis.

Jerry Wald felt that after three successful films in a row she deserved a vacation. Crawford agreed, and off she went . . . "for two whole days." [25] That was enough. She wanted to keep working as she was riding on the biggest professional high of her two-decade career. She found a new project, but it was not at Warner Bros. In the winter and spring of 1947, she was spotted dining with Otto Preminger. Was it personal or professional? It turned out that she coveted the title role in *Daisy Kenyon*, a film which Preminger had been planning to make since mid-1945 when 20th Century-Fox paid $100,000 for the film rights to Elizabeth Janeway's best-selling novel. The publisher claimed 20 million copies had been sold. Crawford had wanted it for herself, but either she or Warner Bros. had lost to Fox. Gene Tierney had been widely advertised as Preminger's star, and regardless of whether she pulled out, or Preminger simply decided to replace her, Crawford got the role and filming began in early summer.

Playing Daisy, Crawford returned squarely to her MGM roots. Here was another story of a woman torn between two men, one wealthy and unhappily married, the other a nice guy and a returning war veteran. The rivals were played by Dana Andrews and Henry Fonda. Who would she choose? Ruth Warwick played Andrews's wife. At forty-two, she was too old to play such a role, but carried off the soapy melodrama with typical Crawford style although the story is so slight that even Preminger's able direction couldn't make it more than a diversion. Sparks were predicted to fly when tempestuous director met the exacting actress on the set. Reports were to the contrary. "I had a happy time making *Daisy Kenyon*," Preminger wrote in his memoirs, "with that remarkable, independent, and competent woman." He may have been softened by her generosity and recalled that she made him a gift of beautiful garden furniture after noticing his rather shabby outdoor furniture on a visit to his house. He also noted that Crawford insisted the set be kept cool, too cool for the comfort of her male costars, so she delivered to both sets of long underwear. [26]

Crawford and Dana Andrews on the set of *Daisy Kenyon*, 1947.

Daisy Kenyon looks good thanks to the cinematography of four-time Oscar winner Leon Shamroy (eighteen nominations in total). Reviews, however, were tepid, but stalwart Crawford fans showed up at theaters: the film took in a respectable $1,750,000, but still registered a loss for 20th Century-Fox. Today it seems to be gaining a following as an unheralded Preminger minor masterpiece, although the director wrote that he hardly remembered the picture. Whatever the current sentiment on *Daisy Kenyon*, the film doesn't afford Crawford a magnificent central character that equals her three earlier Warner Bros. pictures.

While *Daisy Kenyon* was in preparation Crawford was in the midst of another adoption. Twin girls had been born in Tennessee in January 1947, and through the Tennessee Children's Home Society, a sketchy agency run by Georgia Tann, she was able to add two more children to her family, Cynthia and Cathy. Crawford's soaring ego and perceived invincibility precluded any thoughts of the ethics of a single woman purchasing children and having them conveniently adopted out-of-state. *Daisy Kenyon* completed filming in late summer so Crawford may have waited until retakes were finished before having the babies flown to Los Angeles.

Crawford resting in her backyard after an especially exhausting game of badminton. Photo by Eric Carpenter.

"Four little faces, changing daily as they responded to each new filament and fragment of living," she wrote about her brood. "Four pairs of hands reaching to clasp mine. They changed my life. . . . Being a mother is a full-time job." With two more children in the house, Christina and Christopher moved into what had been Terry's bedroom, and the room they previously shared became a nursery. Household rules were strict and unalterable. Regardless of what time Crawford got up, if "Mommie was home and asleep we were not allowed to speak above a whisper . . . we also had to walk on tiptoe as long as Mommie slept."[27] She was clear about her philosophy of parenting: "Discipline is part of a child's security. If the adults he believes in fail to punish him for wrong doing, he ultimately loses confidences in those adults."[28]

With four small children in the house, she took off a year before working again.

Later Films at Warner Bros.

AFTER COMPLETING FOUR PICTURES AND GETTING THE BEST NOTICES of her career, Crawford decided to take time off to look after her new babies. A lavish lifestyle, a generous spirit, and four children, however, soon took care of most of the $700,000 that Crawford had earned since she joined Warner Bros., so Jerry Wald's call to make a new film was answered. He proposed *Flamingo Road*, a script based on a 1942 novel of the same name.

Flamingo Road had been promoted in 1947 as a film for Ann Sheridan to be directed by Vincent Sherman, but the next year Wald reimagined it for Crawford with Michael Curtiz directing. It had a long journey from a successful 1942 novel to 1946 Broadway flop and finally to being bought by Warner Bros. and turned over to Curtiz. Following his many successes with the studio, he was able to form his own production company under the Warner Bros. banner. *The Unsuspected* in 1947 was the first and two more followed, all of which broke even, but barely. Curtiz was in a difficult situation. He didn't like the script for *Flamingo Road*, but if he rejected the directing job he risked the future of his production deal. Wald had it rewritten to make Crawford's character more interesting. Curtiz capitulated.[1]

At forty-four, she would play a long-in-the-tooth carnival hoochie-coochie dancer, and although she was still attractive, *Flamingo Road* is the first film in which the magic of cinematography cannot conceal the brutal fact that she was now middle-aged. It was also the first film since *The Women* in which she was not the driving force of the action although she had top billing. Crawford was the principal woman in an ensemble cast that featured Sydney Greenstreet and Zachary Scott, each giving one of their finest screen performances, along with ter- rific newcomer David Brian. It is Greenstreet's film, but the four make a dynamic troupe in this dark tale of corrupt politicians, graft, suicide, and murder. Scott and Brian, romantic rivals for the leading lady, were both nine years younger than Crawford, but they read older on the screen, and she younger than her forty-four years. She was treading close to the point where she would look foolish playing opposite dashing younger men, but for the moment Crawford's indomitable will

Crawford with Zachary Scott and Sidney Greenstreet on the set of *Flamingo Road*, 1949. Photo by Fred Morgan.

and the fine planes of her face still convinced audiences, except during the unfortunate opening scene where she is seen in a revealing outfit swiveling her hips.

All involved must have hoped that Curtiz and Crawford could reignite the magic they had made with *Mildred Pierce* four years earlier. They came close, and gave audiences another atmospheric story of a strong woman and the men who surround her. Ted McCord was cinematographer—he had won the Oscar the year before for *Johnny Belinda*—and would work on several Crawford films in the 1950s. Travilla designed Crawford's wardrobe, but Sheila O'Brien finally got screen credit for sewing the costumes. In many future Crawford films, she would be acknowledged as costume designer. Gladys George played the madam at the establishment (brothel) where Crawford worked, and small parts were given to three actresses who had once had promising screen careers: Gertrude Michaels, who played the part of Millie, the waitress who is one of Crawford's few friends in the rough-and-tumble town they inhabit; Alice White, who had starred in several films back in the 1920s; and Iris Adrian, who had played second leads in the 1930s.

Many years had passed since Crawford had sung in a film, but Curtiz gave her a spot in *Flamingo Road*. During a long pan shot in the crowded club we hear "If

I Could Be With You (One Hour Tonight)," and as the camera moves through the guests, it is Crawford singing a few bars of the popular tune. Her delivery is terrific and suggests that her forte was not jazz or classical, but that her voice was best suited as a torch singer.

Curtiz had the first success under his production deal, and the film almost doubled its cost, taking in nearly $3 million. Still, Warner canceled the agreement, signaling the end of Michael Curtiz Productions, and he returned to the studio's stable of directors. For Crawford and Warner Bros. the film was a hit, popular with audiences, critics, and at the box office. "Don't miss" *Flamingo Road* said *Movieland*. "Joan Crawford has done it again! Given a good plot she can turn in a performance that is truly magnificent."[2] "She is without doubt an actress of outstanding ability," wrote *Showman's Trade Review*,[3] and Elsa Branden in *Photoplay* decreed, "An amazing actress—Joan Crawford. She adds lustre to every part she plays."[4]

Predictably, Bosley Crowther didn't like it. Reading his scathing review in the *New York Times* three-quarters of a century later, it is fascinating how so many of his criticisms now seem, if not compliments, like pieces of the bedrock of Crawford's now-legendary persona. "Miss Crawford runs this gamut," Crowther writes describing the film's many dramatic moments, "and we think it significant that she isn't even winded in the end. Indeed, she has evidently conditioned herself to the point where she can go through such an ordeal without showing the slightest strain . . . she moves like a sleek automaton . . . hers is a Spartan demonstration of bearing-up-under-it-well." "This picture," he wrote, slamming his point home, "was really designed to achieve a mechanized demonstration of Miss Crawford's fortitude." He is correct on all points but, what he wasn't able (or willing) to acknowledge back in 1949, was that these traits were among the reasons why fans adored her, and still do today.[5]

Just before she began work on *Flamingo Road*, Crawford posed for Canadian photographer Yousef Karsh. Karsh had been commissioned by *Collier's* magazine to provide a photo for an article titled "Handsome Joan from San Antone" that appeared in the March 12, 1949, issue. This is regarded as a seminal image of the actress's mature period, and was used on the cover of Bob Thomas's 1978 Crawford biography. The accompanying article quotes Helen Hayes, a longtime friend: "The first thing I think of when I come to Hollywood is Joan Crawford. I've always thought she was born with an invisible star on her forehead."[6]

A project that was close to Crawford's heart was a script called *Miss O'Brien*, about a schoolteacher. Warner Bros. owned the property, and it had been mentioned in the press as filming before *Flamingo Road* but was delayed as the studio was having difficulty coming up with an acceptable script. When Wald decided to cancel the film in mid-1948, Crawford bought the rights with the intention of making *Miss O'Brien* at Columbia. Curtis Bernhardt, who had directed her in *Possessed* was engaged, and the trade papers and fan magazines in late 1948 were

filled with articles about the upcoming film. Crawford's production deal with Columbia gave her a share of the profits and producer's control. Filming dates were announced for late winter 1949. With no explanation, all mentions of the film ceased. Either Crawford or Columbia had second thoughts, reaching the same conclusion as Wald that it would not be a suitable project for Crawford. This was her first experiment with independent production, but after a quarter of a century, she may have realized that she preferred the prerogatives of stardom rather than the financial and organizational responsibilities of being the producer.

Crawford did find time to play her second cameo at Warner Bros. and was cast in *It's a Great Feeling*, where she had a short but wonderful scene that is a spectacular parody of her. The film, shot in Technicolor, starred Doris Day, Jack Carson, and Dennis Morgan. Crawford's moment was set in a fashion house, where seated, she is seen knitting while nearby Carson and Morgan were waiting for Day while she tried on a dress. A bit of *double entendre* banter between the gents is overhead by Crawford, who stands suddenly and scolds them. When Morgan responds, "You don't think Jack and I would take advantage of a situation like this?" "Are you kidding?" is Crawford's retort. She then looks Carson straight in the face and delivers a spoof of the famous dialogue from *Mildred Pierce*: "I have never denied you anything . . . get out before I kill you." She slaps them both and turns away. "What's that for?" Carson asked baffled. "I do that in all my pictures," Crawford says merrily as she turns to walk away. Watch the film or find the clip on YouTube.

She always had a reputation for being a perfectionist, both on the set and in her private life. During this period, her fans got word that Crawford was obsessive when it came to keeping her house immaculate. "At least twelve times a year she cleans everything . . . armed with pounds and pounds of cleaning soaps and fluids, a pail and two strong scrubbing brushes, Joan for hours that add up to days, scrubs and scrubs the house from top to bottom." Maintaining a tidy home is one thing, but her frenzied behavior kept the household in turmoil. "Joan's passion for perfection has cost her an army of servants, as well as husbands. I don't think even a quiz kid could add up the number of help that has been hired and fired."[7]

Controlling her environment by keeping it clean didn't seem to help her loneliness after she and Greg Bautzer parted ways for good. Crawford was always most settled and confident when there was a man in her life (and in her house), and during those moments when there wasn't, not even the responsibilities of raising four youngsters (or cleaning) was sufficient to keep her content. Hedda Hopper, who was Crawford's close friend during this period (but also a journalist), kept careful notes of their many conversations and telephone calls. At one point, Crawford left the children with governesses, took off alone by car with her white poodle, Clicquot, for company, and drove north hundreds of miles on back roads seemingly without purpose. She stayed in motels and ate in diners. She told Hopper about the courtesy of truck drivers, and about being recognized in

coffee shops in the little towns she visited.[8] What was she doing? If she wanted to be spotted and admired, she could walk down any street in Los Angeles or New York. If she was looking for male company, were anonymous encounters in rural California the best choice for a single mother of four? Was she remembering the days of her youth, the time before moving to New York, when the long stretches of road leading away from Kansas City promised opportunities? She had reached the goals she had set long before: professional success, financial security, and children. It wasn't enough. All of us carry a bit of our youthful selves, and for Crawford, Lucile and Billie were never far below the surface. Garbo and Shearer walked away from the cameras before they turned forty. Crawford outdid her former rivals and proved that in middle age she could still prevail. Still, she must have known that the real battles ahead would not be with motion picture executives or critics, but with age that was swiftly erasing her thrilling beauty.

When it was time to go back to work Wald proposed *The Victim*, a script whose title was later changed to *The Damned Don't Cry*. It was a story taken out of the contemporary headlines and was based on the gangster Bugsy Siegel and his mistress Virginia Hill. As in *Flamingo Road*, Crawford's character climbs from poverty into the criminal underworld, and in both films ends up with the boss, although with different consequences. The director was Vincent Sherman, who had joined Warner Bros. in 1939 and soon made his mark with films such as *Across the Pacific*, with Bogart, and *Old Acquaintance* and *Mr. Skeffington*, both with Bette Davis. He was also attractive and charming (and married) but still carried on not-so-discreet affairs with his leading ladies including Davis.

Crawford set her sights on him the first time they met. In his memoir, published two decades after her death, Sherman is candid about both the professional and sexual nature of their relationship. Although he claimed not to have wanted to get involved with Crawford, when, soon after they met, she made overtures to him in a screening room where they were watching a print of *Humoresque*, he succumbed. As a gentleman, he rejected her desire to get down on the floor and asked her to wait until they could go to her dressing room. His wife. Hedda, knew about the affair, and he claimed she said, "I suppose it is too much to ask of any man that he turn down the chance to sleep with Joan Crawford." *The Damned Don't Cry* was an artistic and financial success so it was followed up with another collaboration, *Harriet Craig* and then a third, *Goodbye, My Fancy*. Between the early fall of 1949 and the late fall of 1950, they were constantly in each other's company whether working at the studio or spending time together in Brentwood. He was introduced to the children as "Uncle Vincent." [9]

The Damned Don't Cry is a typical Crawford rags-to-riches narrative. She leaves her dull, working-class husband after the tragic death of their child, and heads to the big city where, changing her identity (and wardrobe) she becomes the glamorous Mrs. Lorna Hansen Forbes, secretly bankrolled by a mobster. Co-starring was David Brian, who had made a successful screen debut in *Flamingo*

Crawford and Eddie Marr on the set of *The Damned Don't Cry*, 1950.

Road and had finished filming *Beyond the Forest*, with Bette Davis, when he was cast in *The Damned Don't Cry*. As one of the studio's most promising newcomers, he was awarded above-the-title costar status with Crawford. The other leading men vying for her attentions were Steve Cochrane and Kent Smith. Smith plays a seemingly decent guy who with a nudge from Crawford becomes a mob accountant. Soon he is working with the top men, and just as quickly she moves on to the bosses, Cochrane and Brian. At forty-five, she could still find herself in the midst of a romantic triangle as she had so often in her films from the 1930s, although this time it is a quadrangle or perhaps even a pentagon if we count the husband she deserted. This would be the last time, and in the future her screen romances would be more typical of middle-aged (female) characters.

Earning well over $2 million, *The Damned Don't Cry* almost doubled its cost. "A scintillating performance by Joan Crawford," wrote *Film Bulletin*, "paralleling her 'Mildred Pierce' and 'Flamingo Road' roles both in quality and type."[10] She had entered a new arena where her characters could be complex and unlikeable as long as they were strong and interesting. Critics were having a hard time catching up to the new Crawford, who "lacks sympathy," as *Variety* claimed, "a factor that keeps this one from being a thoroughly topnotch 'woman's picture.'" She wasn't

Crawford and director Vincent Sherman on the set of *Harriet Craig*, 1950. Photo by William E. Thomas.

interested in making women's pictures any longer. The same reviewer did like the rough-and-tumble nature of the film and noted "nifty physical splashes for those scenes requiring gangland opulence."[11] Also noticing the brutal subject matter was the National Legion of Decency, which rated the picture "B," a classification that deemed it "morally objectionable in part for all." Earlier, the scripts and final prints of Crawford's films were trimmed aggressively to remove overt sexual references. Now, it was underworld violence taken from the headlines that caused outrage, although not with the ticket-buying public.

The second film, *Harriet Craig*, was made at Columbia rather than Warner Bros. According to Sherman, Crawford was offered the script, then titled *Lady of the House*. She asked Sherman to read it, figuring that if they both liked it, she could prevail on the brass at Columbia to hire them as a team. When he discovered it was a remake of *Craig's Wife*, a Pulitzer Prize winning Broadway play that had been filmed fifteen years before with Rosalind Russell, he told her that it was an old-fashioned story and not a good part for her. Sherman assumed that was the end of it, but then Steve Trilling, second in command at Warner Bros., told him

that he had been loaned out to Columbia to direct that very film with Margaret Sullavan in the lead. He tried to reject the job, but the deal had been made and he was stuck. Crawford was furious. If Sherman was going to helm *Harriet Craig*, then she wanted the starring part, remake or not.[12] She convinced Columbia to cast her, and received a temporary release from her home studio. Her salary of $200,000 would now be paid by Columbia. As part of the deal, she required a dressing room that had overnight sleeping quarters and kitchen so that she did not have to make the long drive back and forth to Brentwood, and also to provide a convenient trysting place with Sherman.

Harriet Craig tells the story of a woman who in early middle age marries a wealthy man for social position and financial security. She takes control of his household and manipulates all around her, alienating the staff, her devoted cousin and companion, neighbors, and even her husband. "The actions of a cold, calculating woman, whose chief thoughts are for her own financial security," wrote one critic, makes "the mercenary leading character a hateful woman, one who is devoid of audience sympathy."[13] Wendell Corey played her husband, and plum supporting roles were played by Lucile Watson and Ellen Corby. Awful character or not, Crawford was dressed in superb costumes designed by Sheila O'Brien, and she sported a dashing new hairstyle with her hair cut severely short.

Whatever trepidation she and Sherman had about Crawford appearing in *Harriet Craig* must have evaporated the moment audiences watched the first previews. Crawford is excellent in the role that may be closest to her real personality: the controlling, judgmental perfectionist who keeps everyone in her path, from husband to maid, quaking at the prospect of the next outburst. "Here is a strange and exciting woman," read the copy on one of the posters, "at war with everything and everyone who stood in her way." Sherman, who was in the midst of a complicated relationship with Crawford, must have smiled when he read those words.

Good reviews followed the fine performance, "quite superbly acted," wrote the Roman Catholic journal *Focus*, but *Harriet Craig* performed tepidly at the box office.[14] Movie revenues were down nationally the fall the film premiered, but it was such a niche picture, directed squarely at Crawford's admirers that it was unlikely to become a hit for Columbia. It is one of her films that plays better seventy years later than when it debuted. In the prescient view of *Variety*, "Miss Crawford's domination of home and all who live in it takes on Freudian tones." In the post-*Mommie Dearest* era, where nearly all of Crawford's motivations have been analyzed by one writer or another (including her children), *Harriet Craig* seems startlingly biographical.

Soon after the film was completed, Crawford became ill and was hospitalized for influenza.[15] As soon as she recovered, she took her brood (and her poodle Clicquot) up the Santa Ynez valley for a vacation at the Alisal Ranch where the children could swim, play tennis, ride horseback, and sit by camp fires in the evening.[16]

Crawford was damned if she cared who saw them, so after sending the children back to Brentwood, she and Sherman embarked on a driving trip north to Lake Louise, Canada.

We registered under fictitious names in motels along the way and ate in quiet places. Joan was careful to avoid being recognized; she wore dark glasses and a bandanna around her head. Everything went well until we came to a small town somewhere in the state of Washington late one afternoon and decided to spend the night. We checked into a motel and ate early in a restaurant where several young people who were obviously movie fans spotted her and later followed us to the motel. They must have called the local newspaper. A few days later the story was back in Hollywood: Joan Crawford was seen in the company of a man at a motel.

Situations like this, unavoidable given that Crawford was among the most famous and recognized people in the world, made the vacation unhappy for both. She gambled that the time together, and the tension the trip would create between Sherman and his wife, would provoke a divorce. Sherman, whether cad or not, would not give in to Crawford, and his wife, for better or worse, put up with his now public philandering.[17]

They made it to Lake Louise, and Sherman took a few snapshots of Crawford (and her ever-present dog) documenting their time in the Canadian mountains. They returned to Los Angeles sooner than they planned. *Variety* reported that Crawford "underwent an emergency appendectomy at Hollywood/Presbyterian hospital last night [August 14]. Condition is described as satisfactory."[18] "Appendectomy," in those days, was often a press code word for abortion, although in Crawford's case this is unlikely, given her age and presumed infertility, but it could have been a cover for another condition. Appendectomy or something else, the hospitalization delayed the start of *Goodbye, My Fancy*.

Goodbye, My Fancy is a peculiar film, part romantic drama, and part left-wing propaganda. Neither part is particularly successful. Based on a play by Fay Kanin that played on Broadway in 1948, it tells the story of a member of Congress, Crawford, who is invited to her alma mater to receive an honorary degree. There, she rekindles a college romance with a former professor, played by Robert Young, who is now the college president. She learns, two decades later, that the idealistic young man she fell in love with has lost his intellectual courage and now is beholden to the conservative trustees. Set in 1950, at the height of the McCarthy era and soon after the Hollywood purge by the House Un-American Activities Committee (Kanin was blacklisted), the film also deals with censorship and freedom of speech. Crawford's character wants to screen a film at commencement showing the horrors in Europe during and immediately after the Second World War. The trustees considered it too brutal for college students (all women) and canceled its

A snapshot, probably taken by Vincent Sherman on a vacation to Lake Louise in Canada, 1950. Crawford is accompanied by her poodle, Clicquot.

showing. Crawford is forced to blackmail her former lover to ensure the film is screened, thus acknowledging that she cannot continue a romantic relationship with him. Along with Robert Young, Frank Lovejoy plays a *Life* magazine photographer, fellow traveler, and rival for Crawford's attention. Eve Arden, playing Crawford's secretary, steals each of her scenes.

This was the first time that Wald would not produce one of Crawford's films since she had come to Warner Bros. While *Goodbye, My Fancy* was in

preproduction, Wald announced that he was setting up an independent production company in partnership with writer Norman Krasna and their films would be distributed through RKO. Warner Bros. could not entrust a valuable star like Crawford to an executive who was on his way out. Henry Blanke stepped in.

Sherman recalled that Jack Warner took an active role in the film's editing and requested that Crawford not have any close-ups as she was "getting too old." The director reduced the number, and used them when "deemed absolutely necessary."[19] This seems a strange request as Crawford looks terrific in the film and in her (few) close-ups. Nonetheless, Warner was remembering Crawford from her earlier glory days, and did not share our contemporary perspective in which we appreciate the mature beauty witnessed in her films of the 1940s and early 1950s.

The film got fair notices and did commensurate business, another break-even for Sherman and Crawford. It would be their last collaboration. Affairs usually have an expiration date, and Crawford's increasing pressure on him to leave his wife—something he vowed never to do—triggered the split. After three films and more than a year in each other's company, they parted.

He did provide a glimpse into her family life; once, observing her heavy-handed treatment of her son Christopher, he "begged her to stop." "Don't you ever interfere between me and my children" was her response.[20] Although he enjoyed the professional association with Crawford, noting that "she took direction easily . . . anticipated almost every move or idea I offered . . . I had never worked with anyone who was so keen, so knowledgeable about filmmaking," outside the studio, she was more complicated.[21] He described her as a "vortex of insecurity from which she could not seem to escape."[22] Late one evening after *Goodbye, My Fancy* was completed, Crawford called Sherman. In a "barely audible" voice, she said, "'Good bye, Vincent,' and I heard the phone drop." He rushed to her home and found her groggy with an open bottle of sleeping pills. He had her maid make a pot of coffee, and he walked with her until she was awake.[23] A few days before that evening, Crawford had called Hedda, who reported back to her husband, "Your girlfriend called and said she was sending you back to me."[24] Would that she had been true to her word and not attempted suicide. Still, even with their complicated history, they remained cordial, and she continued to send notes to Vincent and Hedda for years to come.

During the year that Crawford was busy making three films with Sherman, and enjoying his company outside of work, the Hollywood press had noticed that "the personal and private life of Hollywood's most exciting and glamorous star, Miss Joan Crawford, has been a complete blackout as of recent date." Coinciding with the end of the Sherman affair, "her first advent into a nightclub in eight months, to be exact, was the other eve on the arm of Cesar Romero."[25] Romero was a reliable old friend but never a romance and provided Crawford the ideal cover to announce that she was available. Kirk Douglas took notice; he was her type and almost a dozen years younger. When he called for her on the evening of their date

he found "she had the evening's itinerary precisely arranged. . . . Claustrophobia began to set in. [She] all by herself was equivalent to [my] six sisters and mother. I had to assert myself." When he suggested a different restaurant than the one she had in mind, Crawford "sulked a bit, not accustomed to having her orders countermanded." When they returned to Brentwood after a dinner, "we never got past the foyer. The door closed and she slipped out of her dress . . . there we were on the rug. . . . Afterward, we got dressed. She took me upstairs and proudly showed me the two children . . . I got out fast."[26]

Crawford's 1943 six-year deal with Warner Bros. called for three films and provided a salary of $500,000; once those films were completed, the contract was amended to pay her $200,000 per picture. She had starred eight times (two on loan-out) and appeared twice in cameos. On December 11, 1950, she signed a new five-year $1 million contract to make five films for the studio. It would be ten months before she started on the first, *This Woman is Dangerous.*

This Woman is Dangerous treads the fine line between being a sappy soap opera and a dull crime drama. Crawford had graduated, as far as film roles were concerned, to being the boss, heading a vicious gang of thieves, one of whom, David Brian, plays her lover. But she is plagued with failing eyesight and needs a dangerous operation performed by the still (barely) dashing Dennis Morgan. When the surgery is successful, they fall in love, thus Crawford is torn between a doctor and a murderous thug, a life of comfort or a life on the run. This was a film only for her most dyed-in-the-wool fans.

Crawford approved Felix Feist to direct, which was surprising as he often directed "A" level stars in what were essentially "B" pictures. This was the sort of script a studio boss offered a star on the way out the door, not as the first film in a brand-new million-dollar contract. For once Bosley Crowther got it right: "for people of mild discrimination and even moderate reasonableness the suffering of Miss Crawford will be generously matched by their own."[27]

As 1951 was waning, and even before any audiences had seen *This Woman is Dangerous*, Crawford knew it was time to end her association with Warner Bros. The picture was a stinker, and the studio wasn't offering her any good scripts. The irony was that she was still popular with fans, the legion who had supported her for decades. "I am a normal woman in the prime of life who works for a living as an actress," she wrote that fall. "I love fans who ask me for autographs. I sign all of them. I love to pose with moviegoers. I love to answer their mail."[28] Louella Parsons observed that the Crawford fire still burned bright when she wrote, "For 20 years Joan Crawford has been the darling of the press (sometimes referred to as its meal ticket). She's hot copy queen."[29] As Crawford had figured out back in 1943, when she turned her back on a lucrative MGM contract to join Warner Bros., she still had plenty to offer her public. Only one year earlier, she signed a $1 million renewal with the studio, but now another change was necessary. She asked Jack Warner to release her after a single yet to be released film. He agreed.

Independent

AGAINST NEARLY IMPOSSIBLE ODDS FOR SUCCESS, CRAWFORD DECIDED to leave MGM in 1943, move to Warner Bros. to seek better roles, and take on Bette Davis. Looking back over their films of the late 1940s, even the most ardent Davis fan might concede that *Mildred Pierce, Humoresque, Possessed, Flamingo Road*, and *The Damned Don't Cry*, some of which are considered film noir classics, outpace Davis's work in *The Corn is Green, A Stolen Life, Deception, Winter Meeting*, and *June Bride*. Davis left Warner Bros. in 1949 for the same reason Crawford had departed MGM a half-dozen years before: poor scripts. Two years later, Crawford would follow Davis out the door for the same reason.

Lightning rarely strikes in Hollywood, but it did for Crawford when she defied probability back in 1925 and became a movie star. Who could have predicted that she would be able to start fresh at Warner Bros. and successfully reimagine her stardom as a middle-aged woman, but she did and won an Oscar. Fed up with what was being offered as upcoming film projects, she severed ties with them at the end of December 1951. She was forty-six. Crawford's Warner Bros. contract gave her the ability to make films outside the studio without incurring a penalty. Nevertheless, she decided it was time to make her own creative choices and to assume financial risks. Before beginning work on *This Woman is Dangerous*, she was offered a script by independent producer Joseph Kaufman. Lightning was about to strike for Crawford a third time.

Kaufman had bought the screen rights to a 1948 suspense novel, *Sudden Fear*, by Edna Sherry. Lenore Coffee, a longtime MGM veteran who specialized in adapting books for films, was brought in to write the screenplay. Coffee, who two decades earlier had adapted Crawford's *Possessed* (1931) for the screen, collaborated with Robert Smith, and they came up with a script Kaufman thought would be perfect for Crawford. Crawford thought so too, and they signed an agreement in the summer of 1951. Kaufman and his star entered into a profit-sharing deal (her first): Crawford would forego her usual fee of $200,000 and instead take forty percent of the film's profits.[1] The producer arranged for the film to be shot

at and distributed through RKO. *Sudden Fear* was scheduled to have been filmed in late 1951, but was delayed until the following winter as Crawford first wanted to cancel her contract with Warner Bros. David Miller, who had been noticed about town as Crawford's most recent and frequent escort, was signed to direct.

The story was well suited to Crawford at this moment in her career. She played a successful and wealthy playwright who falls in love with a younger actor whom she had rejected for a part in one of her plays. The two marry in haste, and soon the audience is aware that he is up to no good. Neither is his beautiful girlfriend, and co-conspirator. Crawford's character discovers that they intend to murder her, and this leads to an exciting climax.

Crawford wanted Clark Gable to play the actor but, aside from the fact that Kaufman could not afford two star salaries, even if one was working on a percentage, the producer knew he was wrong for the part. They needed a younger actor, one who had a strong presence and who could be convincingly sinister while still charming. Kaufman and Miller settled on Jack Palance. The trick was to convince Crawford to accept as her leading man an actor who had only two film credits. One evening at her home, she and Miller screened *Panic in the Streets*, Palance's first film. At the conclusion, he told her his idea and Crawford exploded. "You don't love me . . . you don't respect me. How could you ever suggest I accept such a leading man? Don't you realize I have played with the biggest stars in films?" They ran the film again the next evening. "Why do you want me to play opposite this man?" she asked after the film concluded. His answer must have surprised her: "In your last few pictures, Joan, you've played not only the female lead but the male lead as well. That won't work in this picture. We need suspense for the audience." Predictably, she was unhappy, but he convinced her that actors such as David Brian were fine, but Wendell Corey, Kent Smith, and even Dennis Morgan were no match for her on screen. "All right, I'll take Jack Palance."[2]

Palance was thirty-two and Crawford forty-seven, but he looked older with brutal good looks that defied the notion of matinee idol. Central to the film's tension was her obsession with a younger man who left her emotionally vulnerable. Palance's on-screen girlfriend was played by Gloria Grahame, blond, beautiful, twenty-nine, and already in possession of an Oscar nomination for *Crossfire*. "Gloria Grahame irritated her to no end," Miller later remembered. "Gloria was 15 years younger and smoking hot."[3]

Crawford's affair with Miller continued through the making of *Sudden Fear*, although he claimed she made an unsuccessful pass at Palance. Miller was among the many directors with whom she worked who had nothing but praise for her knowledge and professionalism. "She knew more about lighting and camera angles than anybody I ever met," he recalled in a 1982 interview. "She never wasted a moment on the screen."[4]

The film was shot mostly on location in San Francisco by Charles Lang Jr., who had recently completed *Ace in the Hole* and *A Foreign Affair*. His eighteen Oscar

Crawford with Virginia Huston and Bruce Bennett on the set of *Sudden Fear*, 1952. Photo by Frank Tanner.

nominations for cinematography are a testament to his talent, and he made the city crisply stylish and ominous at the same time. Crawford was so taken with his work—he managed to create deep black and white contrasts typical of the best film noir while still photographing her softly—that she used him on many of her later films. Her costumes were designed by Sheila O'Brien, and she hired Frank Tanner with whom she had worked at MGM to shoot stills.

"Heartbreak . . . poised in a trigger of terror" was one of the tag lines used to promote the film. There was plenty of suspense, and in several sequences there is almost no dialogue, Crawford relying on the tricks she learned as a silent actress. One compelling sequence finds Crawford trapped in a closet with a sliver of light illuminating her face while someone outside the door wants to kill her. The dramatic conclusion was filmed late at night as Crawford is hunted on the steep streets of San Francisco. "I can still hear the clickity clack of her heels on the brick pavement," Miller recalled, and it is these sorts of sounds, rather than dialogue, that reveal Crawford as isolated and alone in her terror.

As independent producers, Kaufman and Crawford could not count on the unlimited financial and staff resources of a major studio, so the pair took an active hand at promoting their picture. Along with traditional marketing tools such as magazines, radio, and personal appearances, they decided to rely on a

new medium, television. The radio and television trade journal *Sponsor* described the method:

> To promote its "Sudden Fear" this past summer, RKO Pictures ran TV saturation campaigns in several major cities around the country. "We found that there was a great difference in box-office receipts where TV was used to promote the picture and where it wasn't," [said an RKO representative]. In New York, for instance, RKO plugged the movie with heavy schedules of announcements and participations on WCBS TV and WABC (total cost about $25,000). "Sudden Fear" opened at Loew's State Theatre, New York. In its first week it grossed $61,000, topping by far the average opening week's gross at the theatre of $20,000 to $25,000. It ran for seven weeks, an unusually long run for the summer season.[5]

Kaufman's merchandising strategy included personal appearances by the stars whose appearances at theaters would be used to galvanize audiences. Crawford, who loved interacting with her public, crisscrossed the country so that folks nearly everywhere would have a chance to meet her. At Loew's State in New York, Crawford spent part of one afternoon selling tickets at the box office. After New York, she made trips to Boston, Philadelphia, Cleveland, and Detroit, before heading west to Los Angeles. Kaufman generally accompanied Crawford, as did Miller who did not like to engage in these sorts of publicity stunts. Palance and Grahame also met with fans and gave interviews promoting the film. Kaufman also noted, perhaps hyperbolically, that "the picture will benefit from publicity and other breaks equivalent to $5,000,000 worth of commercial advertising." He explained one of his many marketing tools: *Sudden Fear* "was written to include a trip on a Western Pacific Railroad train. As a consequence, the railroad company will ballyhoo the picture via 24 sheets [large posters] in all stations it controls, window displays, plugs on all its railroad tickets, and by expending $5,000 for the picture's opening in San Francisco."[6]

The producers held expenses to $600,000,[7] and when the film turned out to be a hit Crawford earned more than $800,000, far more than the $200,000 she was receiving at Warner Bros. and a payday for which it was worth breaking her Warner Bros. contract.[8] "For Miss Crawford the picture is a triumph as a performance," wrote *Daily Variety*.[9] "'Sudden Fear' is one of the best dramatic pictures that Joan Crawford has been in during her picture career," deemed *Harrison's Reports*. "It is so well directed and acted that it keeps one in tense suspense all the way through."[10] It was not only Crawford who was admired but the film as well. "A taut thriller . . . a gripping story of terror and suspense . . . a genuine shocker," wrote the *Hollywood Reporter*, "which serves as a tour de force for Joan Crawford, whose truly brilliant performance will make a conversation piece for a long time to come."[11] The *New York Daily Mirror* summed it up: "One of the screen's all-time

thrillers."[12] François Truffaut, for *Cahiers du Cinéma*, extolled Miller, writing, "there is not a shot in this film that is not necessary for the drama." As to Crawford, she was a "matter of taste" ("question du goût"), but he acknowledged her essential role in getting the film made (his taste ran closer to Gloria Grahame).[13]

Academy Award nominations were announced in February. Crawford was among those up for Best Actress along with Shirley Booth for *Come Back, Little Sheba*, Bette Davis for *The Star*, Julie Harris for *The Member of the Wedding*, and Susan Hayward for *With a Song in My Heart*. Also nominated from the film were Jack Palance, Charles Lang for Best Cinematography and Sheila O'Brien for Best Costumes. Gloria Grahame was nominated for Best Supporting Actress, but for another film she made in 1952, *The Bad and the Beautiful*. She took home the Oscar. Shirley Booth won the Best Actress award. This would be Crawford's last Academy Award nomination. She was also nominated for a Golden Globe award.

Bette Davis received an Oscar nomination for *The Star*. The script had been written for Crawford by Katherine Albert and her husband, Dale Eunson. Albert was not only one of Crawford's closest friends but had served as her publicist for a decade, and they had known each other almost since Crawford had arrived in Hollywood back in 1925 when Albert was working at MGM. As a Tinseltown journalist, Albert wrote countless articles about Crawford over the years, and was a major supporter of her career. So close were the two that when Albert gave birth to a daughter in 1934, she named her Joan, and asked her namesake to be godmother. Crawford was devoted to young Joan, and she supported her decision to become an actress and helped steer her early career. Taking the name Joan Evans, she had success starting at fifteen working at Goldwyn Studios and costarring with Farley Granger in a popular series of films. When she was sixteen, she met Kirby Weatherly, a decade her senior. They fell in love. Her parents thought her too young to marry. When Louella Parson broke the story that the couple were planning to elope on her eighteenth birthday, the news took Albert and her husband by surprise. Evans assured them no elopement was forthcoming. One evening, a week after her eighteenth birthday, in July 1952, Crawford invited Joan and Kirby to dinner. After the meal, they were chatting about their future, and Crawford decided that Joan and Kirby should be married that evening. As the hour approached midnight, Crawford called a judge to her house to perform the ceremony, and asked her old friend photographer Hymie Fink to record the occasion. At 12:05 in the morning, the marriage took place with Crawford and Fink as witnesses. The young couple spent their wedding night in Crawford's home.

Of the calls made that evening none was to Albert. She was furious when she discovered that her only child had been married without her knowledge, and that she had not been included at the ceremony. She vowed never to speak to Crawford again, and didn't. What made Crawford betray her old pal? The script for *The Star* told the story of an alcoholic aging star desperate to reimagine her earlier successes. Crawford undoubtedly saw herself in the script. After an evening

fueled by drinks, she decided that by furtively arranging Joan Evans's wedding she could inflict the ultimate punishment upon Joan's mother.

Crawford was seen at restaurants and clubs throughout 1952 in the company of MCA agent Jennings Lang. Not only was Lang married, he was also the victim in a notorious Hollywood scandal in December 1951. Producer Walter Wanger believed that Lang was having an affair with his wife, actress Joan Bennett. One afternoon in a Hollywood parking lot Wanger confronted the couple and shot Lang in the groin. Lang survived, and Wanger was sentenced to four months in jail, after which he returned to his wife. When Lang recovered, he started seeing Crawford. David Miller was out, and Lang was now her new favorite escort. They had been working together on potential projects for television, and were often written about in columns and shown together in fan magazine photographs. "The hep crowd whispers that they spend too much time together dawdling over lunch at the Vine Street café for it to be only business."[14] In October 1952, Lang's wife Pamela committed suicide. Crawford claimed she had been a close friend of Pamela Lang, and was devastated by the news. In a depression, she fled Los Angeles. When she returned she continued to be spotted in public with Lang.

Crawford got into a different sort of tussle in the late winter of 1953, when comments she made about Marilyn Monroe, to use twenty-first century parlance, went viral. Monroe had two films scheduled to be released in 1953, *Gentleman Prefer Blondes* and *How to Marry a Millionaire*, and advance word was that 20th Century-Fox had a new star. *Look* magazine gave her an award for most promising newcomer, and *Photoplay* acknowledged her as the fastest rising star of 1952. Arriving late to the *Photoplay* dinner in February 1953, Monroe appeared in a skintight gold lamé dress with a neckline plunging almost to her waist and that was so snug it was difficult for her to take more than baby steps forward. A shimmering sex goddess was the look Monroe intended, and she was met with catcalls from the boys and host Jerry Lewis jumped on a table to show his admiration. Crawford was furious at the obvious display of carnality.

She was interviewed three days later by Bob Thomas and the intended topics were her Oscar nominated performance in *Sudden Fear*, and her plans for television. "What did you think of Marilyn Monroe at the *Photoplay* dinner?" asked Thomas. "It was the most shocking display of bad taste I've ever seen" was her reply. "Look—there's nothing wrong with my tits, but I don't go around throwing them in people's faces." On March 2, with Crawford's approval, Thomas filed his story with the Associated Press. "It was like a burlesque show," he quoted Crawford as saying, "the audience yelled and shouted. . . . Sex plays a tremendously important part in every person's life . . . but they don't like to see it flaunted in their faces. . . . The publicity has gone too far, and apparently Miss Monroe is making the mistake of believing her publicity." Crawford should have been a bit savvier for her words caused a storm of notoriety for both women. Thomas noted that both Walter Winchell and Louella Parsons took Monroe's side and left it to

others to say that Crawford was jealous of the room-stopping beauty that had been Crawford two decades before (and often in iridescent lamé).[15] The protective studio-controlled cocoons that had surrounded Crawford and other stars back in the 1920s, 1930s, and 1940s, had vanished, and publicity was evolving into a spectator sport with winners and losers. She never apologized to Monroe, but she did become somewhat philosophical: "I wish I could say I didn't say those things, but I did say them. But, believe me, in the future I will think twice before I talk so openly."[16]

Even negative publicity kept her name in the papers, and this along with another screen success and Oscar nomination, ensured that Crawford's name came up for plum parts. The most interesting was *From Here to Eternity* based on the James Jones bestselling novel about the attack on Pearl Harbor. Crawford would have been terrific playing the adulterous wife of an army captain who is having an affair with a sergeant (Burt Lancaster). She asked director Fred Zinnemann to use cinematographer Charles Lang Jr., who had exquisitely photographed *Sudden Fear*, and she demanded full control of her makeup. Zinnemann wanted the film to have a more realistic feel and rejected Crawford's demands. He cast Deborah Kerr in the role, and put Burnett Guffey (*All the King's Men*, *In a Lonely Place*) on camera. Another possibility was *Lisbon*, a crime drama that Nicholas Ray was preparing for Paramount that would have been filmed in Europe with Crawford as star. Whether it was the script or the escalating cost, Paramount abandoned the project and sold it to Republic. In 1956, the project was made starring Maureen O'Hara with Ray Milland as director and costar.

Had Crawford agreed to Zinnemann's terms, she might have followed *Sudden Fear* with another Academy Award nomination, but instead she decided to make a musical, *Torch Song*, that would bring her back to MGM for the first time in a decade. It would also be her first complete color film (the final sequence in *Ice Follies of 1939* was filmed in color, as was *It's a Great Feeling*, in which she had a cameo). MGM was not the same studio she had left a decade earlier. Mayer was gone, having been replaced by Dore Schary in 1951, and Harry Rapf had died in 1949. Her old studio may have been glad to have her back, but for the first time in her career she took a substantial pay cut. Crawford signed a two-picture deal at $125,000 per picture. *Torch Song* would be the first.[17] Her old friend Dore Freeman, for whom she had arranged a job with MGM back in 1935, was now head of studio publicity. He planned a big ovation to welcome her back with a red carpet, trumpets announcing her arrival, and all the top brass on hand to greet her. The queen had returned to her former domain. On the first day of shooting, Crawford presented director Charles Waters with a huge bowl filled with birds of paradise, and hanging from the flowers, a cashmere sweater, bedroom slippers, cologne, and even two lamb chops.[18] When the film was completed, he gave her a portrait of herself by the Laguna Beach artist John Morris to add to her growing collection of painted Crawfords at home.

Crawford played a celebrated Broadway singing and dancing star rehearsing a new show, and at war with everyone, including herself. "A bitter, brassy case study of an unpleasant woman," wrote Janet Graves in *Photoplay*, "provides Joan Crawford with a spectacular vehicle."[19] Since *Mildred Pierce*, she could entertain her fans playing one difficult or even terrible woman after the next. Costarring with Crawford were Michael Wilding who plays a blind pianist who accompanies the show in rehearsal, and Gig Young as a handsome gigolo who escorts Crawford about town, but has nothing but looks to recommend him. MGM Technicolor musicals had to end on a happy note, so in the final scene Crawford's heart succumbs to Wilding's charms. Old-time Broadway and silent actress Marjorie Rambeau played Crawford's sharp-tongued mother so well she garnered an Academy Award nomination.

Wilding was married to Elizabeth Taylor, who was filming *Rhapsody* on a nearby sound stage. Taylor liked to stop by during the day to visit her husband, but Crawford resented the intrusion of the attractive woman on her set. All visitors were soon banned, including Taylor. Wilding resented Crawford's behavior and it created a frosty tension between them.[20] When Louella Parsons told her readers about the friction, Crawford reacted, and to set the record straight sent Parsons a letter, dutifully published. The official version now stated the columnist had gotten it all wrong, and that all had gone well during filming. "Now, as far as Mrs. Wilding goes," wrote Crawford, "she was on the set time and time again—we took many pictures—I had her in for tea and cocktails and she was charming and delightful and of course, as you know, beautiful beyond belief."[21] But that wasn't the end of it. The Wildings referred to Crawford, ironically, or maybe snidely, as "the Queen of Hollywood." For her revenge, she saw to it that "the Wildings found themselves missing out on several top social affairs and the reasons their invitations were not forthcoming was traced back to the hard-working La Crawford, who let it be known the Wildings were no longer welcome at her Brentwood estate."[22] She won this skirmish, but Taylor, a couple of husbands later, rose to outpace even Crawford as an international celebrity.

Crawford had a chance to dance on screen again and does a routine as the film opens with director Charles Walters as her partner. It might be the best dancing she ever did in the movies, although there are still moments when you notice that she looks down to her feet. She claimed to have done her own singing, but her vocals were dubbed by India Adams. One exception, there is a sequence where she plays a record of her character singing "Tenderly" and accompanies it using her own voice. The film's most outrageous sequence is a lavish musical number, "Two-Faced Woman," recorded by Adams to have been "sung" by Cyd Charisee in *The Band Wagon*. It was adapted as a number for Crawford in *Torch Song*, and she plays the number in blackface, reaching a professional low that she never equaled again even in late career mistakes such as *Berserk!* and *Trog*. As had been the case for many years, reviews hardly mattered, as the fans who were

loyal would line up once again to buy tickets. Still, one reviewer revealed a bit of weariness: "This movie's too slick to believe, but Joan Crawford's too glamorous to deny, which about neutralizes the problem."[23] Another problem was that MGM did not have a follow-up film to offer, thus her two-picture deal expired after a single film in the fall of 1954.

Before Crawford could start her next feature, *Johnny Guitar*, Lang found an ideal part for her television debut. *Revlon Mirror Theatre* was a half-hour weekly dramatic anthology, filmed in Hollywood and running through the summer and fall of 1953. She starred in the episode titled "Because I Love Him" that aired on September 19, playing a woman who has found out from her doctor that her husband has a year to live. William Ching played her husband, and Virginia Grey and Ellen Corby had supporting roles. *Revlon Mirror Theater* was shot on film, and Crawford saw to it that her current favorite, Charles Lang, was engaged as cinematographer. Crawford adapted to the new medium, playing her part with the confidence of a MGM/Warner Bros. star. She would continue taking roles on television dramas.

"The acquisition of Miss Crawford is the biggest star news Republic has had to boast in years," wrote one industry trade paper.[24] What brought Crawford, blue-chip Hollywood star, Academy Award winner, and successful independent producer, to Republic Pictures? It had been founded by Herbert Yates in 1935 as an amalgamation of six Poverty Row studios.[25] Never one of the majors, it was successful for two decades and noted for westerns. Crawford had bought the screen rights to the 1953 Western novel *Johnny Guitar* by Roy Chanslor, who had been writing screenplays since the 1930s and occasionally published a novel. He dedicated *Johnny Guitar* to Crawford, although it is unknown whether or not they were acquainted. Before Paramount canceled *Lisbon*, it had been Crawford's intention to delay *Johnny Guitar* until that film was completed. Now it was her top priority.

Nicholas Ray had been scheduled to direct *Lisbon*. Following his debut, *They Live by Night* (1959), he was one of Hollywood's most sought-after directors. After he divorced Gloria Grahame, with whom Crawford had worked in *Sudden Fear*, he began an affair with Crawford. When the *Lisbon* project stalled, she asked him to take on *Johnny Guitar*. He was offered associate producer status, although she was the boss. They weren't concerned about industry perceptions as Republic was renowned for excellent facilities for shooting Westerns. The budget was reported as $2 million (likely a gross exaggeration), with Crawford taking her usual $200,000 plus a piece of the profits. Ray's salary was $75,000.[26] Another reason to work at Republic was their reputation for keeping budgets under control.

As *Johnny Guitar* was getting underway, Crawford and Ray took an evening off to attend the premiere of the biblical spectacle *The Robe* at Grauman's Chinese Theater. Arriving at the theater, "the announcer proclaimed Joan as the greatest star in Hollywood." As they entered, the couple discovered that someone else

Crawford and Sterling Hayden on the set of *Johnny Guitar*, 1954.

was sitting in their seats. "The greatest star in Hollywood" and her escort turned and left in a huff.[27]

Johnny Guitar had modest success back in 1953, but it is regarded as a motion picture classic today. Truffaut called it "dreamlike, magical, unreal to a degree, delirious."[28] It is the story of two strong-minded late-nineteenth-century Western women, Vienna (Crawford) and Emma (Mercedes McCambridge), in love with the same man, a bandit named the Dancin' Kid (Scott Brady). McCambridge played Crawford's nemesis on screen but was equally so in real life. Johnny Guitar (Sterling Hayden) was the guitar-playing gunslinger whom Vienna hired to entertain at her saloon, and conclude unfinished business. This character plays an important but secondary place in the film. As the script was shaped to focus squarely on Crawford at the expense of the other characters, it should have been titled "Vienna," underscoring both her prominence, and the central narrative that dominates the landscape: the friction between two women, something unusual in Western films. On some of the posters, a tag line was added between Crawford's name and the film's title: "Joan Crawford / as the woman who loves / Johnny Guitar." Ray gathered a superb group of character actors to round out the cast including Ernest Borgnine, John Carradine, and Ben Cooper.

For six decades after the film was released, it was available to view only in a faded pinkish version, but a restoration brought back its magnificent palate of brilliant color. Location shooting was in Sedona, Arizona, and it was filmed in Truecolor, a Republic Studios inexpensive alternative to Technicolor, which originally revealed beautiful saturated colors but soon faded badly. The captivating narrative, Ray's elegant direction, the superb performances, and now the dazzling color together contribute to the film's classic status, justifying its inclusion in the National Film Registry of the Library of Congress in 2008.

Whether it was her drinking (twenty cases of 100 proof vodka accompanied Crawford to Sedona), the new experience of filming on location in the Arizona desert, or something else, this was the first time that Crawford got a slew of bad publicity. She and McCambridge took an instant loathing to one another although both were professional enough to save their tantrums for times when the camera wasn't running. Alas, others were there to report, and both women found time to pick up a phone and report back to Hollywood about the bad behavior of the other. Crawford may have been the worst as Ray found her late one night, drunk, and tossing McCambridge's costumes on the road.[29] McCambridge, in her memoirs, provided insight into "location" filming:

> For the scene in which I died . . . my fall was done by a great stunt man . . . however, until the moment of the fall, the person on the balcony was me. . . . The reverse angles of that sequence—i.e, Miss Crawford's footage—were shot inside, back at the studio . . . The lighting crew painted the lustrously soft light and shadows on the constructed indoor balcony against a canvas

sky, and when all was set Miss Crawford was escorted from her lavishly decorated dressing-room trailer, retinue surrounding her . . . director, as-sistant director, second assistant director, script man, secretary, costumer, wardrobe woman, makeup man, hairdresser, and propman with sweat spray and spirits-of-ammonia ampules . . . the spray for the skin's glow, the am-pules for the eyes' tears. . . . She looked absolutely dazzling, squeaky-clean and velvet-skinned, moisty eyed.

McCambridge, who was filming her scenes outside in the Arizona desert under natural light, was not only shabbily dressed but had a natural appearance as might be expected in a Western. Viewing the final film, McCambridge was struck by how different the two women looked on screen. "It was a dirty rotten trick," she said of Crawford. She also called her a "mean, tipsy, powerful, rotten-egg lady."[30] "I wouldn't trust McCambridge as far as I could throw a battleship," Crawford was quoted as saying.[31] It was a draw.

One day Crawford was scheduled to be interviewed by Maggie Wilson, a re-porter from the *Arizona Republic* making the long journey north from Phoenix, but at the last minute she refused to meet. Instead of a fluff piece about star and film, Wilson wrote "a violent attack on Miss Crawford," But that wasn't the end of it.

Two weeks later the *Republic*'s competitor, the *Phoenix Gazette*, carried a three-column, five inch ad . . . It read: "To whom it may concern: anyone who happens to be suffering with what might be diagnosed as chronic sour grapes poisoning . . . Hear this: We would like the world to know Joan Crawford. We have worked with this great lady in a wide variety of circumstances, in sometimes difficult and exhausting situations . . . and we are prepared to to testify that if there is a more cooperative, charming, talented, understanding, generous, unspoiled, thoughtful, approachable person in the motion picture business, we have not yet met him or her . . ."[32]

What fun Crawford and her publicists must have had writing this self-tribute with such a singly mean-spirited goal: to rub in the earlier snub to Maggie Wilson. Crawford's formerly sterling reputation with the press—she had often been voted the most cooperative star in Hollywood—was starting to get tarnished.

Crawford's relationship with Ray also deteriorated as the film progressed. The one-time lovers became enemies. As the company divided between pro-Crawford and pro-McCambridge, Ray was perceived to be in the McCambridge camp. She took his name off the film as associate producer. He remembered filming back at Hollywood as "an appalling experience," and called her "one of the worst human beings he'd ever encountered."[33]

Critics in 1954 expected a traditional Western, and when it turned out to be more philosophical than gun-slinging, it left many baffled. "The actress should

Crawford and Charles Drake on the set of *Female on the Beach*, 1955.

leave saddles and levis to someone else and stick to city lights," wrote the critic for *Variety*, who blamed the writer and director for becoming "so involved with character nuances and neuroses all wrapped up in dialog, that 'Johnny Guitar' never has enough chance to rear up in the saddle and ride at an acceptable outdoor pace."[34] Bosley Crowther couldn't get beyond his hatred for the star, and as usual he directed his venom towards her. "[Crawford] is as sexless as the lions on the public library steps and as sharp and romantically forbidding as a package of unwrapped razor blades. . . . Let's put it down to a fiasco. Miss Crawford went thataway."[35] Others were kinder and saw quality in the film. "Republic has an unusual and exciting western in 'Johnny Guitar,' . . . the result is a change of pace story that will satisfy women as well as men."[36] "Well enacted, rough, gripping fare emerges as sort of a female version of 'Shane,'" wrote the reviewer for *Screenland*.[37] Describing Crawford, Truffaut wrote in 1954, "She is beyond considerations of beauty . . . she has become unreal, a fantasy of herself. Whiteness has invaded her eyes, muscles have taken over her face, a will of iron behind a face of steel. She is a phenomenon."[38] Good or bad, as so many times before, critics didn't matter as much as the box office, and the film took in over $2,500,000, making it a triumph for Crawford and Ray, and Republic's biggest moneymaker for 1954.

From a creative point of view, the decade that included *Mildred Pierce* and *Johnny Guitar* was Crawford's most vital. She had earned over $2 million in salaries plus a big payday as producer of *Sudden Fear*. Although she rigorously adhered to the fiction that her birthday was in 1908, in fact she was about to turn fifty. Mother to two difficult teenagers, she sent Christina and Christopher to boarding schools. The younger twins were at home, raised mostly by nannies, and when she was working Crawford almost always spent nights at the studio. There were shelves loaded with awards and she had money in the bank, yet she always felt unsure about her prospects and her ability to keep earning the funds to support her lavish Brentwood lifestyle. Had Crawford been wise with her money, like Garbo and Shearer, she might have become wealthy and could have decided to retire, or to make films for the fun of it and not for the salary. But money slipped through Crawford's fingers.

Nearing fifty, she seemed to be as preoccupied with finding a wealthy husband as the next good part. If the two went together, all the better. One candidate was Milton Rackmil, the president of Universal International.[39] She met him through Rock Hudson, who, when he landed in Hollywood in the late 1940s, attracted the attention of almost everyone in town. Crawford tried unsuccessfully to bed him, but instead they became friends, and he was a regular at her parties. By 1952, Hudson was starring for Universal, and his boss became one of Crawford's regular escorts. After her affair with Nicholas Ray ended, there was talk in the papers about a possible marriage to Rackmil. Naturally he wanted her for one of Universal's upcoming projects so offered her the starring part in *Female on the Beach*, agreeing to her usual salary of $200,000. It was produced by Albert Zugsmith, who had a reputation for making money from cheap films. Joseph Pevney was assigned to direct. This was not the sort of top team that typically surrounded a Crawford production, but she did demand Charles Lang as cinematographer and Sheila O'Brien to design costumes.

As *Female on the Beach* was getting started, a new contender for her attentions appeared. On New Year's Eve 1954, while Crawford was still at the studio, she received a call from her old friend Earl Blackwell, who ran New York-based Celebrity Service, one of the first agencies promoting actors. He was hosting a party in Las Vegas and among his guests was Alfred Steele, president of Pepsi. Crawford and Steele had met casually several years before. "What are you doing in your dressing room alone on New Year's Eve?" he wanted to know, and she told him she was tired after having worked all day. He mentioned that he would soon be coming to Los Angeles and hoped to see her.[40] What Crawford didn't know at the time of the late December call was that Steele was in the process of divorcing his wife. It was his second marriage, and he had a child by each wife, an older daughter and a younger son.

Aside from the strong presence of Jeff Chandler who had been moving up as a Universal star, *Female on the Beach* has little to recommend it. Even the title was

awful, and they might as well kept that of the original story, *The Besieged Heart*. "Not too plausible murder mystery," decried *Photoplay*. "Joan Crawford is a rich widow who falls in love with chief suspect Jeff Chandler, charming good-for-nothing."[41] Whether or not Rackmil thought she was worth the money for studio prestige, the film had little impact at the box office. Their relationship continued and he was one of her more constant escorts that winter, but Steele soon would be competing for her hand.

Before filming began on *Female on the Beach*, which in hindsight looks like little more than a quick and lucrative payday for Crawford, she had put together a more interesting project. In mid-1954, she had acquired the screen rights to *The Queen Bee*, a 1949 novel by Edna Lee. It was a story that resembled *Harriet Craig*, another wealthy domineering woman causing havoc in her household. She put together a deal that included Ranald MacDougall as both screenwriter and director, and then offered the package to her old friend Jerry Wald, who was now producing at Columbia. Wald agreed to Crawford's terms, which included him as producer. She also saw to it that Charles Lang was hired. Jean Louis was Columbia's resident costume designer, and he designed a splendid wardrobe for Crawford, perhaps her best since leaving MGM. He was responsible for many of Hollywood's most famous costumes, included Rita Hayworth's dresses for *Gilda*, Marlene Dietrich's form-fitting gowns that she wore during her concert tours, and Marilyn Monroe's spectacular and outrageous dress that outlined her silhouette when she sang "Happy Birthday" to President Kennedy at Madison Square Garden.

Harriet Craig was a nasty character in a household of decent folks who were forced to bend to her will (until it became impossible). *Queen Bee* ("the" was dropped from the film's title) reveals a household of rascals with two young women, one weak (Betsy Palmer), the other strong (Lucy Marlow), who provide the dramatic tension. Crawford played the matriarch, and she is the worst of the bunch, but her alcoholic husband (Barry Sullivan) and duplicitous former lover (John Ireland) come close. Fay Wray has a thankless part as Crawford's husband's former fiancée whom he left at the altar when he ran off with Crawford. Crawford had played a lot of stinkers since moving to Warner Bros., but this was her worst, and this time her character got what she deserved. Though stylish and well-acted, it is a sour film. "Sick, sick to the core," wrote *Modern Screen*. "First there's a suicide and a couple of nasty other little nuisances."[42]

Crawford had the month of February 1955 off between films, and this was the period when Steele started courting her in earnest. They continued to see one another during the production of *Queen Bee*, but Crawford had little time for social life when she was working. Moreover, Steele's job was based in New York City. Still, they saw as much of each other as possible although there were few mentions connecting them in the gossip columns. That changed dramatically in May. On May 9, Crawford was serving as hostess for a Pepsi evening at Romanoff's, the

Crawford and John Ireland on the set of *Queen Bee*, 1955. Photo by Gene Kornmann.

posh Los Angeles restaurant. Although the two had been an item only for a couple of months, late in that evening Steele proposed that they hop aboard the Pepsi jet, fly to Las Vegas, and get married. Crawford, who was terrified of flying and had only a single experience in the air when she flew between Catalina Island and Los Angeles while making *Rain*, said no.[43] But, he convinced her, and by two o'clock the next morning they were standing before a justice of the peace in the penthouse suite at the Flamingo Hotel. Crawford was fifty and her new husband

Press photo taken in Las Vegas the evening of Crawford's marriage to Alfred Steele (May 10, 1955).
AP Wirephoto.

was fifty-five. Bert Knighton, Steele's assistant, and Ben Goffstein, the hotel's general manager, served as witnesses. Crawford seems not to have given any thought to telling her four children that "Uncle Alfred" had become their new stepfather.

Crawford's sudden marriage brought her name back in the news. In the 1950s, however, stars could no longer count on good press. In December 1952, a new magazine, *Confidential*, hit the newsstands, and thenceforth performers could no longer hide safely behind the high walls of studio publicity offices. Founder Robert Harrison "knew what a publisher could get away with and what the film industry wanted to keep under wraps."[44] Scandal and smut were now out in the open. Crawford's FBI file reveals a lengthy correspondence about a visit that Howard Rushmore, editor of *Confidential*, made to the FBI offices just after her marriage to Steele, inquiring about two stories that had been simmering for

decades. Rushmore had it on good authority that Crawford had been arrested for prostitution in Detroit back in 1924, and that at some point before the start of her Hollywood career had appeared in a pornographic film. A lengthy discussion of the merits of these claims covers a dozen pages of the file. The FBI discovered that a purported Crawford file from the Detroit police, once sent to Washington, had been lost, so that allegations of prostitution could not be verified. The file does state that "one of the old agents in the Detroit office remembered Joan Crawford at one time during the Prohibition era had been a stripteaser in one of the dives of Detroit."[45] Files were searched under the names of both Crawford and Lucille [sic] Le Sueur, and none were located. There is no indication that Billie Cassin, the name she would have been using in 1924, was ever considered. The most stubborn of all rumors that hounded Crawford throughout her career was that she had made a stag film before coming to Hollywood. The FBI files claim that no copy of the film was known to exist in 1955, but they "had talked to over 500 people who had claimed to have seen [her] obscene film," and that "Metro-Goldwyn-Mayer had spent thousands of dollars buying up [her] obscene film. . . . Of only a few prints of the film available . . . these were in the possession of top studio executives and most of them had been bought up by studio executives, Joan Crawford herself and some of her recent husbands."[46] The files indicate that an extensive look into the existence of the stag film was conducted in 1944–5. The conclusion then was as follows: "It is a generally accepted fact among purveyors of obscene film that there is in existence an obscene film portrayed as its female character, Joan Crawford, well-known motion picture actress. . . . While negotiations have been made on a number of occasions to obtain a copy of this film, none has ever been forthcoming, and at the present time the actual location of any copy of this alleged film is not known."[47] If FBI chief J. Edgar Hoover couldn't confirm its existence in 1945, and no new evidence except hearsay had come to light ten years later, then the film might never have existed. Later in the memorandum a section titled "Subversive References" reveals that Crawford "in the late 1930s was very antifascist and lent her name and prestige to organizations later identified as subversive . . . such as Russian War relief. Files also indicate that, since World War II, Joan Crawford has been anti-Communist and one of the leaders in fighting communism in the movie industry."[48] Unable to confirm with the FBI proof of prostitution or the existence of the stag film, Rushmore was unable to move forward with his story, although whispers followed Crawford through the rest of her life.

After completing *Sudden Fear*, Crawford managed her career like a general would an army. Over a three-year period, she bought the screen rights to *Johnny Guitar* and *Queen Bee*, signed a two-picture deal with MGM, and in March 1955 entered into a production agreement with United Artists.[49] For Universal, she agreed to make *Female on the Beach*, and for Columbia, to star in *Autumn Leaves*. At the time of her marriage, only *Autumn Leaves* had yet to be filmed, although

two had still to be released (she never made a picture with United Artists). She had rushed into this marriage so fast that it is not clear whether or not she had a strategy for the future. Would she continue working after completing *Autumn Leaves*, or become a corporate wife?

Right after the elopement, Crawford returned to Los Angeles and Steele to New York, but the couple planned a two-month trip to Europe, sailing in late May. As she didn't have time to shop, "the studio [Columbia] let her have more than twenty gowns, coats, hats and accessories . . . from 'Queen Bee.'"[50] The boat docked in Le Havre and they traveled on to Paris where, Earl Blackwell, who was responsible for the reunion that resulted in marriage, hosted a cocktail party for them. Louis B. Mayer and his second wife, Lorena, attended, as well as Steele's daughter, Sally. They traveled on to Italy before Crawford was called back to begin work on *Autumn Leaves*.

To welcome the newlyweds back to California, Crawford's best friend, former silent star and now top interior decorator Billy Haines hosted a black-tie dinner in their honor. Clark Gable and his new wife Kay Spreckels weren't able to attend, but neither was the groom who was "detained in New York."[51] Wagging tongues suggested that the couple were fighting, but the party went on anyway.

Autumns Leaves, originally titled *The Way We Are*, was announced back in the fall of 1954, but didn't go before the cameras for almost a year. The producer was William Goetz, son-in-law of Louis B. Mayer, who had been a founder of Twentieth Century-Fox and later president of Universal-International. In the 1950s, he became an independent producer associated with Columbia Pictures. The title of the film, which better captures its narrative—an older woman who falls in love with a younger man—was changed to capitalize on the popularity of its theme song written back in 1945. Roger Williams had a number one hit with "Autumn Leaves" in the fall of 1955, but it was Nat King Cole's rendition that was heard in the film. Robert Aldrich brought the project to Goetz in return for the director's job, and Crawford saw to it that Charles Lang was back behind the camera.

Although Crawford's characters had played opposite younger actors, *Autumn Leaves* was the first time the age gap was part of the plot line. Cliff Robertson was cast as a returning Korean War veteran who meets and falls in love with Crawford. The eighteen-year age difference between the pair corresponds with the actual age gap of their characters. Vera Miles and Lorne Greene have supporting roles. It was another perfectly tailored Crawford vehicle, plenty of drama and anguish, and this was the first time she committed a husband to a mental hospital (although a few would have benefited in the past). In the final scenes, the two are reunited—whether happily, or forever, is up to the audience to decide.

"The first time I met Joan Crawford," wrote Eve Arnold, "she took off her clothes, stood in front of me, and insisted I photograph her." Arnold was a preeminent photographer, a member of Magnum Photos, known as a photo journalist but beginning in the 1950s was sought after by magazines to shoot celebrities.

Arnold had been engaged by *Woman's Home Companion* to provide photos and a short essay for a feature promoting *Autumn Leaves*. They met at the studio of fashion designer Tina Leser: "When she was completely nude, she imperiously told me to start photographing. It was obvious she had been drinking.... I knew she would not be happy with the pictures she kept insisting I take." Exhausted, Arnold had finished the day's work before realizing that the first group of photos, the nudes, "had been exposed on colour film . . . I had colour film in the camera in anticipation of the colourful frocks I expected her to pirouette in." This caused a dilemma. Arnold typically developed her own black and white stock, but not color. "I realized there was no one I could trust to process the film." Arnold, who had never developed color film, had to buy a manual and learn how to do it. The expected call from Crawford's secretary came a few days later. Arnold was invited to lunch at Crawford's favorite New York restaurant, the 21 Club. When Arnold arrived she found her host already seated, and as she approached the table Crawford's outstretched arm readily accepted the small box containing the 35mm slides. "One by one she held up the transparencies to the light." When she was finished, Crawford "raised her vodka glass and said, 'Love and eternal trust—always.'"[52]

The *New York Times* predictably hated *Autumn Leaves*, but others thought it was good. Crawford had taken a reduction in salary and was paid $100,000. *Autumn Leaves* made money for Goetz and Columbia, and encouraged Aldrich to find another project for him and Crawford. They selected *Storm in the Sun*, and Columbia approved it, but then dropped it soon after it was announced in the press. It sounded like a great role for Crawford who would have played "a woman lawyer who defends a schoolteacher wrongly accused of raping one of his girl students."[53] Perhaps it was a story that was too provocative to film back in the mid-1950s.

As soon as *Autumn Leaves* was finished, Crawford set out on a national tour to promote *Queen Bee*, which had opened in early November 1955. It was a campaign that rivaled *Sudden Fear* and saw her frantically crisscrossing the country before she could get back to Brentwood to celebrate Thanksgiving with her whole family, four children, and their new stepfather. As a holiday treat, she packed up her entire brood and took them to Switzerland for Christmas.

For a moment, Crawford settled into the role of corporate wife. In the winter of 1956, she and Steele bought two apartments at 2 East Seventieth Street facing Central Park on Fifth Avenue in order to combine them into one magnificent duplex. Billy Haines was hired to plan the project and to decorate. For the first time, Crawford would turn away from the traditional and asked that new place be the epitome of midcentury modernism. The enormous renovation project took a year to complete, which might have been one reason that Crawford accepted a role in *The Story of Esther Costello*, to be shot in England. Another was that acting was a lot more fun than entertaining Pepsi wives. Marriage to Steele had also ignited a lust for travel. She had thought nothing of making train trips back

"Masterpiece," who tried to eat the flowers Joan was arranging, has the run of the house, but that's 'cause he has the cleanest paws in New York.

My index finger was pointed at the bell marked "Mr. and Mrs. Alfred Steele," but before I could make contact, the door flew open. A suntanned man stood before me and he looked like the sort of man who, if I'd seen him on the subway, I'd have been sure he was taking the ride because he was thinking of buying the company. He had that look.

"Darling!" came a cry from behind him. "It's so good to see you."

It was Joan Crawford. She waved me into the striking white foyer and I tried not to stare. I'd only met Joan once before and I still hadn't gotten over being dazzled. Seeing her here, in the $100,000 duplex apartment that had made even her Fifth Avenue neighbors gasp, I began talking real fast, hoping she wouldn't see that I was a little nervous.

"Gosh, would you believe it? It's March, the end of March," I said as I unbuttoned my coat, "and it's snowing outside! The elevator man blames it on the H-bombs. Imagine, snow at this time of year."

"I know, darling," Joan said. "So why don't you take off your shoes as well as your coat."

"Oh, they're not wet," I said, flattered that Joan would be so interested in whether I might catch cold. "I was wearing a pair (*continued*)

Joan's white rug is usually untouched by human shoes, but she and Al broke their own house rule to pose for this picture on their suspended staircase.

A view of the staircase in the Steele's magnificent Fifth Avenue penthouse designed by Billy Haines. [*Photoplay*, April 1959, p.57.]

Crawford was presented to Queen Elizabeth II at a gala evening in London in 1956. Brigitte Bardot can be spotted left of Crawford, and Anita Ekberg is at her right. London News Agency Photo.

and forth across between New York and Los Angeles, but except for one trip to Paris with Fairbanks Jr. back in 1932, she had avoided international travel. Now she was about to embark on her third transatlantic voyage in little more than a year.

The Story of Esther Costello was based on a 1952 novel by Nicholas Monsarrat, a writer best known for his wartime naval stories. Set in Ireland, it is a complicated story about a deaf, blind, and mute teenaged girl and the wealthy American woman who tries to help her. "In all fairness," read an ad placed in trade journals for exhibitors, "ask your patrons not to tell what happens to the girl." They could have included Crawford, too. David Miller directed the Columbia release, Rossano Brazzi costarred as Crawford's husband, and newcomer Heather Sears played the teenaged girl. A slightly loopy Crawford introduced Sears on British television just before filming began. Sears got the best notices and won the BAFTA (British Academy of Film and Television Arts) Award for Best Actress. The title was changed to *The Golden Virgin*, but clearer heads prevailed before the release and

On April 17, 1959, Alfred Steele, president of the Multiple Sclerosis Society, with his wife at his side, presented then Senator John F. Kennedy with a plaque recognizing Kennedy's work on behalf of the organization. Steele died the next day at home in New York.

it was restored to *The Story of Esther Costello*. Crawford had another success, and Columbia one of its top grossing films for 1957.[54]

Crawford had traveled to England in late July and spent six months there due to an unusually long production schedule (late August–late December). The twins were with her in August before heading back to school in America. On October 29, 1956, Crawford was invited to attend a Royal Command Performance of a British spectacle, *Battle of the River Plate*, at the Odeon Leicester Square. At a reception before the film was screened, she was presented to Queen Elizabeth II and Princess Margaret. Other film stars in attendance were Marilyn Monroe, Anita Ekberg (standing next to Crawford), and Victor Mature. When Crawford's work was completed, the twins joined their parents in Switzerland for a second Christmas holiday abroad.

Once she moved into her spectacular modernist apartment, Crawford decided that working with Steele and serving as an unofficial Pepsi ambassador might be a meaningful way to spend her time. After all, good scripts had been in short supply. Her previous aversion to flying disappeared (drinking might have helped),

and she logged thousands of miles, with and without her husband, promoting the soft drink's brand. There were occasional television spots, appearing on a Bob Hope special and as a guest on *What's My Line*, and she took roles in a couple of episodes of the *General Electric Theater*. Home life was a bit more complicated and her son Christopher, age fifteen, was arrested in May 1958 for shooting out lights and windows on Long Island while driving around with friends. He was charged with delinquency and released into the custody of a child psychiatrist.[55] He had never been an easy child, but having been largely abandoned by his mother did not help his behavior. In August, while she and Steele were vacationing in Bermuda, Crawford's mother died in Los Angeles. Christina Crawford wrote about their long-term estrangement: "Mother and Grandmother didn't get along very well. Grandmother was not included in any holiday festivities, she was not invited to our birthday parties, she never stayed to have lunch or dinner with us, and there were no photographs of her anywhere in the house."[56] Crawford flew back to California to arrange burial at Forest Lawn.

Throughout 1958 and into 1959, the Steeles were always on the go. Crawford accompanied her husband opening bottling plants and visiting corporate offices. Steele was expanding his company week-by-week and even with a jet airplane at his service, it was an exhausting schedule. They took time off for trips to Jamaica and visits to family, but their vacations were as intense as work. After a particularly grueling "whirlwind six-week nation-wide business trip," they arrived back at their New York apartment. Their last stop had been to Washington, DC, where Steele, as chairman of the National Sclerosis Society, presented a citation to Senator John F. Kennedy.[57] Early Sunday morning, April 19, 1959, Steele suffered a fatal heart attack in his bedroom. Crawford found him when he failed to wake her. He was fifty-seven.

What Ever Happened to Baby Jane?

"JOAN CRAWFORD ADMITS SHE'S BROKE" WAS THE HEADLINE TO Louella's Parson's column in the *Los Angeles Examiner* on June 1, 1959. It turned out not to be true, but close. What happened to all that money? Let's start with Steele, who was a well-paid corporate executive drawing $125,000 a year, which was a considerable salary back in the 1950s. In order to support his lavish lifestyle, married to an extravagant movie star, he borrowed heavily from Pepsi-Cola, hoping that in the long run he would be able to pay back his debt. Stock options would be granted, the stock price would rise, and all would be well. He also borrowed from Crawford. But Steele's house of cards collapsed. Crawford made a lot more money than her husband. From the time she started making films at Warner Brothers in 1945, she averaged about $200,000 per film. A few paid her less, but others, like *Sudden Fear*, considerably more. Sixteen films over thirteen years had brought Crawford at least $3.2 million. Extravagant living in Brentwood and New York, raising four children, but primarily denying herself nothing, had consumed most of her earnings. When she married Steele she expected, accepting the male chauvinism of the period, that he would foot all the bills. Crawford did contribute to the expensive renovations of the Fifth Avenue apartment, but it was money she expected to get back from her husband. At the Pepsi-Cola annual meeting, scheduled for three weeks after Steele's death, he was meant to have received a lifetime contract and options on 75,000 shares of the company's stock, but this never came to pass. When his estate was settled there was nothing left. Taxes, money due his ex-wife and minor son, and secured loans from Pepsi-Cola took it all. Crawford had the New York apartment, the Brentwood house, and her savings, but no inheritance to generate the cash flow needed to maintain either of these properties or her standard of living.

Recognizing the value she had been to the company working alongside her husband, Pepsi-Cola elected Crawford to the board of directors, the first woman ever to hold a board position at the company. She was awarded an annual salary of $50,000 plus an additional $40,000 for expenses. This would temporarily keep

the wolf away from the door, but it was not enough. She would have to go back to work. But where would a fifty-four-year-old former movie queen find roles?

Old friend Jerry Wald was the first to call. He was producing a film at 20th Century-Fox, *The Best of Everything*, based on a novel by Rona Jaffe, and there was a plum supporting role that he thought would be perfect for Crawford. Since 1929, she had twice appeared in cameos but never in a supporting part. And this time, if she accepted, she would be supporting three beautiful, and much younger, women. The part for Crawford was as a senior book editor at a large Manhattan publishing house, but the real drama concerned three young women recently hired as secretaries and played by Hope Lange, Suzy Parker, and Diane Baker. Lang was the picture's star, and the leading man was Stephen Boyd. Crawford accepted, with a salary reported as $65,000, and she was working in Los Angeles in May.[1] Also cast was another survivor from the old days at MGM, Brian Aherne, with whom Crawford had costarred in *I Live My Life* almost a quarter of a century earlier. Credit was handled diplomatically on both the film's credits and posters. After the stars were named, the two featured supporting players completed the lineup and were listed singularly—first, Louis Jourdan as David Savage, followed by Joan Crawford as Amanda Farrow.

The three leading actresses had different experiences on the set with Crawford. "She was pretty much a vulnerable, tear-ridden person, trying to hold it together," recalled Baker, so she tried to be kind, which temporarily created a warm relationship between the women. With Lang there was more competition, which she remembered as positive for the film as "our scenes were built-in with tension." Gorgeous Suzy Parker, who was as famous a face worldwide in the 1950s as Crawford had been on the 1930s (Avedon versus Hurrell), served "as a kind of shield" understanding better than the others the power of beauty and what its loss might mean to a great star (or top model).[2]

Jean Negulesco directed; he and Crawford had worked together fifteen years earlier on another Wald picture, *Humoresque*. "When in New York for location work," Negulesco wrote in his memoirs, "I went to see Joan. Her apartment was fabulous—white everywhere, shoes off at the door. . . . We went from room to room on a tour of the apartment. She drank vodka continually. I noticed she never carried a glass with her. There was a new full glass in every room in a convenient spot." There were minor tantrums on the set, but Crawford was forced to bow to the will of the director. For the first time in a quarter of a century, she was not the star. When she agreed to assist with a test for an up-and-coming actress, it was on the condition that a bottle of Pepsi would be prominently placed in the scene. Negulesco said no, and described her reaction as "crash, tragedy, hysteria."[3]

Crawford made the most of her few scenes as the veteran editor terrorizing her staff of young women. Wald had a special dramatic scene set in a bar written for her. When she was stood up by her date (presumably the married man with whom she had been having a long-term affair), in an increasingly inebriated state

she regaled the bartender with the story of her life. The scene did not appear in the final film, which must have disappointed Crawford. Without it hers was decidedly a secondary role, and no matter how hard she tried, Amanda was the faded older woman to the vibrant youthful beauties just starting out.

Yet, as she slipped in the credits, Crawford never lost her perch in the public imagination. *Life* gave her a ten-page spread in October 1959. "The Durable Charms of Joan the Queen" was accompanied by twenty-two photographs taken by Eve Arnold. They were the most candid and intimate pictures of Crawford ever published, and they depict her receiving a massage, applying her makeup, and playing gin rummy with her daughters. Gone is the glamour girl, but Arnold's magnificent photographs reveal the intelligence, strength—both physical and mental—and most of all, the diligence that made her a star. Arnold had proposed the photo essay and it was accepted by her editor at *Life*. Crawford liked the idea but asked Arnold if she might work with her in the dark room: "Translated, this meant she wanted editorial control." Arnold knew this was unacceptable, but told Crawford she would speak with her editor. Later that evening, Henry Luce, the publisher of *Life*, had a wild call from Miss Crawford complaining that that Arnold woman was trying to withhold her (Crawford's) editorial right to say which pictures were to be used. Arnold figured that when Crawford was sober the next day, she might soften her position, which turned out to be right. But there was a catch. She told Arnold, "If I don't like what you do, you'll never work in Hollywood again."[4]

Arnold's story also recounts an argument with Negulesco, and a caption under a photograph of a visibly distraught Crawford reads: "Once friends, Joan suffers miseries from tyrant director." Another colleague, an unidentified man, who worked with her on many movies, told the reporter: "She is . . . a man's woman. She drinks well and she swears well and she tells stories well and she plays cards well. She does not like opposition." Thirty years after achieving stardom, she was still receiving 10,000 fan letters each month—and she still responded, personally, to as many as possible. *Life* called her "Razzle-Dazzle and Drive." "There is a demon inside her," Hedda Hopper is quoted as saying, "She cannot stop going. . . . Joan does everything 1,000%." Crawford, too, was interviewed. "I do not kid myself," she told the writer, who asked why she drives herself so relentlessly, "I do it to keep from being lonely."[5]

The *Life* article was timed to coincide with the opening of *The Best of Everything*. The racy story from a popular novel, combined with a top cast in glorious widescreen color, contributed to make the film a hit. Wald came back to Crawford with a second plum supporting role, playing Roberta Carter in *Return to Peyton Place*. Loyal to Wald, and in need of another payday, Crawford agreed to take the part, but the story turned complicated.

Crawford had a now well-known and well-anthologized antagonistic relationship with her daughter Christina. This was a Shakespeare-worthy love-hate

story between a mother and a daughter. One minute, best friends, the next, mortal enemies. At the time of Steele's death, they were on good terms, at least according to Christina and as evidenced by surviving letters. Such good terms that Crawford had encouraged Wald to assist with Christina's burgeoning acting career. Wald was almost part of the family, and he was another "uncle," although not romantically involved with her mother. He was producing an upcoming Elvis Presley movie, *Wild in the Country*, and arranged a small part for Christina. Filming began in early November.

Before Christina was scheduled to start work, "Revolt of Joan Crawford's Daughter" appeared in the October issue of *Redbook* magazine. Christina had been interviewed and spoke candidly about the trials of growing up as Crawford's daughter, the rules and discipline, how her mother dictated her wardrobe, the schools she attended, and what she considered the capricious changes from one to another without any input from her daughter, disagreements about college, and her decision to become an actress. Crawford must have been consulted, too, and writer Morton J. Golding confessed that "the conflict" between the two "has reached such intensity, that when interviewed, mother and daughter often give contradictory versions of the same events." Christina recounted good and bad moments in her childhood, noting especially the happy early years when she was her mother's constant companion. "It has been eighteen years of disappointment," Crawford said of her daughter.[6]

On November 5, Crawford wrote to Christina that she had seen her screen test, and "thought you were just lovely. I am glad you had the loving care of Jerry Wald." Christina had been offered a long-term contract at 20th Century-Fox, and the Presley movie was intended to be the first of many. Five days later, Wald announced to the press that Crawford would appear in *Return to Peyton Place*. Hoping to reignite that old-time MGM glamour, he also tried, alas unsuccessfully, to convince Norma Shearer to come out of retirement. Others in the cast were Carol Lynley, Jeff Chandler, and Eleanor Parker. At this point the saga takes a twist. In early December, Wald called Christina into his office. "'You mother has just informed me that she is unable to do *Return to Peyton Place*.' He almost had tears in his eyes. 'We've been discussing this for months. It was all set! . . . What do you think happened?'"[7] Christina knew what had happened. Even though Crawford needed the money, and relished the chance to work again, her mercurial personality punished Wald for assisting Christina. Wald had rushed to Crawford's aid when she needed a job, but this time she rejected his offer over a perceived grievance. Thus ended what had been a long and fruitful professional association for both. Mary Astor took the role originally scheduled for Crawford. After the small part in the Presley film, Christina lost her long-term contract with 20th Century-Fox.

Wald had reimagined the Crawford brand back in the mid-1940s and without him Crawford might have faded away and not had the critical and financial successes of the previous fifteen years. His brilliant career would end in 1962, when

he died at the age of fifty. Crawford had a small group to thank for her decades of motion picture success: Rapf, Mayer, Mankiewicz, Hurrell, Adrian, and Gable, and to that list needs to be added Jerry Wald.

Gable and Crawford were names that together had lighted up theater marquees around the world and guaranteed long lines at box offices. Their on-again, off-again affair endured for decades between and during marriages. She counted him among her closest friends. Gable died on November 16, 1960, soon after filming completed on *The Misfits*. He was fifty-nine. "When he died I was so stunned I couldn't even cry. All I could do was remember the good times we'd had together," Crawford told an interviewer.[8] First she lost Steele and then Gable; the realities of late middle age were encroaching.

Crawford had the security of steady work and a tidy salary from Pepsi-Cola. Film work was another matter. Rejecting Wald so offhandedly ended a reliable source of future screen work. Should she have been more attentive to her film career, and been grateful for the chance to play decorous parts? This was a complicated moment for Crawford. She was a widow, under financial stress, and embarking on a new career with Pepsi-Cola. She still needed the additional income from acting, but her superb career strategy temporarily deserted her. If film work had stalled, acting jobs would now have to come from television. But the pay for guest spots was slight so she would have to accept many offers.

Crawford decided to consolidate her life in New York in order to control expenses. Her biggest asset after the Fifth Avenue apartment was her house in Brentwood, the home she had shared with four husbands and four children. To bolster her financial position, she decided to put it on the market, and in May 1960, she sold the house to actor Donald O'Connor. "Thirty-one years and what memories they held for this woman who put the 'G' in glamour and the 'S' in stardom," wrote Sara Hamilton in *Photoplay*. "And so was written another paragraph in the passing of the old regime in Hollywood, of the life, the glamour, the excitement of an era gone forever."[9]

As she was getting the house ready to sell, a story, maybe apocryphal, but just as likely true, was circulating. One day Crawford was scrubbing the house clean when the doorbell rang. The lady of the house answered, looking nothing like the glamorous star of the screen. A young man was standing there and, apologizing for the intrusion, said that he was great fan of Miss Crawford and might she be able to take a minute to meet him. Since he apparently didn't recognize the woman who answered the door, Crawford told him, "Sorry, she's in New York on business." He politely persisted asking in that case might he have a peek inside. "I've been her housekeeper for many years," said the lady with the mop, "she won't mind." The young man was treated to an hour long tour of the house. When they were saying goodbye, she told him, "I'm glad you like Miss Crawford so much. She'll be happy to hear it." As he turned to walk down the sidewalk he glanced back one more time. "Thanks for everything—Miss Crawford."[10]

Crawford appearing on *The Bob Hope Show*, October 1958.

Since 1960s television was awash with variety shows and celebrity-driven specials, once she settled in New York there were many opportunities to remain in the public eye. Bob Hope, who for four decades was the reigning monarch of the television special, invited Crawford to appear on the *Bob Hope Buick Show* in October 1960[11]. She was presented as one of the most glamorous figures in Hollywood and then introduced the Hollywood Deb Stars, a dozen beautiful young women currently working in television and the movies who were predicted to have a bright future. Among the chosen were Paula Prentiss and Shelley Fabares, both of whom had long careers. Crawford also accepted roles on the *Zane Grey Theater*, appeared on the game show *What's My Line*, and recorded radio spots promoting Maxwell House coffee. But she continued to harbor dreams of returning to film work.

Variety reported, in October 1961, a meeting between Crawford and Robert Aldrich, her director for *Autumn Leaves*, after which he expected her "to sign for the lead in the upcoming *What Ever Happened to Baby Jane?*," based on a novel by Henry Farrell published the year before.[12] Aldrich, who intended both to produce and direct, had secured the film rights, and Crawford had expressed interest in playing either of the two leading roles of sisters, each of whom were former stars: Baby Jane, in vaudeville, and Blanche, a 1930s movie queen. The action takes

Crawford as the head nurse training her staff in martial arts in *The Caretakers*, 1963.

place in 1963, when after living together for thirty years, the truce between the sisters shatters. Crawford decided she would prefer the role of Blanche. For the second sister, the title character Baby Jane, Aldrich wanted Bette Davis, so did Crawford, and if asked, every movie fan would have agreed. That winter Davis was appearing in *The Night of the Iguana* on Broadway; Crawford attended a performance, went backstage, signed the guestbook, and left a copy of the novel. Hedda Hopper broke the news in April 1962 that the two screen veterans, once Warner Bros. rivals, would costar in *What Ever Happened to Baby Jane?*

While Aldrich was preparing the script and casting his film, Crawford was offered a supporting part in *The Caretakers*, also based on a recent novel. Produced and directed by Hall Bartlett, and starring Robert Stack and Polly Bergen, the film was set in a mental hospital, and was a plea for physicians to consider talk therapy in place of strait jackets and shock treatments. Crawford would share above-the-title credit with the stars, but was listed third. To underscore her importance, her credit was distinctive and named her character: Joan Crawford as Lucretia. She played the hospital's conservative chief nurse who resisted new treatments for treating psychiatric illnesses. The film's most fun sequence is set in a gymnasium where Crawford teaches judo to the younger nurses. "Never trust

a patient, never turn your back on them," she tells her trainees, "from the very beginning the patient must know you are in control." Wearing a skin-tight black leotard, she looks terrific for her fifty-seven years.

The Caretakers was filmed before *What Ever Happened to Baby Jane?*, but Bartlett, watching the remarkable publicity that Davis and Crawford were generating in the press, decided to hold its release until the next year. He calculated well, and by waiting six months was able to ride the fresh wave of Crawford enthusiasm. The film made over $3 million at the box office and was one of the year's top moneymakers. It also received an Academy Award nomination for Best Cinematography and a Golden Globe nomination for Best Picture. Little viewed today, and often considered near the bottom of Crawford's screen work, at the time it was well-regarded, and audiences liked its almost documentary approach to a sensitive subject.

Aldrich had a script and two star leads, but what he lacked was the money to make the film. After being turned down by many studios, he made a deal with Seven Arts Productions, a company which largely financed films (*The Misfits* [1961], *West Side Story* [1961]). When Seven Arts funding was secured, he went to Jack Warner who agreed to release the film but didn't have any available studio space. The film was shot at the venerable former Clune Studios (later Fairbanks, and in 1962, Producers Studios) on Melrose Avenue. In an interview with *Cinema* magazine in 1963, Aldrich described his frustrations in getting the film started.

> Seven Arts made the picture, which per se, says already that they were more liberal and far-sighted, even as money lenders, than anybody else because nobody else would make the picture [nine companies turned it down]. . . . Seven Arts wouldn't make the picture without enormous guarantees, without heavy economic contributions from me and my company, with no reward for me or my company, except nominal unless the picture is profitable. . . . By the time the picture breaks even, three or four people, [and] Davis and Crawford, will have gotten reasonably good recompense, the distributor [Warner Bros.] will have made a small fortune, the lending company. . . . Seven Arts, received a handsome interest on their money, their overhead will be paid . . . the lawyers . . . will be paid in full. . . . How did it happen? It happened because one man wanted to make a picture and he has not been recompensed at all.[13]

That one man was, of course, Aldrich, but he also got financial concessions from his leading ladies. Crawford agreed to a huge reduction in salary and settled for $30,000 plus 15 percent of the net profits over $850,000 (the intended budget of the picture). Davis wanted more money, feeling that working on a percentage was a waste of her time. She was paid $60,000 and had a 5 percent (or 10 percent—sources vary) stake in the picture.[14] The shooting schedule was for six weeks, with

Long time screen rivals Crawford and Bette Davis finally met on the screen in *What Ever Happened to Baby Jane?*, 1962.

two additional unpaid weeks at the beginning for rehearsals. In addition, both agreed to a seventh week, also unpaid, for retakes and postproduction work. If filming went beyond seven weeks (exclusive of rehearsal time), Crawford was to receive $5,000 and Davis $10,000 per week.

Aldrich had the problem of assigning credit. Who would be listed first? One Saturday evening Hedda Hopper invited the stars to dinner at her home and the question came up. "'We tossed a coin and I won,' said Bette proudly. 'She comes first,' said a smiling Joan. 'She plays the title role.'"[15] That's the way Hopper reported it, and it might be true, or perhaps there was an agreement reached at the time the contracts were signed.

Jack Warner hosted what Hopper described as a "packed luncheon" at his studio welcoming the ladies back. It was quite a gathering," the columnist wrote, "because two more gutsy dames never lived."[16] Filming began in late July 1962. One thing Crawford and Davis could agree on was hiring Ernest Haller as cinematographer. He had worked with both at Warner Bros., with Crawford on *Humoresque* and Davis on *Mr. Skeffington* and *Deception* (among others).

Although the sisters dominate the action, there were four choice small parts: Maidie Norman played Elvira the housekeeper, Victor Buono was the youthful accompanist Jane hired when she fantasized about a comeback (hints of *Sunset Blvd.*), Marjorie Bennett played Victor's mother, and Anna Lee was the noisy next door neighbor. Davis's fifteen-year-old daughter, B. D., also had a small part playing the daughter of the neighbor, so she had plenty of chance to observe Crawford firsthand. She met Crawford for the first time on the set and described the moment in the autobiography she wrote about growing up as Davis's daughter. "I extended my hand. . . . She pulled back from me, putting her hand behind her back as if I were diseased." Then Crawford spoke. "One thing . . . my daughters, Cindy and Cathy . . . I would appreciate it if you would not try to talk to them. They have been very carefully brought up and shielded from the wicked side of the world. You, obviously, have not." B. D. was five months younger than Crawford's twins.[17]

Crawford's and Davis's dislike for each other fueled the competition on the set, which complemented the film's narrative. Their screen characters had also been rivals, and to establish background Aldrich treated audiences to clips of the stars in their prime: Davis in *Parachute Jumper* (1933) and Crawford in *Sadie McKee* (1934). Forty years later, they remained at the top of their game. Davis played Baby Jane as a demented hag and wore extreme makeup that accentuated both her age and declining mental state. Crawford, whose character had been a glamour girl, insisted that her still good looks be on view, and portrayed the vulnerable wheelchair-ridden Blanche as an object of pity.

If you find yourself driving through Hancock Park in Los Angeles, you might happen upon the house, little changed, used for the film's exteriors. Interiors were all shot at the studio, and the final beach scene was filmed mostly in Malibu, but close watching reveals that some of the close-ups were made in a studio recreation. It was more cost effective to bring sand into the studio than the cast back to the beach.

More than a half century after *What Ever Happened to Baby Jane?* opened in theaters, Crawford and Davis once again were talk of Hollywood when it became the subject of an excellent 2017 FX miniseries, *Feud*. Jessica Lange portrayed Crawford and Susan Sarandon played Davis, and over eight episodes the stars gave us a slightly fictionalized account of the making of the film. What *Feud* gets right is the dislike the two women felt for one another. Back in 1962, the press was encouraged to report that there was no hostility between the stars, and that they

were working beautifully together. *Feud* looked head-on at the Crawford–Davis antipathy. Audiences young and old were enthralled, and *Feud* garnered eighteen primetime Emmy nominations.

What was the source of the tension between them? Davis admitted that she fell in love with Franchot Tone when they were making *Dangerous* at Warner Bros. back in 1935, the same year he married Crawford. But it seems to have been a fling without lasting consequences. There are hardly any reports in the press of Crawford and Davis seen together, much less socializing, even in the late 1940s when they were working at the same studio. In their glory days, they were queens at rival studios although Crawford was known for her beauty and glamour, and Davis for her acting. It might be that simple. It is impossible to imagine two more self-centered, competitive, and successful performers, yet each likely resented the other for what was different. Davis was never going to be the supreme glamour girl, and Crawford was never going to garner ten Academy Award nominations.

"During the preview at Pantages in Hollywood, the applause was so tremendous at times, it was difficult to hear the dialog," wrote *Box Office*, adding that *What Ever Happened to Baby Jane?* "has enough suspense, drama and excitement going for it to make this film a memorable movie going event."[18] "I thought they'd blow the roof off," wrote Jack Warner after he watched the New York preview. "Baby Jane lit up the skies like a paint-factory fire."[19] The critic for *Film Bulletin* caught its dark side writing, "reality is bathed in the grotesque cloaking of a nightmare world," and adding "Miss Crawford is outstanding."[20] Andrew Sarris wrote that "if *Baby Jane* is about anything at all it is about Bette Davis and Joan Crawford" and described the dynamic between the pair as the meeting of "the screen's eternal masochist confronting the screen's eternal sadist."[21]

The film was a bigger hit than almost anyone expected and took in $4.5 million in the United States and that much again overseas. For the last quarter of 1962, *What Ever Happened to Baby Jane?* was the third top grossing film after *The Longest Day* and *Girls! Girls! Girls!*, and number one for Warner Bros. Simple arithmetic shows the amount of money Crawford made: $9 million less the cost of $850,000[22] equals $8,150,000, and multiplying that number by Crawford's 15 percent of the net brings her payday to over $1.2 million. This was more money than the cool million Elizabeth Taylor was paid for *Cleopatra*, widely heralded at the time as the biggest salary ever paid a film star. With later releases, television rights, VHS and DVD sales, there might still be an income being generated sixty years later.

If you look closely, in the scenes filmed in the neighbor's house, hanging on the wall is a work by Margaret Keane, creator of the famous "Big Eyes" paintings. Crawford was a devoted collector of Keane paintings, and in 1961 hosted a reception at the Keane Gallery on Madison Avenue in New York. In 1970, Margaret revealed that it was she and not her former husband Walter who was actually the artist. Crawford had commissioned a three-quarter length portrait— did she

Crawford and Bette Davis on the set of *What Ever Happened to Baby Jane?*, 1962.

know it was painted by Margaret or thought it was by Walter (who originally took credit)?—and it decorated her New York apartments. It is seen hanging on the wall in the cover photograph used for her 1971 biography, *My Way of Life*. Jean Negulesco claimed she had "the most spectacular penthouse in New York City, but the lousiest taste in paintings."[23]

The psychodrama of battling sisters was added to the National Film Registry in 2021. So famous has it become that many who have never see the film can quote verbatim the most famous lines. Blanche: "You wouldn't be able to do these awful things to me if I weren't still in this chair." Jane: "But you are, Blanche, you are." The performances were so finely calculated, and extreme, that they have been subject to lampoon almost since the film was released. The first was *What Really Happened to Baby Jane*, a production of the GGRC (Gay Girls Riding Club), a drag parody that appeared soon after the release of the original featuring Frieda as Baby Jane and Roz Berri as Blanche. It was directed and shot by James Crabe,[24] who would later find mainstream prominence as cinematographer of *Rocky* and *The China Syndrome*. For thirty minutes, the cast gives a picture-perfect summary of the film. The beach scene at the end veers off from the original with Blanche

on the beach at Malibu next to her overturned wheelchair clutching her Oscar. In the final moments, the film nods to Fellini's joyous melodic ending in *8 ½* and provides a conclusion that should be as palatable to audiences as the original.

Crawford and Davis both released autobiographies while *What Ever Happened to Baby Jane?* was underway: Crawford, *A Portrait of Joan*, and Davis, *The Lonely Life*. *Variety* reviewed them together. "The two books are accurate reflections of their creators: Crawford sleek, polished, disciplined, shimmering; Davis stormy, unpredictable, dynamic, alternately a skyrocket or a sizzler that fails to explode."[25] Crawford had been working for many years with Jane Ardmore, a well-respected journalist who wrote for the *Los Angeles Times* and the *Saturday Evening Post*, and was a regular contributor to *Photoplay* and *Modern Screen*. Ardmore had completed a biography of silent star Mae Murray, *The Self-Enchanted*. *A Portrait of Joan* (finished just after Steele's death) is candid about former husbands and her philosophy of raising children in a strict environment. Davis's book, *The Lonely Life*, was written with Sanford Dody. As *Variety* reported, it is the more vibrant book. Both would write second autobiographies; Crawford published *My Way of Life* in 1971, and Davis's 1987 *This 'N That* gave her the chance to respond to her daughter's memoir, *My Mother's Keeper*, as well as to criticize Crawford, by then dead and unable to challenge her many unkind assertions.

Soon after the opening of *What Ever Happened to Baby Jane?* on Halloween, October 31, 1962, Davis made an appearance on *The Jack Paar Program* to promote the film (and her new book). Paar told his audience that the film had made back its original investment a week after its premiere. When Paar asked, "What the wise guys in Hollywood said when [Aldrich] tried to [raise] money for you and Joan," Davis responded, "Those two old broads, I wouldn't give you a dime." Seconds later, she told Paar that but for Aldrich, "we would have been re-cast."[26] After the broadcast, Crawford contacted Davis and asked that she never call her a "broad" again. Crawford had her moment on national television when she appeared on the inaugural *Tonight Show with Johnny Carson*. She was respectful of her costar and called Davis "a great, great lady, fantastic talent . . . a real pro."[27]

Davis's biggest beef with Crawford concerned the 1963 Academy Awards. When nominations were announced, *What Ever Happened to Baby Jane?* was recognized with five: Cinematography, Costume Design, Sound, Supporting Actor for Victor Bruno, and Best Actress for Davis. Although Warner Bros. promoted both stars, Crawford was left off the list. She was too gracious to complain about this slight in public, but she put together a scheme that might just work out and show up Davis on Oscar night. While Davis told anyone who would listen that she wanted to win and become the first actress to gather three Academy Awards, Crawford stealthily contacted three of the nominees each of whom she assumed would be unable to attend the ceremony: Anne Bancroft who had been nominated for *The Miracle Worker*, Geraldine Page for *Sweet Bird of Youth*, and Lee Remick for *Days of Wine and Roses*. She asked if she might be the proxy to pick

up a potential winning Oscar. They all agreed. Bancroft was working on stage in New York in *Mother Courage* and Page was appearing on Broadway in *Strange Interlude*. The fifth nominee was Katharine Hepburn for *Long Day's Journey into Night*, and although she never attended Oscar ceremonies, there is no evidence that Crawford approached her.

Davis expected to win and was standing off-stage at the Santa Monica Civic Auditorium when Maximillian Schell took the podium to announce Best Actress. Crawford was there, too, with an entourage, magnificently gowned ("crystal dewdrops from shoulders to feet . . . the largest diamond clip she owns"),[28] and acting like she, and not Frank Sinatra, was the real host of the evening (she was, backstage, providing food, drink, and Pepsi for all). When the big moment came, Schell announced Anne Bancroft, and Crawford swept on-stage, ignoring Davis, and received the Oscar as though it had been her name called. Continuing the charade, she posed for pictures, holding Bancroft's Oscar in photographs with the other winners, Gregory Peck (Actor), Patty Duke (Supporting Actress), and Ed Begley (Supporting Actor). Davis was furious. She believed—incorrectly—that Crawford had sabotaged her chance of winning. What Crawford did was upstage her on Oscar night. It was a spectacular act of hubris, directed at Davis, but in no way was she responsible for the outcome. Davis never forgave Crawford, and plotted revenge. As for the Oscar, truth be told, Bancroft deserved it, and the award solidified her reputation as a motion picture star, a career she kept going at the highest level for the next forty years.

Davis did take home a significant award, *Photoplay*'s annual gold medal for Best Actress. The film was honored by the 1963 Laurel Awards with a special prize under the category "Sleepers," calling it "a masterpiece of suspense with Oscar-winners Bette Davis and Joan Crawford turning in two of their finest performances." Crawford and Davis were both nominated for BAFTA awards as Best Actress but Patricia Neal won for *Hud*. Davis attended the film's screening at the Cannes Film Festival, where she was nominated as Best Actress.

What Ever Happened to Baby Jane? reimagined theater's *Grand-Guignol* and ushered in a new genre of filmmaking called popularly, if unattractively, hag-sploitation. Former star actresses of a certain age, those over fifty (even over forty), had few opportunities for meaningful screen work. The success of *What Ever Happened to Baby Jane?* resulted in producers scrambling to capitalize by dusting off horror film projects that might be suitable for the big names that once headlined movie theater marquees. Davis and Olivia de Havilland, along with Mary Astor in a supporting role, made *Hush . . . Hush Sweet Charlotte* (a film intended for Crawford). De Havilland made *Lady in a Cage* (another film intended for Crawford). After *What Ever Happened to Baby Jane?*, Davis appeared in *Dead Ringer*. Others in the genre included *The Night Walker*, costarring Barbara Stanwyck, and her ex-husband and the one-time MGM star, Robert Taylor. Tallulah Bankhead made *Die! Die! My Darling!*

What Ever Happened to Baby Jane? restored Crawford's finances and proved that she was still a marketable commodity in the motion picture business. The avalanche of publicity for the film also helped the Pepsi-Cola brand as Crawford was closely identified with the company, tirelessly working to promote the soft drink. She wanted to continue both making motion pictures and serving as the Pepsi-Cola ambassador. Her role at the company was well-defined and for the moment secure. The open question was: would she continue to be offered interesting and lucrative acting roles?

Last Years

FLUSH FROM THE SUCCESS OF *WHAT EVER HAPPENED TO BABY JANE?*, Crawford must have hoped film offers would be plentiful and that she could pick projects at her convenience. In the meantime, she was busy traveling for Pepsi becoming a popular representative of the soft drink. She carved out time for occasional television appearances such as a spot on *The Merv Griffin Show* filmed close to home in New York. But the anticipated flood of good projects did not come her way.

William Castle was an unusual choice as producer for Crawford's next film. He had been directing low-budget films at Columbia since the early 1940s, delivering to audiences such fare as: *The Fat Man* (1951), *New Orleans Uncensored* (1955), and *Uranium Boom* (1956), among many others. In the late 1950s, his horror films started making money. *House on Haunted Hill* (1959), with Vincent Price, and *Homicidal* (1961) were successes, and Columbia promised him larger budgets. *Strait-Jacket* was the brain child of prolific crime writer Robert Block, who had written the novel *Psycho*, which was adapted into a 1960 film directed by Alfred Hitchcock. Block's next project, *Strait-Jacket*, was an original screenplay, and Castle snapped up the property. Columbia granted him enough money to look for an established star to play the leading role, an ax murderer who is convicted and sent away for twenty years. He settled on Joan Blondell, who was announced for the role in March.

Before filming began, Blondell was hurt in an accident and unable to work.[1] Castle then turned to Crawford, figuring the part of an ax murderer might be a good follow-up to Blanche in *What Ever Happened to Baby Jane?*, and Crawford, aware that the hoped-for flurry of offers hadn't materialized, accepted. She signed a contract to play the part of Lucy Harbin in late May, with filming scheduled for July and August. Her salary was $50,000 against 15 percent of the film's net profits. Might there be a repeat of the bonanza she had reaped the year before? To announce her participation in the film, Columbia feted her at a cocktail reception at her favorite New York restaurant, the 21 Club, which was attended by studio

brass and a full complement of the press. Another party in her honor was held at the studio when she arrived in Los Angeles to start work.

Yes, Crawford played an ax murderer. At the film's opening, her character discovered her husband in bed with another woman, and in a rage, picked up an ax and slaughtered the two. The scene is graphic. By chance, her three-year-old daughter witnessed the crime. Diane Baker, with whom Crawford had worked on *The Best of Everything*, played her daughter as an adult. Crawford, as usual, insisted on a good cinematographer, and the task went to Oscar winner Arthur Arling (*The Yearling* [1946], *I'll Cry Tomorrow* [1955]).

Strait-Jacket was among the films that ushered in the contemporary "slasher film." "Castle is an old hand at terror," wrote *Motion Picture Exhibitor* as the film opened, "and each scene is designed to pile on one sensationally bloody thrill after another."[2] After the gory murder, Lucy is committed to an insane asylum for two decades, and when released comes to stay with her daughter who had spent the intervening years living with an aunt and uncle played by Rochelle Hudson and Leif Erikson. See the movie to find out what happens next. *Strait-Jacket* has a terrible reputation, but it is a good example of its kind. Ads for the film were designed to bring fans of the genre to theaters. "Warning!" was emblazoned on one of the film's posters, which continued, "'Strait-Jacket' vividly depicts ax murders." And, with a photo of a screaming Crawford, and an ax being wielded by "anonymous" hands, who could resist buying a ticket?

One prop used in the film was a dramatic sculpture of Crawford's head. It was supposed to have been made by the character played by Diane Baker, an artist. Crawford must have encouraged its inclusion to remind audiences of what a beauty she had been decades previously. The bust had been created back in 1941 by the sculptor Yucca Sallamunich and is made of plaster patinated to look like bronze. Cukor, who directed *A Woman's Face*, allowed Sallamunich to set up a mini-studio in a space near the set for *A Woman's Face*. It seems strange that he would allow this project so close to where he was working unless he intended the bust to appear in his film, although it does not. Crawford kept the sculpture, and it decorated her various residences until her death. When it was sold at auction in 1994, the catalogue revealed that it has a dedicatory inscription to Christina Crawford, who would have been two years old back in 1941.[3]

Many critics avoided the picture figuring it had a niche audience who would find it, or not, although one distinguished reviewer sunk his claws into it. By now, Bosley Crowther should have grown weary of needling Crawford, but he hadn't. "Joan Crawford has picked some lemons, some very sour lemons, in her day. But nigh the worst of the lot is 'Strait-Jacket' . . . the only conceivable audience for this piece of melodramatic rot is those who have a taste for ghoulish violence (of which there are plenty)." Crowther was right, there were plenty—so many, in fact, that the film brought in more than $2 million, giving Crawford another windfall of $200,000 against her guarantee of $50,000.[4]

Crawford photographed the set of *Strait-Jacket*, 1964, with the Yucca Sallamunich bust made back in 1941.

What the fan magazines focused on, as they had for three and a half decades, was the star's lingering glamour. "Joan Crawford confounded the calendar watchers with her svelte figure and radiant beauty," wrote *TV Radio Mirror*, quoting an "old-timer." "You could leave her out in the rain for forty days and she'd still look better than the new ones."[5] One of the new ones was Elizabeth Taylor, whom Crawford had known, and disliked, for years. Columnist Earl Wilson asked if she was going to see the blockbuster *Cleopatra* that had recently opened. "I refuse to see a picture," Crawford responded, "that contributes to the delinquency of adults—not that I think Miss Taylor and Mr. Burton are adults . . . they're spoiled brats. I wouldn't be caught dead seeing a film that's destroyed so many lives, misled so many children, brought so much shame on the industry. Look, sex is here to stay; but don't hold up production of a picture for it. Do it on your own time!"[6]

Her fans still turned out to see her when she made personal appearances promoting the film. Even those who might have avoided seeing *Strait-Jacket* still wanted a glimpse of their longtime favorite actress. Castle had calculated brilliantly when he hired Crawford. Her fame and power at the box office was one thing, but she came with a publicity apparatus that hardly a star in Hollywood could match. The Pepsi public relations department, anxious to keep Crawford in the spotlight as the brand's ambassador extraordinaire, would oversee her

schedule, and her work for Pepsi would coincide with appearances at theaters on behalf of the film. Like a general, Crawford could organize many different divisions operating at the same time. From a series of rooms at a hotel, for example, television and radio reporters were stationed in designated spots so each might have a few minutes with the star. Film and business print journalists might be in different rooms placed so each could have a private few minutes allowing "exclusive" conversations. All of this was supported by the Pepsi jet made available during her tours.

Crawford made a trip to Boston in the early winter of 1964 to publicize *Strait-Jacket* and to do business for Pepsi. She stayed at the Ritz Carlton, and a press agent for Columbia, John Markle, assisted with the arrangements.[7] *Life* magazine, in a February 1964 special report, "A Well-Planned Crawford," treated readers to a peek into the enormous preparations taken when Crawford was on the road. The reporter was given a copy of her schedule for the Boston visit. Most interesting is an attachment that described the courtesies expected when she traveled: "The instructions leave very little to chance and even less to the local man's imagination." They began with her arrival.

Miss Crawford will be met in an air-conditioned, chauffeur-driven, newly cleaned Cadillac limousine. Instruct your drivers they are not to smoke and that they may not at any time drive in excess of 40 miles an hour with Miss Crawford in the car. Miss Crawford will be carrying a minimum of 15 pieces of luggage. Along with the limousine you will meet Miss Crawford's plane with a closed van for the luggage. . . . Fifteen pieces is the estimated minimum. There may be considerably more.

Under accommodations:

The top suite (including three bedrooms) in the hotels indicated. This should be the best suite available. . . . Note: The three bedroom suite is for Miss Crawford and Miss Brinke [her maid].

"The third room holds the Crawford wardrobe," noted the reporter. "On the road Miss Crawford, the perennial clotheshorse, changes costumes six to 10 times a day."

Under Special preparations at the Hotel:

Use this check list very carefully; there may be no deviations.

a) A uniformed security guard is to be assigned to the door of the hotel suite 24 hours a day.

b) The following items are to be in the suite prior to Joan Crawford's arrival:
 i) Cracked ice in buckets—several buckets
 ii) Lunch and dinner menus
 iii) Pens and pencils and pads of paper
 iv) Professional-sized hair dryer
 v) Steam iron and board
 vi) One carton of Alpine cigarettes
 vii) One bowl of peppermint Life Savers
 viii) Red and yellow roses
 ix) Case of Pepsi-Cola, ginger ale, soda
c) There is to be a maid on hand in the suite when Miss Crawford arrives at the hotel. She is to stand by until Miss Crawford dismisses her.
d) The following liquor is to be in the suite when Miss Crawford arrives
 i) Two fifths of 100 proof Smirnoff vodka. Note: this is not 80 proof and it is only Smirnoff
 ii) One fifth Old Forester bourbon
 iii) One fifth Chivas Regal
 iv) One fifth Beefeater gin
 v) Two bottles Moët & Chandon champagne (type: Dom Pérignon)

The local person in charge of the tour was reminded, in capital letters: "IN MOST CITIES IT WILL BE POSSIBLE TO WORK A DEAL FOR HOTEL AC-COMODATIONS REQUIRED. IT WILL BE TO *YOUR* CREDIT IF YOU CAN."

"Joan rarely leaves her hotel when she is on tour, and she does much of her work in her own suite. There she receives distinguished visitors, specially select-ed reporters and local bottlers. Maximum press contact and publicity must be achieved in minimum time." Under Miss Crawford's schedule was the following:

There is a specific way of handling Miss Crawford's schedule in each market. The following detailed outline will provide you with all of the information you require to execute this schedule to the complete satisfaction of everyone.

a) Miss Crawford will not go to any radio, television studios or newspa-pers offices. Don't suggest it, don't request it.
b) Plan a print media press conference for 10 a.m. Miss Crawford will sit on a couch in front of a coffee table with chairs arranged in a half-moon around the couch and table.
c) Arrange radio interviews for 10:30 or 11:00 depending on the number of reporters at the press conference. . . . Arrange for a number of card tables with two chairs each for various places in the suite, as Miss Crawford will go from one to the other for exclusive radio interviews.

d) Television should be arranged for the same suite.

e) EXCLUSIVES: When it is absolutely necessary, and the person involved is of truly top stature, Miss Crawford will give an exclusive.

"When it was over, Joan had raced through nine newspaper interviews, seven radio tapes, two TV tapes, one newsreel. She autographed 76 pictures and copies of her autobiography, and posed for scores of pictures . . . all in a matter of three hours and nine minutes . . . the exclusive interview yielded next day a column and a half of gushing publicity and a review of *Strait-Jacket* that was mild and moderate in contrast to what critics have said about it in other cities where it has been panned." The reporter's favorite bit of the "instructions" was the "clangorous coda":

Miss Crawford is a star in every sense of the word; and everyone knows she is a star. As a partner in this film, Miss Crawford will not appreciate your throwing away money on empty gestures. YOU DO NOT HAVE TO MAKE EMPTY GESTURES TO PROVE TO MISS CRAWFORD OR ANYONE ELSE THAT SHE IS A STAR OF THE FIRST MAGNITUDE.[8]

Star of the "first magnitude," she might have been, but she still needed, or at least wanted, work. Since film directors were not calling, her follow-up to *Strait-Jacket* was a guest-starring appearance on *Route 66*, filmed on location in Maine in the late summer of 1963. The popular one-hour drama featured Martin Milner and Glenn Corbett (the fellows with the Corvette convertible), and Crawford was cast as Morgan Harper in the episode titled "Same Picture, Different Frame." The episode, which aired in October, featured Crawford and Corbett working at a grand equestrian camp, and we have the chance to see Crawford back on horseback after many years. The two developed a close relationship, and she demonstrated that at fifty-eight, she could still give a man—even one half her age—the once over, and mean it.

Television, Crawford seems to have thought, was going to have a place in her future, so she decided to co-produce with Four Star Television a pilot for a potential series. Over two weeks in October, she filmed *Royal Bay*, starring Paul Burke and Charles Bickford. If the show had been picked up by a network, she would have made occasional guest appearances. Crawford is mighty good as the town's matriarch (the sort of role Barbara Stanwyck would play in *The Big Valley*) whose daughter, played by Diane Baker again, has a medical condition that prevents her from going outdoors. It is a confusing pilot because the drama concerns two characters (Crawford and Baker) who would not be regular members of the series cast. *Royal Bay* never made it as a television series, but the seventy-minute pilot was long enough to be released theatrically as a feature and came out in 1965 with the title, *Della*, Crawford's character.

Crawford on the set of *Hush . . . Hush, Sweet Charlotte*, 1964, shortly before she was fired.

Aldrich was among the last to be paid for his work on *What Ever Happened to Baby Jane?*, but when the receipts were counted the producer/director made a nice income. What better idea than to repeat the formula and hope that audiences were enthusiastic a second time. Henry Farrell, who had written the novel *What Ever Happened to Baby Jane?*, followed up that work with a short story, "What Ever Happened to Cousin Charlotte?" It is another tale of betrayal and murder featuring crazy older women. Who better than Crawford and Davis to reignite their macabre magic of two years earlier?

Crawford signed on first, committing to *What Ever Happened to Cousin Charlotte?* in January. Again, she would be paid a salary and have a percentage of the gross. Davis resisted at first, not wanting another pairing with Crawford: "I told [Aldrich] I would not work with Joan again."[9] She changed her mind. Was it the prospect of another big bonus should history repeat with a second box-office success? There was one condition: she wanted the title changed. Davis claimed it was she who came up with the new title, *Hush . . . Hush, Sweet Charlotte*. Aldrich wanted to keep the original as he thought it would draw a bigger audience, but relented.[10]

Cast and crew flew to Baton Rouge, Louisiana, in late May to shoot location footage. They worked for two weeks before returning to Los Angeles. This is where

the story gets complicated. Crawford's biographer and longtime AP reporter Bob Thomas claimed that Davis was hostile to her costar from the beginning. "My God, is that the way she is going to play it?" Davis reportedly said to Aldrich within Crawford's earshot. Thomas believed Crawford "felt powerless. She had never encountered an adversary as steel-willed as Davis."[11] Crawford began work in Los Angeles but soon took ill and was admitted to the hospital with what was reported as a respiratory condition, possibly pneumonia. She was released a month later and able to work a couple of hours a day for a few days, but then relapsed. "Joan Crawford, plagued with illness since early June, entered Cedars of Lebanon Hospital for the third time in two months with a recurrence of pneumonia," wrote *Motion Picture Exhibitor* in mid-August. "Producer-director Robert Aldrich had closed down production of 'Hush . . . Hush Sweet Charlotte' for the second time when it appeared that Miss Crawford could not maintain a normal schedule."[12] Third time was not the charm for Crawford, and Aldrich was told by the studio, "Replace Crawford or cancel the picture."[13] Davis didn't believe she was sick and called it "an indefinite kind of illness."[14] Was Crawford really ill, or at least too ill to work? The caption on an AP wire photo dated July 19 reads: "Joan Crawford, recuperating in the hospital because of her bout with pneumonia, points to a $110,000 sapphire necklace which she's wearing with her hospital gown by Dior." Fully made-up and being visited by reporters and photographers, she didn't seem to be suffering. It was also rumored that her meals were being brought in daily from top LA restaurants. Crawford was a veteran performer who knew that she couldn't hold up a production for three months and expect that the director wouldn't be under pressure to replace her. She was also shrewd enough to know that she couldn't quit the film without exposing herself to a lawsuit for breach of contract. If sickness was the reason she couldn't work, insurance would cover the days she missed. Aldrich was left with no solution but to fire Crawford. In early September, he announced that Olivia de Havilland had taken Crawford's role. Always the diplomat—at least in front of the press—Aldrich was quoted as saying, "We feel a great sense of sorrow at not being able to complete our picture with Joan."[15] Nevertheless, there are production photos showing the director and crew welcoming de Havilland in which the principals hold Coca-Cola bottles. Davis was ecstatic. Getting Crawford fired from *Hush . . . Hush Sweet Charlotte* was the revenge she sought after Crawford's behavior at the Oscar ceremony two years before.

Was this the outcome Crawford intended? Had she decided that working with Davis wasn't worth the paycheck? Or had she gambled incorrectly that she could prevail over her costar and director? There were reports that, upon learning of her dismissal, she cried for nine hours. She never forgave Aldrich.[16]

She wasn't well enough to work for Aldrich, but Crawford was able to take a supporting role for William Caste in *I Saw What You Did*. After *Strait-Jacket*, he made another film with a top cast, *The Night Walker*, starring Barbara Stanwyck and Robert Taylor, but it wasn't successful. *I Saw What You Did* was produced

Crawford portrait made during the production of *I Saw What You Did*, 1965.

on a small budget, with $50,000 going to Crawford. She played a woman in love with a man who had gruesomely murdered his wife. Two teenage girls spend an evening making crank calls. When an unsuspecting person answers, the caller says, "I saw what you did, and know who you are." This foolish adolescent game had deadly consequences. And this time, Crawford was one of the victims. She had only one costume (and her jewelry was almost worth the price of admission), which made it possible for Castle to shoot her scenes efficiently and quickly. If you would like to watch Crawford lose control of herself when a "rival" appears ("Get out of here, you little tramp"), this film is a good opportunity. Even with top billing, her character was dead within the first fifty minutes. Taking in a million dollars, it wasn't as successful as *Strait-Jacket*, or nearly as good.

Over the next couple of years either no film projects were offered to Crawford, or none that appealed to her. She appeared on a few interview and game shows, but spent most of her time working on behalf of Pepsi. It was a busy time for the company. In the summer of 1965, Pepsi-Cola merged with Frito-Lay to create PepsiCo, Inc. Crawford remained a director of the soft drink subsidiary, Pepsi-Cola, and retained her salary and perks. The following January, she added Frito-Lay to her portfolio when she was elected a board member of that subsidiary as well. PepsiCo was not only expanding into new products and markets, but engaged in a "cola war" with Coca-Cola, its archrival. Crawford's star luster was important to the brand, and throughout the 1960s she became so closely associated with Pepsi that many thought she was the company's president. This created a tension with president and later board chair Donald Kendall, but for the moment he understood her worth.

Crawford had tremendous value as a corporate spokesperson, but her importance as a movie star seemed to diminish with each film she made in the 1960s. The huge success of *What Ever Happened to Baby Jane?* never translated into meaningful offers. She made money on *Strait-Jacket*, and whether or not it is a good example of a slasher film, it was an ignominious late step in a spectacular career. It would have been better had she stopped with *Strait-Jacket*, and ridden out her career with occasional guest appearances on television. The decision to keep going in spite of what was offered is a peculiar one for a Hollywood legend living in luxury on Fifth Avenue, dining at the most fashionable restaurants, chatting with Merv in the afternoon and Johnny late at night, and having fun with guest appearances on popular television programs. Why did she need to make *Berserk!* and then *Trog*?

In late summer 1966, she signed a contract to make a British horror film, *Circus of Blood*, produced by Herman Cohen and directed by Jim O'Connolly. Unlike her early black and white films in this genre, it was filmed in rich, deeply saturated colors. Before it was released the title was changed to *Berserk!* Crawford flew to London that fall returning once to America to attend a PepsiCo board meeting. "I'll make a deal with you," Cohen told his star before work began. "On the picture

you can never drink in the morning, and you can never drink without getting your producer's permission." Like many alcoholics, she was either unaware of the extent of her drinking problem, or in denial of how it affected her life. "I'm just a sipper," she told Cohen, "it makes me feel good."[17]

Crawford portrayed another harridan—this time she is the owner and ringmaster of a traveling circus—and gave arguably the weakest performance of her career. Before long, a series of horrific deaths occur. What was happening at her circus? Shades of *Strait-Jacket*, it turned out her daughter was the culprit. "The film does project a kind of defiant suspense," wrote the *New York Times*, "that dares you not to sit there, see who gets it, and why." The same reviewer noted things that hadn't changed a bit over the decades including "Miss Crawford's portrayal of a ruthless iceberg," adding that she was "certainly the shapeliest ringmaster ever to handle a ring microphone."[18] Shapely or not, the age difference between Crawford and her leading men had become ridiculous. Ty Hardin, who played her love interest, was thirty-six and she was sixty-one. *Berserk!* has little to recommend it, but there are spectacular circus acts, especially those featuring high-wire artists. Another Crawford film shot on a miniscule budget, it was a financial success and took in over $2 million at the box office.

Upon returning to the States, Crawford accepted a guest role on the television spy series, *The Man from U.N.C.L.E.* She appeared in part one of a two-part episode, "The Five Daughters Affair." On the first day of filming, the series regulars Robert Vaughn and David McCallum presented her with red roses to welcome her onto the set. The two forty-five-minute episodes were combined and released overseas as a feature film titled, *The Karate Killers*. On posters advertising the feature, Crawford's name is in the same font, color, and size as Vaughn and McCallum's, sometimes in the top position.

A spot on *The Lucy Show* in early 1968 caused distress both to the regulars, Lucille Ball and Vivian Vance, and the guest star. The script was ideal. Lucy and Vivian are out driving when their car breaks down. They knock on a door to ask for help and find they are standing in front of Crawford's house. She is dressed for cleaning, and they decide she must be broke. It is a perfect comic set up. Ball, one of television's veterans, had the filming of a weekly show down pat: day one was the read-through, then rehearsals, followed by the blocking of scenes, and on the fifth day taping before a live audience. "[Crawford's] early readings were tentative and humorless," wrote Bob Thomas, "she displayed an inability to memorize lines, and the mention of a live audience filled her with terror. And she was drinking." Ball felt she was unprofessional and threatened to replace Crawford. Crawford was, however, if not a television star, nonetheless a pro, and on the fifth day when she walked on the set, the audience gave her a standing ovation. From that moment on she was letter perfect.[19]

Crawford decided to sell her Fifth Avenue apartment in the summer of 1968, claiming that she "could no longer afford the nearly $3,000 monthly maintenance."

Crawford hosting ABC's *Hollywood Palace*, April 1967.

She found a smaller and less expensive place on East Sixty-ninth Street in the Imperial House, a modern building completed in 1961 and designed by the renowned architect Emery Roth. Crawford took a nine-room apartment on the twenty-second floor: three bedrooms, a large living room, dining room, family room, and two terraces. There were three baths as well as a maid's room and bath. If she was looking for less expensive quarters, this luxurious rental provided her a capacious place to call home. For the first time she turned to a decorator other

than Billy Haines, selecting Carleton Varney, whom she had met three years earlier and who had become a close friend. So close, she even plotted for him to marry her daughter Christina, but that fantasy went unfulfilled. "Joan and I planned her new nine-room apartment down to the last shelf," Varney recalled. "We turned the former maid's room into a hat and shoe room." The second bedroom was her dressing room, and the third bedroom was for Mamacita (Anna Marie Brinke), her maid. Varney described his work for Crawford in his memoir, *There's No Place Like Home*. "Black framed chair seats were covered alternately in lime green and yellow washable vinyl" was Crawford's request for the dining room. "But it was rarely used for a sit-down dinner. Joan usually took her guests out for dinner." When there wasn't company "she ate sparrow-fashion on a tray with Mama in the kitchen or alone at her desk." Varney also mentioned photographs of three close friends that always had a prime place in her apartments: Noël Coward, Barbara Stanwyck, and Helen Hayes.[20]

In the fall of 1968, Crawford made what was the most foolish blunder of her career. Her daughter Christina, with whom she was then on good terms, was having success as an actress, sometimes working on stage, and had a part on a soap opera, *The Secret Storm*. Christina needed to have an emergency operation and would miss shooting for several days. The morning after the surgery, Christina awoke to find her mother and the show's producer in her room. Still groggy, it took her a few moments to understand that Crawford had volunteered to replace her. Crawford would play the same twenty-eight-year-old character as her daughter.[21]

Neither Crawford nor the show's producers could resist the attention that would result from the temporary cast change: "Nothing in recent years had given Mother as much publicity as taking over my part in the soap opera."[22] The rehearsals went well, but problems began when Crawford got on the set.[23] The episodes featuring Crawford aired in late October shortly before Christina left the hospital, so Christina watched them from her bed. "As the scene progressed my heart sank into the pit of my stomach," wrote Christina. "She wasn't just nervous. Mother had been drinking when this scene was taped. She was not sober when she did this work." Later shows were no better. "My mother was appearing on the programs drunk."[24]

Rod Serling, who became a television household name with *The Twilight Zone* (1959–64), later created a similar type of sophisticated horror program called *Night Gallery*. A special two-hour pilot was aired in November 1969 and featured three thirty-minute stories. Crawford starred in the second, "Eyes," working with Barry Sullivan and Tom Bosley. The episode marked the directorial debut of twenty-two-year-old Steven Spielberg. Crawford, who was paid a generous $50,000 for her appearance, played an extraordinarily wealthy woman, blind since birth, who had an opportunity to gain her sight for about twelve hours.[25] The twist is that the eyes must come from a healthy living person. One character, an artist who, ironically, painted her portrait, one she will never see, calls her a "tiny, fragile,

little monster," and only someone fitting that description would be able to pay a donor for his eyes. Crawford is excellent in the role, a narcissist without a soul. "My abiding concern, doctor" she tells Barry Sullivan, "and my singular preoccupation, is myself." Wanting to be alone in her apartment at night with her temporary vision, she waits until the sun has set to remove her bandages. As she becomes accustomed to her first sensations of light and color, suddenly, all becomes dark. There is a city-wide blackout denying her the promised dozen hours of sight.

Before they started working together, Crawford invited Spielberg to the apartment she rented in Los Angeles on Fountain Avenue after she sold her Brentwood house. She received him wearing an eye mask hoping to prove she was up to playing a blind woman. From there they went to Luau, a restaurant in Beverly Hills. Feeling comfortable with the nascent director, and perhaps remembering her early years, she told Spielberg, "I'll be your guardian angel."[26] Eight years later, Spielberg spoke at Crawford's memorial service. "She treated me like I knew what I was doing, and I didn't. I loved her for that."[27]

Crawford was among the first "legends" to participate in a series of advertisements for Blackglama mink that began in 1968. Each "legend" was photographed by Richard Avedon or Bill King and were featured, full-page, without any identification except the tag line above: "What becomes a legend most?" Crawford, photographed by Avedon, appeared in the fall of 1969 (others photographed that year were Marlene Dietrich and Lena Horne). As payment, each "legend" kept the fur coat that she modeled.

The glamorous, or at least formerly glamorous, Crawford was sought out to model fur coats, but she had less success getting the attention of directors as they were wary of hiring her. Crawford's excessive drinking while working was well-known, and the four episodes of *The Secret Storm*, and her guest appearance on *The Lucy Show*, indicated that she could not be trusted. Herman Cohen, the producer of *Berserk!*, felt he could still manage her, and knew that a $50,000 investment with a big name was a fair risk, and would allow him to make money on another cheap film. He invited her back to England in the summer of 1969 to make *Trog*. Freddie Francis directed.

Trog is short for troglodyte (prehistoric cave dweller). Crawford plays an American anthropologist working in England whose team discovers, deep in a cave, a surviving troglodyte who is (affectionately, for the moment) named Trog. In a weird spin on the story of beauty and the beast, Crawford attempts to civilize him, and has some luck before the authorities want to get involved and turn Trog into a monster. From there, beauty and beast segues awkwardly to mimic poorly the final scenes in Universal's *Frankenstein* (1931). The child is saved, the monster is dead, and Crawford has lost her friend.

When asked after she completed filming *Trog*, her last feature, why she had agreed to make the ludicrous horror picture, her answer was simple. "The need to work is always there, bugging me."[28] After decades of being a favorite subject of

Pressbook for *Trog*, 1970.

articles in *Photoplay* and *Motion Picture*, not to mention *Life* and *Saturday Evening Post*, in the late 1960s she added a new category and was featured in *Fangoria*, *For Monsters Only*, and *Cinefantastique*. The latter gave *Trog* a proper review and looked kindly on the star. "While it is not a fright film beyond criticism, Miss Crawford is . . . in a role that would surely defeat a lesser actress, Miss Crawford manages to look dignified and she puts her indelible stamp of authority on all this foolishness . . . Miss Crawford gives it class."[29] She does, indeed, look good and is well dressed even when she is in a cave searching for Trog. That's what customers wanted, a fleeting glimpse of the old movie magic, which she continued to provide even in a lousy picture made as she was about to turn sixty-five.

While in England, she met critic Alexander Walker, who would write an excellent biography of Crawford in 1983. He had put together the script for a documentary for the BBC on the life of Garbo, and he asked Crawford if she would narrate the film. She agreed, was respectful of her one-time MGM colleague, and seemed almost enthralled by the Garbo legend. She spoke about Garbo never making a film after 1941 although countless offers had been made trying to lure her back to pictures. Crawford said Garbo never found the right project. As she had been at MGM in the twenties and thirties, Crawford was Garbo's opposite, the ebullient Crawford versus the taciturn Garbo, the former demanding the spotlight, the latter avoiding it altogether. A quarter of a century after Garbo abdicated her throne, Crawford still desired to continue working no matter what, and to keep her name in the headlines at almost any cost.

The Sixth Sense was a 1972 television series modeled on *Night Gallery* but focusing more expressly on ESP. Crawford took a leading role in an episode broadcast in October 1972, "Dear Joan: We're Going to Scare You to Death." Gary Collins was usually the star, but for the Crawford episode, he introduced the story and then appeared in a short interview with the star at the conclusion. They discussed ESP, and she described a moment where she believed she had ESP—the knowledge that an accident would soon happen to one of her dogs—and it did, according to Crawford, exactly as the dream predicted.

Hollywood publicist and friend to the stars John Springer hosted as a series of special evenings devoted to the movies' legendary ladies at New York's Town Hall on Forty-third Street. The first was held in February 1973 and featured Bette Davis. The evenings consisted of film clips highlighting the actress's career followed by an on-stage interview and concluding with questions from the audience. Myrna Loy was Springer's second legendary lady in March, and Crawford took the stage in April.[30] Crawford was charming and candid in answering questions from many of the 1,500 fans gathered. When asked about how she made the transition from movie star to corporate ambassador she answered, "I sold Joan Crawford for so long all I have to do now is let Joan Crawford sell Pepsi-Cola." When an audience member wanted her to compare Mayer and Warner she didn't hesitate: "One was a beautiful man [Mayer] and one was a stinker." And another was interested in her part in *Humoresque*: "I love playing bitches, and I was a bitch in that." Hundreds gathered in the street after the show concluded, surrounded her limousine, and prevented it from moving, Crawford's devoted fans wanted one more glimpse of a real movie star. The Town Hall evening turned out to be her last appearance before an audience.

Crawford's days were numbered at PepsiCo when Donald Kendall became board chair in 1971. He had been a protégé of Steele's and was named CEO in 1963. Kendall was, by all accounts, a brilliant strategist and turned Pepsi-Co into a billion-dollar company. He also had a huge ego and did not like to share the limelight with a former movie star who happened to be the widow of a predecessor.

An article that ran in the business pages of the *New York Times* in late 1972 spelled out the problem succinctly: "No matter that some people in Tanzania and Squib, Wash., where Mr. Kendall was born, still think that Joan Crawford the actress, runs Pepsi."[31] Kendall ran Pepsi, and took the opportunity in 1973 to retire her from active duty on the board, although he allowed her to retain her salary of $50,000 as a pension. All other perks, such as limousines and private jet travel, were terminated as of the end of 1974, as was the $40,000 annual amount for Pepsi-Cola-related expenses, primarily secretarial services. She called him "Fang," and disliked him as much as he did her. His decision coincided with her official sixty-fifth birthday in March (although she was in fact sixty-eight), but, retirement age or not, Kendall had had enough of Joan Crawford. In a 1975 interview for *Esquire*, Kendall told the reporter there were four topics he would not discuss: his first wife, Richard Nixon, Coca-Cola sales, and Joan Crawford.[32] She had always wanted to be ahead of her press, but Kendall's decision caught her off guard. She took retirement badly, and immediately fired all but one of her secretaries and curtailed her voluminous correspondence. After almost two decades of loyalty and hard work, she felt that PepsiCo owed her a lifetime sinecure, not merely a monthly retirement check. She had fallen victim to American corporate culture. Corporations, like movie studios, were businesses, and being on top one day was no guarantee that there would be a place for you the next.

William Haines knew the experience of falling from stardom to near professional oblivion. When, in 1932, he refused Mayer's demand that he give up his longtime companion, Jimmy Shields, and get married in order to counter the relentless rumors that he was gay, Haines refused. Mayer dropped his contract, and he made two films at a Poverty Row studio, Mascot Pictures, before quitting pictures for good. Haines had a second act waiting, and he set up an interior design business. Crawford was one of his earliest clients. They had been acquainted practically from her first days at MGM, and their friendship endured for almost fifty years. Haines died in December 1973, and Crawford lost one of her oldest and dearest friends. She once described Haines and Shields as "the happiest married couple in Hollywood."[33]

The Imperial House became a cooperative in 1971, and in 1973, after she lost her positions on the Pepsi-Cola and Frito-Lay boards, Crawford decided to buy an apartment in the building. She gave up her nine-room rental and purchased the apartment next door. It was considerably smaller, only five rooms, and she turned once again to Carleton Varney to decorate the new place for her. It was featured in *Architectural Digest* in 1976: "Her new apartment is a crisp, functional and compact home."[34] Varney mentioned to Crawford that he was considering writing a book about Dorothy Draper, the legendary decorator who had been his mentor. She was enthusiastic and encouraged him: "Write it, we'll sell it to the movies, and I'll play Dorothy Draper." He never wrote the book, but he noted that she was acting all the time, whether or not the cameras were running. "Joan's

all-time favorite role," said Varney, "was the tycoon. Playing the successful businesswoman represented for her the ultimate opportunity to be womanly, well dressed, and powerful all at the same time."[35]

John Springer, along with Jack Hamilton, wrote a tribute to his favorite film stars in 1974, *They Had Faces Then*, and arranged a book launch that also was a party in honor of his friend Rosalind Russell. Crawford was announced as host of the evening at the glamorous Rainbow Room atop Rockefeller Center. Joan Bennett, Peggy Lee, and Andy Warhol were among the guests. Soon after Russell's arrival, Crawford abruptly left the party. "The press agent-author of a book announced I'd be hostess without asking me," she told a reporter at the 21 Club where she went for dinner the next evening. "I went along so's not to embarrass Roz."[36]

Crawford made a new friend, Carl Johnes, at the time she was getting her first Imperial House apartment ready for sale. He had been recommended by Leo Jaffe, who ran Columbia Pictures, to help organize her library and to pare it down for the upcoming move into smaller quarters. The two hit it off, and soon he was a regular visitor, always invited for 6:30. After Crawford's death, he wrote a book lovingly describing her last years and providing a unique window into the period after her public engagements ended. She taught him to play backgammon, a game she had enjoyed since the thirties. "Crawford turned out to be a stern, gentle, impatient, entertaining, obsessive, and ultimately hilarious instructor."[37] Between 1973 and the end of 1976, he claimed to have been invited over a hundred times. "I had begun to realize that the real reason for my visits was because she was lonely."[38] He described visits from other friends, including Mary Jane Raphael, a former colleague at Pepsi; Peter Rogers, who had masterminded the Blackglama advertising campaign; Leo Jaffe; and her daughter Cathy. "Without exception," Johnes wrote, "Betty Barker, Miss Crawford's Los Angeles secretary, called at about 7:15 every night to report on the day's events and to find out what chores she was expected to perform the following day."[39] A couple of years before her death, Crawford suffered a fall. He wasn't sure, but it could have been attributable to her drinking, and whether true or not, she stopped. He described hints of the old Crawford wit, such as when the *Architectural Digest* article appeared. "It looks like I live in some *nouveau riche* efficiency apartment in Queens, or some goddamned place, and I feel like throwing everything out and starting over!"[40] Crawford continued to have friends dropping by until the end of 1976, the same time that invitations to Johnes to come over for backgammon games ceased. They continued to speak by phone in 1977, but he found her increasingly weaker each time they spoke. She never spoke to him about being ill, but he could see the slow progression of an unspoken disease.

John Engstead first photographed Crawford back in 1943 for *Harper's Bazaar*. He had gotten his start in the 1920s shooting stills at Paramount, and by the 1940s he was a well-regarded portrait artist beloved by Hollywood veterans. Engstead was one of the few photographers from Hollywood's golden age still active in

the 1970s. In September 1976, Crawford asked him to come by her apartment to make a new set of portraits. Since she was no longer working, this request had poignancy. Knowing she was ill, did she want to send out one last photo to her friends? Or, was she consciously adding a capstone to her legacy as one of the twentieth century's most extraordinary photographic subjects? Although she could not have known in 1976 that her portraits by Hurrell would soon define Hollywood glamour and become art deco emblems, she would have been acutely aware that her image was one of her era's most indelible.

"I arrived at her apartment at 12:30 for a one o'clock appointment," Engstead wrote. "Not only was Joan ready but so was the apartment. She had covered all the carpets where we would work with heavy white canvas, and the chairs with plastic. Joan answered the door barefoot." He photographed her in at least three different outfits, all quite simple, and the only jewelry she wore were simple earrings, not any of the spectacular necklaces that friends and fans had been accustomed to seeing. The most oft reproduced photographs from the session show her wearing a simple dark collarless sweater, and holding in her lap her faithful companion, her dog, Princess Lotus Blossom. His photographs were a fitting final tribute to a magnificent portrait subject, and though elderly, she is still in command of the camera. "We both work fast." Crawford, the consummate professional, took little of Engstead's time. "At 2:30 I left, since she had other appointments."[41]

Crawford and her eldest daughter saw little of one another in the 1970s as Christina lived on the coast, but they communicated by phone and letters. "Though she lived a progressively more solitary life," recalled Christina, "she never allowed herself to be alone in the apartment."[42] During her last months, Crawford was cared for by a small circle that included her Christian Science practitioner, visiting nurses, and a woman named Darinka Papich. There is no indication that she sought the advice of a doctor during her last years; instead, she relied on Christian Science and the care of nurses to keep her as comfortable as possible. She seems to have kept the details of her sickness from her family and most friends, although Carl Johnes and Carleton Varney, among others in her circle, were aware of the seriousness of her illness. Cards and gifts arrived to acknowledge her birthday on March 23. Two weeks later, she sent a "tardy note" of thanks to her eldest daughter for the cards Christina had sent.[43] Crawford knew she was dying and made the painful decision to give away her beloved Shih Tzu, Princess Lotus Blossom. Darinka Papich, who had been caring for Crawford regularly, gave the dog to her sister Zora, who lived in New York's Greenwich Village. There was the promise that Princess would come up to Sixty-ninth Street each Sunday to visit.[44] May 8 was Mother's Day, and Crawford received calls from her twin daughters, and flowers from Christina. Papich was staying with Crawford at the time. Some Crawford biographers have written that on Tuesday, May 10, 1977, she got up early to make breakfast for those looking after her and then went back to bed. It is a lovely story, but impossible to believe as Crawford was too weak,

and likely had little or no use of her legs. That morning she died at home at 10 o'clock. The death certificate states the immediate cause was a heart attack but does not reveal any longer-term maladies.[45] She had been unreservedly private about the exact nature of the disease that took her life. The woman who had always wanted to control her story was able to do it one last time. Thus it is fitting that the official record states that she was sixty-nine, and a sudden heart attack, not a lingering debilitating illness, ended the most spectacular acting career in the history of the movies.

Mommie Dearest

CRAWFORD HAD SPENT MOST OF HER LIFE, AND HER ENTIRE CAREER, carefully shaping her image. Beginning when she was a young woman with ambitions to be a dancer, her forceful personality and ebullient charm covered the fact that she was untrained. It wasn't dancing or acting talent that got her work on the New York stage; rather, she was able to convince a series of influential men that her determination and motivation might be enough to propel her to success in show business. She proved them all right. This was followed by her remarkable transformation, first a new name and then a reimagined new personality. Lucile and Billie invented a movie star named Joan Crawford. When she died fifty years later, Crawford was a motion picture legend.

She became a star in an era when the private lives of performers were protected from serious intrusion by the press. Fans expected their favorites to be role models on-screen and -off, and the studios didn't want to disabuse those ticket-buyers. Almost any infraction could be covered up if a star was valuable. Crawford didn't cause much stress for the publicity offices at MGM or Warner Bros. Colleagues such as Clark Gable, Billy Haines, and Jean Harlow were another matter. Later, when Crawford's drinking began to interfere with her work, reporters chose to ignore the rumors. Her reputation as a tough mother was just that, and after all, in the 1940s and 1950s, parents were expected to be strict. As far as the public was concerned, she was a wonderful and doting parent, and the many photos published showing Crawford and her brood testified to that fact.

Her eldest daughter, Christina, published in 1978 a book about her childhood traumas as the daughter of a troubled movie star. The claims made were astonishing, and Crawford was accused of treating her children brutally. *Mommie Dearest* became a best seller, and the *New York Times* described it a couple of months after publication as "one of the most sensationally successful books in today's literary marketplace."[1] The book spent forty-two weeks in late 1978 and well into 1979 on the paper's bestseller list, often in the number one position. When the paperback version came out in the fall, it too jumped to number one. Millions

Crawford poses in a costume for *Letty Lynton* (1932). John Kobal Foundation.

of copies eventually were sold, testimony that interest in Crawford had hardly waned over the decades. This difference was that the image that Crawford had worked so assiduously to maintain was shattered—the result of new and lurid details about a woman many felt they knew well.

Three days after Crawford's death, on Friday, May 13, there was a family funeral at Frank E. Campbell Funeral Chapel on Madison Avenue. Gathering there, Christina wrote, were "longtime friends I'd known since childhood . . . former secretaries . . . hairdressers, manicurists, publicity people . . . a gathering of only the people closest to Mother."[2] Following the service, she was buried in the mausoleum at Ferncliff Cemetery in Hartsdale, New York, interred next to her last husband, Alfred Steele. The family then returned to New York and gathered at the Drake Hotel for the reading of Crawford's will. Her personal property, including her Academy Award, was given to her daughter Cathy. Cathy and her sister Cindy were each beneficiaries of trust funds in the amount of $77,500. Her longtime secretary Betty Barker was bequeathed $35,000. The bulk of her estate was divided among five charities, with the Motion Picture Country Home the largest single recipient. At the closing of Crawford's will, she specified, "It is my intention to make no provision for my son Christopher or my daughter Christina for reasons which are well known to them."

On May 17, a memorial service was held at All Souls Unitarian on Lexington Avenue that had been arranged by PepsiCo. Admission was by invitation. Eulogies were given by Geraldine Brooks, Anita Loos, and Cliff Robertson. Pearl Bailey sang the hymn "He'll Understand." "I consider Joan Crawford my sister," Bailey was overheard saying.[3] "Most of the people at the service were business associates and bottlers," Christina Crawford remembered. "PepsiCo handled everything beautifully, tastefully, and with fastidious care."[4] The next month Christina attended a special tribute to her mother held at the Samuel Goldwyn Theater in Los Angeles. Crawford's one-time director and old friend George Cukor was host of an evening that included film clips and reminiscences from friends and co-workers. Myrna Loy, with whom Crawford had worked in *Pretty Ladies* in 1926, told the assembled, "We really were friends. Not just two movie queens in ermine and diamonds and orchids . . . but two biddies, talking about kids and recipes and re-covering couches, and the havoc dye did to your hair—and husbands." Loy also made a reference to Crawford's last years. "I miss growing older along with her, an art in itself—and one in which she was not very good." Another speaker was Robert Young, a frequent costar in the 1930s and a member of her inner circle for nearly four decades.

A few weeks after Crawford's death, George Cukor offered an article for the *New York Times* that is as good a summation of her career as any ever written:

She was the perfect image of the movie star and, as such, largely the creation of her own indomitable will. She had, of course, very remarkable material to

work with: a quick native intelligence, tremendous animal vitality, a lovely figure and above all, her face, that extraordinary sculptural construction of lines and planes, finely chiseled like the mask of some classical divinity from fifth-century Greece. It caught the light superbly, so that you could photograph her from any angle, and the face moved beautifully.

Cukor and Crawford were first colleagues—he directed her three times at MGM in *The Women*, *Susan and God*, and *A Woman's Face*—and came to know each other well over the ensuing decades. He described her as "a loyal and generous friend, very thoughtful . . . she forgot nothing—names, dates, obligations. These included the people at Hollywood institutions who helped make and keep her a star." [5] The person described so well and accurately by Cukor was her official version, the Joan Crawford she created in 1925, refined and polished and presented to fans and friends. "The perfect image of a movie star" could not be sustained twenty-four hours a day, year after year. Garbo, for one, didn't even try. Crawford did try, and in the 1940s started using alcohol to fuel her energy and confidence. For a while, she was successful at ensuring that her co-workers and especially her fans only saw her at her best. The public illusion of perfection started to crack when she appeared on *The Secret Storm* and on television chat shows notably intoxicated. Colleagues knew what was going on—Lucille Ball threatened to fire her—but it was a time of conspiracy, and stars, unless they got into serious trouble, were no more subject to honest open scrutiny than were politicians. It changed in the 1970s. There was Watergate, and there was *Mommie Dearest*.

The book came out after the tributes had quieted and by right Crawford should have slipped into the motion picture past, an actress whose best pictures from a stellar four-and-a-half-decade career would continue to delight audiences at revival houses or on the late show. In the 1970s the academic study of film history was beginning, and scholars had yet to place Hollywood producers, directors, and performers in their proper historical context. The portraits made at Hollywood studios, part of the vast publicity enterprise, were regarded as stills and not as serious photography. A snap of Garbo was still avidly sought by newspapers, but few would look twice if Norma Shearer or Lana Turner passed by on the street. That would change in the next decade. All authors and their publishers hope for a successful book, but neither Christina Crawford nor the folks at Morrow could have had any premonition of how successful the memoir would be. They also couldn't have known how *Mommie Dearest* would affect Crawford's reputation. Christina later sold the motion picture rights, and when the film *Mommie Dearest* was released, it created a new wave of interest about what really happened in the Crawford home.

Christina's book stripped bare the private life of a famous movie star. What made it so powerful was the book's focus: child abuse. It might have been titillating for readers to learn about the number of men who had been invited to Crawford's

Crawford with her son Christopher and twin daughters Cathy and Cynthia on the set of *Queen Bee*, 1955.

bedroom. But even back in 1978 this was old news as any devoted fan magazine reader with a sharp pencil and pad could make an accounting of Crawford's conquests as reported over the years by Hedda, Louella, or others. Christina recounted an astonishing story of what it was like being a child in the Crawford household. She narrated it from a child's point of view, and she told it beautifully.

Mommie Dearest was a pioneering work in what now is an industry devoted to protecting abused children. What Christina described well were her mother's late-night, alcohol-fueled rages during which she might awaken her children and terrorize them. Sometimes Crawford would find fault with a child's behavior, and her daughter would give us a terrifying account of, for example, what happened when Mommie discovered wire hangers in Christina's closet. Or when a bathroom wasn't as clean as Mommie might like it, Christina might be pounded with cans of cleaning powder until they exploded all over the room. Christina, born and adopted in 1939, writes specifically about events that occurred in the household she knew in the 1940s, after the adoption of her brother Christopher in 1942. Crawford's two younger children, born in 1947, have different memories of growing up in the Crawford household. *Mommie Dearest* brought the question of child abuse to the public. Had Christina not been the daughter of a famous woman her book likely never would have been published. As it was, *Mommie Dearest* was a catalyst for conversations that probably saved thousands of children from abusive homes.

"'My God, Joan . . . you're going to kill her,' the secretary yelled!" During one particularly violent fight between mother and daughter the secretary was forced to call for outside help. A juvenile officer was summoned to the house. Apparently, he interviewed both Crawford and Christina. It was an era when a child had no authority, and an adult's word was usually taken as absolute. "He said that I'd have to try harder to get along with my mother because if she called the authorities again, he'd have no choice but to take me to Juvenile Hall and book me as an incorrigible."[6] A child, no matter that her mother was beating her unmercifully, didn't matter. The officer blamed Christina. There was no concern for Crawford's alcoholism, violent outbursts, depression, or abuse. Christina simply had to behave herself, and then everything would be fine.

As difficult as it was for Christina, she was always more concerned for her little brother. Crawford had fabricated "a barbaric device she called a 'sleep safe' . . . to make sure Christopher could not get out of bed. It was like a harness made of heavy canvas straps, and fastened at the back."[7] Her mother "made no allowances for the normal energies of a growing preteen boy."[8] Christopher had originally been named Phillip Terry Jr. but after his parents' divorce, his name was changed to Christopher Crawford. Terry "agreed to give up all rights to see [Christopher] on the condition that a trust fund be established for his college education and to ensure financial security." Crawford reneged on this obligation, and in fact had

little to do with her son after he passed his teenage years. "What she couldn't control," Christina wrote, "Mother either dismissed or destroyed." [9]

Children generally are happiest with consistent routines. Christina, on the other hand, describes growing up in what might be described as a schizophrenic household. "The world was full of contradictions. When the publicity people and photographers were around, I was treated like the golden-haired princess." [10] At Christmas, photographers would come and take pictures of the family by a tree overflowing with presents. But when they left, Christina would be allowed to keep only the one from her mother, and the rest were given away to hospitals or a children's home, although a few were saved in a special closet to be regifted to friends for birthdays. [11] Of course, Christina would be expected to write thank you notes for gifts she was not allowed to keep. Crawford had matching outfits created, one for Queen Joan and the other for Princess Christina. Did she really want a daughter, or a miniature Joan Crawford? Or did she expect her children to be factotums, and maybe she was happiest when her children resembled the sycophants who surrounded her? "Sweet-talk her, say yes every time she opened her mouth, be at her beck and call, fall over her with praise and even token admiration, and she'd give you the whole world." [12] Crawford's exceptionally erratic behavior throughout the 1940s was attributable to personal and professional unrest. Crawford left MGM in 1943 to join Warner Bros. but didn't make her first film there until 1945. She divorced third husband Phillip Terry in 1946, but they had been separated for some time. Evidence suggests that Crawford was insecure about her talent and had a manic-depressive personality: she was on top of the world when she was working, but the opposite when she was waiting for the right script. She always needed to share the company of a man. When she was in a good relationship, she was content. When alone, demons possessed her. Understanding Crawford's personal and professional life during the years about which Christina writes, however, does not justify her behavior to her children.

Recalling the book's title is enough to remind almost anyone who knows the name Joan Crawford that her daughter wrote an indictment of her mother. It should be noted, however, that Christina also described happy times. She told of a surprise fifteenth birthday party her mother hosted for her at the Mocambo nightclub in West Hollywood. The Mocambo was the hottest spot in town and was at its heyday in 1954. Christina's boyfriend was included, and Crawford brought along Jennings Lang. There was dinner and dancing, and Christina, decades later, recalled it as "the perfect teenage birthday." [13]

Crawford's former colleagues, friends, fans, and nearly everyone else had an opinion about the book. Her twin daughters denounced it, and it caused a permanent estrangement between the older and younger sisters. Many famous names rushed to Crawford's defense claiming the incidents described could never have happened, or at least this sort of behavior had not been witnessed firsthand.

There is probably an irony that many of the famous parents who had children in the 1940s and 1950s decried Christina's memories at a time when corporal punishment was common. Fan magazine articles in the late 1940s and into the 1950s are filled with comments from Crawford herself extolling the virtues of strict parenting. Discussing her children in 1972, Crawford told an interviewer, "They loathed me for a while. . . . It would have been simple to give in, but I didn't. Children need love. But they also need guidance or they will have no aims or purpose of life."[14]

Had there only been the book, it is possible that after the public volley for and against Crawford subsided her reputation might have begun to heal. But, three years after the book was published, a face was added to the story—and it was not Crawford's, but Faye Dunaway's. Dunaway played the title role in the motion picture version of *Mommie Dearest*. Christina told talk show host Larry King that she was "devastated by the movie,"[15] She had sold the motion picture rights, but had no input to the final script, and the film that appeared was different from the book in many crucial ways. The biggest change was the narrative structure. The book told Christina's story from the point of view of the child. The movie focused squarely on Crawford, but a Crawford as imagined in Dunaway's histrionic performance. That she could become more outrageous than the subject she was portraying took splendid acting. "Mother was prone to exaggeration about everything," Christina wrote.[16] Dunaway managed to transmogrify Crawford into a frightening caricature. The film became the "truth" about what happened in the Crawford house. It was no longer sufficient for drag queens to imitate Crawford's particular mannerisms, now it was Dunaway's portrayal that became the prototype.

Too many people lined up to see the film for it to go away quietly. The phrase "wire hangers" still conjures up an image of Dunaway's monstrous Crawford savagely beating her child. Christina never wrote that her mother hit her with a wire hanger, but fiction, as Crawford knew better than anyone, is far stronger than truth.

The film was a commercial success but a critical failure. *Mommie Dearest* was awarded the Golden Raspberry Award as the Worst Movie of 1981; Dunaway was called out as Worst Actress, and it was also announced as the Worst Screenplay. Nine years later, in 1990, the Golden Raspberry Awards selected *Mommie Dearest* as the worst picture of the previous decade.

What did the barrage of bad publicity surrounding the publication of *Mommie Dearest*, and the release of the related film, do to Crawford's reputation? P. T. Barnum is sometimes credited as the first to state that there is no such thing as bad publicity. If one subscribes to that position, both book and film kept Crawford's name in the news. Still, no one wants to be known as an abusive parent, least of all Crawford, who worked harder than any other stage or screen performer to create and then sustain a flawless image before her adoring public. Christina

Crawford and her mother, Anna, circa 1913.

and Christopher suffered terribly at the hands of their mother. The twins seem to have fared better, and they defended Crawford, allowing some to figure that maybe it wasn't as bad as Christina made it out to be. Is it enough to say that she was a terrible mother, but that she was also a magnificent performer who left a rich professional legacy? Aside from the stories of discipline and abuse, there were plenty of examples of lavish vacations, and looking at Christina's life from the outside, wouldn't any child rather live in a Brentwood mansion, staffed with servants, with a swimming pool, and other accoutrements of Hollywood royalty? How can these contradictions be reconciled?

Crawford was only able to adopt children because she was wealthy and determined. Infant blond girls and boys were sold to the highest bidder. Baby mills were unregulated. Judges could be bribed. Birth certificates could be manipulated. Crawford desperately wanted children and adopted five at a time when it was almost unthinkable for a single person, male or female. Her reasons seem to have been narcissistic rather than maternal. Many biographies of Crawford have been written, and nearly all give accounts of her tormented childhood. Maybe Anna was a worse mother than her daughter. We now understand that abuse often begets abuse. Was Crawford trying to undo the memories of her difficult childhood by raising her children in an environment of luxury and privilege? Whatever her reason, she was too much like the mother she loathed. Environment was not the critical issue; it was the love of a parent. Crawford was unable to provide that for her two older children but managed to give the younger siblings different memories due to the relative stability provided by her later marriage to Steele.

Perhaps it is not possible to reconcile the movie star, the extraordinary actress, the devoted friend, and the generous hospital patron with the subject of the pages of Christina's book. Writing *Mommie Dearest*, Christina tried to comprehend her mother. She was clear-eyed when she wrote, "Mother had simply not developed a way of dealing with a relationship that required give-and-take or the effort of working through any misunderstandings."[17] Christina never absolved her mother, although she came close to understanding her.

This book is another attempt to understand Crawford. Some may find fault with her use of men to propel her career, and others with her multiple marriages and promiscuity. More recently we have been confronted with her behavior as a mother. It was not out of a desire to settle these issues, however, that this book was written, or why those interested in Crawford will read it. Crawford's career stands as a monument in motion picture history. Almost a half century after her death, she is still beloved by fans, most of whom weren't old enough to see any of her films when they were new to theaters. Her film legacy is one of Hollywood's finest. As a portrait subject, she may never have had an equal. Who can resist turning on *Mildred Pierce* when it appears on Turner Classic Movies? *Grand Hotel* and *The Women* are masterpieces of 1930s cinema. Film aficionados have rediscovered *Sudden Fear* as an exemplar of film noir, *Johnny Guitar* as a bold modern Western,

and *What Ever Happened to Baby Jane?* as a pinnacle of the horror genre. She will always be the screen's dancing lady. Crawford is the movies' true Cinderella, the working-class woman who, in film after film, succeeded through guts and determination. And when she did she was dressed by Adrian, and romanced by Gable. Long before there was the concept of an influencer, Crawford may have been the first, and a generation of women looked up to her as a template for style, fashion, and manners. Most of all Joan Crawford was a star.

NOTES

INTRODUCTION

1. Barry Paris, *Louise Brooks* (New York: Knopf, 1989), 136.
2. Bob Thomas, *Joan Crawford* (New York, Simon & Schuster, 1978), 238.
3. George Frazier, "Handsome Joan from San Antone," *Colliers*, March 12, 1949, 58.

CHAPTER 1: LUCILE LE SUEUR

1. Although most biographers have used the spelling "Lucille" rather than "Lucile, the latter corresponds with all early known Crawford signatures, and is the spelling found in her Stephens College yearbook.
2. Christina Crawford, *Mommie Dearest* (New York, Morrow, 1978), gives the year as 1904; Douglas Fairbanks Jr., *Salad Days* (New York: Doubleday, 1988), suspected 1904 or 1905 (143), although Crawford never admitted the true year to him.
3. Joan Crawford, *A Portrait of Joan* (New York: Doubleday, 1962), 37.
4. Crawford, *A Portrait of Joan*, 37.
5. John Springer in Roy Newquist, *Conversations with Crawford* (Secaucus: Citadel Press, 1980), 25.
6. Crawford, *A Portrait of Joan*, 40–42.
7. Roy Newquist, *Conversations with Joan Crawford*, 41.
8. Crawford, *A Portrait of Joan*, 44.
9. Christina Crawford, *Mommie Dearest*, 60
10. Crawford, *A Portrait of Joan*, 45.
11. Roy Newquist, *Conversations with Joan Crawford*, 43.
12. Ruth Biery, "The Story of a Dancing Girl," Part I, *Photoplay*, September 1928, 123.
13. Ray Thayer Sterling (1905–1973), buried: Miami, Florida, Flagler Memorial Park.
14. Crawford, *A Portrait of Joan*, 46.
15. Christina Crawford, *Mommie Dearest*, 61.
16. Crawford, *A Portrait of Joan*, 46.
17. Crawford, *A Portrait of Joan*, 46.
18. Crawford, *A Portrait of Joan*, 47.
19. Harry T. Brundidge, *Twinkle, Twinkle, Movie Star* (New York: E. P. Dutton, 1930).
20. Ruth Biery, "The Story of a Dancing Girl," Chapter II, *Photoplay*, October 1928, 68.
21. Crawford, *A Portrait of Joan*, 48–49.
22. Muriel Elwood, *Pauline Frederick: On and Off the Stage* (Chicago: A. Kroch), 1940.
23. Harry T. Brundidge, *Twinkle, Twinkle, Movie Star*, 83.
24. Harry T. Brundidge, *Twinkle, Twinkle, Movie Star*, 83.

25. Crawford, *A Portrait of Joan*, 49.

26. Crawford, *A Portrait of Joan*, 49.

27. Doris Denbo, "Her Kingdom for a Friend," *Motion Picture*, April 1927, 115.

28. Denbo, "Her Kingdom for a Friend," 115.

29. Denbo, "Her Kingdom for a Friend," 115.

30. Brundidge, *Twinkle, Twinkle, Movie Star*, 84.

31. "Cabaret," *Variety*, September 23, 1921, 8.

32. Crawford, *A Portrait of Joan*, 51.

33. Crawford, *A Portrait of Joan*, 51.

34. Brundidge, *Twinkle, Twinkle, Movie Star*, 85.

35. Brundidge, *Twinkle, Twinkle, Movie Star*, 85.

36. Crawford, *A Portrait of Joan*, 51.

37. "News from the Dailies," *Variety*, December 9, 1925, 20.

38. Brundidge, *Twinkle, Twinkle, Movie Star*, 86.

39. Crawford, *A Portrait of Joan*, 51.

40. Harry Richman, *A Hell of a Life* (New York: Duell, Sloan and Pearce, 1966), 114.

41. "Harry Rapf to 'Scout About' for Material in New York, *Moving Picture World*, November 29, 1924, 549.

42. "Broadway," *Exhibitor's Herald*, January 10, 1925, 20.

43. Interview with Maurice Rapf, Hanover, New Hampshire, February 16, 1997.

44. Brundidge, *Twinkle, Twinkle, Movie Star*, 87.

45. Crawford, *A Portrait of Joan*, 8.

46. Crawford, *A Portrait of Joan*, 8.

CHAPTER 2: 1925, ARRIVAL IN HOLLYWOOD

1. Joan Crawford, *A Portrait of Joan*, 10.

2. For a photograph of the card see: Anna Raeburn, *Joan Crawford* (London: Pavilion, 1986), illustration 29. The negative is in the John Kobal Foundation Archive.

3. "Pretty Ladies," *Variety*, July 15, 1925, 32.

4. *1925 Studio Tour* is the title of the film today. The title card is a later addition, and it is unknown what the film was originally called.

5. Erté, *Things I Remember* (New York: Quadrangle, 1975), 85.

6. Joan Crawford, *A Portrait of Joan*, 12.

7. Joan Crawford, *A Portrait of Joan*, 14.

8. Joan Cross, "Name Her and Win $1,000," *Movie Weekly*, March 27, 1925, 4–6, 33.

9. Alexander Walker, *Joan Crawford: the Ultimate Star* (New York: Harper & Row, 1983), 12.

10. Roy Newquist, *Conversations with Joan Crawford*, 31.

11. Bob Thomas, *Joan Crawford*, 54.

12. Joan Crawford, *A Portrait of Joan*, 15.

13. Roy Newquist, *Conversations with Joan Crawford*, 45.

14. Frederica Sagor Maas, *The Shocking Miss Pilgrim* (Lexington: University Press of Kentucky, 1999), 72.

15. "Old Clothes—Metro-Goldwyn," *Photoplay*, January 1926, 49.

16. H. Mark Glancy, "MGM film Grosses, 1924–1948: the Eddie Mannix Ledger," *Historical Journal of Film, Radio and Television* (1992): 129.

17. Matthew Kennedy, *Edmund Goulding's Dark Victory* (Madison: University of Wisconsin Press, 2004), 54.

18. "Sally, Irene and Mary," *Film Daily*, December 13, 1925, 7.

19. "Sally, Irene and Mary," *Variety*, December 9, 1925, 42.

20. Mordaunt Hall., "Three Chorus Girls," *New York Times*, December 7, 1925, 19.

21. Barry Paris, *Louise Brooks* (New York: Knopf, 1989), 135.

CHAPTER 3: LEADING LADY, 1926–27

1. Joan Crawford, *A Portrait of Joan*, 17–18.

2. Joan Crawford, *A Portrait of Joan*.

3. Margaret Reid, "How to See the Stars in Hollywood," *Picture Play*, March 1926, 17.

4. Walter Ramsay, "These Things Have Counted," *Silver Screen*, April 1935, 70.

5. "Joan Crawford Engaged," *Variety*, February 3, 1926, 29.

6. Cudahy's gravestone records his birth and death dates as November 24, 1908–February 14, 1947.

7. Cal York, The Real Hellraisers of Hollywood," *Photoplay*, June 1927.

8. Joan Crawford, *A Portrait of Joan*, 30.

9. "Young Cudahy's Mother Warns of Annulment", *Los Angeles Times*, May 6, 1926.

10. "Love Knot Untied by Fair Joan," *Los Angeles Times*, June 8, 1926.

11. "Metropolitan Signs Crawford," *Film Daily*, April 3, 1927, 8.

12. "Tramp, Tramp, Tramp," *Variety*, May 26, 1926, 17, 19.

13. "Tramp, Tramp, Tramp," *Motion Picture News*, April 10, 1926, 1617.

14. "Tramp, Tramp, Tramp," *Indianapolis Times*, April 3, 1926, 4.

15. "Paul Bern Out of M.-G.," *Variety*, November 13, 1925, 43.

16. Matthew Kennedy, *Edmund Goulding's Dark Victory*, 57.

17. Mordaunt Hall, "The Seamy Side of Paris," *New York Times*, June 1, 1926, 29.

18. "Paris," *Film Daily*, June 13, 1926, 13.

19. "Paris," *Variety*, June 2, 1926, 14.

20. *Moving Picture World*, June 12, 1926, 565.

21. "Vaudeville on the Wane, Says Mayer," *Motion Picture News*, May 29, 1926, 2551.

22. "Cosmopolitan Productions Announces Elaborate Program for Next Season," *Moving Picture World*, May 15, 1926, 229.

23. "The Understanding Heart," *Film Daily*, May 15, 1927, 7.

24. Mordaunt Hall, "The Fugitive," *New York Times,* May 10, 1927, 24.

25. Newquist, *Conversations*, 68.

26. Robert Cannom, *Van Dyke and the Mythical City of Hollywood* (Culver City: Murray & Gee, 1948), 151.

27. Fred W. Fox, "Little Girl in the Big City," *Hollywood Vagabond*, May 12, 1927, 5.

28. Ann Sylvester, "Not for Publication," *Picture Play*, November 1927, 33.

29. "Pictures and People," *Motion Picture News*, April 1, 197, 1117.

30. "Story of the Box-Office," *Film Spectator*, August 20, 1927, 20.

31. Virginia Morris, "Who really Makes the Stars," *Moving Picture Stories*, May 1, 1928, 7.

32. Laurence Reid, "The Unknown," *Motion Picture News*, June 24, 1927, 2457.

33. Joan Crawford, *A Portrait of Joan*, 30.

34. Eve Golden, *John Gilbert* (Lexington: University Press of Kentucky, 2013), 145–46.

35. James Quirk, "Close-Ups and Long-Shots," *Photoplay*, December 1927, 27.

36. "Twelve Miles Out," *Variety*, July 27, 1927, 18.

37. Margaret Reid, Has the Flapper Changed," *Motion Picture*, July 1927, 28–29, 104.

38. Salvatore Ferragamo, *Shoemaker of Dreams: The Autobiography of Salvatore Ferragamo* (Sillabe, 1985 [1957]), 90.

39. The next year, Wright designed a splendid modernist hillside villa for Novarro's accountant, Louis Samuel, but within a short time Novarro took occupancy.

40. Alexander Walker, *Joan Crawford*, 34.

41. *Film Daily*, November 11, 1927, 5.

CHAPTER 4: LEADING LADY, 1928

1. Douglas Fairbanks Jr., *Salad Days* (New York: Harcourt, Brace, 1988), 122.

2. Crawford, *A Portrait of Joan*, 58.

3. Douglas Fairbanks Jr., *Salad Days*, 127.

4. Joan Crawford, *My Way of Life* (Los Angeles: Graymalkin Media, 2017), 39.

5. "Joan Crawford Tells it all. Her Own Life Story," *Western Mail*, November 3, 1938, 36.

6. Crawford, *A Portrait of Joan*, 61.

7. Katherine Reid, "That Indian Love Call," *Picture-Play*, April 1928, 50–51, 114.

8. *Film Daily*, December 18, 1927, 10.

9. "Kyne Story Stopped Before Too Late," *Variety*, February 29, 1928, 9.

10. *Photoplay*, June 1928, 19.

11. Norbert Lusk, "The Screen in Review," *Picture-Play*, January 1929, 71.

12. "Our Dancing Daughters," *Harrison's Reports*, October 13, 1928, 163.

13. T.O. Service, "Service Talks," *Exhibitors Herald*," September 22, 1928, 50.

14. Delight Evans, "Our Dancing Daughters," *Screenland*, October 1928, 44.

15. "Cinema," *Time*, October 22, 1928, 48.

16. Crawford, *A Portrait of Joan*, 64.

17. "Our Dancing Daughters," *Screenland*, October 1928, 44.

18. "Our Dancing Daughters," *Exhibitor's Herald and Moving Picture World*, December 22, 1928, 53.

19. "Claims 'Dancing Daughters' will Harm American Prestige," *Film Mercury*, February 15, 1929, 10.

20. Crawford, *A Portrait of Joan*, 63.

21. "When It's a Picture It Draws, *Variety*, October 24, 1928, 5.

22. "Four Walls," *Photoplay*, September 1928, 54.

23. "Too Many Close-Ups," Film Spectator, September 1, 1928, 7.

24. Douglas Fairbanks Jr., *Salad Days*, 129–30.

25. "The Duke Steps Out," *Exhibitor's Herald World*, May 11, 1929, 58.

26. "The Duke Steps Out," *Variety*, April 17, 1929, 22.

27. Margaret Reid, "Joan Crawford Now," *Screenland*, October 1928, 37.

28. Crawford, *A Portrait of Joan*, 63.

29. "JOAN CRAWFORD TO BE STARRED," *Exhibitor's Daily Review*, October 15, 1928, 3.

30. "Four Walls," *Screenland*, November 1928, 47.

CHAPTER 5: 1929, STARDOM

1. "Our Modern Maidens," *Time*, September 16, 1929, 22.

2. Elizabeth Taylor and Richard Burton had a well-publicized affair during the production of *Cleopatra* (1963).

3. "Our Modern Maidens," *Motion Picture News*, May 24, 1929, 1532.

4. Fairbanks Jr., *Salad Days*, 141.

5. Margaret Reid, "Joan Crawford Now," *Screenland*, October 1928, 89.

6. Brian Connell, *Knight Errant* (New York: Doubleday, 1955), 54.

7. Fairbanks Jr., *Salad Days*, 143.

8. "Fairbanks Jr., 19 Weds Joan Crawford Here," *New York Times*, June 4, 1929, 1.

9. Fairbanks Jr. *Salad Days*, 139.

10. "Welcoming a New Star . . . ," *Photoplay*, June 1929, 15.

11. Howard Gutner, *Gowns by Adrian* (New York: Abrams, 2001), 38.

12. Adrian, "The Modern Maid's Clothes," *Screenland*, April 1929, 46.

13. "Untamed," *Motion Picture News*, December 14, 1929, 35.

14. T.O Service, "Service Talks," *Exhibitor's Herald-World*, December 14, 1929, 44.

CHAPTER 6: NUMBER 1 AT THE BOX OFFICE

1. "'Brides' for Women; Teaches 'Em Things,'" *Variety*, August 6, 1930, 55.

2. "Martin Quigley, Wrote Film Code," *New York Times*, May 5, 1964, 43.

3. "New Orleans for 'Location,'" *Variety*, June 11, 1930, 2.

4. Harriet Parson, "Studio Rambles," *Photoplay*, October 1930, 154.

5. Joan Crawford, *A Portrait of Joan*, 69.

6. "Paid," *Variety*, January 7, 1931, 22.

7. Joan Crawford, *A Portrait of Joan*, 87–88.

8. Frances Hughes, "Filmland's Royal Family," *Photoplay*, November 1929, 27.

9. Joan Crawford, *A Portrait of Joan*, 73–74.

10. Joan Crawford, *A Portrait of Joan*, 75.

11. Joan Crawford, *A Portrait of Joan*, 77–78.

12. Douglas Fairbanks, *Vanity Fair*, May 1930; Mary Pickford, *Vanity Fair*, June 1930; Joan Crawford, *Vanity Fair*, July 1930.

CHAPTER 7: GEORGE HURRELL

1. See John Kobal, *The Art of the Great Hollywood Photographers* (New York: Knopf, 1980), 125–49.

2. Whitney Stine, *Hurrell* (New York: John Day Company, 1976), 76.

3. Vieira, *Hurrell*, 30.

4. Irene Borger, "George Hurrell's Hollywood Glamour," *Architectural Digest*, April 1992, 74.

5. Wesley Hale, "Dancing Damsel who Relaxes as she Rushes is Our Gorgeous Joan," *Screen Mirror*, March 1941, 21.

6. Paul Trent, *The Image Makers* (New York: McGraw-Hill, 1972), 54.

7. G.T. Allen, Glamour by Hurrell," *U.S. Camera*, January 1942, 25.

8. Borger, "George Hurrell's Hollywood Glamour," 77.

9. Herbert Allen, "George Hurrell: An Interview with One of the Motion Picture's Foremost Portrait Photographers," *International Photographer*, September 1941, 3.

CHAPTER 8: *GRAND HOTEL*

1. Walker, *Joan Crawford*, 75.

2. Walker, *Joan Crawford*, 75

3. "Crawford–Shearer Truce after Favoritism Change," *Variety*, April 22, 1931, 3.

4. Joan Crawford, *A Portrait of Joan*, 88.

5. "Voice of the Industry," *Motion Picture Herald*, July 11, 1931, 50.

6. Gwenda Young, *Clarence Brown* (Lexington: University Press of Kentucky, 2019), 131.

7. Letter to Maurice Rapf from Samuel Marx, November 5, 1931. Collection of Joanna Rapf.

8. Gwenda Young, *Clarence Brown: Hollywood's Forgotten Master* (Lexington: University Press of Kentucky, 2018), 138–39.

9. Jane Morris, "When Love Scenes Get Hot," *Photoplay*, May 1962, 74.

10. Dorothy Manners, "Looking them over," *Movie Classic*, December 1931, 46.

11. Walter Ramsay, "The Inside Story of 'Grand Hotel,'" *Modern Screen*, April 1932, 95.

12. Robert Herring, "Grand Hotel Reservations," *Close Up*, March 1932, 60–61.

13. Matthew Kennedy, *Edmund Goulding's Dark Victory*, 120.

14. Letter from Joan Crawford to Clifton Webb, posted April 19, 1932, author's collection.

15. Cecilia Ager, "Vicki Baum See Coast as Torture," *Variety*, April 12, 1932, 3.

16. Vicki Baum, "What the Author Thinks of 'Grand Hotel,'" *Modern Screen*, July 1932, 114.

17. "Court Exonerates M-G-M of Charge of Plagiarism," *Film Daily*, July 30, 1932, 1.

18. "Apportionment of Profits in 'Lynton' Plagiarism Case Okayed by Court," *Film Daily*, March 26, 1940, 1, 6; "Supreme Court Limits Claims in Copyright Infringements," *Motion Picture Herald*, March 30, 1940, 35.

19. "The Low Down," *Hollywood Reporter*, January 20, 1933, 2.

20. Hal Herrick, "He Decides Fashions for the Stars," *New Movie Magazine*, March 1934, 53.

21. Barrett C. Kiesling, *Talking Pictures* (New York: Johnson Publishing Company, 1937), 239–40.

CHAPTER 9: *RAIN*

1. Walker, *Joan Crawford*, 92.

2. "A Little from "'Lots,'" *Film Daily*, May 5, 1932, 7.

3. Abel [Green], "Rain," *Variety*, October 18, 1932, 14.

4. Norman Lusk, "The Screen in Review," *Picture-Play*, January 1933, 46.

5. Ruth Biery, "The New Shady Dames of the Screen," *Photoplay*, August 1932, 28.

6. "Our Hollywood Neighbors," *Movie Classic*, January 1933, 72.

7. It was not only men who impersonated Crawford. Carol Burnett did superb parodies of Crawford twice. On her show that aired November 11, 1976, she presented "Mildred Fierce," a spoof of *Mildred Pierce*, and on January 22, 1977 she gave audiences "Torchy Song," a send-up of *Torch Song*.

8. Fairbanks Jr., *Salad Days*, 186–87.

9. Crawford, *Portrait of Joan*, 82.

10. Connell, *Knight Errant*, 59.

11. Fairbanks Jr. *Salad Days*, 190.

12. Faith Service, "The Man Jean Harlow Has Married—Paul Bern," *Motion Picture*, October 1932, 51, 76–77. The mural is illustrated on page 76.

13. Todd McCarthy, *Howard Hawks: The Grey Fox of Hollywood* (New York: Grove Press, 1997), 63, 178–86.

14. Mark Vieira, *Hurrell's Hollywood Portraits* (New York: Abrams 1997), 68.

15. Stine, *Hurrell Style*, 78.

16. Fairbanks Jr. *Salad Days*, 207–208.

17. "Fairbanks, Jr, Sued for Alienation," *New York Times*, March 17, 1933, 20.

18. Fairbanks Jr. *Salad Days*, 200.

19. "Fairbanks, Jr, Sued for Alienation," *New York Times*, March 17, 1933, 20.

20. "Milestones," *Time*, March 27, 1933.

CHAPTER 10: $7,500 PER WEEK

1. "Asides and Interludes," *Motion Picture Herald*, January 7, 1933, 16.

2. Warren G. Harris, *Clark Gable*, New York: Harmony Books, 2002, 110.

3. Crawford, *A Portrait of Joan*, 98

4. Crawford, *A Portrait of Joan*, 101.

5. "Joan Crawford Comes Right Out and Names Best Friends," *Lowell Sun*, November 15, 1934, 28.

6. "Joan Crawford Tells It All. Her Own Life Story," *Western Mail*, November 3, 1938, 36.

7. "Rambling Reporter," *Hollywood Reporter*, January 30, 1934, 2.

8. "Joan Crawford—Good Samaritan," *Movie Classic*, November 1934, 86.

9. "Rambling Reporter," *Hollywood Reporter*, June 21, 1934, 2.

10. "News and Gossip from Hollywood," *Motion Picture*, April 1935, 37.

11. Walker, *Crawford*, 104.

12. Norbert Lusk, "No More Ladies," *Picture-Play*, September 1935, 49.

13. Crawford, *A Portrait of Joan*, 108.

14. "Curtain Delays," *Variety*, October 9, 1935, 3.

15. "Record publicity for 'Dream,'" *Variety*, October 16, 1935, 4.

16. *The Sport of Queens* was announced in *Variety* on September 4, 1935, 4; *Elegance* was announced in *Film Daily*, September 7, 1935, 4.

17. Mervyn Douglas and Tom Arthur, *The Autobiography of Melvyn Douglas* (Lanham, MD: University Press of America, 1986), 90.

18. "Double premiere necessary," *Film Daily*, August 28, 1936, 14.

19. Joan Crawford, *A Portrait of Joan*, 114,

20. "On and Off the Set," *Picture-Play*, November 1936, 37.

21. Crawford, *A Portrait of Joan*, 113.

CHAPTER 11: QUEEN OF THE MOVIES

1. "The Most-Copied Girl in the World," *Motion Picture*, April 1937, 5.

2. Joan Crawford, *A Portrait of Joan*, 115.

3. June Lang Hunt, "Their "Home Work," *Silver Screen*, February 1935, 22.

4. "The Talk of Hollywood," *Motion Picture*, June 1936, 59.

5. Crawford, *A Portrait of Joan*, 109.

6. Crawford, *A Portrait of Joan*, 109.

7. Phil M. Daly, "Along the Rialto," *Film Daily*, November 25, 1936, 4.

8. Kenneth L. Geist, *Pictures Will Talk* (New York: Scribners, 1978), 89.

9. Sydney Ladensohn Stern, *The Brothers Mankiewicz* (Jackson: University Press of Mississippi, 2019), 134.

10. Kenneth L. Geist, *Pictures Will Talk*, 82.

11. "Joan Crawford Makes the Movie of the Week," *Life*, March 1, 1937, 46.

12. "Next M-G Rainer Film from Molnar Trieste," *Variety*, February 10, 1937, 2.

13. Bob Thomas, *Joan Crawford*, 113.

14. Eileen Creelman, *The (New York) Sun*, October 15, 1937, 34.

15. "The Bridge Wore Red," *Variety*, September 23, 1937, 3., quoted in *Motion Picture Review Digest*, December 27, 1937, 22.

16. William Boehnel, *New York World–Telegram*, October 15, 1937, 31.

17. Joan Crawford, *A Portrait of Joan*, 119.

18. Joan Crawford, *A Portrait of Joan*, 119.

19. Roy Newquist, *Conversations with Joan Crawford*, 81.

20. Joan Crawford, *A Portrait of Joan*, 121.

21. *Variety*, December 22, 1937, 16.

22. Frank Nugent, *New York Times*, January 21, 1938, 15.

23. Kenneth L. Geist, *Pictures Will Talk*, 92.

24. Roy Newquist, *Conversations with Joan Crawford*, 84.

25. Alexander Walker, *Joan Crawford*, 124.

26. "Divorce Granted to Joan Crawford," *New York Times*, April 12, 1939, 27.

27. "Second Guessing on the Pictures," *National Box Office Digest*, April 3, 1939, 6.

28. "3 New Numbers Sung by Crawford for 'Ice Follies,'" *Studio News*, December 3, 1938, 2.

29. "'Ice Follies of 1939' just a 'So-So' Job," *Box Office Digest*, March 4, 1939, 5.

CHAPTER 12: THE END OF HER REIGN AT MGM

1. "Laszlo Willinger," in John Kobal, *People will Talk* (New York: Knopf, 1986), 376.

2. "A Lavish Premiere for ,The Women,'" *Box Office*, September 2, 1939, 38.

3. "The Women," *Cue*, September 16, 1939, 38.

4. Frank S. Nugent, "The Women," *New York Times*, September 22, 1939, 27.

5. "George's Women," *Screenland*, August 1938, 73.

6. Joan Crawford, *A Portrait of Joan*, 131.

7. Joan Crawford, *A Portrait of Joan*, 130.

8. Sonia Lee, "I'll Never Marry Again," *Hollywood*, September 1939, 22.

9. "Legion of Decency Takes Slap at 'Strange Cargo,'" *Film Daily*, March 28, 1940, 2.

10. "Legion of Decency Lifts Ban on 'Strange Cargo,'" *Film Daily*, October 8, 1940, 9.

11. Alexander Walker, *Joan Crawford*, 129.

12. So confident was MGM that she would be cast in *Susan and God* that Greer Garson's portrait by Clarence Sinclair Bull, in character, was published in *Photoplay*, March 1940, 42.

13. Joan Crawford, *A Portrait of Joan*, 125–26.

14. "The Screen in Review," *New York Times*, July 12, 1940, 11.

15. Louis Raymond, "Giving Joan the Works," *Motion Picture*, October 1940, 72.

16. "Susan and God," *Modern Screen*, Sept 1940, 12.

17. "Susan and God," *Photoplay*, August 1940, 41.

18. Sullivan's comments and Crawford's response are both found in Joan Crawford, "An open letter to Ed Sullivan," *Hollywood*, January 1941, 21–22, 60.

19. Alexander Walker, *Joan Crawford*, 137.

20. Christina Crawford wrote that they first drove to Miami before heading to New York where she celebrated her first birthday (Christina Crawford, *Mommie Dearest*, 25.)

21. Crawford signs a letter to her old friend Genie Chester dated January 31, 1940 as Joan and Cynthia (Vogel, *Joan Crawford: Her Life in Letters*, 61).

22. Christina Crawford, *Mommie Dearest*, 24.

23. Louis Raymond, "Giving Joan the Works, *Motion Picture*, October 1940, 72.

24. Sonia Lee, "Joan Crawford's 'Houseguest,'" *Hollywood*, April 1940, 28.

25. Among the first mentions of the adoption in a fan magazine is in a caption under a photograph of Crawford in *Modern Screen*, August 1941,21.

26. Joan Crawford, *A Portrait of Joan*, 133–34.

27. "Stars over Broadway," *Motion Picture*, August 1940, 69.

28. Joan Crawford, *A Portrait of Joan*, 132.

29. Gladys Hall, "The Women I Hate," *Motion Picture*, June 1941, 77.

30. "John Crawford Went on Strike," *Wireless Weekly*, April 4, 1942, 12.

31. Irving Drutman, "Joan Crawford's Most Daring Role," *Hollywood*, June 1941, 25.

32. Gavin Lambert, *On Cukor*, 161–63.

33. Melvyn Douglas and Tom Arthur, *The Autobiography of Melvyn Douglas* (New York: University Press of America, 1986), 91.

34. Elizabeth Wilson, "Crawford Comes Back," *Screenland*, May 1941, 32, 90.

35. "A Woman's Face," *Variety*, May 7, 1941, 12.

36. "A Woman's Face," *Showman's Trade Review*, May 10, 1941, 19.

37. "A Woman's Face," *Photoplay*, July 1941, 24.

38. Howard Gutner, *Gowns by Adrian* (New York: Abrams, 2001), 194.

39. For an accounting of the circumstances around the adoption of the "first" Christopher, see his autobiography: D. Gary Deatherage, *The Other Side of My Life* (Nashville: Winston-Derek Publishers, 1991).

40. "Joan Crawford Went on Strike," *Wireless Weekly*, April 4, 1942, 12.

41. "Crawford Filling Lombard's Role; Salary to Charities," *Film Daily*, January 29, 1942, 1, 8. National coverage included "Joan Gets Carole's Role," *Boston Globe*, January 29, 1942, 9.

42. Joan Crawford, *A Portrait of Joan*, 135.

43. Joan Crawford, *A Portrait of Joan*, 135.

44. *Film Daily.*

45. *Film Daily.*

46. "Reunion in France," *New York Times*, March 5, 1943, 20.

47. *Modern Screen*, March 1943, 23.

48. "Above Suspicion," *New York Times*, August 6, 1943, 10.

49. Lawrence J. Quirk and Lawrence Schoell, *Joan Crawford: The Essential Biography* (Lexington, University Press of Kentucky, 2002).

50. Joan Crawford, *A Portrait of Joan*, 128.

51. Alexander Walker, *Joan Crawford*, 142.

52. Joan Crawford, *A Portrait of Joan*, 129.

CHAPTER 13: WARNER BROS. AND *MILDRED PIERCE*

1. Joan Crawford, *A Portrait of Joan*, 136.

2. Sally E. Parry, *The Minnesota Stories of Sinclair Lewis* (St. Paul, Minnesota, Historical Society Press, 2005), xvi.

3. Matthew Kennedy, *Edmund Goulding's Dark Victory*, 216, 220–21.

4. "Co-Starring Crawford and Adrian," *Screenland*, September 1944, 50–53.

5. "Miss Christina Crawford—Terry Entertains the Very Youngest Set," *Movieland*, October 1943, 32–33.

6. Joan Crawford, *A Portrait of Joan*, 137.

7. Joan Crawford, *A Portrait of Joan*, 137.

8. Joan Crawford, *A Portrait of Joan*, 138.

9. Fred Stanley, "Warners and Actors Guild Smoke Peace Pipe," *New York Times*, April 30, 1944, 3.

10. "'Hollywood Canteen' Budget $1,550,000," *Film Daily*, January 13, 1944, 16.

11. See: Ed Sikov, Dark Victory: *The Life of Bette Davis* (New York: Henry Holt, 2007), 248; Axel Madsen, *Stanwyck* (New York: Harper Collins, 1994), 221.

12. James Cain, "Why Did Mildred Pierce Do It?" *Modern Screen*, August 1946, 97.

13. Alfred J. LaValley, *Mildred Pierce* (Madison: University of Wisconsin Press, 1980), 47.

14. Joan Crawford, *A Portrait of Joan*, 139.

15. Alan K. Rode, *Michael Curtiz* (Lexington: University Press of Kentucky, 2017), 380.

16. "Film Parade: Mildred Pierce," *Ebony*, January 1946, 30.

17. For a full elucidation of the many writers involved and the various scripts Wald reviewed, see Albert J. LaValley, *Mildred Pierce*, 18–42.

18. Alan K. Rode, *Michael Curtiz*, 375.

19. Daniel Madden, *The Voice of James M. Cain* (Guilford, CT: Lyons Press, 2020), 158.

20. Alan K. Rode, *Michael Curtiz*, 377.

21. David Chierichetti, "The Shocking Miss Crawford," *Films of the Golden Age* (Winter 2013/14): 30.

22. David Chierichetti, "The Shocking Miss Crawford," 26.

23. Joan Crawford, *A Portrait of Joan*, 139.

24. Ed Raiden, "In Hollywood, It's News," *Showman's Trade Review*, December 2, 1944, 59.

25. Joan Crawford, *A Portrait of Joan*, 139.

26. Louella Parsons, „These are the Unforgettables," *Modern Screen*, June 1945, 81.

27. Cook, *New York World Telegram*, quoted in "'Mildred Pierce' Some Pan It, Some Praise It," *Film Bulletin*, October 15, 1945, 24.

28. "Mildred Pierce," *Variety*, October 3, 1945, 20.

29. "Current Cinema," *New Yorker*, October 6, 1945, 95.

30. "Mildred Pierce," *Photoplay*, November 1945, 142.

31. Ruth Waterbury, "Story Passage for Joan and Phil," *Photoplay*, March 1946, 29, 122–23.

32. Joan Crawford, *A Portrait of Joan*, 141.

CHAPTER 14: WARNER BROS. STAR

1. Jean Negulesco, *Things I Did . . . and Things I Think I Did* (New York: Linden Press/Simon & Schuster, 1984), 131.

2. Jean Negulesco, *Things I Did . . . and Things I Think I Did*, 135.

3. Jean Negulesco, *Things I Did . . . and Things I Think I Did*, 132.

4. David Chierichetti, "The Shocking Miss Crawford," 26–27.

5. "Inside Stuff—Pictures," *Variety*, January 16, 1946, 25.

6. Dorothy Kilgallen, "Dorothy Kilgallen Selects 'Humoresque,'" *Modern Screen*, February 1947, 24.

7. Dorothy Kilgallen, "Dorothy Kilgallen Selects 'Humoresque,'" 24.

8. "Humoresque," *Motion Picture*, February 1947, 16.

9. "Humoresque," *Variety*, December 25, 1946, 12.

10. "Movieland Applauds: 'Humoresque,'" *Movieland*, January 1947, 76.

11. Louella Parsons, "Louella Parsons' Good News," *Modern Screen*, May 1946, 60.

12. "Crawford-Davis Fuss," *Film Bulletin*, October 11, 1946, 23.

13. Cal York, "Cal York's Inside Stuff," *Photoplay*, March 1946, 10.

14. Ruth Waterbury, "Un-possessed," *Photoplay*, August 1947, 110.

15. Elsa Maxwell, "Oh Those Hollywood Parties," *Photoplay*, June 1947, 84–86.

16. Edith Gwynn, "Party Lines," *Photoplay*, June 1947, 74.

17. Christina Crawford, *Mommie Dearest*, 66.

18. Ruth Waterbury, "Un-possessed," *Photoplay*, August 1947, 110.

19. "Joan Crawford in a Deal with Skirball-Manning," *Showmen's Trade Review*, May 18, 1946, 44.

20. "Joan Crawford Starts New S-M Contract in December," *Showmen's Trade Review*, August 24, 1946, 41.

21. "Possessed," *Variety*, June 4, 1947, 16.

22. Humoresque, *Movieland*, August 1947, 22.

23. "Cinema: The New Pictures," *Time*, June 16, 1947.

24. Bosley Crowther, "Humoresque," *New York Times*, May 30, 1947, 25.

25. "Crawford-Davis Fuss," *Film Bulletin*, October 11, 1946, 23.

26. Otto Preminger, *Preminger: An Autobiography* (New York: Doubleday, 1977), 100.

27. Christina Crawford, *Mommie Dearest*, 46–47.

28. Joan Crawford, *A Portrait of Joan*, 144–45.

CHAPTER 15: LATER FILMS AT WARNER BROS.

1. Alan K. Rode, *Michael Curtiz: A Life in Film* (Lexington: University Press of Kentucky, 2021), 422–26.

2. "Flamingo Road," *Movieland*, June 1949, 93.

3. "Flamingo Road," *Showman's Trade Review,* April 9, 1949, 13.

4. Elsa Branden, "Flamingo Road," *Photoplay*, 30.

5. Bosley Crowther, "The Screen in Review: 'Flamingo Road,'" *New York Times*, May 7, 1949, 10.

6. George Frazier, "Handsome Joan from San Antone," *Collier's,* March 12 1949, 15

7. Sheilah Graham, "The House that Joan Built," *Photoplay*, September 1948, 104.

8. Alexander Walker, *Joan Crawford*, 155.

9. Vincent Sherman, *Studio Affairs: My Life as a Film Director* (Lexington: University Press of Kentucky, 1996), 195–218.

10. "The Damned Don't Cry," *Film Bulletin*, April 24, 1950, 11.

11. "The Damned Don't Cry," *Variety*, April 12, 1950, 6.

12. Vincent Sherman, *Studio Affairs: My Life as a Film Director*, 206–209.

13. "Harriet Craig," *Harrison Reports*, October 29, 1950, 170.

14. "Harriet Craig," *Focus*, December 1950, 366–37.

15. "Hollywood," *Variety*, June 7, 1950, 62.

16. "How Old is Young," *Modern Screen*, November 1950, 50–51.

17. Vincent Sherman, *Studio Affairs: My Life as a Film Director*, 211–12.

18. "Joan Crawford's Op," *Variety*, August 16, 1950, 2.

19. Vincent Sherman, *Studio Affairs: My Life as a Film Director*.

20. Vincent Sherman, *Studio Affairs: My Life as a Film Director,* 213.

21. Vincent Sherman, *Studio Affairs: My Life as a Film Director*, 204.

22. Vincent Sherman, *Studio Affairs: My Life as a Film Director*, 212.

23. Vincent Sherman, *Studio Affairs: My Life as a Film Director*, 214.

24. Vincent Sherman, *Studio Affairs: My Life as a Film Director*, 214.

25. "How to Handle Defeat," *Screenland*, June 1951, 31.

26. Kirk Douglas, *Ragman's Son* (New York: Simon & Schuster, 1988), 162–63.

27. Bosley Crowther, "This Woman is Dangerous," *New York Times*, February 28, 1952, 23.

28. Joan Crawford, "What Men Have Done to Me," *Modern Screen*, November 1951, 98.

29. Louella Parsons, *Modern Screen*, September 1951, 35.

CHAPTER 16: *INDEPENDENT*

1. Bob Thomas, *Joan Crawford*, 180.

2. Bob Thomas, *Joan Crawford*, 178–79.

3. Jim Bawden, "David Miller Remembered," www.loststory.net.

4. Jim Bawden, "David Miller Remembered."

5. "New developments," *Sponsor*, December 29, 1952, 16.

6. "Joseph Kaufman," *Independent Film Journal*, August 9, 1952, 16.

7. *Motion Picture Herald*, May 24, 1952, 11.

8. "It's Merely Money," *Photoplay*, February 1953, 34.

9. *Daily Variety*, review quoted in an ad for *Sudden Fear*, *Variety*, July 30, 1952, 19.

10. "Sudden Fear, *Harrison's Reports*, July 26, 1952, 120.

11. *Hollywood Reporter*, review quoted in an ad for *Sudden Fear*, *Variety*, July 30, 1952, 19.

12. *N.Y. Daily Mirror*, review quoted in an ad for *Sudden Fear*.

13. François Truffaut, "Les Extremes me touchent, *Cahiers du Cinéma*, no. 21 (March 1953): 61–63. "Hormis deux séquences fort brèves, mas assez déplaisantes (un rêve et un projet images), pas un plan dans ce film qui ne soit nécessaire à la progression dramatique."

14. Florabel Muir, "Hollywood Whispers," *Photoplay*, July 1953, 4.

15. Bob Thomas, *Joan Crawford*, 181–82.

16. Jack Wade, "Crawford Meets the Critics, *Modern Screen*, March 1954, 92.

17. Alexander Walker, *Joan Crawford*, 158,

18. Jack Wade, "Crawford Meets the Critics, *Modern Screen*, March 1954, 92.

19. Janet Graves, "Torch Song," *Photoplay*, December 1953, 11.

20. Jack Wade, "Crawford Meets the Critics, *Modern Screen*, March 1954, 92.

21. Louella Parson, "Louella Parsons' Good News," *Modern Screen*, January 1954, 12.

22. Danton Walker," *Hollywood on Broadway, Screenland*, February 1954, 43–44.

23. Florence Epstein, "Torch Song," *Modern Screen*, January 1954, 14.

24. "Joan Crawford to Report in August for 'Johnny Guitar,'" *Film Bulletin*, July 13, 1953, 14.

25. Chesterfield Pictures, Invincible Pictures, Liberty Pictures, Majestic Pictures, Mascot Pictures, Monogram Pictures.

26. Patrick McGilligan, *Nicholas Ray* (New York, Harper Collins, 2011), 244.

27. Mike Connolly, "Hollywood Report," *Modern Screen*, January 1954, 65.

28. Francois Truffaut, "A Wonderful Certainty," *Cahiers du Cinéma: The 1950s, Neo-realism, Hollywood, New Wave*, ed. Jim Hillier (Cambridge: Harvard, 1985), 107.

29. Bob Thomas, *Joan Crawford*, 189.

30. Mercedes McCambridge, *The Quality of Mercy* (New York: Times Books, 1981), 12–13.

31. Patrick McGilligan, *Nicholas Ray*, 255.

32. Jack Wade, "Crawford Meets the Critics, *Modern Screen*, March 1954, 93.

33. Patrick McGilligan, *Nicholas Ray*, 254.

34. "Johnny Guitar," *Variety*, May 5, 1954, 6.

35. Bosley Crawford, "Johnny Guitar," *New York Times*, May 28, 1954, 19.

36. "Johnny Guitar," *Independent Film Journal*, May 15, 1954, 20.

37. Reba and Bonnie Churchill, "Johnny Guitar, *Screenland*, July 1954, 12.

38. Quoted in David Denby, "The Escape Artist: The Case for Joan Crawford," *New Yorker*, January 3, 2011.

39. Alice Hoffman, "Someone to Watch over Me," *Modern Screen*, August 1955, 49.

40. Bob Thomas, *Joan Crawford*.

41. "Female on the Beach," *Photoplay*, December 1955, 10.

42. "Queen Bee," *Modern Screen*, December 1955, 20.

43. Bob Thomas. *Joan Crawford*, 201.

44. Anthony Slide, *Inside the Hollywood Fan Magazine* (Jackson: University Press of Mississippi, 2021), 180.

45. FBI Joan Crawford file, Office Memorandum, United States Government, To: Mr Tolson, From: L.B. Nichols, Date: 6/11/55, 2.

46. FBI Joan Crawford file, Office Memorandum, United States Government, To: Mr. Nichols, From: M.A. Jones, Date: May 17, 1955, 1.

47. FBI Joan Crawford file, Office Memorandum, United States Government, To: Mr. Nichols, From: M.A. Jones, May 17, 1955, 5.

48. FBI Joan Crawford file, Office Memorandum, United States Government, To: Mr. Nichols, From: M.A. Jones, May 17, 1955, 6.

49. On March 11, 1955, the *New York Times* reported: "Frank Sinatra became the third personality United Artists has agreed to finance in independent film production. The others signed this week were Robert Mitchum and Joan Crawford" (March 11, 1955, 20).

50. Edith Gwynn, "Hollywood Party Line," *Photoplay*, August 1955, 33.

51. "Cal York's Inside Stuff," *Photoplay*, November 1955, 16.

52. Eve Arnold, *Film Journal* (New York: Bloomsbury Publishing, 2001), 31–38.

53. 'Focus on "Realism,"' *Variety*, December 21, 1955, 46.

54. "Some Indies Hit Big," *Motion Picture Exhibitor*, December 25, 1957, 51.

55. "Joan Crawford Son Called Delinquent," *New York Times*, May 11, 1958, 84.

56. Christina Crawford, *Mommie Dearest*, chapter 6.

57. "A. N. Steele, Pepsi Boss, Dies, Husband of Joan Crawford," *Bridgeport Post*, April 20, 1959, 31.

CHAPTER 17: *WHAT EVER HAPPENED TO BABY JANE?*

1. Laura Jacobs, "The Best of Everything," *Vanity Fair's Tales of Hollywood* (New York: Penguin Book, 2008), 119.

2. Laura Jacobs, "The Best of Everything," 119–20.

3. Jean Negulesco, *Things I Did and Things I Think I Did*, 136–38.

4. Eve Arnold, *Film Journal*, 38–40.

5. "The Durable Charms of Joan the Queen," *Life*, October 5, 1959, 136–45.

6. Morton J. Golding, "Revolt of Joan Crawford's Daughter," *Redbook*, October 1960, 46, 85–89.

7. Christina Crawford, *Mommie Dearest*, 243.

8. Roy Newquist, *Conversations with Joan Crawford*, 137.

9. Sara Hamilton, "Sara Hamilton's Inside Stuff," *Photoplay*, August 1960, 22.

10. "Joan Crawford—The Visitor," *Modern Screen*, March 1960, 18.

11. Crawford also appeared on a Bob Hope special in October 1958.

12. "Aldrich Look to Pact Joan Crawford for his Projected 'Baby Jane,'" *Variety*, October 4, 1961, 15.

13. "Hollywood . . . Still an Empty Tomb: An Interview with Robert Aldrich, *Cinema* 1, no. 3 (May 1963): 5.

14. Alexander Walker, *Joan Crawford*, 171.

15. Hedda Hopper, *Los Angeles Times*, September 16, 1962, quoted in Shaun Considine, *Bette & Joan: The Divine Feud* (New York, E. P. Dutton, 1989), 305.

16. "Under Hedda's Hat," *Photoplay*, October 1962, 24.

17. B. D. Hyman, *My Mother's Keeper* (New York: William Morrow, 1985), 59.

18. "Whatever Happened to Baby Jane?" *Box Office*, November 5, 1962, 2680.

19. Ed Sikov, 344.

20. "Whatever Happened to Baby Jane?" *Film Bulletin*, October 29, 1962, 27.

21. Andrew Sarris, "Whatever Happened to Baby Jane?" *Movie* (April 1963): 6–7.

22. The final cost of the film was $1,075,664 (Ed Sikov *Dark Victory*, 245), but Crawford's agreement was to receive her percentage for net above $850,000.

23. Joan Crawford, *My Way of Life*, 51.

24. William J. Mann, *Behind the Screen: How Gays and Lesbians Shaped Hollywood, 1910–1969* (New York: Viking, 2001), 343.

25. Bob Downing, "Coincidental Crawford-Davis Biogs; Both OK, Both Cast for 7 Arts Pic," *Variety*, July 18, 1962, 263.

26. Bette Davis appeared on *The Jack Paar Program* on November 16, 1962.

27. Joan Crawford appeared on the *Tonight Show with Johnny Carson* on October 1, 1962.

28. Hedda Hopper, "Under Hedda's Hat," *Photoplay*, July 1963, 29.

CHAPTER 18: LAST YEARS

1. Shawn Considine, *Bette & Joan; The Divine Feud*, note, 334.

2. "Strait-Jacket," *Motion Picture Exhibitor*, January 8, 1964, 5121.

3. "Joan Crawford and the Golden Age of Hollywood," Swann Galleries, January 27, 1994, lot 238.

4. *Daily Variety*, August 19, 1963, reported the film's budget at $550,000.

5. "What's New," *TV Radio Mirror*, October 1963, 12.

6. "Joan Speaks her Mind," *Motion Picture Exhibitor*, July 10, 1963, 6.

7. "Joan Crawford Stars in All-Media Campaign," *Motion Picture Exhibitor*, February 5, 1964, EX-565.

8. Richard Oulahan, "A Well-Planned Crawford, *Life*, February 1, 1964, 11–12.

9. Bette Davis, *This 'N That*, 142.

10. "The New York Scene," *Motion Picture Exhibitor*, January 8, 1964, 17.

11. Bob Thomas, *Joan Crawford*, 230.

12. "Crawford Illness Quiets "Hush," *Motion Picture Exhibitor*, August 12, 1964, 11.

13. Bob Thomas, *Joan Crawford*, 231.

14. Bette Davis, *This 'N That*, 142.

15. "De Havilland for Crawford in 20th-Fox's 'Hush,'" *Motion Picture Exhibitor*, September 2, 1964, 10.

16. Bob Thomas, *Joan Crawford*, 231.

17. Bob Thomas, *Joan Crawford*, 234.

18. Howard Thompson, "Circus Thriller," *New York Times*, January 11, 1968, 42.

19. Bob Thomas, *Joan Crawford*, 236.

20. Carleton Varney, *There's No Place Like Home* (Indianapolis: Bobbs-Merrill, 1980), 44–69.

21. Christina Crawford, *Mommie Dearest*, 252.

22. Christina Crawford, *Mommie Dearest*, 253.

23. Bob Thomas, *Joan Crawford*, 243.

24. Christina Crawford, *Mommie Dearest*, 254.

25. Bob Thomas, *Joan Crawford*, 236.

26. Bob Thomas, *Joan Crawford*, 236–39.

27. Joseph McBride, *Steven Spielberg: A Biography*, second edition (Jackson: University Press of Mississippi, 2011), 176.

28. *Films in Review*, November 1969, 526.

29. Robert L. Jerome, "Trog," *Cinefantastique* (Winter 1971): 36.

30. To view a transcript of the evening, see thetownhall.org/the-1970s.

31. Ernest Holsendolph, "Pepsi's Sparkling World of Big Deals," *New York Times*, December 17, 1972, 3.

32. Robert Scheer, "The Doctrine of Multinational Sell," *Esquire*, April 1975, 124.

33. Eve Golden, *Golden Images: 41 Essays on Silent Film Stars* (Jefferson, NC: McFarland and Company, 2000), 45.

34. "Architectural Digest Visits: Joan Crawford," *Architectural Digest*, March/April 1976, 80.

35. Carleton Varney, *There's No Place like Home*, 60.

36. Jack O'Brien, "The Voice of Broadway," *Lebanon (Pennsylvania) Daily News*, October 1, 1974, 17.

37. Carl Johnes, *Crawford: The Last Years* (New York: Dell, 1979), 41.

38. Carl Johnes, *Crawford: The Last Years*, 36

39. Carl Johnes, *Crawford: The Last Years*, 70.

40. Carl Johnes, *Crawford: The Last Years*, 122.

41. John Engstead, *Star Shots* (New York: Dutton, 1978), 57–58.

42. Christina Crawford, *Mommie Dearest*, 258.

43. Christina Crawford, *Mommie Dearest*, 270.

44. Carleton Varney, *There's No Place Like Home*, 67.

45. In an article in the *Daily Mail*, April 3, 2017, for which Crawford's grandson Casey La Londe was interviewed, the cause of Crawford's death was listed as pancreatic cancer.

CHAPTER 19: *MOMMIE DEAREST*

1. "Christina Crawford," *New York Times Book Review*, January 14, 1979, 38.

2. Christina Crawford, *Mommie Dearest*, 275.

3. "Pearl Bailey Eulogizes Joan Crawford in Song," *Santa Anita Register*, May 18, 1977, 10.

4. Christina Crawford, *Mommie Dearest*, 280.

5. George Cukor, "She was Consistently Joan Crawford, Star," *New York Times*, May 22, 1977, 15.

6. Christina Crawford, *Mommie Dearest*, 161–62.

7. Christina Crawford, *Mommie Dearest*, 53.

8. Christina Crawford, *Mommie Dearest*, 170.

9. Christina Crawford, *Mommie Dearest*, 144.

10. Christina Crawford, *Mommie Dearest*, 96.

11. Christina Crawford, *Mommie Dearest*, 78–79.

12. Christina Crawford, *Mommie Dearest*, 231.

13. Christina Crawford, *Mommie Dearest*, 166

14. Peer J. Oppenheimer, "Lunch with Joan Crawford." *Lowell Sun*, February 21, 1971, 121.

15. Christina Crawford appeared on *Larry King Live*, August 10, 2001.

16. Christina Crawford, *Mommie Dearest*, 50.

17. Christina Crawford, *Mommie Dearest*, 237.

FILMOGRAPHY

Lady of the Night, MGM production 213; directed by Monta Bell; released: February 23, 1925; with Norma Shearer; Crawford (from rear) is an on-camera stand-in for Shearer.

[MGM Studio Tour], short subject released in the summer of 1925 introducing players, technicians, and executives to the public.

Pretty Ladies, MGM production 227; directed by Monta bell; released: July 1925; with ZaSu Pitts, Tom Moore; Crawford is credited as Lucille Le Sueur.

The Circle, MGM production 218; directed by Frank Borzage; released: September 22, 1925; with Eleanor Boardman.

Old Clothes, Jackie Coogan production; directed by Eddie Cline; released: November 9, 1925; with Jackie Coogan.

The Only Thing, MGM production 228; directed by Jack Conway; released: November 22, 1925; with: Eleanor Boardman, Conrad Nagel; Crawford was an extra in a party scene.

Sally, Irene and Mary, MGM production 246; directed by Edmund Goulding; released: December 7, 1925; with Sally O'Neil, Constance Bennett, William Haines.

Tramp, Tramp, Tramp, Harry Langdon production 50; directed by Harry Edwards; released: March 21, 1926; with Harry Langdon.

The Boob, MGM production 234; directed by William Wellman; released: May 17, 1926; with Gertrude Olmstead, George K. Arthur; made in the fall of 1925, the release was delayed until the following spring.

Paris, MGM production 238; directed by Edmund Goulding; released: May 24, 1926; with: Charles Ray, Douglas Gilmore; presumed lost.

Winners of the Wilderness, MGM production 292; directed by W. S. Van Dyke; released: February 2, 1927; with Tim McCoy, Roy D'Arcy.

The Taxi Dancer, MGM production 291; directed by Harry Milarde; released: February 5, 1927; with: Owen Moore, Douglas Gilmore; presumed lost.

The Understanding Heart, MGM production 282; directed by Jack Conway; released: February 26, 1927; with Francis X. Bushman Jr., Rockcliffe Fellows.

The Unknown, MGM production 305; directed by Tod Browning; released: May 29, 1927; with Lon Chaney.

Twelve Miles Out, MGM production 314; directed by Jack Conway; released: July 9, 1927; with John Gilbert.

Spring Fever, MGM production 315; directed by Edward Sedgwick; released: October 18, 1927; with William Haines.

West Point, MGM production 337; directed by Edward Sedgwick; released: December 31, 1927; with William Haines.

The Law of the Range, MGM production 347; directed by William Nigh; released: January 21, 1928; with Tim McCoy; presumed lost.

Rose-Marie, MGM production 325; directed by Lucien Hubbard; released: February 11, 1928; with James Murray; presumed lost.

Across to Singapore, MGM production 354; directed by William Nigh; released: April 30, 1928; with Ramon Novarro.

Tide of Empire, MGM production 357; directed by Lucien Hubbard; released in 1929; soon after filming commenced in the winter of 1928 the project was delayed, and Crawford's role was taken by Renée Adorée.

Four Walls, MGM production 373; directed by William Nigh; released: August 11, 1928; with John Gilbert; presumed lost.

Our Dancing Daughters, MGM production 364; directed by Harry Beaumont; released: September 1, 1928; w/ Johnny Mack Brown, Anita Page, Dorothy Sebastian, Nils Asther.

Dream of Love, MGM production 390; directed by Fred Niblo; released: December 1, 1928; with Nils Asther, Aileen Pringle, Carmel Myers; presumed lost.

The Duke Steps Out, MGM production 406; directed by James Cruze; released: March 16, 1929; with William Haines; presumed lost.

TALKING PICTURES

Hollywood Review of 1929, MGM production 421; directed by Charles Reisner; released: July 1929.

Our Modern Maidens, MGM production 413, directed by Jack Conway; released: September 6, 1929; with Douglas Fairbanks Jr., Anita Page, Rod LaRoque.

Untamed, MGM production 438; directed by Jack Conway; released: November 23, 1929; with Robert Montgomery.

Montana Moon, MGM production 463; directed by Malcolm St. Clair; released: March 20, 1930; with Johnny Mack Brown, Dorothy Sebastian.

Our Blushing Brides, MGM production 493; directed by Harry Beaumont; released: July 19, 1930; with Anita Page, Dorothy Sebastian.

Great Day, MGM production 502; directed by Harry Beaumont; filmed during July and August 1930, the picture was abandoned.

Paid, MGM production 520; directed by Sam Wood; released: December 30, 1930; with Robert Armstrong, Marie Provost.

Dance, Fools, Dance, MGM production 531; directed by Harry Beaumont; released: February 7, 1931; with Lester Vail, Cliff Edwards, Clark Gable.

Laughing Sinners, MGM production 551; directed by Harry Beaumont; released: May 30, 1931; with Neil Hamilton, Clark Gable.

This Modern Age, MGM production 558; directed by Nicholas Grinde/Clarence Brown; released: August 29, 1931; with Pauline Frederick, Neil Hamilton.

Possessed, MGM production 581; directed by Clarence Brown; released: October 21, 1931; with Clark Gable.

Grand Hotel, MGM production 603; directed by Edmund Goulding; released: April 12, 1932; with Greta Garbo, John Barrymore, Lionel Barrymore, Wallace Beery.

Letty Lynton, MGM production 611; directed by Clarence Brown; released: April 30, 1932; with Nils Asther, Robert Montgomery.

Rain, United Artists production 7000; directed by Lewis Milestone; released: October 12, 1932; with Walter Huston.

Today We Live, MGM production 651; directed by Howard Hawks; released: March 3, 1933; with Gary Cooper, Franchot Tone, Robert Young.

Dancing Lady, MGM production 694; directed by Robert Z. Leonard; released: November 24, 1933; with Clark Gable, Franchot Tone.

Sadie McKee, MGM production 731; directed by Clarence Brown; released: May 9, 1934; with Franchot Tone, Gene Raymond, Edward Arnold.

Chained, MGM production 767; directed by Clarence Brown; released: September 1, 1934; with Clark Gable.

Forsaking All Others, MGM production 795; directed by W. S. Van Dyke; released: December 23, 1934; with Clark Gable, Robert Montgomery.

No More Ladies, MGM production 828; directed by Edward H. Griffith/George Cukor; released: June 21, 1935; with Robert Montgomery.

I Live My Life, MGM production 858; directed by W. S. Van Dyke; released: October 4, 1935; with Brian Aherne.

The Gorgeous Hussy, MGM production 919; directed by Clarence Brown; released: August 28, 1936; with Robert Taylor, Lionel Barrymore, Franchot Tone.

Love on the Run, MGM production 948; directed by W. S. Van Dyke; released: November 20, 1936; with Clark Gable, Franchot Tone.

The Last of Mrs. Cheyney, MGM production 972; directed by Richard Boleslawski/Dorothy Arzner; released: February 19, 1937; with Robert Montgomery, William Powell.

The Bride Wore Red, MGM production 997; directed by Dorothy Arzner; released: October 15, 1937; with Franchot Tone, Robert Young.

Mannequin, MGM production 1021; directed by Frank Borzage; released: December 14, 1937; with Spencer Tracy.

The Shining Hour, MGM production 1963, directed by Frank Borzage; released: November 18, 1938; with Melvyn Douglas, Margaret Sullavan, Robert Young.

Ice Follies of 1939, MGM production 1066; directed by Reinhold Schunzel; released: March 10, 1939; with James Stewart, Lew Ayres.

The Women, MGM production 1091; directed by George Cukor; released: August 29, 1939; with Norma Shearer, Rosalind Russell.

Strange Cargo, MGM production 1117, directed by Frank Borzage; released: March 1, 1940; with Clark Gable, Ian Hunter, Peter Lorre.

Susan and God, MGM production 1131; directed by George Cukor; released: June 7, 1940; with Fredrick March, Rita Hayworth.

A Woman's Face, MGM production 1177; directed by George Cukor; released: May 15, 1941; with Melvyn Douglas, Conrad Veidt.

When Ladies Meet, MGM production 1196; directed by Robert Z. Leonard; released: August 29, 1941; with Robert Taylor, Greer Garson.

They All Kissed the Bride, Columbia production 150; directed by Alexander Hall; released: June 11, 1942; with Melvyn Douglas.

Reunion in France, MGM production 1262; directed by Jules Dassin; released: December 25, 1942; with Philip Dorn, John Wayne.

Above Suspicion, MGM production 1278; directed by Richard Thorpe; released: August 5, 1943; with Fred MacMurray.

Hollywood Canteen, Warner Bros. production 617; directed by Delmer Daves; released: December 31, 1944.

Mildred Pierce, Warner Bros. production 638; directed by Michael Curtiz; released: September 28, 1945; with Zachary Scott, Ann Blyth.

Humoresque, Warner Bros. production 658; directed by Jean Negulesco; released: December 25, 1946; with John Garfield, Oscar Levant.

Possessed, Warner Bros. production 667; directed by Curtis Bernhardt; Released: July 26, 1947; with Van Heflin, Raymond Massey.

Daisy Kenyon, 20th Century-Fox production 716; directed by Otto Preminger; released: September 25, 1947; with Dana Andrews, Henry Fonda.

Flamingo Road, Warner Bros. production 362; directed by Michael Curtiz; released: May 6, 1940; with Zachary Scott, Sidney Greenstreet.

It's A Great Feeling, Warner Bros. production 711; directed by David Butler; released: August 20, 1949; with Doris Day, Jack Carson.

The Damned Don't Cry, Warner Bros. production 730; directed by Vincent Sherman; released: May 7, 1950; with David Brian, Steve Cochran.

Harriet Craig, Columbia production 1224; directed by Vincent Sherman; released: November 2, 1950; with Wendell Corey.

Goodbye My Fancy, Warner Bros. production 748; directed by Vincent Sherman; Released: May 19, 1951; with Robert Young, Frank Lovejoy.

This Woman is Dangerous, Warner Bros. production 770; directed by Felix Feist; released: February 28, 1952; with David Brian.

Sudden Fear, Joan Crawford production released through RKO; directed by David Miller; released: August 7, 1952; with Jack Palance, Gloria Graham.

Torch Song, MGM production 1631, directed by Charles Walters; released: October 23, 1953; with Michael Wilding.

Johnny Guitar, Republic production 1964; directed by Nicholas Ray; released: May 7, 1954; with Sterling Hayden, Mercedes McCambridge.

Female on the Beach, Universal production 1788; directed by Joseph Pevney; released: August 19, 1955; with Jeff Chandler.

Queen Bee, Columbia production 1308; directed by Ranald MacDougall; released: November 7, 1955; with Barry Sullivan, Betsy Palmer.

Autumn Leaves, Columbia production 8322; directed by Charles Lang; released: August 1, 1956; with Clift Robertson.

The Story of Esther Costello, Columbia production R-135; directed by David Miller; released: November 6, 1957; with Rossano Brazzi, Heather Sears.

The Best of Everything; 20th Century Fox production 996; directed by Jean Negulesco; released: October 9, 1959; with Hope Lange, Suzy Parker, Diane Baker, Stephen Boyd.

What Ever Happened to Baby Jane?, produced by Robert Aldrich for Warner Bros.; directed by Robert Aldrich; released: October 31, 1962; with Bette Davis, Victor Bruno, Maidie Norman.

The Caretakers, produced by Hall Bartlett; directed by Hall Bartlett; released: August 31, 1963; with Robert Stack, Polly Bergen, Herbert Marshall.

Strait-Jacket, produced by William Castle for Columbia Pictures; directed by William Castle; released: January 8, 1964; with Diane Baker, Leif Erickson.

Della, produced by NBC television; directed by Robert Gist; released: August 8, 1964; with Paul Burke, Diane Baker. Originally a television pilot titled *Royal Bay* for a proposed NBC series that was not picked up by the network, *Della* was later released theatrically.

I Saw What You Did, produced by William Castle for Universal Pictures; directed by William castle; released: July 21, 1965; with John Ireland, Leif Erickson.

The Karate Killers, produced by NBC television; directed by Barry Shear; released: fall 1967; with Robert Vaughn, David McCallum. Originally a two-part episode of the television series *The Man from U.N.C.L.E.* titled *The Five Daughters Affair* (March, April 1967), it was later released theatrically in Europe and Japan.

Berserk!, produced by Herman Cohen for Columbia Pictures; directed by Jim O'Connolly; released: September 1967 (UK); January 11, 1968 (US); with Ty Harden, Judy Geeson.

Trog, produced by Herman Cohen for Warner Bros.; directed by Freddie Francis; released: October 24, 1970; with Joe Cornelius, Michael Gough.

SELECTED BIBLIOGRAPHY

Arnold, Eve. *Film Journal*. New York: Bloomsbury, 2002.

Blake, Michael F. *The Films of Lon Chaney*. Lanham, MD: Vestal Press, 1998.

Brundidge, Harry T. *Twinkle, Twinkle, Movie Star!* New York: Garland, 1977.

Bull, Clarence Sinclair, and Raymond Lee. *The Faces of Hollywood*. South Brunswick, NJ: A. Barnes, 1968.

Cannon, Robert C. *Van Dyke and the Mythical City, Hollywood.* Culver City: Murray & Gee, 1948.

Carr, Larry. *Four Fabulous Faces: The Evolution and Metamorphosis of Garbo, Swanson, Crawford and Dietrich*. New Rochelle, NY: Arlington House, 1970.

Carter, Graydon, ed. *Vanity Fair's Tales of Hollywood*. New York: Penguin Books, 2008.

Connell, Evan. *Knight Errant*. New York: Doubleday, 1955.

Cowie, Peter. *Joan Crawford*. New York: Rizzoli, 2009.

Crawford, Christina. *Mommie Dearest*. New York: William Morrow, 1978.

Crawford, Joan, with Jane Ardmore. *A Portrait of Joan*. New York: Doubleday, 1962.

Crawford, Joan, with Audrey Davenport Inman. *My Way of Life*. Los Angeles, Graymalkin Media, 2017.

Cremonini, Giorgio, introduction. *Joan Crawford Ritratti*, Ravenna: Comune di Ravenna, Assessorato all Cultura, Reparto Cinema, 1995.

Dance, Robert, and Bruce Robertson. *Ruth Harriet Louise and Hollywood Glamour Photography*. Berkeley: CA, 2002.

Davis, Bette. *This 'N That*. New York: Putnam's, 1987.

Davy, Charles, ed. *Footnotes to the Film*. New York: Oxford University Press, 1937.

Deatherage, D. Gary. *The Other Side of My Life*. Nashville: Winston-Derek Publishers, 1991.

Doherty, Thomas. *Pre-Code Hollywood: Sex, Immorality, and Insurrection in American Cinema, 1930–1934*. New York: Columbia University Press, 1999.

Douglas, Kirk. *The Ragman's Son*. New York: Simon & Schuster 1988.

Douglas, Melvyn, and Tom Arthur. *The Autobiography of Melvyn Douglas*. New York: University Press of America, 1986.

Engstead, John. *Star Shots*. New York: E. P. Dutton, 1978.

Erté. *Things I Remember: An Autobiography*. New York: Quadrangle, 1975.

Fairbanks, Douglas, *A Hell of a War*. New York: St. Martin's, Press, 1993.

Fairbanks, Douglas, Jr. *The Fairbanks Family Album*. Boston: New York Graphic Society, 1975.

Fairbanks, Douglas, Jr. *Salad Days*. New York: Doubleday, 1988.

Ferragamo, Salvatore. *Shoemaker of Dreams: The Autobiography of Salvadore Ferragamo*. Sillabe, 1985 [1957].

Geist, Kenneth L. *Pictures Will Talk: The Life and Films of Joseph L. Mankiewicz*. New York: Charles Scribner's Sons, 1978.

Gladstone, James. *The Man Who Seduced Hollywood: The Life and Loves of Greg Bautzer, Tinseltown's Most Powerful Lawyer*. Chicago: Chicago Review Press, 2013.

Golden, Eve. *Golden Images: 41 Essays on Silent Film Stars*. Jefferson, NC: McFarland and Company, 2001.

Golden, Eve. *John Gilbert*. Lexington: University Press of Kentucky, 2013.

Gutner, Howard. *Designs by Adrian*, New York: Abrams, 2001.

Harris, Warren. *Clark Gable*. New York: Harmony Books, 2002.

Haskell, Molly. *From Reverence to Rape: The Treatment of Women in the Movies*. New York: Holt, Rinehart and Winston, 1974.

Harvey, Stephen. *Joan Crawford*. New York: Pyramid, 1974.

Head, June. *Star Gazing*. London: Peter Davies, 1931.

Hillier, Jim, editor. *Cahiers du Cinema: the 1950s, Neo-Realism, Hollywood, New Wave*. Cambridge: Harvard University Press, 1985.

Houston, Davis. *Jazz Baby*. New York: St. Martin's Press 1983.

Hughes, Elinor. *Famous Stars of Filmdom (Women)*. Boston: L. C. Page & Company, 1931.

Hyman, B. D. *My Mother's Keeper*. New York: William Morrow, 1985.

Johnes, Carl. *Crawford: The Last Years*. New York: Dell, 1979.

Kennedy, Matthew. *Edmund Goulding's Dark Victory*. Madison: University of Wisconsin Press, 2004.

Kobal, John. *The Art of the Great Hollywood Portrait photographers, 1925–1940*. New York: Knopf, 1980.

Kobal, John. *People Will Talk*. New York: Knopf, 1985.

Lambert, Gavin. *On Cukor*. New York: G. P. Putnam's Sons, 1972.

LaValley, Albert J. *Mildred Pierce*. Madison: University of Wisconsin Press, 1980.

Maas, Frederica Sagor. *The Shocking Miss Pilgrim: A Writer in Early Hollywood*. Lexington: University Press of Kentucky, 1999.

Mann, William J. *Behind the Screen: How Gays and Lesbians Shaped Hollywood*. New York: Viking, 2001.

Mann, William J. *Wisecracker: The Life of Williams Haines, Hollywood's First Openly Gay Superstar*. New York: Viking, 1997.

Mayne, Judith. *Directed by Dorothy Arzner*. Bloomington: Indiana University Press, 1994.

McCambridge, Mercedes. *The Quality of Mercy: An Autobiography*. New York: Times Books, 1981.

McCarthy, Todd. *Howard Hawks: The Grey Fox of Hollywood*. New York: Simo & Schuster, 1997.

McGilligan, Patrick. *George Cukor: A Double Life*. New York: St. Martin's Press, 1991.

Negulesco, Jean. *Things I Did and Things I Wish I Did*. New York: Linden Press/Simon & Schuster, 1984.

Newquist, Roy. *Conversations with Joan Crawford*. New York: Berkley Books, 1981.

Nourmand, Tony, and Phil Moad. *Hurrell*. London: Rare Art Press, 2012.

Paris, Barry. *Louise Brooks*. New York: Knopf, 1998.

Preminger, Otto. *Preminger: An Autobiography*. New York: Doubleday, 1977.

Quirk, Lawrence, *The Films of Joan Crawford*. New York: Citadel Press, 1968.

Quirk, Lawrence, and William Schoell. *Joan Crawford—The Essential Biography*. Lexington: University Press of Kentucky, 2002.

Raeburn, Anna, and John Kobal. *Joan Crawford*. London: Pavilion Books, 1986.

Richman, Harry. *A Hell of a Life*. New York: Duell, Sloan and Pearce, 1966.

Rode, Alan K. *Michael Curtiz*. Lexington: University Press of Kentucky, 2017.

Rapf, Maurice. *Back Lot: Growing Up with the Movies*. Lanham, MD: Scarecrow Press, 1999.

Schifando, Peter, and Jean H. Mathison. *Class Act: William Haines Legendary Hollywood Decorator*. New York: Pointed Leaf Press, 2005.

Sherman, Vincent. *Studio Affairs—My Life as a Film Director*. Lexington: University Press of Kentucky, 1996.

Sikov, Ed. *Dark Victory: The Life of Bette Davis*. New York: Henry Holt, 2007.

Slide, Anthony. *Inside the Hollywood Fan Magazine*. Jackson: University Press of Mississippi, 2010.

Soares, André. *The Life of Ramon Novarro*. New York: St. Martin's, 2002.

Spencer, Charles. *Erté*. New York: Clarkson N. Potter, 1970.

Spoto, Donald. *Possessed: The Life of Joan Crawford*. New York: William Morrow, 2010.

Stern, Sydney Ladensohn. *The Brothers Mankiewicz*. Jackson: University Press of Mississippi, 2019.

Stine, Whitney, and George Hurrell. *The Hurrell Style*. New York: John Day, 1976.

Swindell. Larry. *The Life of Carol Lombard*. New York: Morrow, 1975.

Thomas, Bob. *Joan Crawford*. New York: Simon and Schuster, 1978.

Varney, Carlton. *There's No Place Like Home: Confessions of an Interior Designer*. New York: Bobbs-Merrill, 1980.

Vermilye, Jerry. *Bette Davis*. New York: Galahad Books, 1973.

Vieira, Mark. *Hurrell's Hollywood Portraits*. New York: Abrams, 1997.

Vogel, Michelle. *Joan Crawford—Her Life in Letters*. Louisville: Wasteland Press, 2005.

Walker, Alexander. *Joan Crawford—The Ultimate Star*. New York: Harper & Row, 1983.

Wayne, Ellen Jane. *Crawford's Men*. New York: Prentice Hall, 1988.

Wayne, Jane Ellen. *Robert Taylor*. New York: St. Martin's Press, 1989.

Young, Gwenda. *Clarence Brown: Hollywood's Forgotten Master*. Lexington: University Press of Kentucky, 2018.

INDEX

ABOUT THE AUTHOR

Robert Dance is author of *The Savvy Sphinx: How Garbo Conquered Hollywood*, *Hollywood Icons*, and *Glamour of the Gods*, and coauthor of *Garbo: Portraits from Her Private Collection* and *Ruth Harriet Louise and Hollywood Glamour Photography*.